W9-AUY-072

THE TEXAS COWBOYS

Cowboys of the Lone Star State

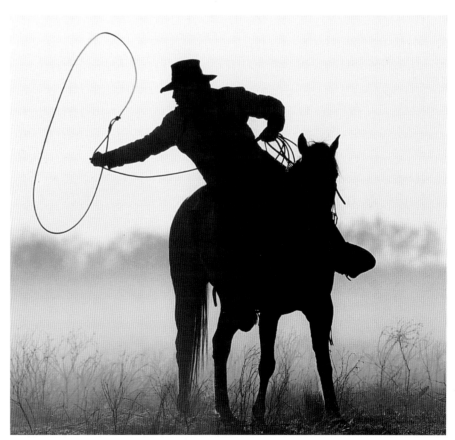

BIG LOOP
Melecio Longoria
McAllen Ranch; Linn, Texas

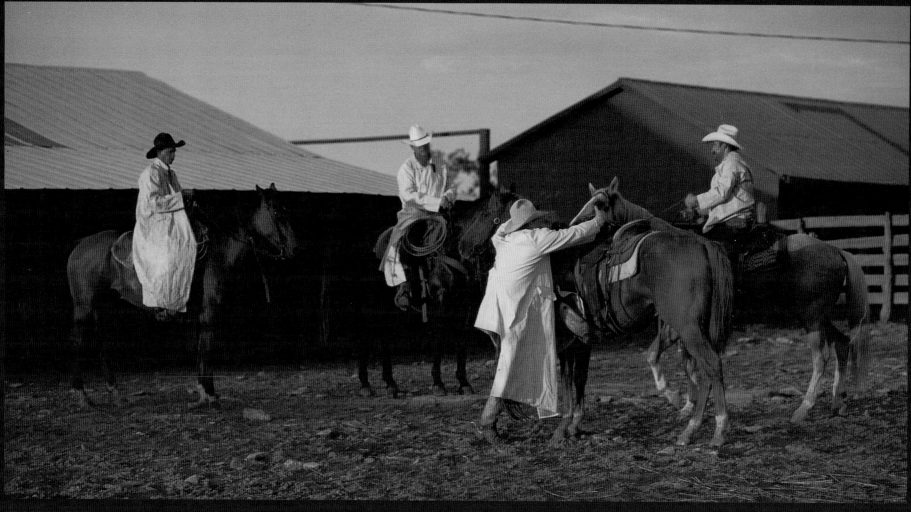

YELLOW SLICKERS
JODY EDWARDS, JIM CALHOUN, WES FARLEY, AND JOHNNY STEWART
Veale Ranch; Breckenridge, Texas

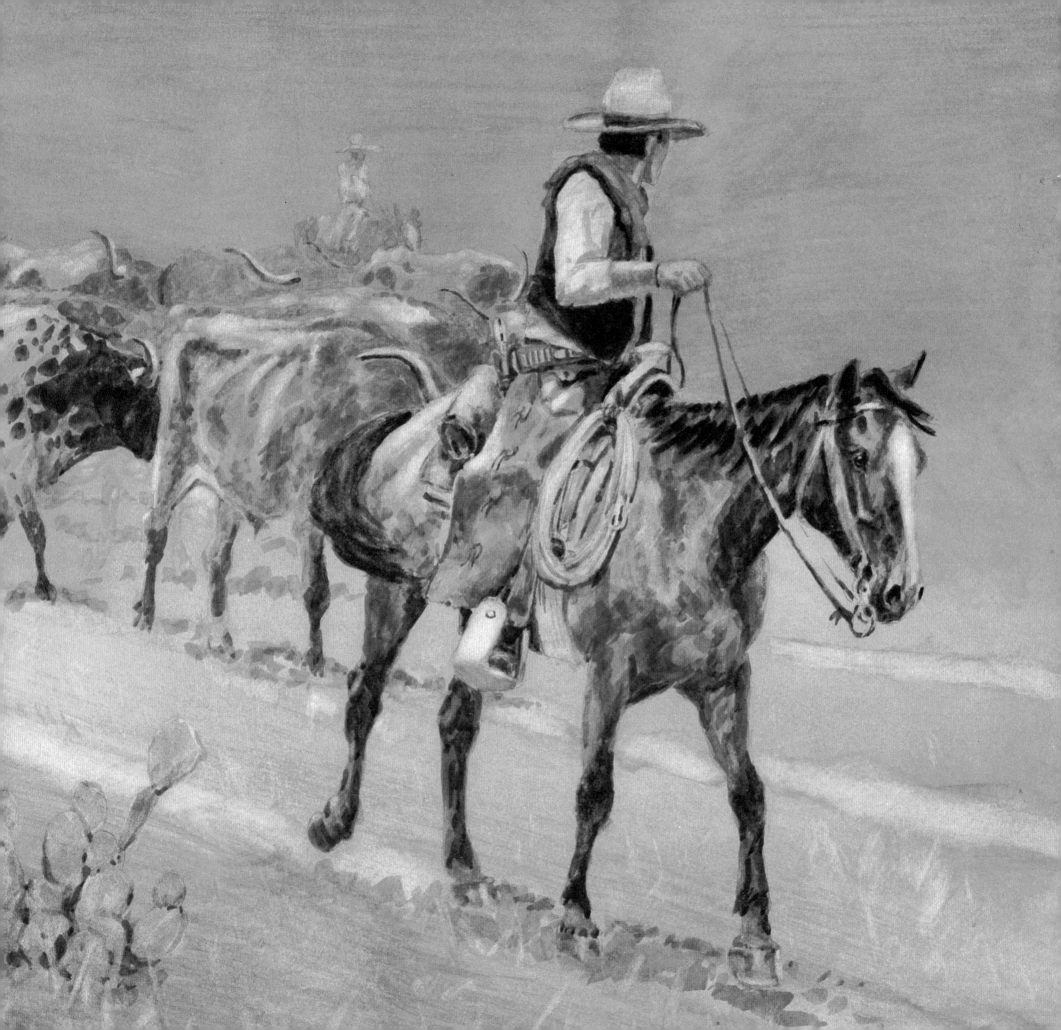

DEDICATION

I dedicate this book . . .

To all those who have ridden the cowboy trail;

To those who swell with pride when they throw a leg over the back of a good horse

that they trust with their lives;

To those who like to hear the squeak of saddle leather and the bawling of a newborn calf;

To those who delight in seeing God's world as he created it—

from the early rays of light in the east,

to the soft red glow of the sun as it sinks on the horizon in the west;

To those who love to feel the cool, gentle breeze of evening against their faces,

and hear the lonesome call of the coyote as God's evening lights begin to shine in the heavens;

To all the cowboys who have gone before, and to all those who will come after;

To my family, which started in Texas in 1850

and has taken part in blazing the trails of the Texas cowboy for the past 150 years;

And especially to my son, Thomas, the sixth generation of Saunders to cowboy in Texas,

who carries on the tradition and rich heritage of his family;

And, of course, to the great state of Texas, the place that made cowboying a way of life.

— Tom B. Saunders IV

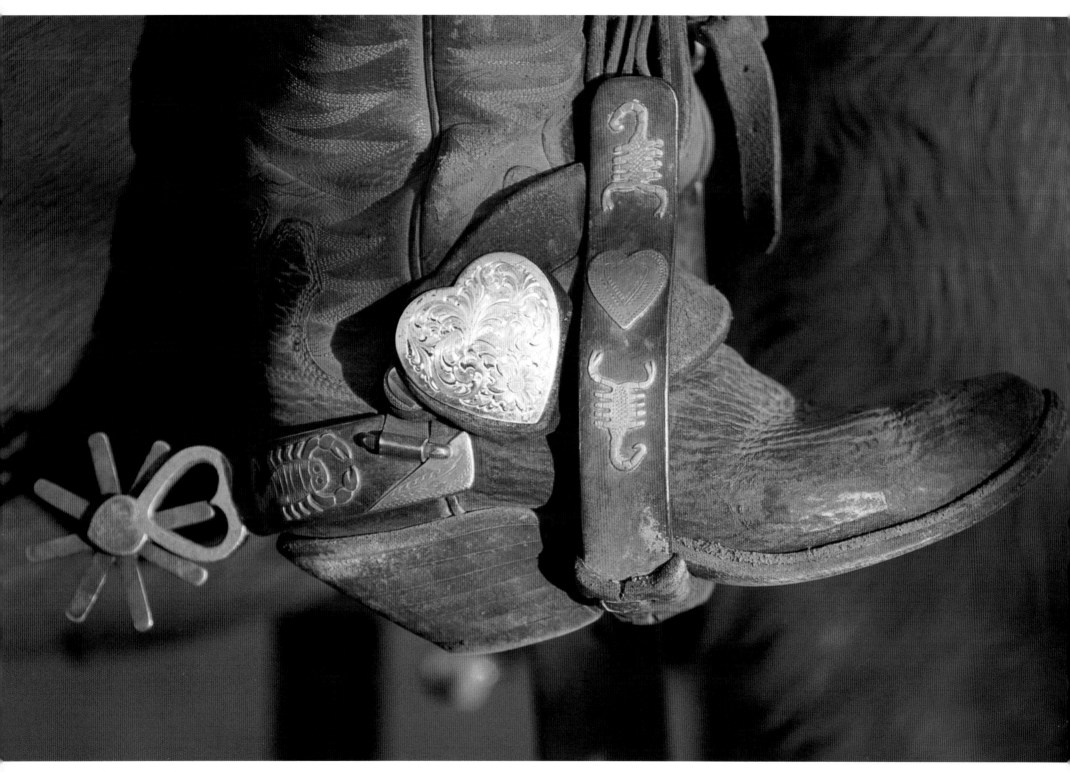

DAVID ROSS'S SPUR
Pitchfork Ranch; Guthrie, Texas

THE TEXAS COWBOYS

Cowboys of the Lone Star State

Photography by David R. Stoecklein

Text by Tom B. Saunders IV

Illustrations by Bob Moline

THE TEXAS COWBOYS

Photographer & Creative Director	DAVID R. STOECKLEIN
Text Researcher & Writer	TOM B. SAUNDERS IV
Illustrator	BOB MOLINE
Producer	JENNIFER R. DIEHL
Art Direction & Design	WOODLAND & KOPFER DESIGN
Text Editor	DAN STREETER
Text Editor	COLLEEN DALY
Text Editor	PREMI PEARSON
Associate Writer	BUSTER McLAURY
Consultant on Texas History & Contributor	JIM PFLUGER
Consultant on Black Cowboys	MICHAEL N. SEARLES
Consultant on Cowboy Songs & Poetry	SCOTT PRESTON

Cover Photo	BUBBA SMITH *Pitchfork Ranch; Guthrie, Texas*
Back Cover Photo	LONGHORN STEER *San Vicente Ranch; Linn, Texas*
End Papers	*Illustration by* BOB MOLINE

We did our best to accurately portray the history of Texas using sources both public and private. We gathered stories that have been passed down through generations of Texas cowboys and ranchers that we hope do justice to the great Lone Star State.

All images in this book are available as signed original gallery prints and for stock photography usage. Stoecklein Photography houses an extensive stock library of western, sports, and lifestyle images. Dave's photographs have appeared in international advertising campaigns and nearly every major magazine. David R. Stoecklein is also an assignment photographer whose clients include Marlboro, Chevrolet, Timberland, Ford, Coca-Cola, U.S. Tobacco, Wrangler, and the Cayman Islands. For more information, please contact:

DAVID R. STOECKLEIN PHOTOGRAPHY
208/726-5191 Fax: 208/726-9752

Stoecklein Publishing
an Imprint of Sands Print Group, Ltd.

201 East Lyndale Avenue #50-512
Helena, Montana 59601
888.449.6540 fax 406.449.6730

Printed in Hong Kong
Copyright ©1997 David R. Stoecklein/Stoecklein Publishing
ISBN 0-922029-60-1; Second Edition, 1998
First Edition printed in 1997
Library of Congress Catalog Number 97-065948

All rights reserved. No part of this book may be reproduced in any form or by any means whatsoever—graphic, electronic, or mechanical, including photocopying or information storage and retrieval systems—without permission in writing from the publisher.

THANKS

I now take this opportunity to say a few words about a few who did so much.

Thanks to Tom B., who is the king of the Texas cowboys, and to his family. Well respected by cattlemen and cowboys, Tom B. was able to open all the right gates and help pull this book together. Tom's wonderful wife, Ann, helped out by keeping Tom organized. Son, Thomas ran the Saunders ranch while Tom B. and I ran around all over Texas.

I also thank Ed Roberts, who introduced me to Phil Livingston, who introduced me to Tom B.

Thanks to Byron Price, former Director of the National Cowboy Hall of Fame and now the Director of the Buffalo Bill Historical Center, who introduced me to Jim Pfluger of the American Quarter Horse Association. Jim set up my first exhibit in Texas, and helped me organize photo shoots and the traveling exhibit for this book.

Thanks also go to all the cowboys I lived with and photographed, and to all the cattlemen in whose bunkhouses and cabins Tom B. and I slept, and in whose dining rooms we ate.

Last and first, I thank my wife, Mary, and my three sons, Drew, Taylor and Colby, for understanding my need to do this book—both for me and for them. I love you all.

P.S.

I would like to give special thanks to Ann Catherine Williams and Amy Elizabeth Haydon. These wonderful ladies are Tom B. Saunders' daughters and were greatly responsible for keeping up the home front and keeping Tom B. going during our 4 1/2 years that we spent working on this book. Thank you, ladies, very much. You helped make all this possible.

David R. Stoecklein

I am eternally grateful to those special individuals who contributed to this book. They all gave unselfishly of their time and energy to supply us with the historical facts, the opportunities, and the facilities that made this book a reality. And very special thanks go to my personal librarian and researcher, Mrs. Dora Belew, and my good friend, Bill Worden, who both have spurred me on. They made "mean" typists when it came to deadlines. My appreciation to my partner and good friend Dave Stoecklein goes without saying, for it was his drive and persistence that has brought this book to the public. And most of all, thanks to my wife, Ann, a dedicated English teacher whose efforts to stamp out ignorance remain relentless. I offer her thanks for her patience and guidance.

Tom B. Saunders

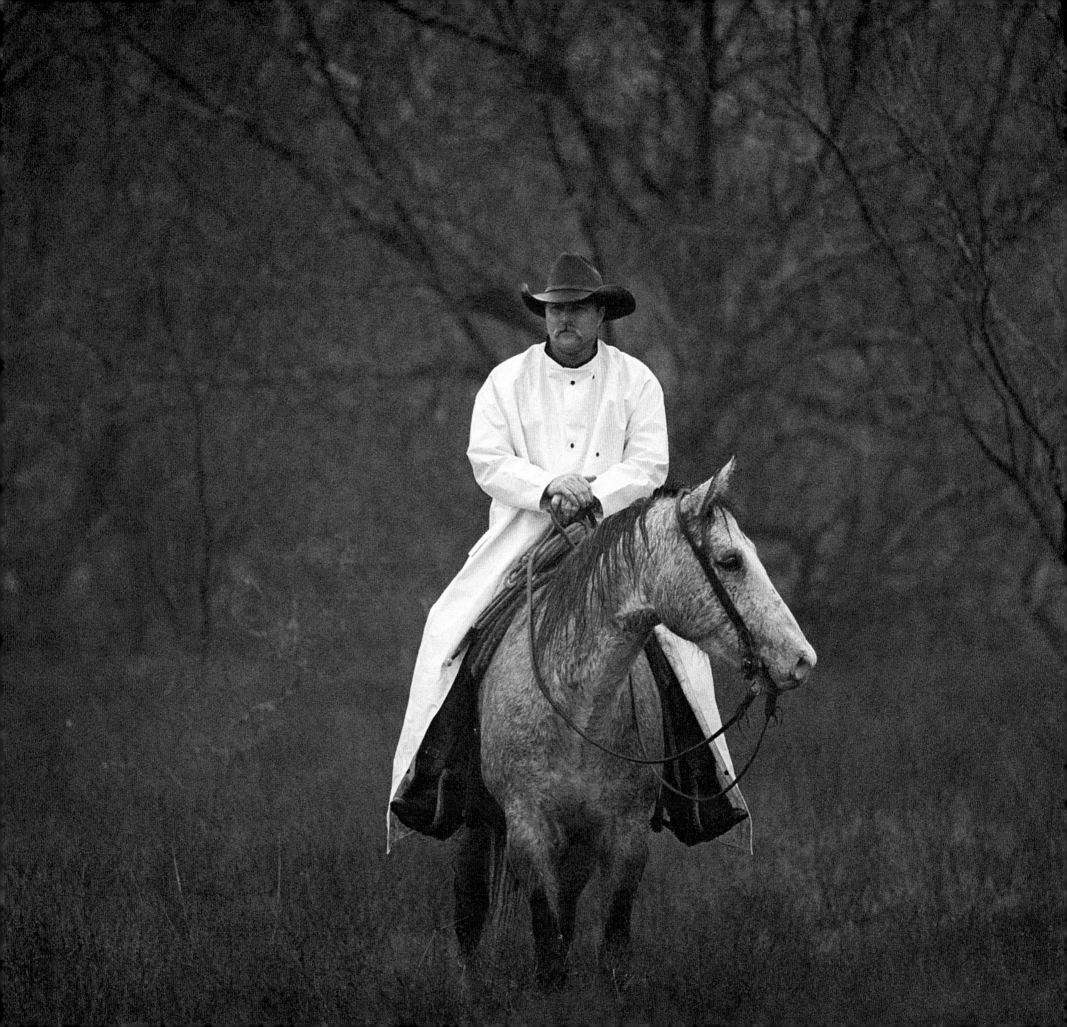

FOREWORD

Ten years ago, I began photographing cowboys for a new portfolio to show to my advertising clients. The first photos I took were of Ray and Mike Seal at the old Busterback Ranch in Stanley, Idaho, as the two shipped summer yearlings off to new owners somewhere in Kansas.

Shooting those photos made for an interesting day. I knew nothing about cowboys, horses, cows, or ranches. I also did not know that that day would change my life forever. From then on, I would spend every free moment photographing cowboys, horses, cows, ranches, cowboy gear, and everything else related to the lives and work of cowboys that I could find. I would read cowboy novels, history books, and the biographies of great cattlemen and their ranches. I would collect Western videos and all sorts of cowboy memorabilia and tack.

Since then, I have authored four books: *The Idaho Cowboy, Cowboy Gear, Don't Fence Me In,* and now, *The Texas Cowboys.* I have also published more than 35 calendars with cowboys, cowgirls, horses, and ranching as their themes. While *The Texas Cowboys* was at press, I began working on two more books in this series—*The Montana Cowboy* and *The Wyoming Cowboy.*

I now wear cowboy boots and a cowboy hat. I ride one of my 15 horses every chance I get, and I would play with a rope all day long if I could. Frankly, I have become obsessed with the West.

Recently, I have found that my work has meaning beyond satisfying this obsession. I have been told by people I respect that I am preserving history, that I am capturing the story of this time in the West and the cowboys who live here today. I am documenting how these men dress and ride, who they really are and what they really are. I have photographed them in Idaho, Oregon, Nevada, California, Wyoming, Montana, Utah, Arizona, New Mexico, Oklahoma, Texas, and Hawaii.

My odyssey began in Idaho, because that is where I live. It was simple to start there, close to home, photographing cowboys I knew and cowboys they knew. My second book, *Cowboy Gear,* was mostly written and photographed here. But to finish, I wanted to go to Texas to photograph different cowboys, scenery, and livestock. I called Ed Roberts, executive secretary of the American Paint Horse Association, in Fort Worth, and asked if he could help me set up a photo shoot.

On my first trip to Texas, Ed introduced me to Phil Livingston. Later, Phil took me out to meet a friend of his who owned a ranch near Weatherford. Phil felt that this ranch might be a good place to take photographs and to find the right cowboys and livestock for the last photos in *Cowboy Gear.* That ranch was the Saunders Twin V, owned by Tom B. Saunders IV, a fifth-generation Texas cowboy and cattleman. As I was walking across the yard to be introduced to Tom B., his dog, Newt, ran out from under the horse trailer and bit my leg so hard that it tore my Wranglers through to my skin. I asked Tom B. if this was the way Texans greeted all Yankees. Unbeknownst to me, and I am sure to Tom B., this meeting was the beginning of a great friendship and the start of *The Texas Cowboys* book.

Tom and I talked about my book *The Idaho Cowboy,* and discovered that we both wanted to produce a book about Texas. We wanted this book to be the best book ever published on the Texas cowboy, and to have photos of century-old ranches and descriptions of the way Texas cowboys lived and worked in each region. Tom B. wasn't a writer, but he was a student of history and his family was part of the history of the Texas cattle industry. I saw in Tom B. the soul of the Texas cowboy. He was cowboy and cattleman all rolled into one. He knew the land and the ranches and the men who worked on them.

Tom's job was to set up the photo shoots with the ranches and cowboys. He found Buster McLaury, who wrote the introduction and the story about West Texas Cowboys, and Bob Moline, who created the illustrations and paintings for the book. Tom wrote *The History of the Texas Cowboy,* as well as the descriptions of each region in Texas and the biographies of each ranch. And so our journey began.

During the past four years, Tom B. and I have traveled more than 5,000 miles in rental cars and on airplanes, slept in too many bad motels, and dined splendidly at chuck wagons and in great ranch houses. We have had hundreds of hours of conversations with cattlemen, cowboys, cowboys' wives and daughters, and other ranch people. Those conversations took place in pickup trucks, over dinner tables, around horse corrals, barns, and lonesome windmills.

Tom B. once said he did not want the research and photography for *The Texas Cowboys* book to ever end. There is so much history and there are so many legends in Texas that we could have gone on forever. What we did was do our best to show the best of Texas, and to show it as it is today.

We could not photograph each and every one of the great ranches and cowboys that Texas has to offer. All of the ranches included in the book are over a hundred years old and steeped in history, and employ real cowboys. Unfortunately, because of time and space constraints, we left out a number of important ranches and cowboys. For this, I apologize. I only hope that we have authentically represented Texas and that we have accurately portrayed the true Texas cowboy.

David R. Stoecklein

LEE HAY
Hay Ranch; Waco, Texas

BUBBA SMITH
Pitchfork Ranch; Guthrie, Texas

CONTENTS

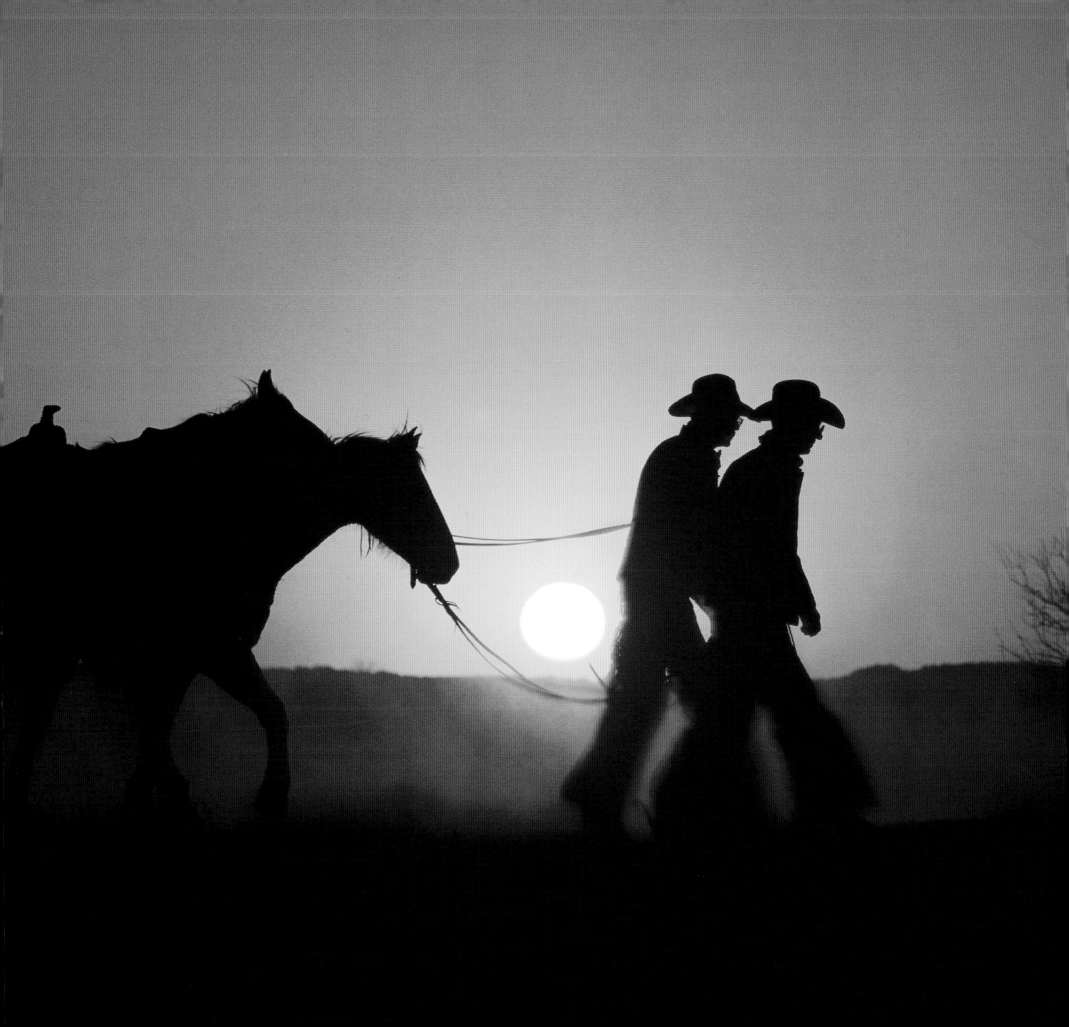

FORK YOUR BRONCS AND FOLLOW ME

Fork your broncs,
And follow me through,
And I'll try to tell you this story
—At least it's partly true.

Facts and figgers
May slip my mind,
But the tracks are there,
And I can still read sign

Of the longhorn cattle
They drove up the trail,
And the ponies they rode
Tell quite a tale

Of some very old-timers
Who have come and gone,
And of the young punchers
Who still sing their song.

So, if you want to hear more of
How the cowboy came to be,
Then saddle your hoss
And come along with me.

We'll start at the first,
When Texas was born,
But we all know she came
From hide and from horn

And how the cowboy and his hoss
Came along with the cow.
We're gonna tell that tale
Of back then and even to now.

So stay with me, Ole Pard,
And I hope you enjoy.
For I'm gonna tell you 'bout
The Texas cowboy.

—*Tom B. Saunders IV*

TOM MOORHOUSE AND FRO WALDEN
Moorhouse Ranch; Benjamin, Texas

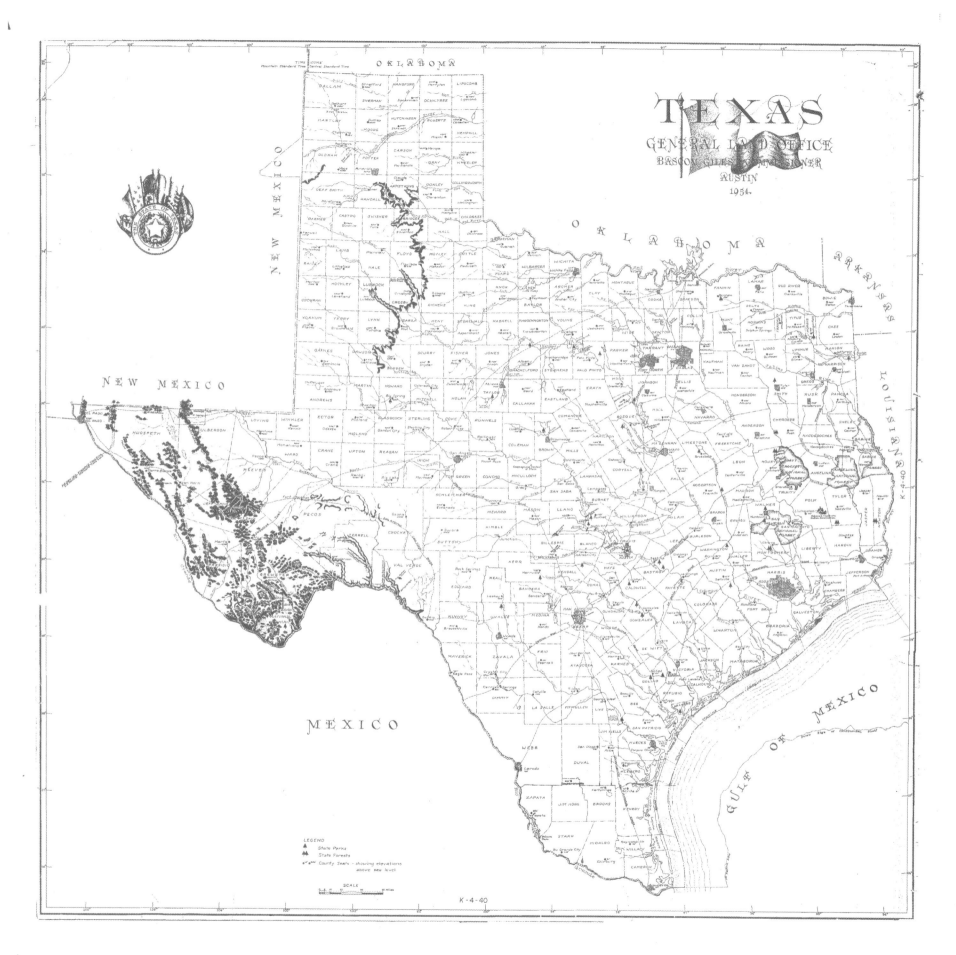

THE TEXAS COWBOYS — INTRODUCTION

INTRODUCTION

Buster McLaury Benjamin, Texas

When you mention the word cowboy, most people immediately think of Texas. And well they should. Cattle have been raised and herded in Texas by men on horseback since the Spanish conquistadors introduced cows and horses to the area around 1541. Over the next three hundred years, the young men who rode the range taking care of the cattle survived summers long and hot, winters of bone-chilling cold, floods, hailstorms, lightning strikes, and other whims of nature. They survived long nights, lean times, loneliness, stampedes, and even wars. Without any fanfare they took their place among the best known, hardest working, and perhaps least understood folk heroes the North American continent has ever produced—the Texas cowboys.

Over those three hundred years the herds grew ever larger, and by the 1860s cattle were so plentiful that Texas ranchers began driving their animals north in search of available markets. The trail drives covered many hundreds of miles and took months to complete. The new cowboys who helped move the great herds learned the ways of cattle and how best to gather, handle, drive, and take care of them. The men who took on this way of life were of many different races and came from all walks of life—veterans from both sides of the Civil War, former slaves, Irish immigrants, and Mexicans, among others.

When the trail drivers reached their destinations in Missouri, Kansas, and Colorado, the cowmen began hearing stories of prime cow country to the north. Soon mixed herds of cows, steers, and bulls skirted the Comanches of the Southern Plains and headed for places like Wyoming, Montana, and the Dakotas; a few even made it into Canada. The ranches started up there—and there were a lot of them—were referred to as "Texas outfits" until well after the turn of the 20th century. Not all the Texas cowboys stayed and braved the cold, but those who did left an indelible mark. They influenced the northern ranchers in the way they ranched and handled cattle, the type of gear they used, and their style of horsemanship. Those influences are still apparent today.

The Texas cattle and cowboys influenced ranching life from Texas north through the plains states—Oklahoma, Kansas, Nebraska, and the Dakotas—into Canada, westward to the Rocky Mountains and into Arizona in the Southwest. That's a pretty good chunk of country.

Not too many years ago, you could look at a cowboy's outfit—saddle, bed, spurs, leggings, rope, bridles—and be able to figure out pretty well what part of the country he was from. For most cowboys that's still true, but due to a melding of styles that comes from cowboys traveling to different parts of the country, it's now sometimes harder to tell.

For the most part, the Texas cowboy is still identifiable. He'll probably be ridin' a swell-forked, double-rigged saddle, and he's liable to have a breast collar of some kind tied onto it. Many cowpunchers have their stirrups covered with little bulldog tapaderos made of heavy leather or rawhide. He still favors a short rope—30 to 35 feet long — tied hard-'n'-fast to the saddle horn.

As for bridles, they'll usually have a leather, split-ear headstall and split-leather reins. Bits will range from a ring to a snaffle to a grazin' bit. They may have a little silver overlay, but you generally don't see the intricate metalwork, inlaid silver, or fancy engraving that buckaroos prefer.

When a cowpuncher leaves the wagon or bunkhouse for a day's work, he'll be sportin' a lid creased to his own special style. The hat will be made of felt in the winter and straw in the summer, with a low crown and a $3^1/_2$ to $4^1/_2$" brim.

This cowboy will put on all the clothes he owns to try to keep warm in the winter, but the outer layer will be made of duckin' or some other heavy material that will turn most of the Texas thorns he'll encounter in any given day. He's liable to wear a Levi or duckin' jacket even during the summer—again, to turn the brush. He'll likely wear a wild rag around his neck in cold weather.

His pants are usually Levis, and they're usually tucked into tall-topped, shop-made boots. His spurs are mostly custom made, have a fairly small rowel (no jinglebobs—this feller has to quietly slip up on somethin' occasionally), and probably have a little silver overlay, but, again, nothin' extra fancy. The brush hands wear shotgun or batwing leggings almost exclusively.

So you can see that the Texas cowboy had, and for the most part still has, a distinctive style of his own. It leans less towards fancy and more towards functional.

And he has pride. He figures, and rightfully so, that he can gather cattle that most people couldn't even find, and that anyone who can make a hand in the thickets and rough country of the Southwest can go anywhere in the world and punch cows with anybody.

You'll notice I keep usin' the present tense in describin' the Texas cowpuncher. That's because that son-of-a-gun is still out there, still ahorseback and still doin' basically the same job his great-grandaddy did. I'm not talkin' from the perspective of a reporter or spectator. I live and work amongst 'em every day. The Lord has blessed me with good company.

Critics have said since the end of the trail-driving era that cowboying is dead—gone. Well, I'm here to tell you that despite barbed wire, farmers, politicians, environmentalists, animal rightists, computers, jet airplanes, four-wheel-drive pickups, low pay, and some ranchers who don't know whether a cow sleeps on the ground or roosts in a tree, these hombres are still on the job. The cowboys are still out here following a callin' to care for and harvest the wild bovine. That's a callin' that goes back to Abraham.

True, the job and responsibilities have changed. There's no denying that. There are no more trail drives to Abilene, Dodge City, or to the Milk River in Montana. It's not that these modern-day cowpunchers aren't up to the task. Just ask any one

and he'll indignantly tell you that he'd be more than happy to make the trip if there weren't so damned many fences and John Deere tractors in the way. The open range is gone.

Cowboys today work on ranches that vary in size from a few thousand acres to several hundred sections. They live, for the most part, on the ranches they work for, either at headquarters or on a camp. Married men are furnished a house, utilities, and a beef or two a year in addition to their wages. Single boys live in the bunkhouse at headquarters and get three meals a day in the cookhouse.

Quite a few outfits still use a chuck wagon during their cow work. Cowboys still take their bedrolls and remuda and follow the wagon as it moves from camp to camp, just as they did 40, 60, 100 years ago. Cooks still serve up beef and beans and taters, and still complain about wet wood and blowin' dust.

The cattle these fellers work are no longer rangy longhorns, and their calves are bigger and more uniform in the fall. But they still have the same bovine instincts that inspire them to avoid cowpunchers. Like the longhorn, they'd rather be left alone to roam the range or get lost in the thickets if they so please. Those thickets of mesquite brush and cedars cover hundreds of thousands more acres now than they did a hundred years ago, making the contemporary cowboy's job tougher than his predecessor's in that respect.

On a modern-day cow outfit you'll find owners and managers concerned about balancing age-old techniques and computer-age technologies, while still trying to turn a profit. There'll be a foreman or wagon boss trying to incorporate the new innovations while trying to keep a crew of cowpunchers ahorseback and happy. And there will be the cowpunchers themselves, who sincerely want to see the outfit make money, but are worried that the old ways will disappear in their lifetimes.

Cowboys understand that they live in modern America, even if they might like to retreat into the past—back to a simpler time. They have to provide for their families, buy groceries, pay bills, and try to put their kids through college on their meager salaries. Just like everyone, they hope the car doesn't break down, or the kids get sick and have to go to the doctor. They hope to save a little money, but usually they live from one paycheck to the next. On paper, cowboyin' doesn't pencil out these days. I doubt if it ever did.

So why do they keep at it? There are any number of different theories. But they are just that, theories. The reasons for cowboyin' are as varied as the individuals who pursue it. Heaven only know what makes a man abuse himself and his family so he can claim this callin'.

My compadre Tommy Vaughn, a cowpuncher from the Big Bend country, put forth his theory. "It's the freedom. Where else can a man spend his days ahorseback —maybe never seein' another human all day—doin' what he knows needs to be done without havin' somebody standin' there pointin' their damned finger at you."

Will all the modernization and computerization that is hammering at the cowboy from all sides someday end his way of life? I doubt it.

They'll never make a machine that can prowl through a pasture, look at the grass and the condition of the cattle, and decide what needs to be done next.

They'll never develop a computer program that can tell if a cow is wet or dry, and then figure out which calf is hers.

They'll never come up with software that knows just how far or fast to push a crippled animal, how tight or loose to try to hold a bunch of trotty ol' cows, or how to look at a track and tell not only the direction and speed that ol' bull's travelin', but about where he might stop and bush up.

No, God gave the ability to reason and use common sense to man alone. And there are far too many intricacies involved in the cow business and punchin' cows to ever program it into a damned machine. If you could someday get the information all written down, just as you finished the weather would change or a bronc would blow up and buck through the roundup, or something else would happen to shoot your computer program all to hell.

On top of this, they'll never build a machine that can stand up to the abuse that a cowpuncher and a cowhorse take on a daily basis.

A cowboy lives by an unwritten code of ethics that involves integrity, morality, and honesty. Does he set himself up as some kind of icon he thinks the rest of the country should follow or look up to? Certainly not. He figures that every man must decide how he wants to live. In that respect, maybe he's the living cornerstone of America's concept of itself.

Like my daddy, Royce McLaury, used to say, "If it was easy, anybody could do it, and everybody would want to."

Last year, David Stoecklein took his camera and his talent and visited 23 Texas ranches during their cow works. In this book you'll find the ranches, cattle, and cowpunchers, just as he found them.

So pour yourself a big, Texas-sized glass of iced tea and enjoy the photographs and the text. Revel in the fact that America's own folk hero is still as real, alive, honest, tough, and bowlegged in 1996 as he was in 1896.

He is still a cowboy.

'Nuff said.

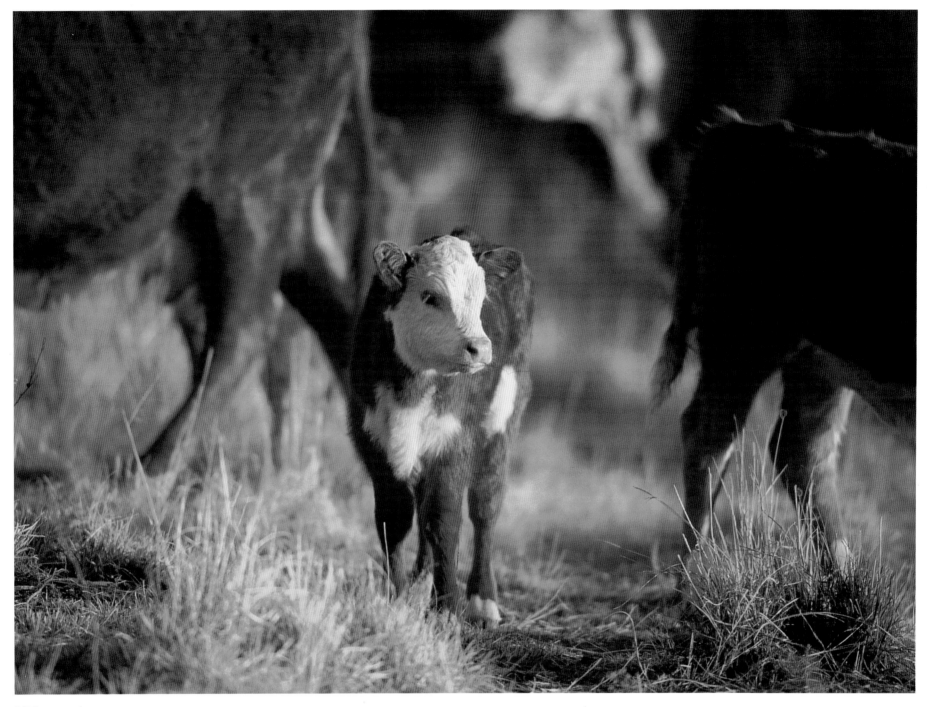

CALF
Pitchfork Ranch; Guthrie, Texas

EVOLUTION OF THE TEXAS COWBOY

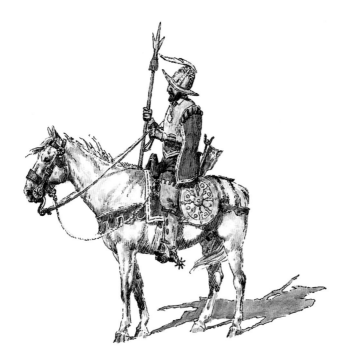

SPANISH CONQUISTADOR

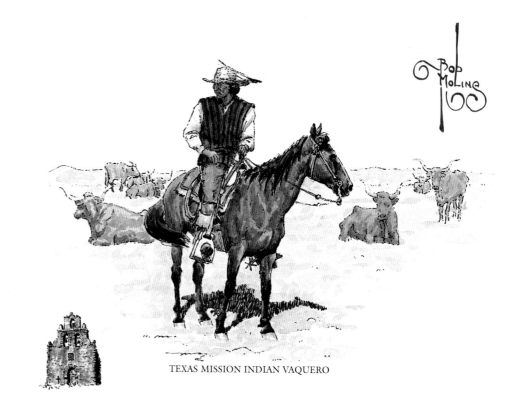

TEXAS MISSION INDIAN VAQUERO

TEXAS CATTLE DROVER

WAGON BOSS

CHARRO

THE TEXICAN

WORKIN' COWBOY OF TODAY

DEFINITION OF A TEXAS COWBOY

The cowboy was a man apart from his work and yet, at the same time, a natural product of his work. He felt more at home astride his pony than he did walking on his own two legs. His mind and body were so attuned to the motion of his horse that horse and rider appeared to be one in the same—one not complete without the other. These men of the saddle might be untutored by books but they certainly were not ignorant. Their profession was one which demanded skill, toughness, both physical and mental, a keen eye for details, and a strong will. As a profession, being a cowboy engendered a pride. Although these cowboys were laborers of a kind, it is true that they regarded themselves as artists, and artists they were. Many years of experience and practice in animal psychology were necessary to perfect a top hand. No cowboy ever suffered from an inferiority complex or considered himself in the laboring class. He considered himself a cavalier—a gentleman on horseback, an aristocrat of all wage earners.

—J. Frank Dobie

A Vaquero of the Brush Country

Young Sam left the Collins Ranch
in the merry month of May
With a herd of Texas cattle
for the Black Hills far away.
Sold out in Custer County
and then went on a spree
A harder set of cowboys
you seldom ever see.

—*Anonymous, "Sam Bass"*

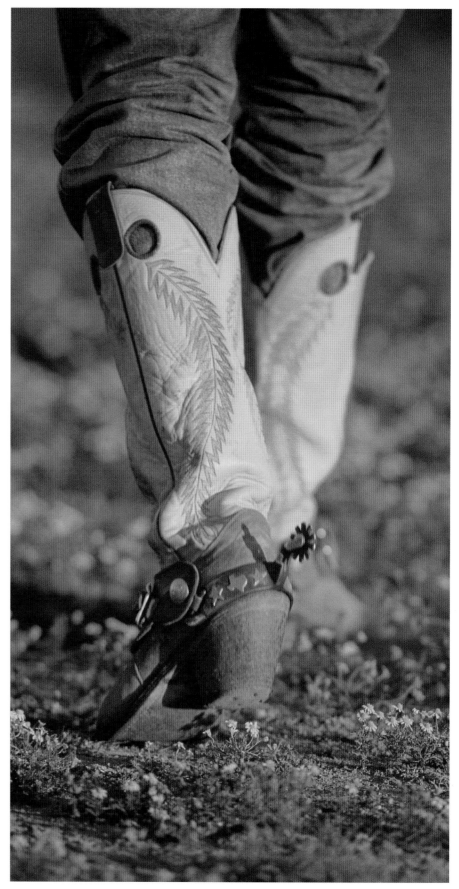

YELLOW BOOTS & TEXAS SPURS
06 Ranch; Fort Davis, Texas

A History of the Texas Cowboy

Tom B. Saunders IV A Fifth-Generation Texas Cowboy's Folk History of his State

Underneath a sky still filled with morning stars, a boy slowly fluttered his eyelids open. His body was stiff and uncomfortable, not from sleeping on the ground, which was still crunchy-cold and white around him, but from riding on the back of the Spanish animal, the animal the conquistadors had brought to these lands of Tejas, as the newcomers called it.

The Indian boy jumped up and threw off his blanket, ready to assume his duties. He was responsible for the care of the cattle at the mission and would ride his horse that day for only the second time in his life. His older brother, two cousins and four other boys, friends of his, would ride with him. The padres at the mission called them vaqueros, from the Spanish word vaca, meaning cow. A vaquero was someone who rode a horse and tended cattle.

The boy could hear the horses shuffling and nickering softly to each other in the pre-dawn quiet. As he rolled up his blanket, dreaming of the adventures the day would hold, he was blissfully unaware that he was the first Texas cowboy.

The Spaniards were the first to settle Texas, riding north from Mexico. As early as 1716, they established mission ranches along the Rio Grande, hoping to convert the Native Americans to Catholicism and a more settled way of life, and to establish a presence in the area. By introducing horses to Tejas, the Spanish added the final magic ingredient to a mix of elements that would eventually establish Texas as the largest cattle- and cowboy-producing state in the nation.

A cowboy rides a horse, a horse pushes cows, cows need lots of land to roam on, and Texas has lots and lots of the kind of land cows like. How much of that land? Millions of acres of grazing lands—about 184 million acres, to be a bit more precise. Cattle were made for Texas and Texas was made for cattle. Even the shape and texture of Texas is considered by some to resemble a roughly skinned cowhide, and the words of Berta Nance take the connection even further:

Other states were carved or born,
Texas grew from hide and horn.
Other states are long and wide,
Texas is a shaggy hide.
Dripping blood and crumpled hair,
Some gory giant flung it there.

Laid the head where valleys drain,
Stretched its rump along the plain.
Other soil is full of stones,
Texas plows up cattle bones.
Herds are buried on the trail,
Underneath the powered shale.
Other states have built their halls,
Humming tunes along the wall.
Texans watched the mortar stirred,
While they kept the lowing herd.
Stamped on Texan wall and roof,
Gleams the sharp and crescent hoof.
High above the hum and stir,
Jingle bridle reins and spur.
Other states were made or born,
Texas grew from hide and horn.

Texas may have grown from hide and horn, but cattle, just like horses, didn't spring up naturally from Texas soil. Stories tell us that cattle were first brought to the New World by Columbus on his second voyage in 1493. Hernán Cortéz imported cattle to his hacienda in Cuba in 1521, and later to his estate in New Spain, now Mexico, at a place called Cernavaca, a word that translates as "cow horn." Cabeza de Vaca was the first explorer to enter what is now Texas, but it wasn't until 1541, when the conquistador Francisco Vasquez de Coronado and his company embarked on a gold-hunting expedition, that the first cattle and horses walked into Texas.

Then there is the story of a certain Alonso de León, who could be described as a cross between the biblical Noah and America's Johnny Appleseed. Traveling in 1690 from Mexico to establish the first Spanish mission in Texas at a remote site, de León reportedly left one bull and a cow and one stallion and a mare at each river he crossed. Scattering seed stock in this methodical way, he virtually created the legendary herds of longhorns and mustangs that would one day roam the Texas hills and ranges.

Alonso de León was a man of vision. One hundred and fifty years later, when Texas won its independence from Mexico and was recognized as a sovereign nation, an estimated 300,000 cimarrones, uncontrollable cattle, ranged free and wild over the region. And there were also large numbers of stock, branded and unbranded, which were routinely rounded up by the vaqueros at the numerous missions and ranches that had been established by then.

The Texas Longhorn

The Texas longhorn were enormously large and powerful critters. Rangy, mangy and sort of spooky looking, they were lantern-jawed, slab-sided, loose-hided, high-withered, low-backed, and cat-hammed. They looked gangly and clumsy when standing still, but they were built for speed.

Longhorns had coats of many colors although they were generally dull and earth-toned, fading into the landscape from a distance. No two were marked the same. They were: black; black with brown; brown with black points about the head and muzzle; blue; speckled blue; grulla (ash colored); red, from dark to light; duns; all hues of yellow; roans-red and blue-white to red spotted.

Many were line-backed, mottle-faced, streak-faced, bonnet-faced, or ring-eyed, and all had long, coarse hair around the ears, atop the head and down the backs of their necks.

Their large frames supported a massive set of horns. On some old steers these horns measured as much as eight feet from tip to tip, and the configuration varied as much as the color. Extremely hearty souls, they could survive in almost any environment, from the lush, highly productive area of eastern Texas to the semi-desert country of western Texas and the Wild Horse Desert of the coastal plains. Equally at home in the dense brush country and the rolling plains, they reproduced prolifically, some cows bearing calves up to the ripe old age of twenty.

Stories tell us that longhorns could travel great distances to water and suffer no ill effects. No natural predator could handle a healthy longhorn, and their herding instincts usually protected the small and the weak of a group against attack. A pack of wolves would starve to death relying on the cattle for sustenance. The only threat to the adult longhorn was posed by man—red and white.

The longhorn was said to have been as strong and ornery as a bear, as agile as a cat, and as fast as a deer. Slow to mature, at seven to eight years old they often weighed 1,100 to 1,200 pounds; at fifteen or sixteen, a ton.

The old-time cowboys were often heard to say, "You better have a deep seat and a lot of horse under you when you tie onto an old mossback. Them critters are shore a loop-full!"

The Native Americans and the Spanish Mustang

No one knows for certain when the Indians of Texas first began using the horse. After the conquistadors came riding along on what the Native Americans called "Elk dogs," the horse became valued for transportation, hunting and, especially, for war.

The Comanche Indians, 30,000 strong and a dominant people of the Southern Plains, became undisputedly the greatest horsemen in North America. The first tribe to adapt their lifestyle around the horse, the Comanche were not cowboys and, in fact, had nothing but disdain for what they called the white man's buffalo. They slaughtered or stampeded cattle whenever possible in an attempt to preserve the grazing lands for the native buffalo they revered and hunted.

The Comanche valued horses as much as they hated cows, and stole them at every opportunity. One account claims that the Comanche had killed or run off 22,000 head of horses from the San Antonio Territory, without leaving one ridable horse for the townspeople.

These lords of the Southern Plains were legendary fighters, virtually unbeatable. Not only did they dominate neighboring tribes and maintain control over the southern buffalo herds, they kept the Spanish from settling Texas for 200 years and kept the Anglo-Texans out of the high plains for 70 years. It was not until Samuel Colt invented the six-shot pistol in the mid 1840s that the tide of power began to shift.

The First Anglo-American in Texas

There were already a few Anglo-Americans in Texas by the turn of the 19th century. Stories have it that the first Anglo child was born in 1804 near Nacogdoches in far eastern Texas, but it wasn't until after Stephen F. Austin secured his father's grant from the Spanish government that the first official Anglo colonists settled in the area, in 1821. When Austin rode away from the Spanish consulate with papers in his pocket authorizing him to colonize 200,000 acres of his choice, he knew nothing of the territory he was about to explore. Traveling southeast some 175 miles, he encountered El Rio de los Brazos de Dios, "The River of the Arms of God," which he described as "the most beautiful land of fine soil with an abundance of timber and water." Here he found large herds of longhorn cattle, wild Spanish horses, and game of all kinds.

When he drew up the boundaries, Austin claimed 11 million acres, some 18,000 square miles—quite a bit more than the measly 200,000 acres he'd been granted in the first place. However, the colony was invalidated almost as soon as it was created on paper, because there was revolution in the air. After the Mexicans overthrew their Spanish rulers, the new government eventually approved the colony and appointed Austin their civil commandant, throwing in 100,000 acres for his own personal ranch.

Potential settlers were promised 4,605 acres: 200 acres for farmland and the balance for ranch land. Although many of the pioneers who arrived had some knowledge of stock raising and could ride a horse, none were true cowboys. But wild longhorns were available to anyone who could rope 'em, and as the ranches took shape, young men quickly adapted to the cowboy way of life. They developed and perfected their skills with the help of the Mexican ranchers and their vaqueros. They adopted the Mexican gear: saddles, reatas or ropes, spurs, leggings and bridles; they adopted the Mexican way of dressing: big-brimmed hats and tight-legged pants; they even adopted some of the Mexican language.

These influences, although modified over the years, are still evident today in the look and the sound and the ways of the Texas cowboy.

Texas Becomes a Nation

By 1830, Austin's colony had some 4,000 settlers, and there were about 16,000 Anglo-Americans in all of Texas, outnumbering the Mexican population four to one.

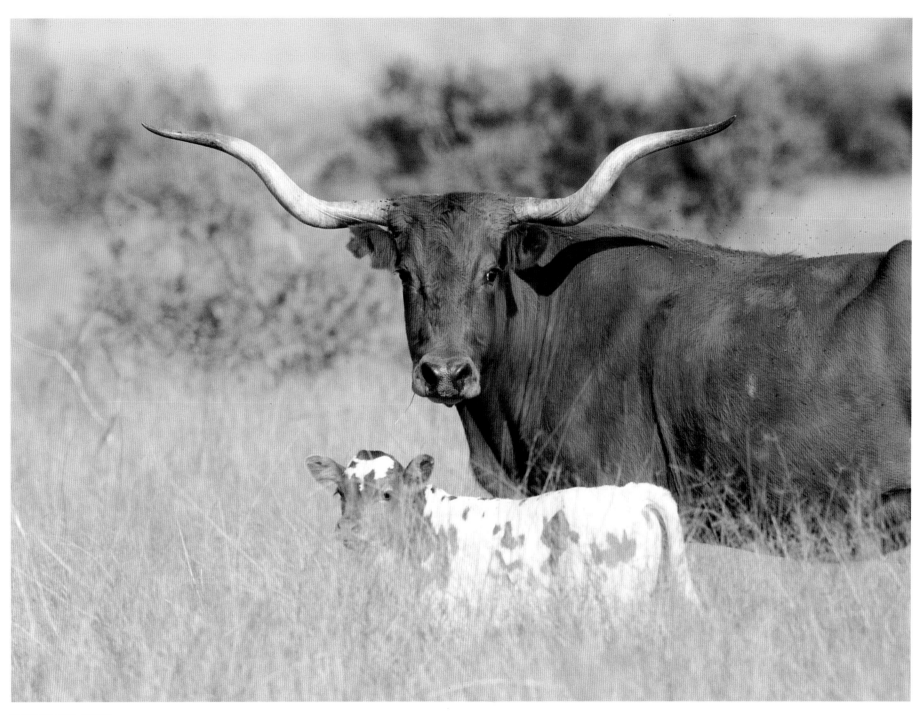

MOTHER AND CHILD
San Vicente Ranch; Linn, Texas

An alarmed Mexican government passed laws halting all Anglo immigration, and placed Texas under military occupation. Anglo immigrants continued to flood across the Red and Sabine rivers into the area, setting the stage for the Texas Revolution.

The first skirmish, in the tiny settlement of Gonzales, located on the Guadalupe River, concerned a small brass cannon that had been supplied by the Mexican government for protection against the Comanche Indians. The Mexicans, fearing the rebellious attitude of the Tejanos, decided to take it back. The Texans, learning of these plans, mounted the cannon on an ox cart draped with a banner reading, "Come and Take It!" When 100 Mexican soldiers crossed the Guadalupe, 160 ranchers and settlers opened fire with their long rifles. The disadvantaged soldiers quickly withdrew to San Antonio.

One man from Tennessee, who had been raised among the Cherokees, knew when he heard about the battle at Gonzales that the time had come for Texas to claim its independence from Mexico. A man of the woods, he had fought in the Creek Wars. A bullet-scarred veteran and a political climber, he had the ear of his important friend, President Andrew Jackson. His name was Sam Houston.

Traveling to San Felipe, Houston met with Austin, and together they created the Texas army. As the Commander-in-chief, Houston inspired volunteers with the call, "Let the brave rally to our standard!" He also mentioned land bounties for all who enlisted.

While Houston was gathering his troops in 1836, some 150 brave Texans prepared to fight to the death at the Alamo at San Antonio de Bexar. The Mexican Army, intent on crushing the rebellious Texans, was led by General Antonio Lopez de Santa Anna, the new dictator of Mexico. Under his command, 5,400 men and 21 cannons raged in battle for thirteen days against the small band of Texans before claiming victory. But Houston's forces were growing, and six weeks later, in April, 800 Texans met the Mexican army on the coastal plains at San Jacinto. Their battle cry, "Remember the Alamo!" inspired the Texans to fight with extraordinary courage and determination. The battle lasted only a few minutes. The Texans captured Santa Anna and won their freedom. The Declaration of Independence was signed, and Texas became an independent republic.

After the war with Mexico, Houston's army disbanded and the young men returned home—back to cowboying, and raising kids and cattle. The country was sparsely settled, with ranches only every ten to fifty miles. Because there was no military force and no organized local protection, only a few established counties and even fewer courts of law, every man had to take the law into his own hands in order to protect his family and his property. The cowboy code called for honesty and fairness, pure and simple. A man's word was his bond, and his reputation depended on it. Thieves found Texas a mighty unhealthy place to pass through—if they were able to live long enough to leave. Swift and stern justice was meted out to all offenders.

The Texas Rangers

As the new republic began to develop, there were growing pains. The Mexicans still claimed the south and southwest portion of Texas along the Rio Grande. The Native Americans held undisputed possession of the Southern Plains, and the Anglo-Americans, who were called Texicans, controlled the timbered portion of the east.

The Mexican soldiers, the native warriors and the Texicans all fought constantly to defend these territories and try to gain supremacy over the entire region.

Austin, recognizing the need for a protective force, in 1835 formed the Texas Rangers. The Rangers were staunch, fearless men whose fighting prowess was unequaled. A volunteer group, they were called upon only when needed to squelch a Mexican raid, retrieve stolen stock, or bring thieves or murderers to justice. Paid one dollar a day and a hundred rounds of ammunition, they furnished their own horses, gear, and personal needs. Most Rangers were young cowboys from the local ranches. Now they are legends.

THE TEXAS RANGERS

The stars have gleamed with a pitying light
On the scene of many a hopeless fight,
On a prairie patch or a haunted wood,
Where a little bunch of Rangers stood.

They fought grim odds and knew no fear.
They kept their honor high and clear,
And, facing arrows, guns and knives,
Gave Texas all they had—their lives.
—W.A. Phelson

For ten years the Rangers were the only law and order in Texas, but as the number of Indian raids increased and the threats of Mexican reprisal continued, the scattered Texans sought the aid and protection of the United States. In 1845, Texas became the 28th and largest state in the Union. This heated up the dispute with Mexico over the southern boundary of Texas, and U.S. General Zachary Taylor and his army were sent to defend the new territories.

The Texas Rangers offered their services, but Taylor was skeptical, having heard in parts north that these cowboys were disorganized and undisciplined. In the end, Taylor considered the Rangers to be his greatest weapon, his best scouts and bravest fighters. It was said that "Jack Hays and his officers and men were not only General Taylor's eyes and ears, but his right and left arm as well." During the two-year war with Mexico, the Texas Rangers always engaged the enemy on the front ranks. Armed with two Walker Colt pistols, a rifle and a Bowie knife, and mounted on fine Texas horses, they were the most feared fighting force of their time.

Finally, the Mexicans were defeated in Mexico City. The war was over and, in early 1848, Mexico and the United States signed the Treaty of Guadalupe Hidalgo, establishing the Rio Grande as the border between the two countries.

The Trail-Driving Period

After the war with Mexico, the young Texans went back to their cowboy duties. Each ranch had a home range, with the headquarters usually located near its center. The headquarters contained the main ranch house, where the owner of the herd and his family lived, and the bunkhouse, where the single cowboys lived. There were

barns and working pens. A separate cookshack eliminated any fire hazard in the main house, and kept it cooler in the summer. The rancher's wife and daughters generally did the cooking.

Since the ranches were not fenced back in the 1850s, it was a constant job to keep the herds on their home range. Branding also kept the cowboys pretty occupied. A man's brand was his signature, and it said to the world, "This cow belongs to me." All men honored another man's brand, and each cowboy was loyal to the brand he rode for.

Until the Civil War, life was good. Many ranches had increased the size of their herds to thousands of animals. With great numbers of wild cattle still unbranded and the open range an endless sea of grass, a man could build his operation as big as he could handle. New Orleans was the major market for tallow, hides, and beef.

When the Civil War started, times got tough. There was no money in Texas, and even the New Orleans market was oversupplied. Cattle that sold for $5 to $15 a head before the Civil War might bring one dollar, if you could find a buyer. Many animals were traded for barter. George W. Saunders told the story of the time when he was twelve years old, and he and his brother Jack drove eight big steers some thirty miles to trade them for a sack of coffee and a set of eating utensils. When they got home, their father and mother were delighted. Life was difficult in the 1860s; most cowboys worked for their bunk and board, and were glad to get it.

After the Civil War, Texas was full of cattle and cowboys, but there was no way to get the beef to market. Then, when the railroads pushed west and a railhead was established at Abilene, Kansas, the trail-driving period was born. Texas ranchers knew there was a great demand for beef in the Northeast, and now they had a way to transport their cattle to the hungry multitudes.

The cow outfits in Texas were not foreign to trail driving, having had experience in pushing herds to New Orleans. Oliver Loving, who became known as the Father of the Texas Trail Drivers, had already driven cattle as far as Illinois in 1858. Soon after that he had headed west, with the first herd to be trailed to the remote region of the Colorado Territory. But it wasn't until 1867 that trail driving began in earnest. Hundreds of cowboys rode the dusty trails over the next 25 years, singing to their cattle on the way to different markets. Some made only one trip, others made many; all of them experienced adventure, but only a few gained any degree of prominence.

The Drovers

Charles Schreiner, a Texas Ranger, rancher and merchant, was a partner in a firm that trailed more cattle to northern railheads than any other transport agency. John R. Blocker, famous for his Blocker loop, said to be twenty feet across, was the co-owner of one of the largest transportation agencies. Dillard R. Fant began driving cattle north in 1869, and by 1885 had delivered more than 200,000 head to market. Charles Goodnight, a major figure in the Texas ranching industry, helped blaze the Goodnight-Loving Trail to New Mexico, Colorado, and points north. The book and movie of *Lonesome Dove* are based on his life.

George W. Saunders became a drover at the early age of seventeen and owned his own trailing firm within a decade. Having ridden up the trail nine times, driving both

horses and cattle north to market, Saunders is credited with trailing more horses north than any other agency. He later helped organize the Union Stockyards Company in San Antonio, and was lifelong member of the Texas Trail Drivers Association.

The Trails

Only rarely did any herd follow directly in the footsteps of another, because the grass was eaten by whatever herd arrived first. They would follow the same general direction when their destinations were the same or because of good water or abundant feed, or to travel easier terrain. The only time one rancher's cattle would trace the exact trail of an earlier bunch was through a pass in the hills, or over a shallow ford on a river, or near a town for supplies. Otherwise they would cut trails to one side or the other of a previous bunch in order to find the best grazing lands.

Many of these different cattle trails, from ranches all over the state, led to the exit points out of Texas. Four trails did become the superhighways of cattle driving: The Eastern Trail (1867-1881) originated in the lower coastal plains and wound north through Austin, then through Fort Worth until it crossed the Red River at Red River Crossing and picked up the Chisholm Trail on to Abilene, Kansas. George W. Saunders estimated that some five million head of cattle and one-half million horses followed this trail. The Western Trail (1874-1890) began in deep southern Texas around Brownsville and made its way up through San Antonio to Fort Mason, then to Fort Griffin, and crossed the Red River near Vernon at Doans' Crossing. It is estimated that six million longhorn cattle and 500,000 head of horses crossed there, destination Dodge City, Kansas, and points north. The Goodnight-Loving Trail (1866-1890) started out in north-central Texas and, avoiding Comanche and Kiowa country, took a southwesterly turn towards Ft. Concho, then went across the Pecos and on into New Mexico, Colorado and points north. The Potter-Becon Trail (1878-1894) originated in central Texas near Albany and the Fort Griffin area and took cattle on a northwesterly direction across the Staked Plains or Panhandle through the western edge of the Oklahoma Panhandle into Colorado and on to Wyoming.

A Heroic Feat

One other trail to be recorded in Texas history was the Saunders Trail, maybe not for the great numbers of longhorns and horses that traveled it, but because of the heroic feat of some Texas cowboys. The incident took place in October of 1862. After the father of seventeen-year-old W. D. H. Saunders told his son to trail 800 steers to the Confederate quartermaster in New Orleans, young Saunders and the cowboys left the ranch near Goliad on a trail they were all familiar with. They crossed the Colorado River, the Brazos, the Trinity, the Natches, and the Sabine River, at Orange, Texas, before crossing into Louisiana. There they met some drovers with 300 steers who informed them that New Orleans had been occupied by the Yankees since April. The two groups combined their herds and changed their route, heading north then northeast toward Mobile, Alabama, which was reportedly still in the hands of the Confederates. Soon they found themselves standing on the west bank of the father of all rivers, the mighty Mississippi.

The cowboys, young though they were, had all made many difficult crossings before, but the Mississippi was much, much bigger than any river they had ever

dreamed of; and certainly it was enormous compared to anything they had ever seen. From bank to bank the water stretched out before them for a mile, and it was forty feet deep. Never before had a herd crossed here, but Saunders and his young cowboys did not know this. With a loud rebel yell and their lariats popping, they led the old lead steer, Blue, into the water. Saunders was next, his horse swimming close to Blue, guiding the herd across the daunting expanse of water. One thousand head made it. Some were sold at Woodville, Mississippi, and the remainder traveled on to the market in Mobile. The hundred steers that refused to make the crossing were sold on the Louisiana side. No one ever crossed the Mississippi here with a herd of cattle again.

The Dangers and Dreams of the Drive

The cowboys who took part in these drives told many stories of hazardous river crossings, hostile Indians who demanded to be paid with cattle for permission to cross their land, and lawless border bandits who tried to cut the herd at night and steal animals. These challenges constantly tested the character and stamina of the young drovers, shaping them into strong, confident, fearless men who could make split-second decisions in any situation. Their lives and the lives of their friends often depended on their courage and determination.

Of all the hardships on the trail, the stampede was the most horrifying. Just the thought of it could send a shock of fear through even the toughest of cowboys. To lose your entire herd in a single night after weeks or months on the trail, after a thousand miles of dust and lonesomeness, was something almost unbearable. Stampedes, terribly dangerous to man and animal alike, were unadulterated hell.

The longhorns, still wild critters at heart, were alert and conscious of everything around them. Like a spooky bronc, a longhorn missed nothing, and the drover was wise to do the same. It was important to understand that no other type of cattle in history was so ready, so eager, so poised to stampede.

The following story is taken from J. Frank Dobie's book, *The Texas Longhorns*.

"The cattle and the night were so quiet that two night herders stopped now and then on their rounds to listen. The air grew warmer and more stifling as the lightning flashes approached and thunder began to rumble. The men could still skylight the cattle. Then the lead steer, 'Old Buck,' lifted his head, slowly rose to his knees and looked around. Evidently he did not like the looks of things and being long experienced in life he was startled. He got to his feet, smelled the air, and gazed toward the coming storm. The two drovers sang as gently as they could songs they had sung over and over to settle the herd. But 'Old Buck' seemed to be expecting something. Another steer got up, stood still, expectant; then others arose until the whole herd was up on its feet, motionless. The cowboys' songs were louder now, unrelenting, even pleading.

"The night drew blacker, the lightning closer and brighter, the humidity more intense. And then, all at once, on every tip of five thousand horns appeared a ball of phosphorescent light. St. Elmo's fire or Will-o'-the-wisp. In the intervals of utter blackness, the two guards could see nothing but those eerie balls illuminating the tips of mighty horns. Their voices rose high in the wild but cow-quieting notes of 'The Texas Lullaby,' which is not made of words, it is made of syllables and tones conveyable only by voices trained in deep thickets. The notes come long, low and tremble. The wailers of 'The Texas Lullaby' were singing their plea, 'Who-o-a-easy, cattle.'

"The ghostly balls of fire on horns must have looked as strange to the steers as it did to the men. The steers began to move at a walk, circling, then the walk became faster. All of a sudden a great flash of lightning came forking down over the milling steers so close that tongues of flames seemed to almost lick their backs. Then a mighty clap, a roar, a crash of thunder shook the heavens and earth. Its answer was the thunder of ten thousand pounding hoofs and horns clacked against horn. A mournful cry, STOM-PEDE, and the herd bolted with the swiftness of the lightning's leap.

"The rest of the cowboys arrived from camp and joined in pursuit. The water poured down in sheets. It rained pitchforks and bob-tailed bull yearlings; it was coming a T. Texas Toad strangler. One minute it was darker than pitch, then the prairie would light up brighter than day. They stayed with the herd, trusting their horses and following the balls of blue fire dancing in the blackness. Truly, they may be the Will-o'-the-wisp that lures men to the Black Death. When lightning wouldn't light the night, they ran by ear. When the lightning blinded and the thunder drowned out all other sounds, they rode hell bent for saddle leather. They had to get to the leaders and turn them in to a mill.

"When morning came, clear and calm, not a man was in sight of the chuck wagon. All of the provisions were drenched and a campfire was out of the question as all of the buffalo chips were soaking wet. The twenty-five hundred steers had been trailed a thousand miles from south Texas towards the market at Dodge City, Kansas without losing a steer. Now, they were scattered to the four winds. As the men came in from all directions with small bunches, the wrangler caught fresh mounts. When the last man was accounted for and remounted, the Trail Boss led them out to search for more cattle. The men would eat later and a trail hand was supposed to get his sleep in the winter."

Every Cowboy Needs a Cook

Yes, there were plenty of adventures along the trail. But there were also plenty of ho-hum times when the most exciting thing to look forward to was a hot meal at the end of the day. An extremely important element of any successful drive was the camp cook.

The cook prepared the meals, tended to the sick, listened to the lonely, and settled petty disputes; he healed the cowboys both body and soul. He practiced medicine, philosophy, and law. Cranky and short-tempered, the cook usually complained about too much work, but the boys all respected him and helped out where they could.

> *Yes, that's him over there by the wagon,*
> *That bald-headed, mean looking cuss,*
> *With the sugar sack tied 'round his belly,*
> *There now, he's looking at us.*
> *I'll bet that in all o' your rambling*
> *You ain't seen a more poisonous look.*

Someday, he'll just swell up and bite his unself.
But say! That ol' buzzard can cook.

—*Jim Fisher*

The cook ruled supreme in his kitchen, a mule- or horse-drawn chuck wagon that he drove down the trail second in line behind only the trail boss. The chuck wagon carried staples such as coffee, flour, dried beans, salt, pepper, and other seasonings like salt pork and onions—all things that needed no refrigeration. Tobacco, along with medical supplies such as aspirin and the cook's home remedies, were also included, along with extra guns.

Most trail outfits also had a hooligan wagon driven by the swamper or cook's helper. This smaller wagon, pulled by two mules or horses, carried the cowboys' bedrolls and any other extra gear.

A cowboy's bedroll was a large piece of canvas that covered a thick mattress and blanket. In the side folds the cowboy stuffed his few clothes and personal effects. The bedroll was folded somewhat like an envelope, then rolled up tight and tied with rope to make it easy to handle. A cowboy's saddle and gear were usually placed near his bed at night and covered with his slicker to keep them protected from dew or rain.

Cowboys are pretty independent by nature, but they always deferred to the trail boss. The undisputed boss of the trail, he alone made the important decisions. He always rode at the head of the drive, pointing the way, sending out scouts from time to time to look for the best grass and water up ahead or maybe to search for the best river crossing. The trail boss drove the herd at a slow pace, usually covering only eight to ten miles a day in order to let the cattle graze as they went. Cattle with full bellies were easier to manage, and they kept their bed ground through the night.

The horse wrangler was responsible for the remuda, a herd or collection of saddle horses kept fresh for remount. Several horses were hobbled near the camp, but the rest were left loose to graze at the end of the day. Every morning the wrangler would round them up into a rope corral held by the trail hands. Each drover would call out the name of the horse he would ride that day, and only one or two men would rope them so as to maintain order in the herd and keep the horses from jumping over the single-rope corral.

The night hawks, or night guards, as they were called, had to stay awake at night and keep the herd from drifting too far away from camp. This job was rotated among all the trail hands, who usually took two- or three-hour shifts.

Each morning when the herd rolled out, the chuck wagon followed the trail boss and the hooligan wagon followed the cook. The extra horses and the wrangler came next, riding out to one side and up ahead of the trail herd. Following at a respectable distance was an old lead steer or "Sancho," the Spanish word for "pet." These old steers were valued by the drovers, for they kept the herd at the right pace and they were trained to walk into river water without hesitation. They received special treatment, right along with the horses. When they reached the end of the trail they were not sold but brought back to Texas with the remuda. Most of them had a name, and some made several trips up the trail.

On either side of the lead steer were the point men. Their job was to keep the herd headed in the right direction. Behind the point came the swing. If the herd had to make a turn in the trail, the swing hands kept the herd following the point. Behind the swing came the flank. These drovers had the responsibility to see that the herd did not fan or spread too much. Next came the cowboys who rode the drag, the most unpleasant job of the drive. Thousands of hooves kicked up so much dust that it was visible for miles around, and the drag boys rode in the thick of it. It was hot, dull, dirty work. Usually the hands would rotate the distasteful duties every day, and always they dreamed about the end of the trail.

What Is a Cowpuncher?

When one Texas trail herd reached its destination, the animals were counted and sold. The drovers then headed to the saloons for a night of "cuttin' the wolf loose." After three months of eating trail dust, these boys had a mighty big thirst. The next morning, with 2,000 steers to load, the trail boss tried unsuccessfully to find one sober cowboy to help him. So he told one of the railroad men to hire some sober locals with long poles who could "punch" the steers up the chutes into the railroad cars. The railroad man asked the trail boss, "And how much can you pay these cowpunchers?" The name stuck.

Law & Order on the Range

When the herd owners and their cowboys rode north up the trail, the unprotected cow herds they left behind were easy pickings for the men of questionable character who were drawn to Texas and the other Southern states during the Reconstruction days after the Civil War. The Texas Rangers tried to keep cattle rustling to a minimum, but with Indian depredation at an all-time high, the Rangers were spread too thin. In 1877, forty ranchers met to discuss what could be done about the cattle losses they were all experiencing. The ranchers decided to band together as a group to fight cattle theft in the region, forming the Texas and Southwestern Cattle Raisers Association (TSCRA) for this purpose.

For six years, association members did their best to look for strays and control theft, but cattle rustling was becoming a lucrative business for a number of outlaws. In 1883 the association hired inspectors with the authority to arrest thieves and retrieve stolen stock. Local sheriffs deputized these inspectors as range detectives, and later they became known as field inspectors. In addition, brand inspectors were assigned to the various trail centers and roundup crews. Ten years later the inspectors were commissioned as "Special Texas Rangers," and the shadow of their authority grew longer and wider.

The TSCRA continues to this day and is now over 15,000 members strong. Not only does it guard against illegal activities, it serves as a leading voice for the Texas and national cattle industry. Oliver Loving's son, J. C. Loving, was a founder of the association and was Secretary-General Manager for 26 years, from 1897 to 1902. His grandson, E. B. Spiller, served the association the next 27 years, and Don C. King of Lost Valley in Jack County came to the TSCRA in 1962 as a field inspector. In 1966 he was appointed Secretary-General Manager, a post he retained for 29 years, serving the longest term of anyone in the hundred-and-twenty-year history of the association.

The End of the Open Range

On a clear day in September of 1874, Colonel Ranald Mackenzie and his soldiers discovered the Comanche stronghold in Palo Duro Canyon. The Comanches, caught off guard in their secluded camp, fled without a counterattack. Mackenzie burned their winter lodges and all their belongings. The soldiers drove some 1,000 head of horses to Tule Canyon and slaughtered them.

The destruction of the Comanche war ponies devastated the tribe, leaving it no means to survive. In the spring of 1875 the Comanche leader, Quanah, surrendered his people at Fort Sill, Oklahoma. This act marked the end of an era. A powerful nation that once ruled over millions of acres from the Arkansas River in Kansas south to the Rio Grande in Texas, from the Rocky Mountains in New Mexico to north-centra Texas, the Comanche were lords of the Southern Prairie no more.

When Charles Goodnight heard that Quanah had taken his people to Fort Sill, he realized the Staked Plains had been opened for ranching. Running Comanche raids with the Texas Rangers as a young man, he had seen the country and dreamed of the perfect spot for the perfect ranch: Palo Duro Canyon. The canyon was a naturally fenced area approximately 100 miles in length, with high walls on either side and Prairie Dog Town Creek running its entire length.

Goodnight didn't have the finances necessary to start such a ranch. The open range was coming to a close and land had to be purchased. Charles found his financial help in Irish-born John Adair, who had arrived in Denver to start a banking business and noticed that there was a great deal of money to be made in the cattle industry. When Goodnight morlgaged his Colorado ranch for $30,000, he secured a partnership with Adair, and the two men set their sites on Palo Duro Canyon.

A land survey company had reached Palo Duro Canyon before Goodnight, and controlled most of its land with a blanket survey. But Goodnight was shrewd enough to talk the land company down from $1.25 to 75 cents per acre, and he was able to choose the acreage.

Naturally he chose all the best land and all the water he could get. His contract allowed him to designate an additional 12,000 acres, which he would have first rights to purchase the following year. Goodnight mapped out land in a pattern resembling a patchwork quilt. Although he owned only a portion of the available acreage, Goodnight made sure that no other ranches could be established in the area; he controlled all of Palo Duro Canyon.

As Adair furnished the money, Goodnight continued to buy land. The ranch prospered and grew in the protected, water-abundant canyon. By 1885, Charles Goodnight and the Adairs had increased their holdings to more than 1,335,000 acres and some 100,000 head of cattle.

Other ranchers, such as Samuel Burk Burnett, who was also a trail driver, purchased land in King, Cottle, and Wichita counties under the 6666 brand. Dan Waggoner and his son began putting together vast tracts of land in Wilbarger, Foard, Baylor, Archer, and Knox counties under the Backward 3 D brand. Burnett, Waggoner and other ranchers leased more than a million acres from the Comanche and Kiowa reservation in Oklahoma Territory.

When the ranching empires were being developed in Texas in the 1860s to the 1880s, land was selling for around 25 cents per acre, and grazing land was leasing for 4 cents per acre. Texas ranchers and trailing firms drove millions of cattle north and returned with hundreds of thousands of cow dollars to buy and fence their land.

Large ranches with hundreds of thousands of acres were formed by men like Ike Pryor of the 77 brand in lower Nueces County; and Richard King and Mifflin Kenedy, who owned the "Running W" brand of the Brasada. C. C. Slaughter was said to have as many as two million acres both leased and owned under the Long S and the Lazy S brands in Howard, Borden, Martin, and Dawson counties. The XIT Ranch was established in 1885, owned by the construction firm of Taylor, Babcock and Company. This company, also called the Capitol Syndicate, built the Texas State Capitol Building in Austin, receiving 3,050,000 acres of land as payment.

Barbed Wire and the Fence-Cutting Wars

The true end of the open range came about when cowmen began fencing their land. Fencing defined the boundaries of neighboring properties and allowed cattlemen to divide their ranches into pastures and then stock each pasture with cattle according to its carry capacity. Experimenting with improving the quality of their herds by crossing English-type bulls with the native longhorns, ranchers could better manage their breeding programs with fenced pastures.

Some ranchers had already built stone and rail fences on a small scale to hold their horses or milk cows and protect their animals from thieves. Building these types of fences was incredibly time-consuming; sometimes it took years to establish the necessary pastures and corrals on a ranch. But barbed-wire fences could be built inexpensively and quickly over great distances. It is said that when the XIT was fenced, it took more than 6,000 miles of fence to cover its outside boundaries.

Some men were still driving cattle when barbed wire came on the scene, and when the herd reached a fence, the trail hands would cut the wire.

In 1883, during a severe drought, many cattlemen cut through fences in search of water and grass for their animals. Tempers rose, threats and accusations flew about and then escalated into a war among ranchers determined to maintain a way of life now seriously in jeopardy. By the fall of that year, damage to fences was enormous. Many men were killed or wounded in the conflict, and so the government stepped in.

In 1884, the Texas Legislature decreed that fence cutting was a felony punishable by one to five years in prison. Carrying fence-cutting pliers on your saddle became illegal and was punishable by law. The range was officially closed.

The 20th Century Cowboy

The cattle industry continued to change as the 1800s faded into the 1900s. The railroad lines reached into the heart of Texas, and huge stockyards were built in San Antonio, Houston, and Fort Worth. These terminal markets, now close to home, became the end of the trail for great herds like those that had once been driven to Kansas and other faraway destinations. The rancher had gained easy access to a national market.

Old cowboys were doing new things, as the ranching industry gradually became more of a science, but was still a way of life. A demand for better-quality beef prompted ranchers to import European breeds such as Herefords, Durhams, and Angus. Later came Brahmans, Charolais, and others. Cross-breeding improved the

taste and texture of the beef, and produced faster-growing, meatier cattle, increasing the ranchers' profits.

As the last quarter of the 20th century approached, ranching had become a high-tech industry. Years ago, cattle weren't rounded up and handled but twice a year. In the spring, they were gathered so calves could be worked. They were roped, branded, dehorned, vaccinated, and the bull calves were castrated. In the fall, they were gathered again so that calves could be sorted and shipped to be sold, along with any cull cows or bulls.

Today, ranchers work their cattle much more often. The ranches have been cut down into smaller, more efficient areas. For example, a 6,000-acre ranch in Parker County, Texas consists of twelve pastures, four traps, three sets of corrals, twenty-four surface ponds, and nine windmills. A cow doesn't have to travel but a few hundred yards to water at any time of the day. The herd is rotated periodically from pasture to pasture, which assures fresh grazing and rests the remaining pasture to maintain maximum production of grass.

This type of operation is called high-intensity, low-frequency grazing. It sounds like some new innovation, but the buffalo practiced this method for centuries. Grass and water are renewable resources, and will not be depleted if managed correctly.

Where does the Texas cowboy fit into this scientific ranching? Some will say the golden age of cowboy culture is gone, but I say the cowboy is as necessary a part of ranching today as he ever was. Without him, that big, juicy T-bone or rib-eye steak you enjoy, or all those hamburgers you and your kids consume, would not be there.

The big outfits of the Trans-Pecos in far western Texas and the large ranches of the Staked Plains still put out a chuck wagon each year, some twice a year. The old-type wagons are usually loaded on trailers and hauled to a location, and some modern wagons with rubber tires are pulled by a pickup. But they all serve the exact same purpose as the old chuck wagons that creaked up the trail behind horses or mules. The old chuck wagon cook is just as cranky as he ever was, cooking up the same kinds of grub in the same types of Dutch ovens, and dishing up the same advice about how he did it when he was "cowboyin'."

The remuda still follows the wagon, and the cowboys still sleep on the ground in the same type of bedroll. They also hobble their horses in the same manner they did 140 years ago.

A cowboy today has a lot more responsibility. He can't just saddle up and stay in a long trot all day, even though riding is part of the job. Pickups and trailers have helped shorten the time it takes to get you and your ponies to the starting point. The trail boss of yesterday has become the general manager, head of operations, today. The trail scout, second in command, has become the wagon boss of today.

The drovers have become camp men, living in homes strategically located over a ranch. Each camp man has his own section of country and cattle that he is responsible for, and may look after up to 20,000 acres. The boys at the bunkhouse are like the boys who rode drag on the trail. They catch all the jobs around headquarters, and help the camp men when needed.

Big outfits hire contractors to build or repair their fences, and they also have a full-time windmill man and mechanic. On smaller ranches a cowboy is a "jack-of-all-trades." He has to repair a little fence, re-leather a windmill, or do any other job that may come up. A lot of them are good welders, but I've never seen one yet who likes to drive a tractor. As my son, Thomas V, would say, "There's no place on that thing to cinch a saddle, and I've got too much money tied up in leather goods to be riding a tractor!"

So, for all those who think the Texas cowboy has ridden into the sunset and onto the great cow range in the sky, have heart! He is still here, every glorious day, serving his Lord and doin' what he knows best—herdin' cows, ridin' cowhorses, and raisin' our future cowboys and cowgirls. Although the Texas cattle range may be wearing more fences than she used to, she still produces lots of high-quality beef, cowboys, and cowhorses.

Amen!

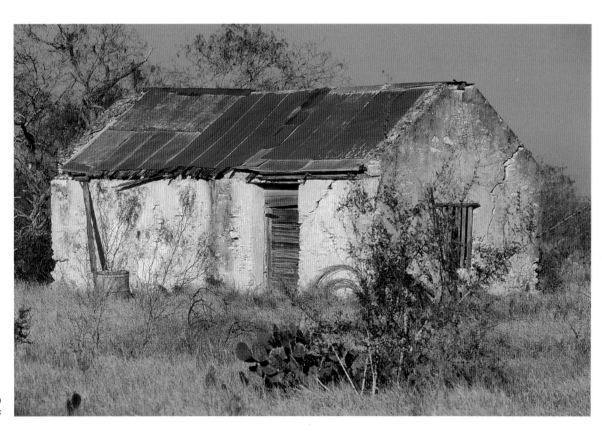

SETTLERS' CABIN, CIRCA 1840
Linn, Texas

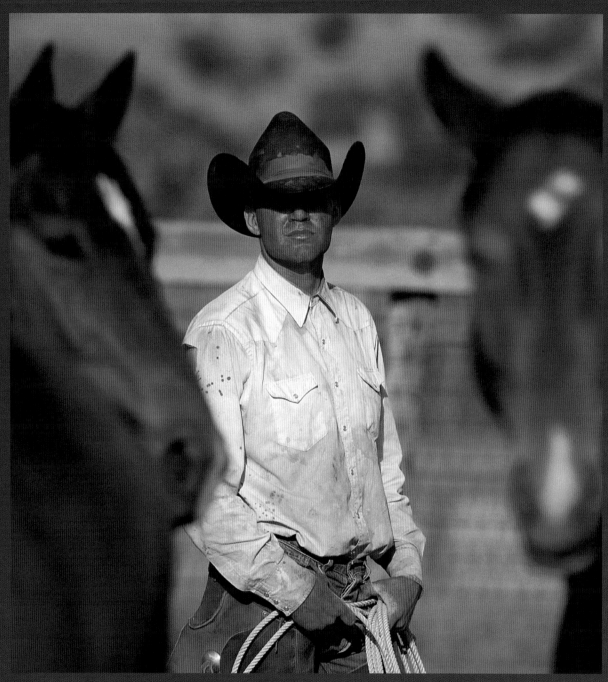

THE WRANGLER
Bubba Smith
Pitchfork Ranch, Guthrie, Texas

THE TEXAS COWBOY

A true Texas "brush popper" worries only about the extreme ends of his anatomy, his head and his feet, for what appears in the middle is necessary only to hold the two ends together. So I'll start this description at the top—with his hat.

A good fit is all-important with a hat, because in a hard run with a high wind, it's got to stay put. A hand can't be pulling up and going back to retrieve his shade in the middle of a cattle drive.

Some boys use what we refer to as a "stampede string" to make sure they don't lose their hats. This is a leather string that goes around the crown of a hat, through the brim on each side, and ties under your chin. This idea came from the vaqueros, and with the size of their sombreros, they surely needed a stampede string.

But most Texas hands rely on a good fit and a strong arm to keep their hats on. You just jerk her down deep and over that little knot on the back of your head and make that hat looks like she grew there.

The choice of size of a hat's brim and the hat's color is purely personal, but most hands prefer a 4-inch brim, and either black or gray. At least, the hat starts out one color or the other, but with hard use some blacks become grays, and some grays become blacks. But that's all right! The older a hat gets, the better she feels, and as long as she sheds water and sun and stays put, she's got a job.

Some of the boys wear straw hats in the summer—panamas or palm leafs. These are a little lighter on your head, maybe a little cooler, too, but they are hard to keep on. It seems like when the wind gets up enough to spin a windmill, these hats want to go back to their roots—to the ground! They sure don't hold up well in a thicket, either. Mesquite limbs do horrible things to their form, and open up air holes where air holes aren't desired.

Needless to say, you may want to treat yourself to a little cool and comfort, but it's short-lived. If you are lucky enough to have one of these hats make it through the Texas hot spots, July and August, you've done well. Eventually you hang up what's left of that straw hat and reach over and get your favorite old felt.

Now, for the other end of the cowboy, it's his boots that are important.

Some may think the high heels on a cowboy's boots are fashioned for the purpose of holding him up out of the cow manure, or for making him appear much taller in stature than he actually is. I'll admit those are not bad reasons, because I've seen some mighty short fellows with some awful tall heels—and they looked dang near normal. I've also seen cow manure half-a-boot-top deep.

But the most important reason for tall heels that carry well up under the arch of your foot is for protection while you are in the saddle. These heels keep the stirrup from swallowing your foot, hanging you up, and letting the horse drag you across the prairie. The heel also holds the stirrup closer to the ball of your foot, where it's a lot more comfortable.

This heel also has a spur ridge on the back, which keeps the spur from slipping off when you hook your old pony in the shoulder when showing off in front of the other hands, showing them just how well he can spin around.

Personal preference determines the height of the boot-tops and how pointed the toes are. A cowboy's boots say a whole lot about who the man is. Short tops, low heels and square toes just don't tell much of a story. But handmade spurs with big 10-point rowels and your brand or name in silver on the sides, buckled up with a handmade silver-inlaid spur-strap buckle, sure wouldn't hurt your image any.

The tops of a cowboy's boots may vary from 12 to 17 inches. Of course, this depends on how long a leg he wears. A short-legged fellow would have a mighty difficult time trying to squat in an overly tall-topped pair of boots.

The colors of boots have really drifted from the old basic browns and blacks that the old-timers always wear. In fact, in the last few years I've seen some respectable hands come riding up wearing purple, red, yellow, sky-blue, green, and even pink-topped boots.

Now, I have to back up a little on those pink tops, because the fellow has not graduated from the school of cow-ology yet, and from his report card it looks like he is a few cows short of having a herd.

I reckon that by now the only part of the Texas cowboy we haven't described is from the neck to the knees.

The most expensive spot in this area is right in the middle. That's where his belt is, and every belt has to have a buckle. The kinds of buckles the cowboys of today wear aren't cheap—I'm talking from $100 to $250 a set, depending on how fancy they are.

These buckles are handmade, with silver initials and fancy designs. No two look alike. They're not trophy buckles like the rodeo boys wear, either—those big, square things with writing all over them. These buckles are small, stay-out-of-the-way belly latches with a man's ranch brand in silver, not a bucking bull.

You know, if God had intended for cowboys to ride bulls, He'd have put a better set of withers on those brutes. For you folks who might not understand my meaning, a bull hasn't any good place to sit a saddle. So, if we were intended to ride a bull, the Main Man would have built them differently.

And as for bulldogging, well, the fellows who do that are either dang-sure afoot or just can't rope. Besides, a sure-'nuff cowboy with any respect for his high-dollar hat and his good, handmade high-top boots is not going to drift up beside a steer and jump off his pony onto a set of high horns, then try to out-stout and persuade a 600-pound steer to lie down on its side—not when he's riding a 1,200-pound, well-bred quarter horse and has a 30-foot nylon rope with him. It just doesn't make sense.

But back to getting the rest of the clothes on this cowboy.

I forgot to mention one very important item—a man's knife. You know, that

might be the most important thing a man's got if he's tied hard-and-fast, sitting in the middle of a bronc with a loose cinch and a high-horned, bad-attitude cow on the end of his string, and she's heading back his way. If he is well-equipped, he can whip out his knife, cut the rope, and abort the mission. That's why cowboys carry knives in places of easy access.

Good, high-dollar, dependable knives that are handmade and can hold an edge cost more than $100, but with that expensive hat and those handmade boots at stake, not to mention what's in the middle, you can't afford to pack a cheap knife.

As far as shirts and britches are concerned, anything that covers bare hide will do, because in the thick country most hands wear a canvas jumper and brush cuffs. And whether working the brush country or the prairie, a Texas cowboy always wears his leggings.

Way down in south Texas, the Mexican boys call their leggings chaparejos. The pilgrims call them chaps. But we Texans call them leggings, and like all other cowboy gear, these are chosen based on personal preference.

For example, I like to wear "shotgun" leggings. They fit you like a pair of britches, and cover you from the waist all the way down to your ankles. And a little fringe and a few conchos make them look "punchie."

In the Texas heat and out on the prairie, the boys may take their worn-out leggings and "dehorn" them, cut them off right below the knee. Some leave a little fringe hanging down so they look good. These are called "chinks." I have no idea where that name came from. Maybe it's because they only protect the important parts of a fellow, and let the rest fend for itself; like chinking up the roof of an old dugout that's got a hole right over the only place you can unroll your bed. Sleeping in a wet roll sure isn't too pleasant.

Chinks do a good job, though, especially where the brush isn't too thick; and they are cooler on a hot Texas day. The boys up north like them even in the winter, because the snow won't build up on the bottom like it will on leggings.

I reckon I've just about covered up this Texas cowboy, except maybe his hands, where any good pair of thin leather gloves will do. I didn't mention his underwear, because most cowboys don't wear any except in the winter, and his "long-handles" are probably too holey and ragged to discuss.

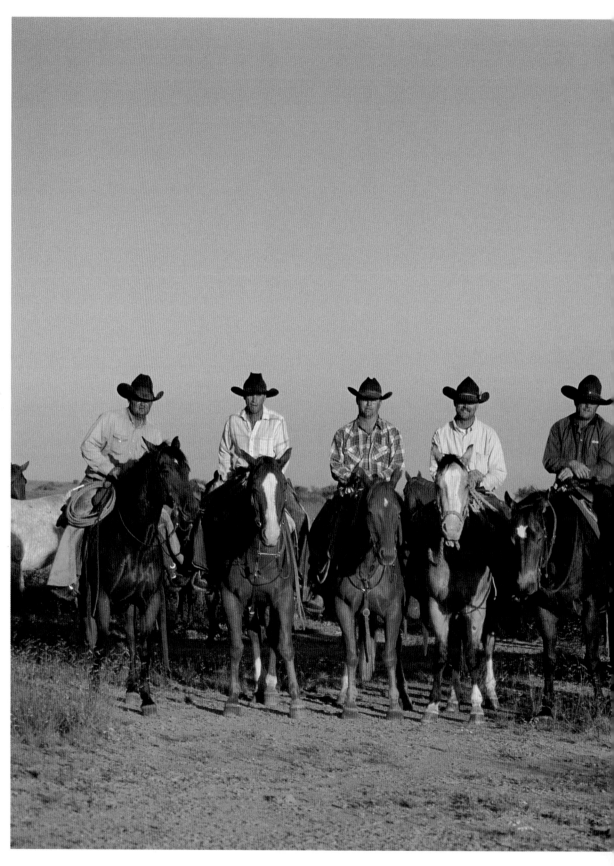

FALL ROUNDUP CREW
Jeff Gray, Marc Lang, Bubba Withers, Tommy Dale Vines,
Rod DeVoll, Dennis Yadon, Donnie Slover, Shiloh Coleman, Zol Owens
06 Ranch; Fort Davis, Texas

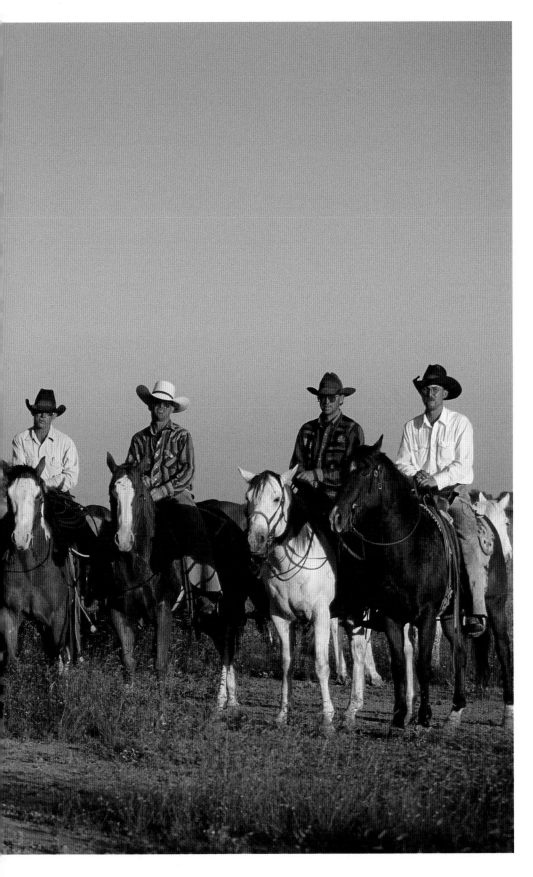

This book ain't about windshield cowboys or pavement pounders who get all duded out in their short-top Acme curb-kickers, their big, shiny, square buckles, and their big-brim hats that some poor quail flew into at a high rate of speed and left his tail feathers stuck on the front of the crown. You know, the wannabes! No sir, this book's about the real Texas cowboys—that old weather-browned boy who saddles up way before daylight, swings a hind leg over his old pony and hits a long lope to where they're goin' to start gatherin' cows. This cowboy wears his legs in parentheses and visits with his horse like he's his best friend. These are the boys who live in a land as God created it, not as man made it. This book is about home folks.

—*Tom B. Saunders IV*

EAST TEXAS

The Piney Woods

A look at early Texas history tells us that settlement of the state had its beginnings in the Piney Woods and the Big Thicket. In 1804, this part of Texas, separated from Louisiana by the Sabine River, saw the birth of the first Anglo in the state—the first native Texan.

Helena Dill Berryman was born in what became Nacogdoches County. Her gravestone remains to tell the story, along with the cabin that she and her husband built early in their married life. Being of strong pioneer stock, they lived into their seventies and eighties, and even their cabin, which was built in 1847, still remains in fair condition.

This part of Texas also boasts the oldest town in Texas—Nacogdoches, established in 1699. Texas history starts in this part of the state.

The good Lord put a completely different set of clothes on east Texas than He did on the rest of this sprawling state. While the western side of Texas has open, slow-rolling prairies that run mile after mile, east Texas has hills and hollows. Where the western part of the state sees only the occasional lonesome mesquite, east Texas holds the state's national forests, the home of majestic pines and hardwood trees.

Texans know this country as the Big Thicket, and that it is. The pines grow to a hundred feet in height, and the sweet gum, white oak, pin oak, and scaly-bark hickory aren't far behind. With 40-plus inches of rain a year, those trees grow thicker than fleas on a boar coon.

Cowboying in the east Texas Piney Woods ain't easy. It takes good horses, good tack, and good dogs—not necessarily in that order. It also takes a good sense of direction because it's still dark in the bottom of the hollows, even at high noon. If the boss says to push the herd to daylight, a newcomer in the area might think the only way that could happen is for hooves to grow claws and for those cows to climb the trees to see sunshine.

A typical day starts before daylight, getting horses and dogs loaded, throwing on your leggings, and making sure your slicker is still tied behind the cantle of your saddle. The fog is usually hanging low and heavy, and you're thinking rain but hoping for sun.

The humidity makes the air thick and soupy, and if you've donned your yellow slicker, parts of you feel like you're trapped in one of those sauna boxes.

TOMBSTONE OF THE FIRST ANGLO-SAXON
BORN IN TEXAS, HELENA BERRYMAN
Alto, Texas

HISTORICAL MARKER
Alto, Texas

When you get underway and finally sight your compadres at the appointed gathering place, the dogs sing out long, yodeling greetings. In this country, the black-mouth cur dog, a fairly large animal weighing around 50 to 60 pounds, is the dog of choice because of its tremendous stamina and grit.

As the cowboys start their drive, each man is responsible for his dogs and his particular area to gather. The trail dogs take the lead, for they have the best noses to scent the cattle. Then, when a cowboy strikes cattle, he sends his dogs around them in the heavy timber. He probably can't see the cattle, but the dogs can be heard a long way when they bay up a bunch of cows with their low, melodious voices.

Once under herd, the cowboy drifts the cattle in the direction he wants them to go by controlling them with his dogs. If a cow decides to break out of the herd, the cowboy will send his "catch dog" to bring her back. And believe me, it doesn't take long for that black-mouth cur to persuade an old cow that she's in the wrong place. She may catch him with a horn and flip him through the air, but as soon as he hits the ground he's right back and grabbing ahold of an ear, and a long-eared Brahman-type cow can't stand too much ear pinching before she changes her attitude and heads back to the herd.

After the cattle settle, the cowboys move them on again through the heavy woods, all the while listening for another cowboy's dogs to bay. When the other dogs announce their discovery, the cowboys head the herd towards them. Once the two herds are thrown together, one of the cowboys leaves with his dogs in search of more cattle.

When all the cattle are finally bayed up, bunched, and herded into a clearing, they are settled and then driven into corrals to be worked. Every three to four months they receive insect-repellent ear tags and are sprayed. These Brahman-type breeds are not only good browsers and good mothers, but they also have a higher resistance to insects than do European breeds such as Hereford, Black Angus, or Charolais. But in the Big Thicket, even Brahman cattle need some assistance in warding off biting insects.

Once the work is done, the cattle are turned out of the corral, the cowboys call off the dogs, and everyone heads for home.

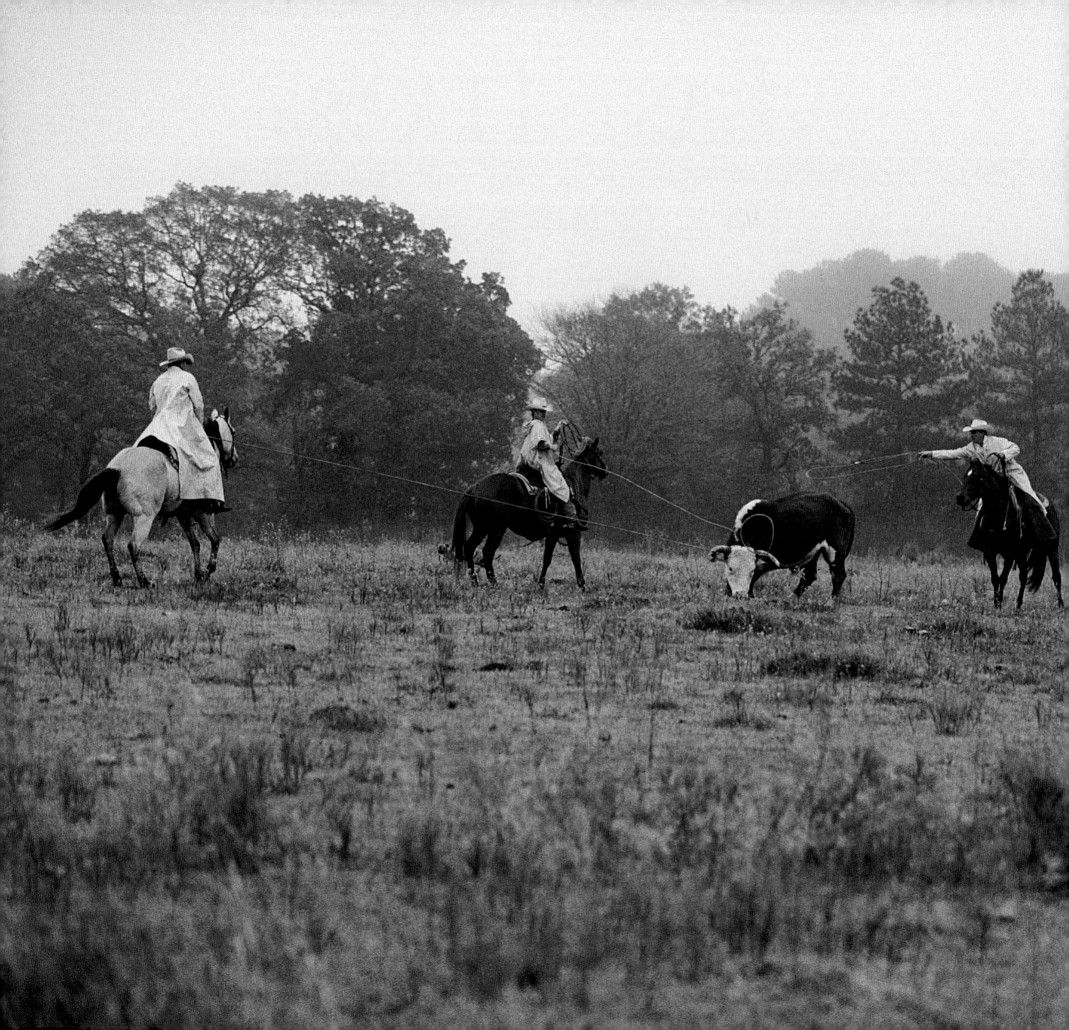

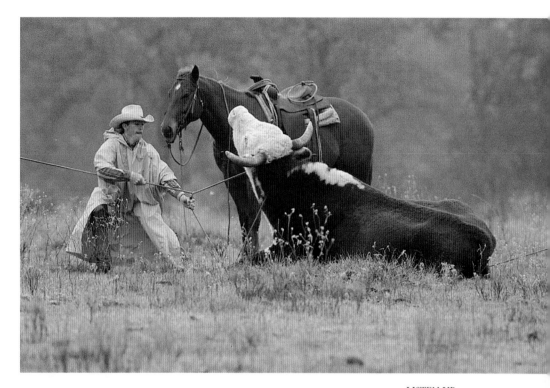

LISTEN UP
Darrell "Shorty" Montgomery
Arnold Ranch; Crockett, Texas

"It was a profession that engendered pride. They were laborers of a kind, it is true, but they regarded themselves as artists, and they were artists. The cowboy was the aristocrat of all wage earners."

—*J. Frank Dobie*

A Vaquero of the Brush Country

DOCTORING EL TORRO
Butch Arnold, Kevin Bauer, and Darrell "Shorty" Montgomery
Arnold Ranch; Crockett, Texas

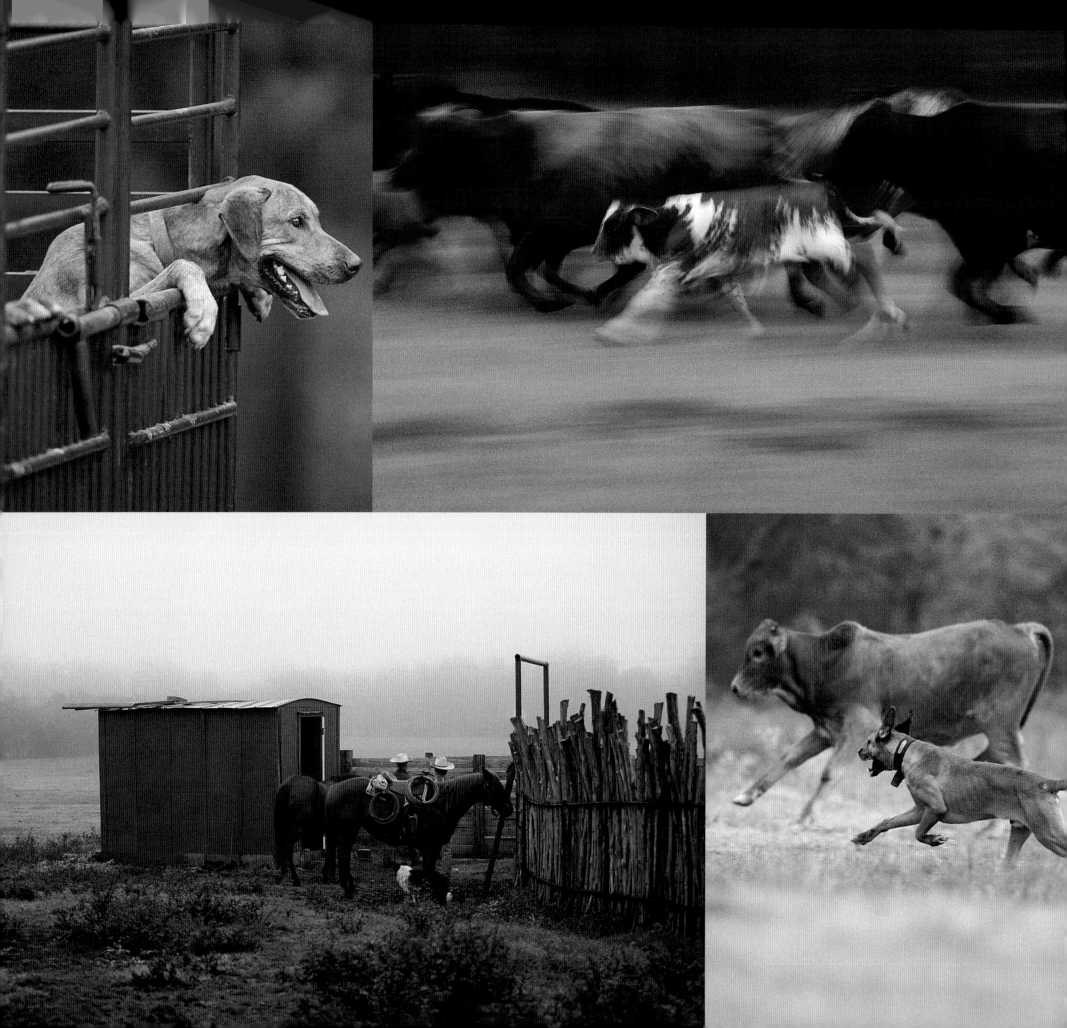

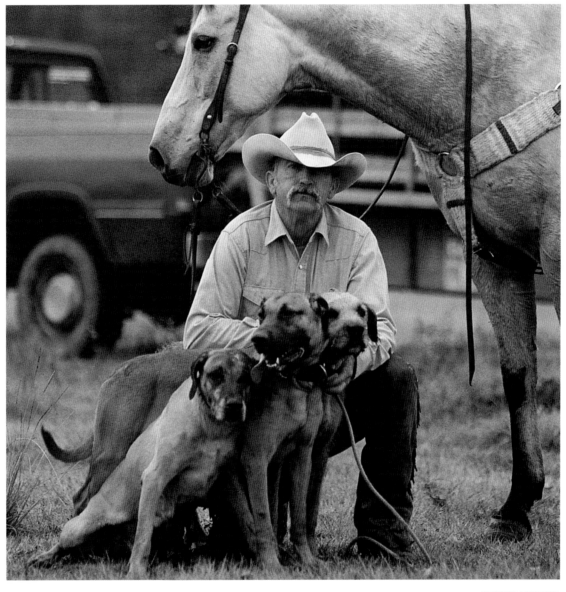

BUTCH ARNOLD
Arnold Ranch; Crockett, Texas

Opposite page: Clockwise from upper left

KEVIN BAUER'S BLACK-MOUTH CURS
Bauer Ranch; Alto, Texas

"THERE THEY GO!"
Bauer Ranch; Alto, Texas

"GET BACK!"
Arnold Ranch; Crockett, Texas

SADDLE UP
Bauer Ranch; Alto, Texas

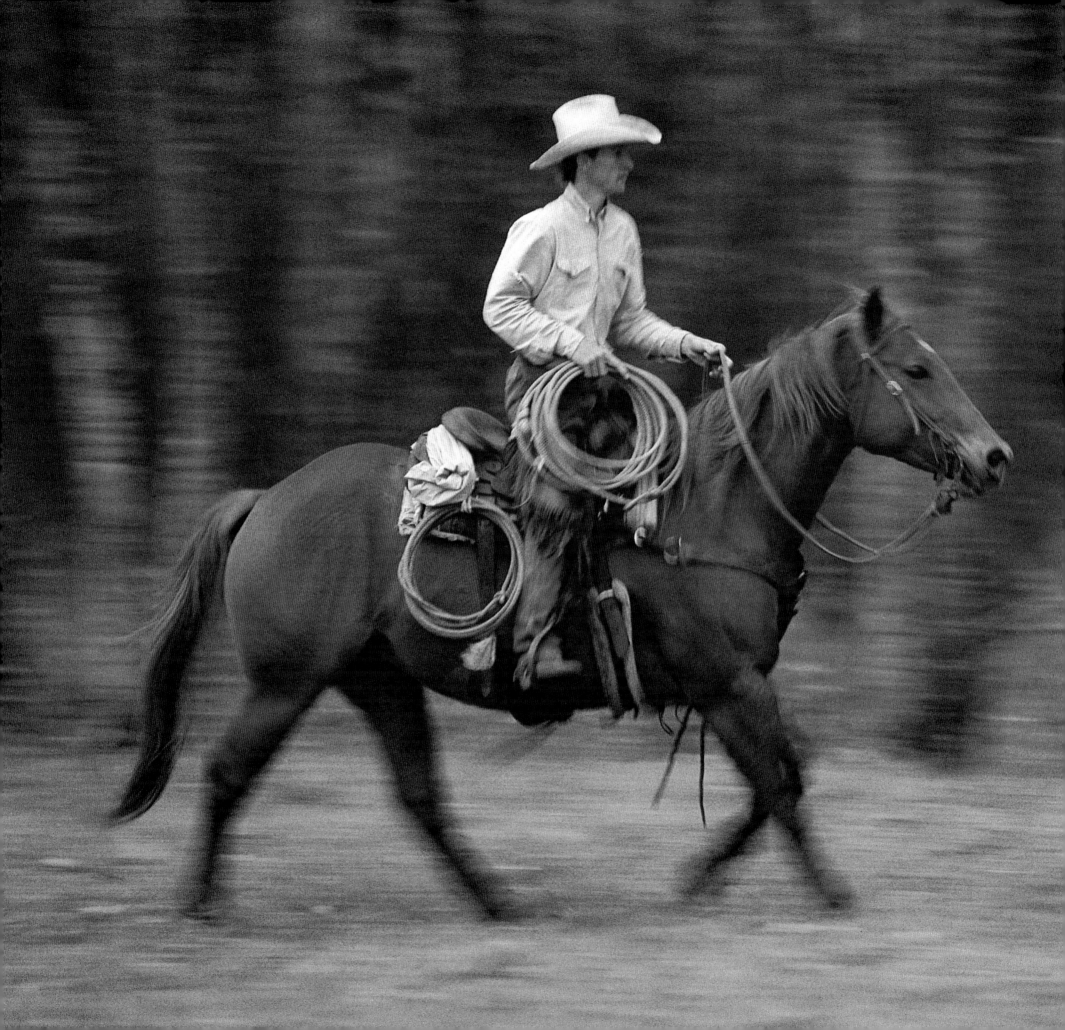

Arnold Ranch; Crockett, Texas

JESUS IS LORD
Rising Sun Cowboy Church
Trinity, Texas

MEMBER
TEXAS
FARM BUREAU
JAMES F. ARNOLD

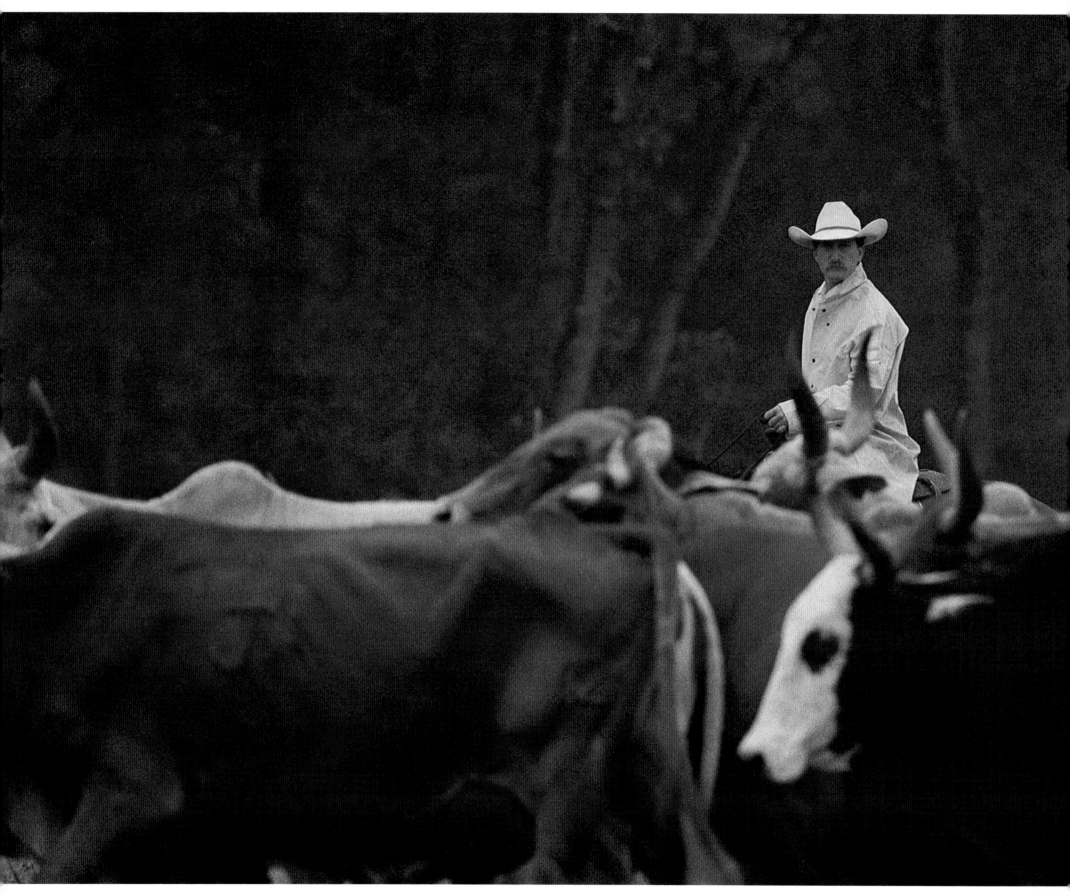

KEVIN BAUER
Bauer Ranch; Alto, Texas

EAST TEXAS COWBOY
Kevin Bauer

I'm in my late twenties, and I've cowboyed in lots of places in Texas and Oklahoma. I figured I'd seen about all the different country God had to offer, until I got to the Neches River in east Texas.

I'd worked on the Pecos, where you could see the mountains 20 miles away and watch a herd of antelope two miles out, grazing among the cattle. And I've worked the brush country in south Texas, where the prickly pear grows eight feet tall and every bush wears a thorn.

This east Texas pine and hardwood country is just as thick as the south Texas brush country, but there are no thorns and cowdogs work well here. In fact, without our dogs we wouldn't be able to gather and pen any cattle.

The cattle in these parts know they can "brush up," and a man can ride right by and never see them. I've seen cattle brush up, lie down and never move, and if a man didn't have a dog that would trail up a cow, he could ride all day and come up empty-handed.

Just about all the cattle in this country are what we call "dog-broke." Here in east Texas, everyone trains or breaks their cattle to honor a dog, and the way they do that begins when they wean their calves and select their replacement heifers. They keep these cattle in a small trap or pasture that has very little brush. They say the worth of a west Texas cowboy is judged by how well his horse handles or how well he can rope. Here, we judge a cowboy on how well he can handle his dogs. Good, well-handling horses are always important to a cowboy, but here good-handling dogs are a must, and we train our dogs to work as a team. Dogs, like men or horses, have different abilities and I try to learn what each of my dogs can do best.

You always have a dominant dog in the pack, and it's usually the dominant female that makes the best trail dog. Your oldest dominant male is usually the most aggressive, and makes the best "catch" dog.

I catch and work a lot of cattle for the ranches in the area where I live, which is between the Neches and Angelina rivers in Alto, Texas. Some of this country has been clearcut, but most of it is still in pine and hardwoods. This timber is thick and maybe a hundred feet high. In the bottoms and bayou country, the underbrush is real heavy and sure enough tough to work.

Cowboying for the public can be real interesting. You can get in some mighty difficult situations.

There are times you pray for the phone to ring. Other times, it seems to ring off the wall—sort of feast or famine. That's the way it is working for the public.

I also break colts for the public. You get some good, some bad, and some ugly ones that sure enough make you earn your money.

I've found the main thing to do is take your time and get to know their personalities. They are all different, and what works on two may not work on the next ten.

I enjoy starting horses, getting to know how they think, how each one reacts to different situations. It's a lot of fun and it gives me a good feeling of accomplishment to take a scared two-year-old colt that tries to buck you off and jumps at his own shadow to a confident, responsive, more mature horse that you can do a day's work on.

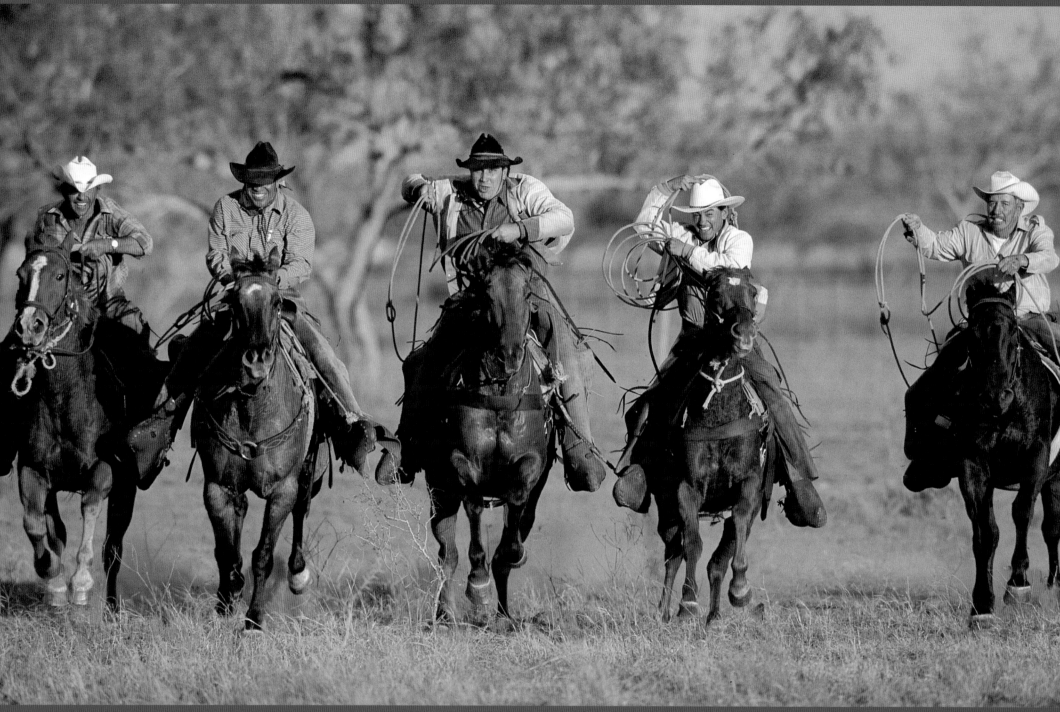

"MINE IS FASTER THAN YOURS!"
Pablo Sanchez, Juan Luis Longoria, Melecio Longoria, Raul
Treviño, and Homer Vela Ramos
McAllen Ranch; Linn, Texas

SOUTH TEXAS

Cowboys from south Texas, that vast area extending from San Antonio south to the Gulf Coast, mostly speak Spanish or some variation of it. They wear big-brim felt hats with stampede strings, brush jackets, brush cuffs, heavy leggings, and high-top boots. Sturdy tapaderos cover their stirrups.

I know all that gear seems like a lot to wear, especially in the heat of a south Texas summer. But the sun doesn't hurt nearly as much as what grows there. Everything, you see, either bites, sticks, or stings.

The rainfall averages 15 to 18 inches a year, and it may all fall in one month. The country is strong, though, and a cow can stay in good flesh even when the weather is dry, as long as the stock water holds out.

It sure does get hot in south Texas during the summer. The nights, however, are cool, and the mornings pleasant. In fact, the working conditions are best just at daylight, the coolest time of day.

When dawn breaks in the east and the cattle begin getting up off their bed ground, the cowboys are already among them, singing low and moving easy, giving the cows time to suckle their calves and start drifting.

Every cowboy keeps a watchful eye out for any cow that throws her head up and heads for the brush. The boys want to make a clean gathering, and they know that if they're not careful, some smart old cows will try to give them the slip in the heavy brush.

Gathering cattle in south Texas brush country isn't like pushing sheep off a golf course. You've got to be alert, know your country, and think way ahead. If the cowboys aren't together, cattle will drop plumb out of sight, then double back.

Working an area is like having a pair of cowboys each holding a chain by an end, and dragging it between them. If one man gets too far ahead or behind, it leaves a hole that cattle can slip through. Staying together is all important, and in heavy brush that's not easy. You have to keep singing to each other to let the next man know where you are, because in heavy brush you can't see—not even straight up. You travel by sound, and use your knowledge of the country.

Working cattle in south Texas brush country has to be done early, before it gets hot. Heat is hard on the cattle, on your old pony, and on you. Nothing likes to travel in the heat, so as soon as you can, you kick the cattle out onto a *sendero,* or path, that heads for the corrals. You handle them as easy as possible, for hot cows and hot cowboys seem to fight, and the cows generally win.

As soon as your work is done, you ease the cows out of the corrals and, if possible, settle them on water. You'll be mighty glad you got an early start, because the temperature has risen about 40 degrees since daylight; it's time to head for shade.

Every critter in brush country "shades up" when the sun is straight overhead, even the two-legged kind. When you hit shade, the first thing you do is take care of what's been taking care of you—your old pony. You strip him of his saddle and gear, lead him to water, and while he's drinking you wash him down good so his back won't gall and get a saddle sore. Then you lead him back to shade and hobble him where he can graze.

Then you're ready for a long drink of cool water, a little bite of beans, and maybe a tortilla or two. You kick off your boots and leggings, stretch out under a good shade tree, and catch a little siesta before you have to saddle a fresh horse for the evening's work.

The horses these boys ride are all American quarter-horse-bred, and of good size. Thorns take their toll on the horses' ankles and knees, so they rarely work beyond 12 to 14 years. The prickly pear in south Texas can grow as high as eight feet, and its thorns are hard on stock as well as man. That's why most of the vaqueros' saddles have tapaderos (leather covers) over their stirrups. These coverings protect the cowboy's boots so the long, needle-like thorns won't penetrate his foot.

These cowboys also use heavier chaparejos, or leggings, than most Texas cowboys, because every bush in South Texas wears a thorn. Believe it or not, most of this brush or cactus is excellent browse for cattle in spite of the thorns, and it's quite an asset for the country. When you talk to a rancher from south Texas about the condition of his range, you inquire not about the growth of the grass, but about how good the brush is. After the spines have been burned off, prickly pear makes a great winter supplement.

Although a part of any weekday on a south Texas ranch involves fighting the natural elements, cowboys in this section of the state are not unlike all the other cowboys in Texas when it comes to Sunday afternoon. Provided that the "ox isn't in the ditch" or, in pilgrims' terms, other critical work doesn't need to be finished, most cowboys follow their herding instincts and gather with others to rope a few steers and fill up on tortillas, fajitas, and cervesa. On special occasions, a wild hog barbeque has been known to draw quite a crowd.

Cafe Mexico

1884

ONE WAY

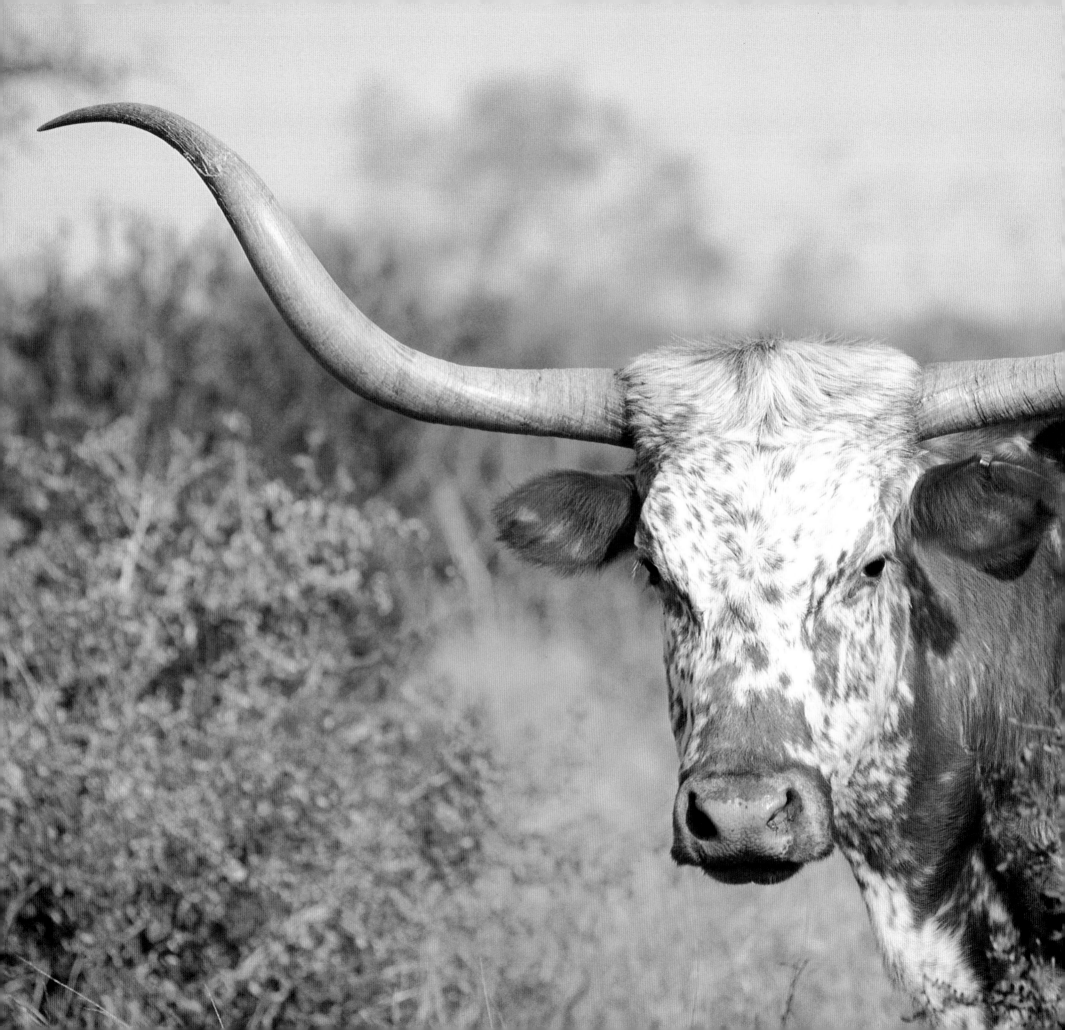

"A man whose experiences have been limited to prairie lands and gentle cattle can hardly conceive of the difficulties involved in clearing a big brushy country of a stock of old-time wild Texas cattle."

—*J. Frank Dobie*

The Longhorns

LONGHORN STEER
San Vicente Ranch; Linn, Texas

SOUTH TEXAS COWBOY

Juan Luis Longoria

My family has been in Texas since the 1790s. They came from Mexico, and there are still some Longoria people in Mexico, but Texas is my home.

There is a strong heritage of Mexican cowboys in this country. That is because most of the ranches around this part of the state have been here for many years, and all they use are Mexican cowboys.

My grandfather was a cowboy. He had his own ranch, but back then it was different. Then you had your own ranch, but you would help out on the surrounding ranches. He cowboyed for most of his life. He was 83 years old and was still riding a horse. My father cowboyed only at his ranch. And when I started rodeoing, he didn't want me to do it. He said it was too hard. After World War II, when he came back from the war, he just didn't do it anymore.

I started cowboying real young. I must have been 15 years old when I got out and started working on my own—here, there and everywhere, on some of the big places around the San Isidro area. I started here at the McAllen Ranch in 1972 and have been here ever since. My boys and daughter were raised here. I've been the caporal—the man in charge of the cowhands—for 18 years.

In the morning we start marking cattle, injecting them for plague leg, things like that. Today is January 21, and this will be the first roundup we'll have this year. After three months of that, we'll just be checking pastures until we start *la corrida grande*, the big roundup, when we wean the big calves.

I take care of most of the fence work, too. I tell the hands what to do, but of course I'm always with them. I make sure everything is just right. I meet with Mr. McAllen every morning, and he lets me know if there's anything special that needs to be done.

We probably do things differently here than they do them in the Panhandle or other parts of Texas. Every outfit has a different way of working.

If I were to walk from this ranch to another one, they might think that since I've been a caporal here all my life, I might consider the way I do it the only way. But a cowboy never gets through learning different ways. It's different anywhere you go. If I'm used to pushing cattle one way, their cattle are probably used to being pushed another way.

Like, here at the McAllen Ranch, we have always driven young heifers on horseback. When we wean them for keepers, what we call replacement heifers, I drive them about three days out of the week for a while. Then I'll go every month and drive them for a couple of miles. That way, we have gentle cattle all the time, used to being driven by people on horseback.

Some ranches just load the cattle on a trailer and go dump them over there, and when they try gathering the cattle they can't catch them because they go over or under the horses. The cattle are not educated to being driven or being held up by a bunch of horses, like we do it here.

The horses on this ranch are all King Ranch blood—full-blooded quarter horses. They started off with some of the best quarter horses at the King Ranch, and it's worked its way down to what we've got today.

We have a horse here that is a grandson of San Peppy, who was a winner of $100,000 at the age of three. These horses are very good at cutting. As a matter of fact, I trained this stud horse for cutting and he turned out beautiful. A television crew came out and filmed him working, and they show that video every year.

Mr. McAllen has a special feeling for the horses that have done a lot of work for him. On most ranches, when a horse gets to be 15 or 20 years old, they just load it up and take it to a sale. Well, we've got about sixty horses that are too old to ride or that have been hurt on the job, out there running free. Mr. McAllen says, "Nobody's gonna kill my horses," and he turns them out to the big pasture. We just let them die of old age. Very few men would do that.

I'm glad this ranch has tried to preserve cowboy history, using horses instead of pickups. I have to be around cattle or horses.

Being a cowboy, you have to live it. Let's just say you have a cow up there that's having problems calving. I can't stand going to sleep thinking that she can't have that calf. I can't go to bed unless I set things right. That has a lot to do with being a cowboy. I don't think everybody could put up with it. It has to be in your heart.

To me, being a cowboy means being able to do everything. It's being able to pull a calf if he needs to be pulled. If a windmill breaks on the top, I get up on the tower where that motor is and try to fix it. If I have to rope a big bull, I'll rope a big bull. And if I have to fix a fence, I'll fix a fence. Being a real, live cowboy is what counts. It's not like learning it in college. That's not good enough for me. It takes many years of experience, and you never stop learning. You learn something new every day.

A good horse, a good saddle, a good rope is important. Some of the people who work for me, they'll coil up a rope and give it to me, and even if I'm not looking at it, I'll tell them that that is not my rope. They'll ask, "How do you know it's not? You're not even looking at it." But I know the feeling of my own rope, and that's because I go through a lot of rope. Just by looking at the way it's sitting on the saddle, I can tell if someone touched it or not.

You take pride in a good horse. You take pride in a good saddle and all the gear that you use. I'm a cowboy, and I take pride in what I do.

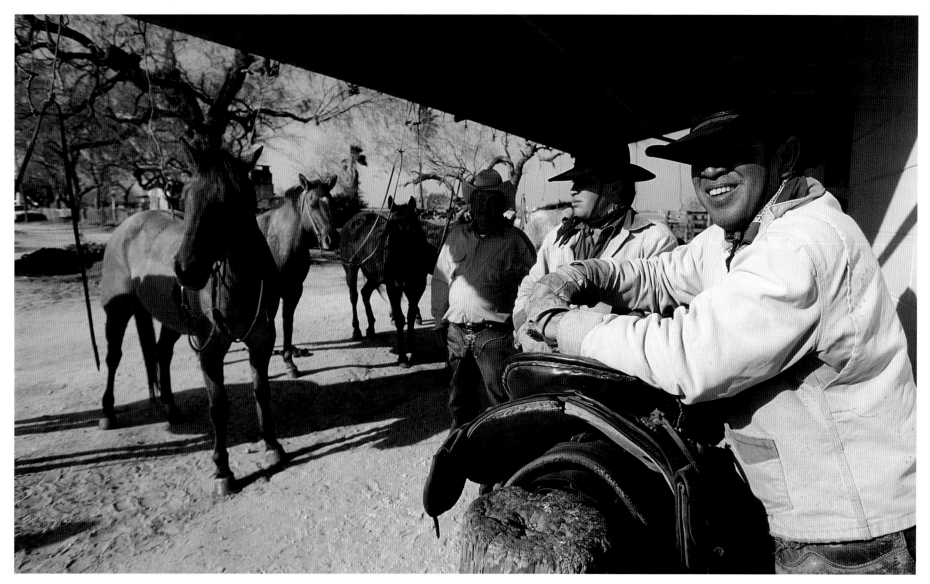

JUAN LUIS LONGORIA, MELECIO LONGORIA, AND HOMER VELA RAMOS
McAllen Ranch; Linn, Texas

"The Texans are perhaps the best at the actual cowboy work. They are absolutely fearless riders and understand well the habits of the half-wild cattle, being unequaled in those most trying times when, for instance, the cattle are stampeded by a thunderstorm at night, while in the use of the rope they are only excelled by the Mexicans."

—*Theodore Roosevelt, 1885, "Hunting Trips of a Ranchman"*

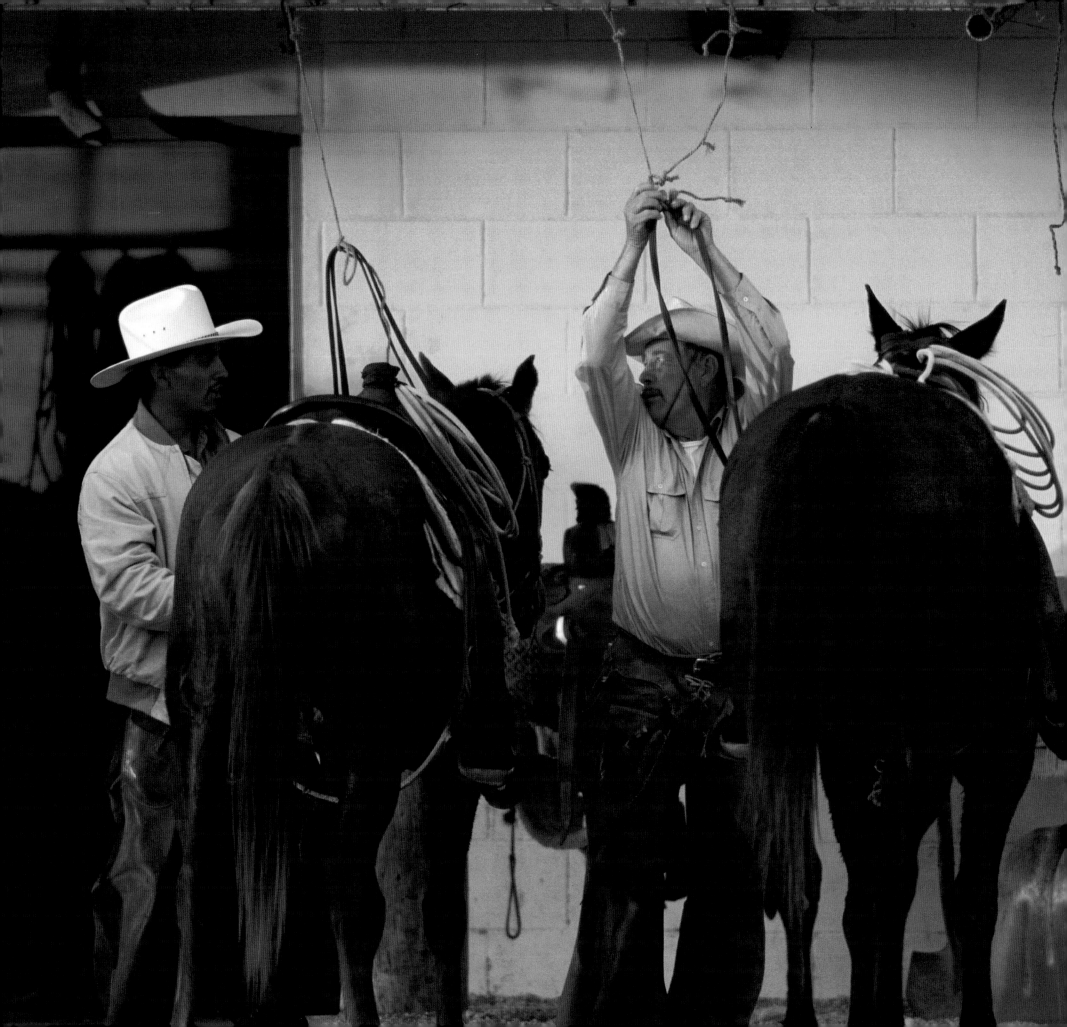

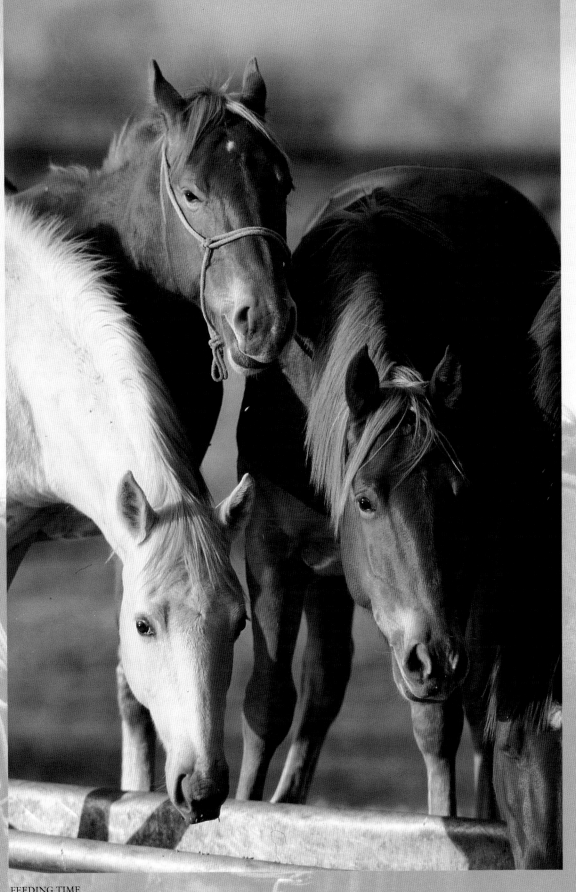

FEEDING TIME
McAllen Ranch; Linn, Texas

SOUTH TEXAS WINDMILL AND BRUSH
McAllen Ranch; Linn, Texas

THE BRUSH COUNTRY *by Scott Preston*

We crossed the wide Pecos, we forded the Nueces / We swam the Guadalupe, we followed the Brazos.
Red River runs rusty, the Wichita clear / But it was down by the Brazos I courted my dear.
 —*"Brazos" (a.k.a. "The Texas River Song")*

The brush country of southern Texas grows deep in the American subconscious. The siege of the Alamo is a great part of this, but so too are the epic solo battles of a cowboy taking on a maverick steer hidden in a canyon, or an exhausted handful of men attempting to turn a stampede in a thunderstorm. In this landscape, a certain set of attitudes—grim determination, stoic patience, and a decided refusal ever to back down, even when life or limb was threatened—became ingrained as occupational virtues, the blood and bone of the land itself.

This was the frontier where the legendary skills of riders descended from Cortez, the Mexican vaqueros, collided with the first farmers of English ancestry to settle west of the Mississippi. The ensuing birth of the cowboy seemed to coincide with the emergence of the longhorn cow, the wildest bovine creature the earth has ever known. The trail they followed, which ended in mythic abandon in Dodge City and Abilene, began in the brush. Even today, this dusty shrine is honored for its part in our country's Western legend.

Few people today know the actual history of Charles Goodnight and Oliver Loving, or the cattle drive that named a major trail in their wake. *Lonesome Dove* borrowed much of it, won a Pulitzer Prize, and somehow managed the trick of creating a vaster myth, through returning to the cowboy's own story the truth of sweat and blood on a human scale.

The birth of the American cowboy—and it was in Texas that he first squalled—was about hard, relentless work, in difficult country under harsh and isolated conditions. It also had a little to do with cultural luck and historical setting, the Civil War, and a coincidental shift in Eastern tastes from pork to beef. According to some accounts, one-third of the riders on the early trail drives were Black, a consequence perhaps of the newly freed looking for employment, which perhaps helped lead to our contemporary appreciation of the cowboy life as one free of anyone's ownership. We sing their songs today as ballads of a time when nothing got in a man's way but the ground beneath his feet and the retreating horizon in the distance.

Clearing the brush is a full-time job in south Texas. The brush grows and chokes out the grass, leaving the rancher with no alternative but to clear it.

McAllen Ranch; Linn, Texas

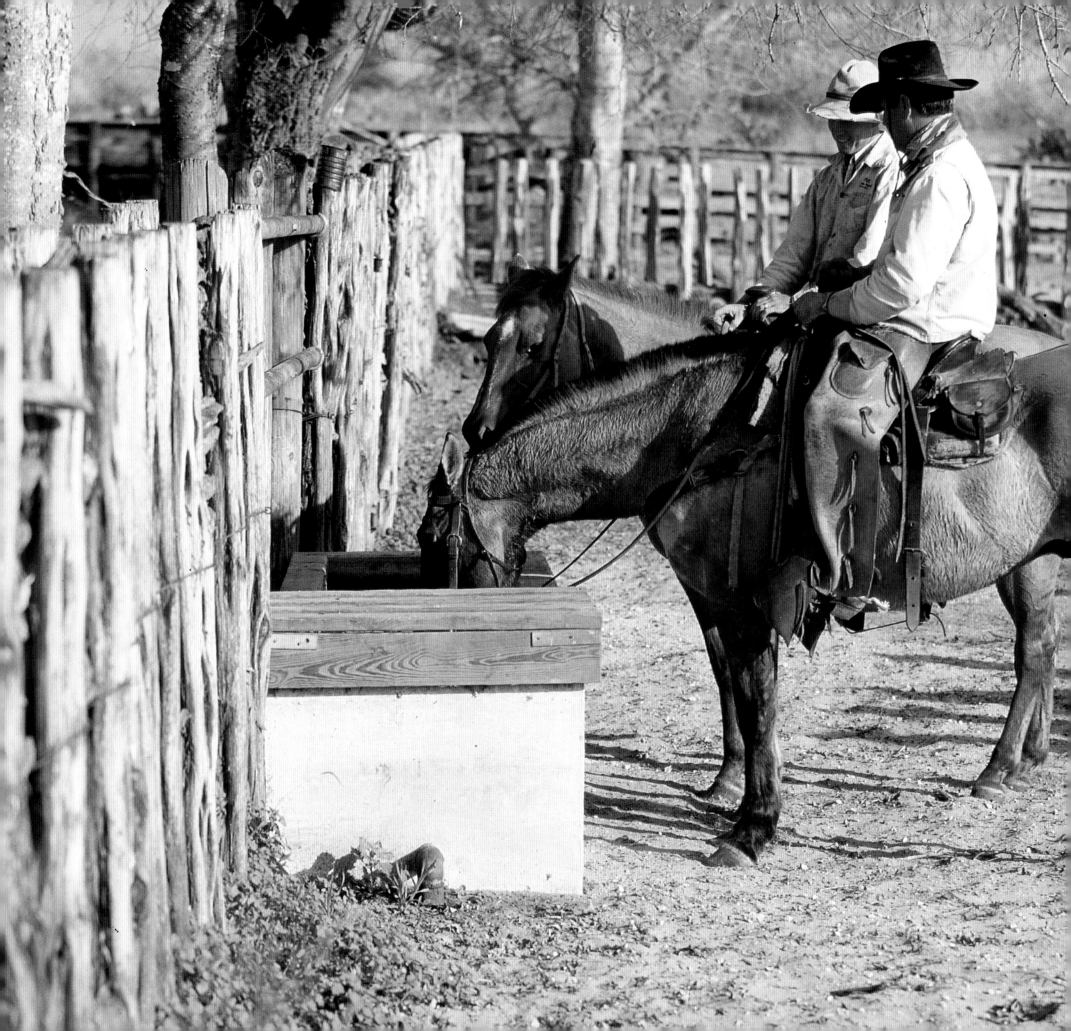

TRAPPINGS OF THE BRUSH COUNTRY

TEXAS SPUR

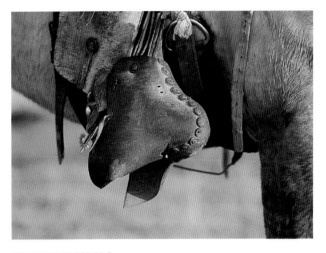

BULLDOG TAPADARO

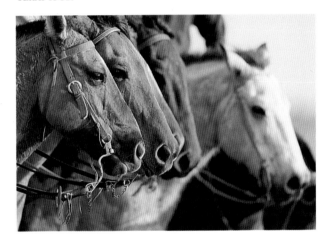

LONG SHANK BIT

BOTTLE-OPENER SPUR

TIME FOR A DRINK
Juan Luis Longoria and Raul Treviño
McAllen Ranch; Linn, Texas

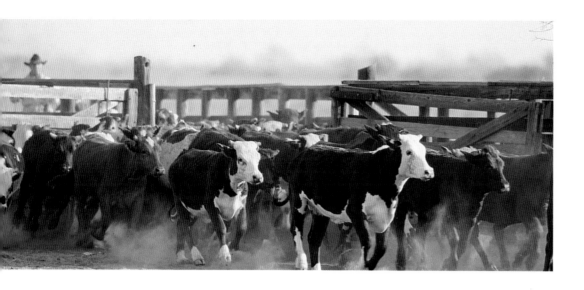

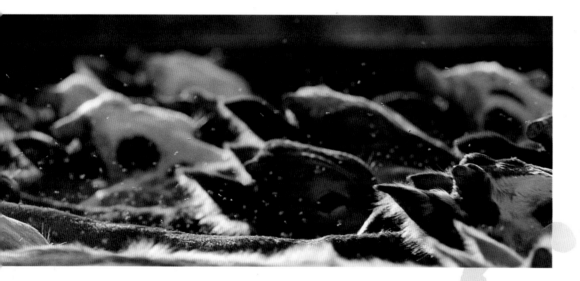

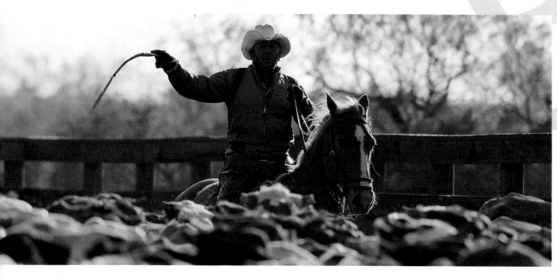

WORKING CATTLE AT THE McALLEN RANCH
Linn, Texas

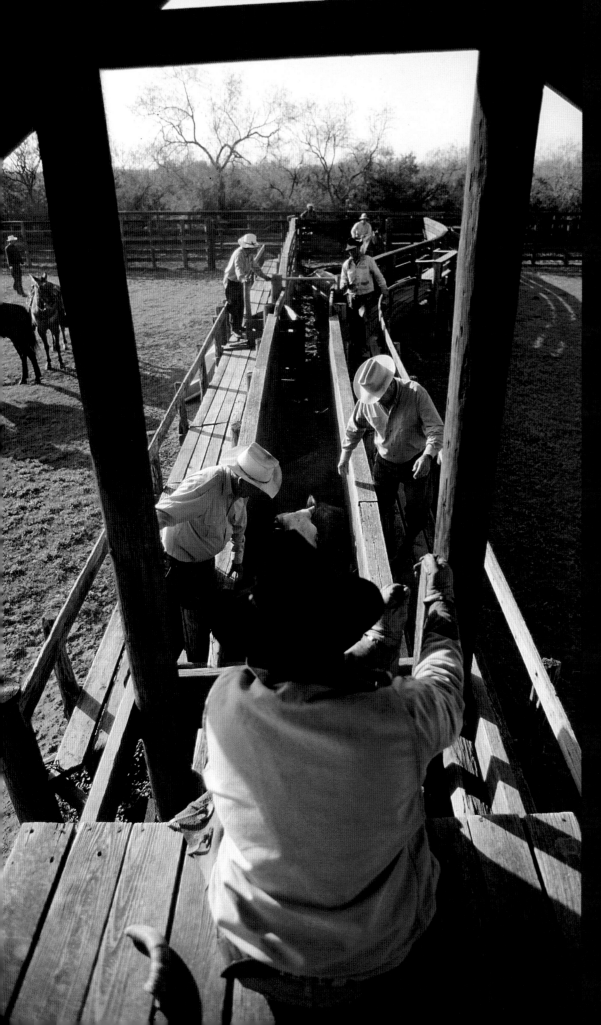

I may be tired of living
But one thing I'll say for sure,
I will never tire of working
'Cause a working man is pure.

—*Andy Wilkinson,*
"I Want My Coffee Black"
©1994 Can't Quit Music (BMI) used with permission

WORKING THE CHUTE
Jim McAllen, Pablo Sanchez, Juan Luis Longoria, Melecio Longoria, Raul Treviño,
Homer Vela Ramos, Ventura Espino, and Oscar Quiroga
McAllen Ranch; Linn, Texas

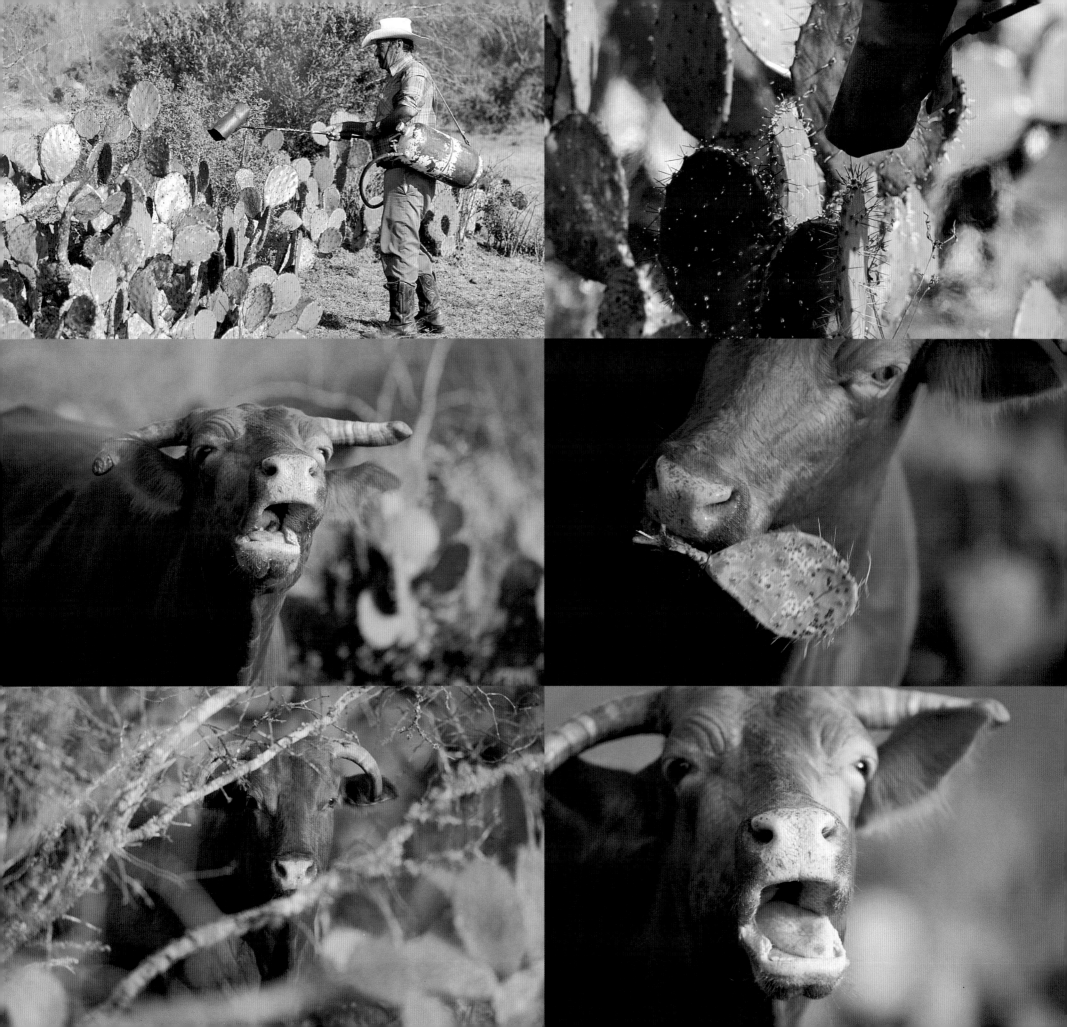

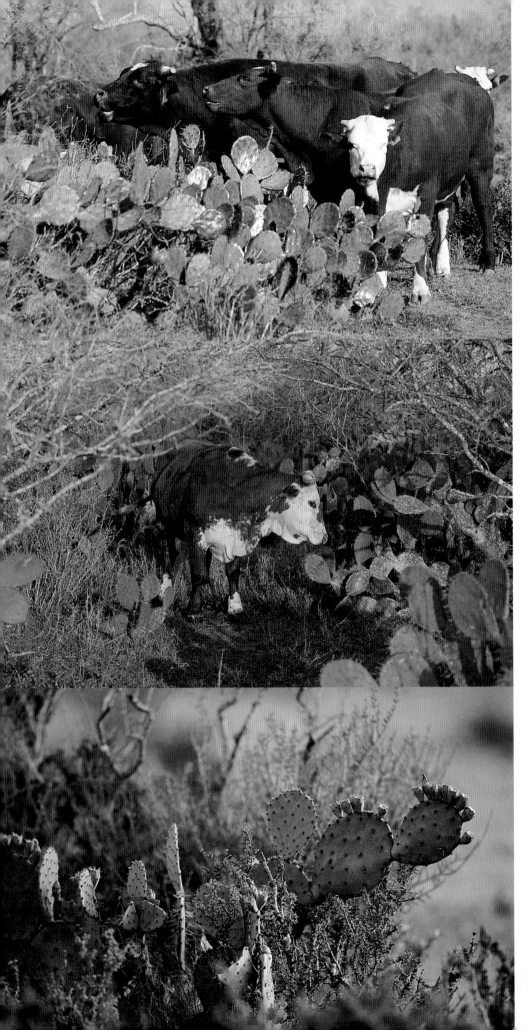

BURNING PEAR

To a south Texas rancher, a stand of prickly pear is like a cornfield to an Iowa farmer. Ranches in this area are valued on how heavy a concentration of "pear" is on their flats, for in the winter when grass does not grow, or during a drought, this plant becomes the main food supplement for the cow herd.

Prickly pear is high in protein and valuable as a source of food, but it is also heavily laden with long thorns. In order for the cattle to eat it and not become sore-mouthed, the thorns have to be burned off.

A butane torch, or "pear burner," as it is called, is used to burn thorns off. When the Mexican boys light up those burners, the roar can be heard for a long distance. Hungry cows come running, knowing they will soon be able to get something to eat.

BURNING THE PRICKLY PEAR
McAllen Ranch; Linn, Texas

61

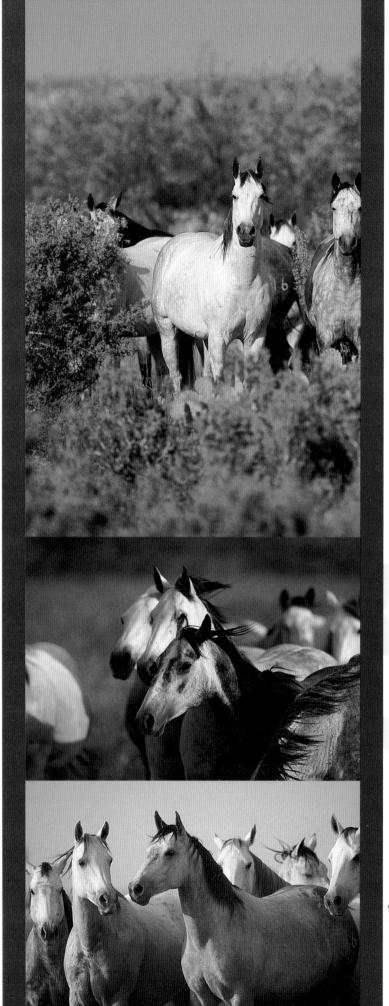

GRAY MARES
Donnell Ranch; Fowlerton, Texas

JAMIE DONNELL
Donnell Ranch; Fowlerton, Texas

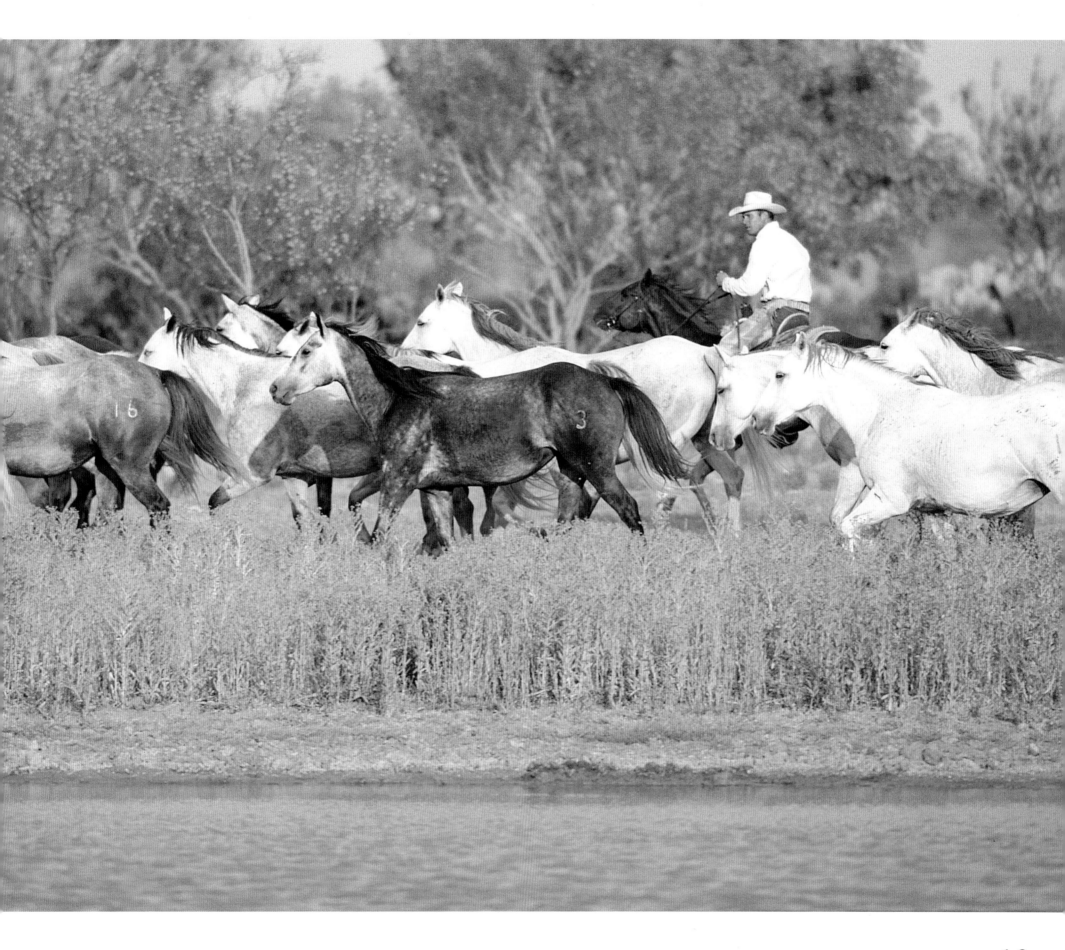

"RIDING IN A CONVERTIBLE"
Donnell Ranch; Fowlerton, Texas

JUST ONE MORE INCH
Jamie Donnell
Donnell Ranch; Fowlerton, Texas

LEROY HALL
Donnell Ranch; Fowlerton, Texas

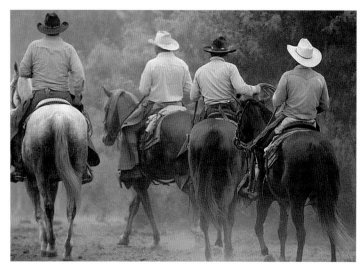

WAYNE SWAIN, TOM SAUNDERS, GLENN ATKINSON,
AND JOHNNY MARTINEZ
Donnell Ranch; Fowlerton, Texas

Donnell Ranch; Fowlerton, Texas

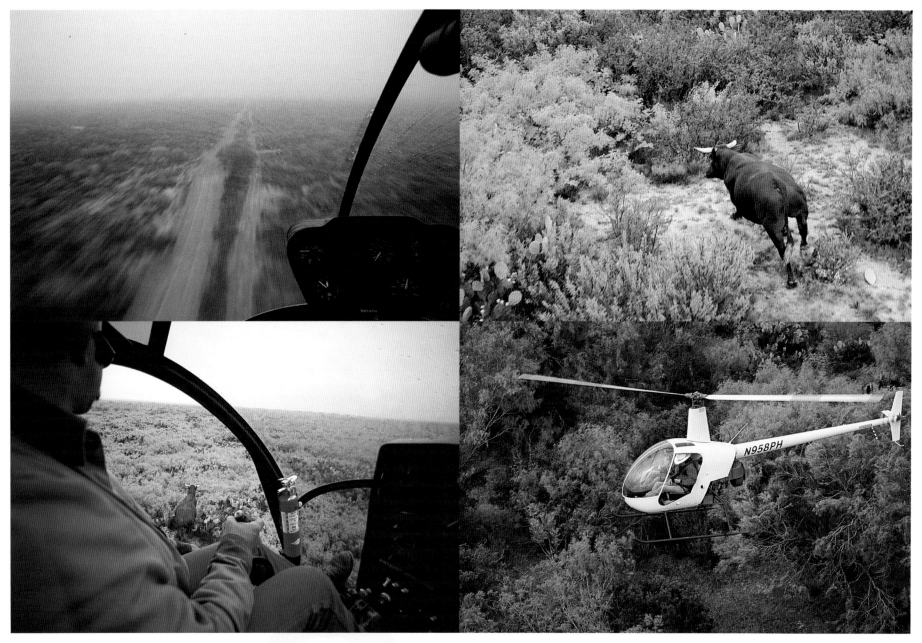

HELICOPTER ROUNDUP
Chip Briscoe and the pilots, Phillip Hinds and Jay Smith
Briscoe Ranch; Fowlerton, Texas

The Devil asked the Lord if he had on hand
Anything left when he made the land.
The Lord said, "Yes, I have lots on hand,
But I left it down on the Rio Grande."

—*Anonymous, "Hell in Texas"*

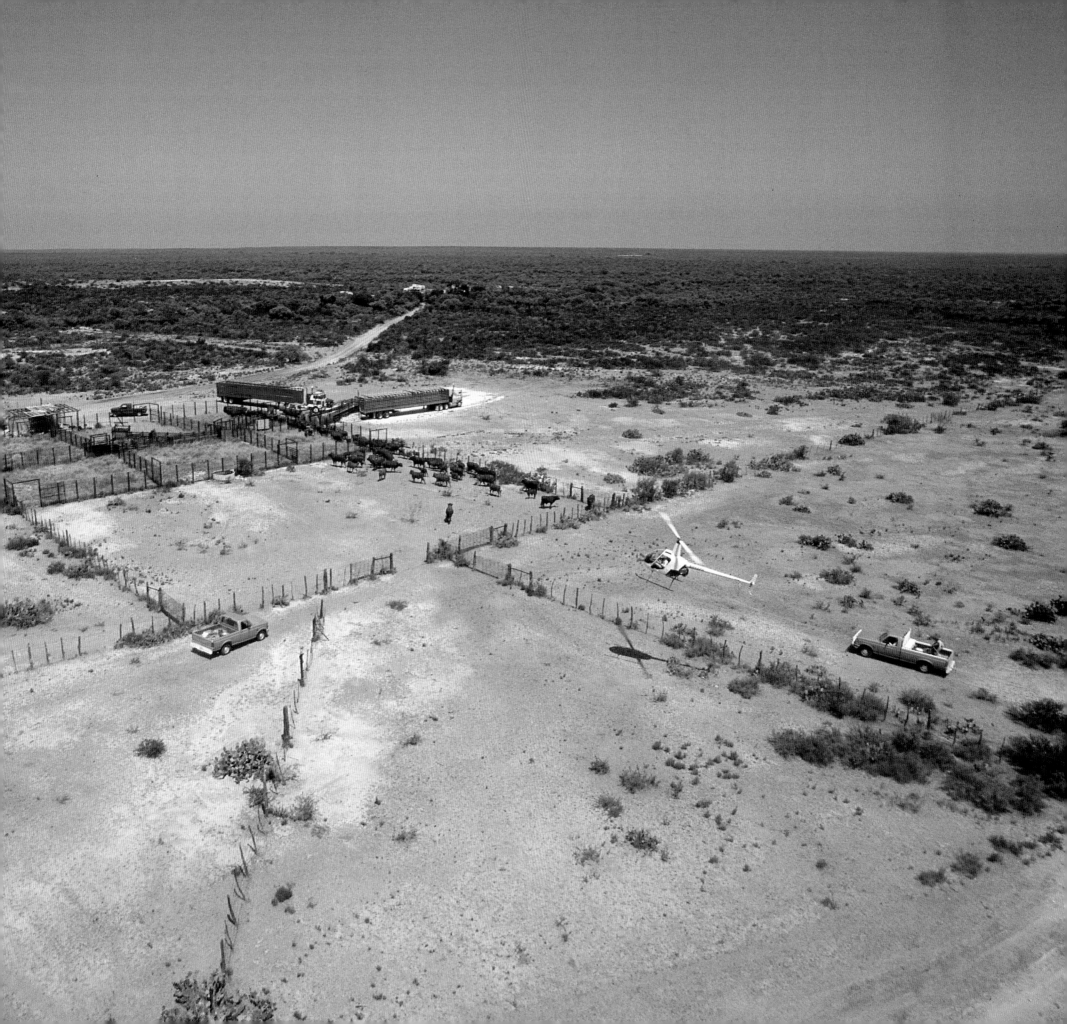

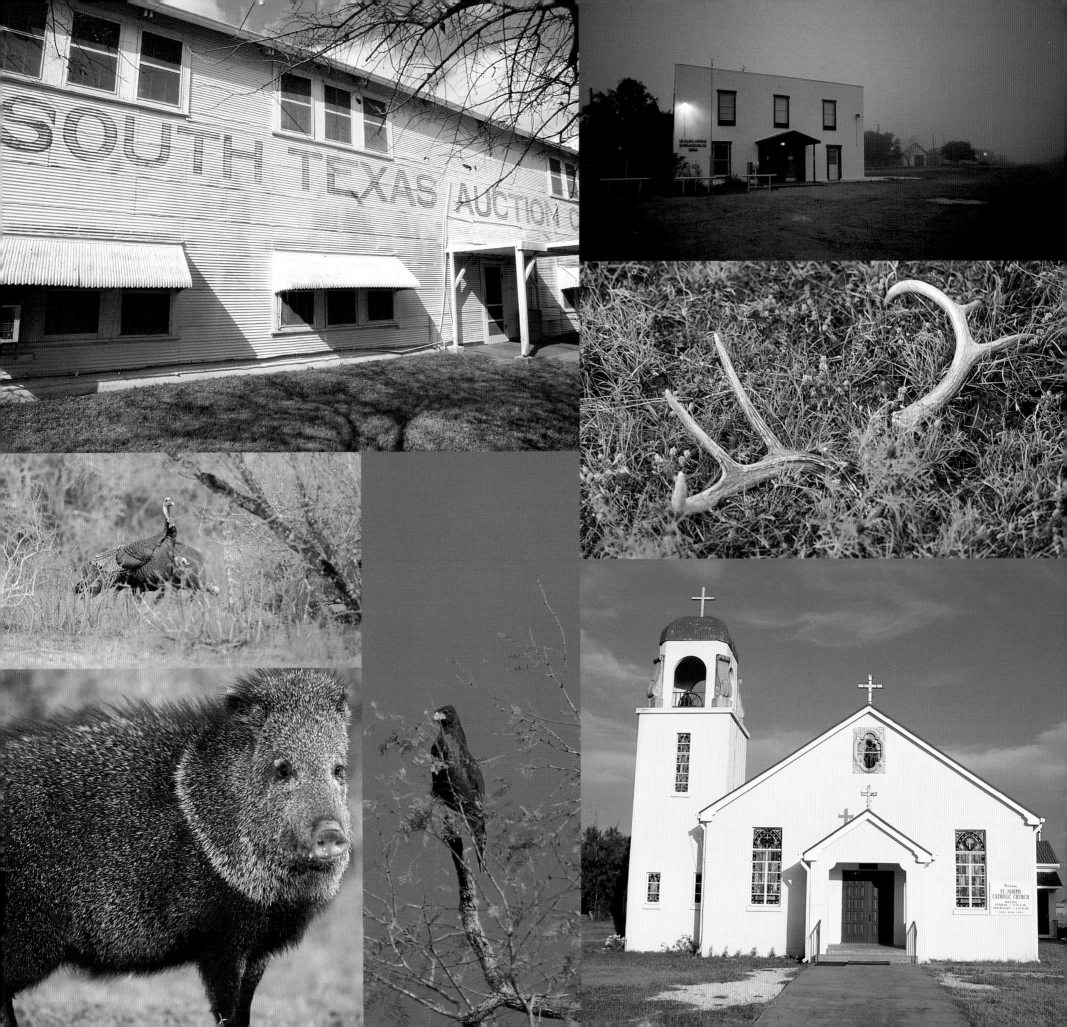

MARTY ALEGRIA AND CANDELARIO "CANDY" AQUILAR
King Ranch; Kingsville, Texas

BUILDING AN EMPIRE
1853 - 1885

After Richard King established land ownership in Texas, he began buying cattle and settling them on his range. He journeyed into Mexico looking for stock and came upon a village that had been ravaged by one of the periodic droughts that plagued the region. The cattle owned by this village were dying from lack of forage and water. King bought the cattle and, realizing that the village was doomed to starvation, offered to relocate the people on his ranch. The entire village went with him, becoming a work force that, through its descendents, has been the backbone of the King Ranch through six generations. They came to be called *Kinenos,* King's men.

—*Stewards of a Vision, A History of King Ranch*
by Jay Nixon, ©1986 King Ranch, Inc.

RICKY FLORES, MARTY ALEGRIA, JERRY ALVAREZ,
CANDELARIO "CANDY" AQUILAR, ALFREDO "CHITO"
MENDIETTA, AND JIMMY VELA
King Ranch; Kingsville, Texas
All of these men are Kinenos, *King's Men; the families of Alfredo*
"Chito" Mendietta and Jimmy Vela have been with the King
Ranch since Captain King started building his empire.

MARTY ALEGRIA, RICKY FLORES, TIO KLEBERG, CANDELARIO
"CANDY" AQUILAR, ALFREDO "CHITO" MENDIETTA
JIMMY VELA, AND JERRY ALVAREZ
King Ranch; Kingsville, Texas

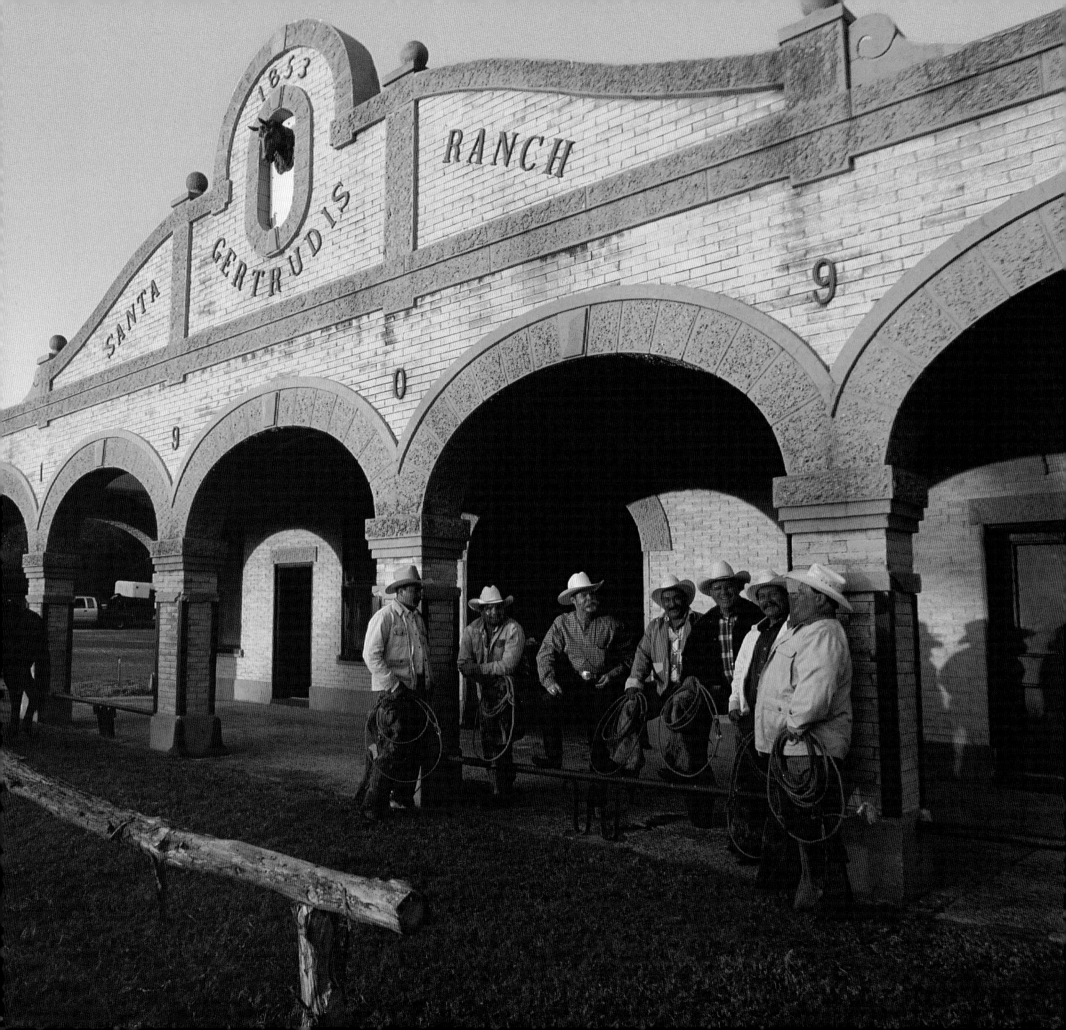

MR SAN PEPPY

Leased to the King Ranch in 1974 and purchased by the ranch in 1975, Mr San Peppy had already gained fame as a world-class cutting horse. Tio Kleberg, Vice President of the King Ranch, wanted to change the breeding procedures at the ranch's divisions to obtain a uniformity among the cow horses by utilizing a small number of top sires. Before, each division bred, raised, and trained its own replacement horses. Kleberg knew of Mr San Peppy's competition record as a cutting horse, but the stallion's pedigree also attracted attention. Mr San Peppy was sired by Leo San by Leo and out of Peppy Belle. Leo was one of the top sires of the American Quarter Horse breed, and in 1989 one of the first four horses inducted into the American Quarter Horse Hall of Fame. Peppy Belle traced back to Old Sorrel, the foundation sire of the King Ranch's American Quarter Horse modern-day remuda.

Mr San Peppy continued his winning ways and his list of achievements are spectacular. He won his first National Cutting Horse World Championship in 1974 and repeated again in 1976. He was the first horse to win more than $100,000 total earnings in cutting competition. In 1974, he was the youngest NCHA World Champion and also the youngest horse inducted into the NCHA Hall of Fame.

In June of 1996, still alive and well twenty years after coming to south Texas, Mr San Peppy was a featured attraction at the dedication of the American Quarter Horse Historical Marker honoring the contributions of King Ranch American Quarter Horses to the ranching industry.

—*Jim Pfluger, American Quarter Horse Heritage Center & Museum*

MR SAN PEPPY
King Ranch; Kingsville, Texas

PEPPY SAN BADGER
King Ranch; Kingsville, Texas

PEPPY SAN BADGER

Peppy San Badger, also called Little Peppy, was sired by Mr San Peppy, and his dam was the mare, Sugar Badger. He was born in 1974, and as a three-year-old, Little Peppy won the National Cutting Horse Futurity, and as a four-year-old, he won the NCHA Super Stakes. He was shown extensively and successfully from 1977 to 1982. At King Ranch, Little Peppy was used to gather and work cattle in the pasture until 1985 when he retired from cattle work.

As a breeder, his first foals were born in 1978 and his last foals were born in 1996. Little Peppy sired over 2,300 foals, many of which have been winners in the arena and on the ranches that were fortunate enough to have Little Peppy horses. His offspring have been exported from King Ranch to Canada, Mexico, South America, and Australia. Although Little Peppy has been retired from stud service, his progenies are still in great demand.

Peppy San Badger is a physically sound and handsome horse who possesses a quiet, gentle manner. He is held in high regard by those that have ridden and worked with him, and he will be fondly remembered when he is no longer with us.

—*John Toelkes, King Ranch*

COLTS AND DONKEYS
King Ranch; Kingsville, Texas

USING BURROS TO HALTER BREAK FOALS

When a foal is 60 days old, we lead the youngster's mother into a stock or confined area, then fit a stake hackamore on the foal's head. The hackamore has an attached 18-inch lead with a secured swivel snap on the lead's trailing end.

Next, a burro is outfitted with a four-inch-wide, heavy leather or nylon web collar that has a D-ring sewn into it. The collar is tightened enough that it will not slip over the burro's head, but can slide up and down its neck. The swivel snap on the foal's hackamore is then snapped onto the D-ring on the burro's collar. The mare is led away and out of sight, and the foal's halter training commences.

The foal soon learns that he cannot leave the burro's side. He also learns that he cannot out-muscle the burro and that he cannot kick the burro or the burro will kick back. The first lesson the foal learns is to stand still, but soon he learns to follow the "leader." He learns that water is available only when the burro drinks, and food is available only when the burro is hungry. These first training sessions last four or five hours, and then the foal is freed and reunited with his mother.

Until now, the foal's food and drink were available only from the mother, and they were available on demand. If he became frightened or was threatened, the mare would come to his aid. After his introduction to the burro, however, mother disappeared and the foal's life changed forever.

The foal's training sessions are repeated for three or four days. Usually during the first day, but at least by the second day, all the foals learn to lead and stand quietly. At the end of the foal's session with the burro, a human handler unsnaps the youngster and leads him for a few minutes.

When it is time to wean the foal, these same steps are repeated, except the foal is snapped to the burro for a 48-hour period instead of just four or five hours. He is then led by a human handler, and trained to stand while tied and to load into a trailer.

We enlisted burros to help us halter break when we had several hundred foals to handle. Prior to this, men did the training, but it was hard and disagreeable work, the cost of which was charged to the horses. By using burros, our costs were reduced, the training was accomplished, and everyone was the better for it.

—*John Toelkes*

BREAKING TO LEAD
King Ranch; Kingsville, Texas

JOHN TOELKES, VETERINARIAN AND QUARTER HORSE MANAGER
King Ranch; Kingsville, Texas

MARES
King Ranch; Kingsville, Texas

MARE PASTURE
King Ranch; Kingsville, Texas

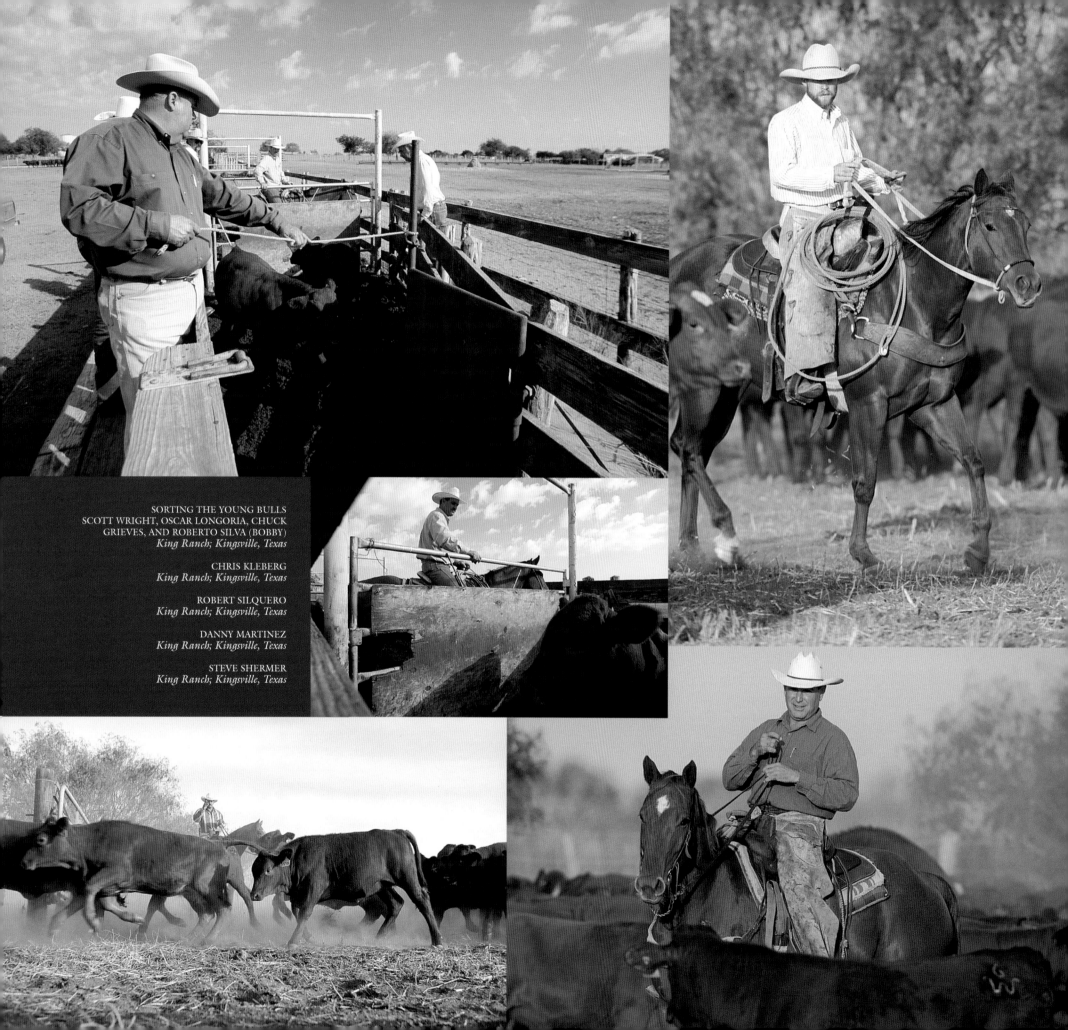

SORTING THE YOUNG BULLS
SCOTT WRIGHT, OSCAR LONGORIA, CHUCK
GRIEVES, AND ROBERTO SILVA (BOBBY)
King Ranch; Kingsville, Texas

CHRIS KLEBERG
King Ranch; Kingsville, Texas

ROBERT SILQUERO
King Ranch; Kingsville, Texas

DANNY MARTINEZ
King Ranch; Kingsville, Texas

STEVE SHERMER
King Ranch; Kingsville, Texas

SAMMY FALCON, THOMAS ESPY, CHRIS KLEBERG, ROBERT SILQUERO, AND DANNY MARTINEZ
King Ranch; Kingsville, Texas

Following pages
SANTA CRUZ CATTLE
King Ranch; Kingsville, Texas

SANTA CRUZ CATTLE
King Ranch; Kingsville, Texas

SANTA CRUZ CATTLE

Santa Cruz cattle are relatives of the Santa Gertrudis. Their name was coined by combining Santa and *cruz*, the Spanish word for "cross."

Production of these cattle began in the late 1980s, when Red Angus bulls and Gelbvieh bulls were crossed with Santa Gertrudis herds. This was done in an attempt to produce calves that could more efficiently meet the carcass-grading standards that had recently been adopted by the beef industry.

Santa Cruz cattle display the genetics of the well-adapted Santa Gertrudis in their ability to thrive under difficult range conditions. They show their Red Angus and Gelbvieh heritage in their quick reaching of maturity, and in their increased fertility and muscle marbling.

—*John Toelkes*

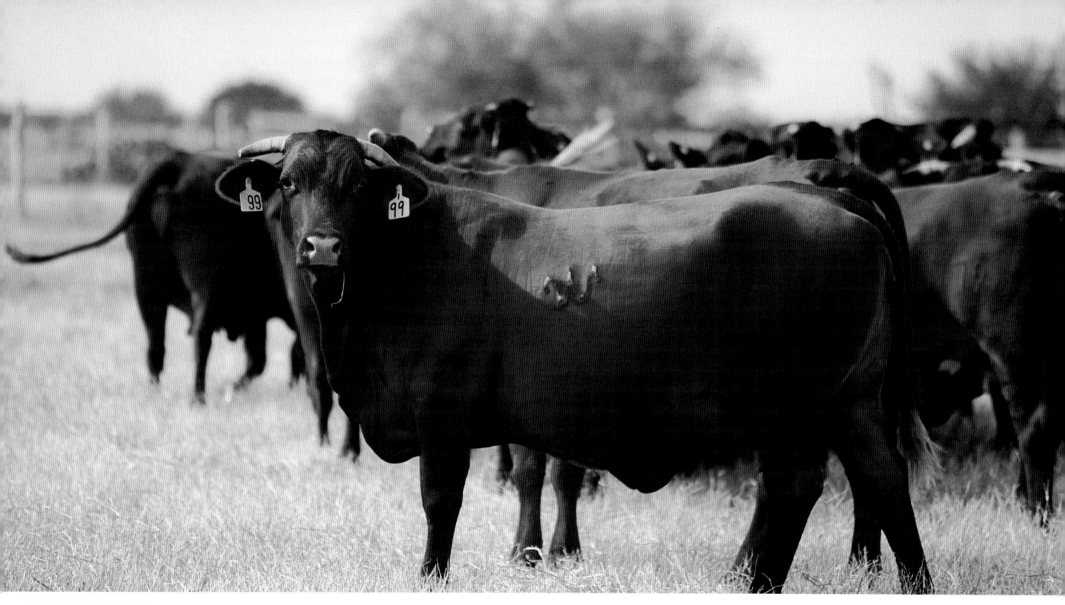

SANTA GERTRUDIS CATTLE
King Ranch; Kingsville, Texas

SANTA GERTRUDIS CATTLE

Santa Gertrudis cattle originated at the King Ranch, and were the first breed of American cattle developed in the United States to be recognized by the United States Department of Agriculture in the 1940s. The King Ranch is headquartered on a tract of land that was known as *Rincon de Santa Gertrudis* during the time of Spanish settlement in the Wild Horse Desert of South Texas. The cattle were named after that original Spanish land grant.

Santa Gertrudis cattle were developed by crossing shorthorn cattle from England with Brahman cattle brought here from India. They are five-eighths shorthorn and three-eighths Brahman. The shorthorn influence provides superior milking ability, a docile temperament, and a better quality of beef. The Brahman contribution includes excellent foraging instincts, superb mothering traits, and resistance to the effects of parasites, heat, and humidity.

—*John Toelkes*

BELL STEER
King Ranch; Kingsville, Texas

USING BORDER COLLIES TO TRAIN REPLACEMENT HEIFERS

At the King Ranch, we use Border collies to help our replacement heifers overcome their fear of man and unfamiliar surroundings, such as corrals or working pens. Our cattle are range animals that see men infrequently—and then most often from a comfortable distance. Otherwise, the cattle come into contact with men in the working pens, where they are branded, vaccinated, or otherwise subjected to uncomfortable procedures. Naturally, they become wary of close contact with men.

For reasons I do not know, the eight Border collies we use have a calming effect on the cattle. Whereas a man on foot or on horseback will oftentimes cause the cattle to split into singles or small groups and try to get away, the dogs cause the cattle to bunch or herd together. When in a herd, the cattle become calm and docile.

For this reason, at weaning, our replacement heifers are moved to a set of pastures where they are looked after by a caretaker who, with the dogs, trains the cattle to bunch, move forward, go through open gates, and follow the dog handler as he leads the cattle where he wants them to go.

The dogs work by subtly moving to the area from which the handler wants the cattle to move. The cattle will then move away from the dogs. Occasionally, the dogs will nip the heels of a slow-mover or the nose of an aggressive heifer who wants to fight, but they do not bark, growl, or howl. They simply move to an area and the heifers move away. The dogs then work back and forth, prompting the heifers to move in the direction of the caretaker, who is walking ahead of the herd, toward the desired destination.

The dogs work from voice commands, hand signals, whistles, or a combination of these. It is rare for the dogs to excite the cattle, or in any way attract attention to themselves.

Late in the training period, the caretaker will travel on horseback while the dogs move the cattle, teaching them to follow a man on a horse.

—*John Toelkes*

HOW THE BELL STEER WORKS

In many ways, "bell steers" are babysitters or scout leaders. A steer is chosen to become a bell steer because of its gentle and docile nature. A belt with an attached cow bell is fitted around the steer's neck, and he is put in with a set of recently weaned steers or heifers. This group is then put into a large pasture.

The bell steer leads the younger, less-experienced cattle to water and choice grazing. The sound of the bell makes it easy to find the herd—by a cowboy, or by a calf that gets left behind as the herd grazes.

Bell horses are used in a similar fashion, to babysit recently weaned fillies or colts.

—*John Toelkes*

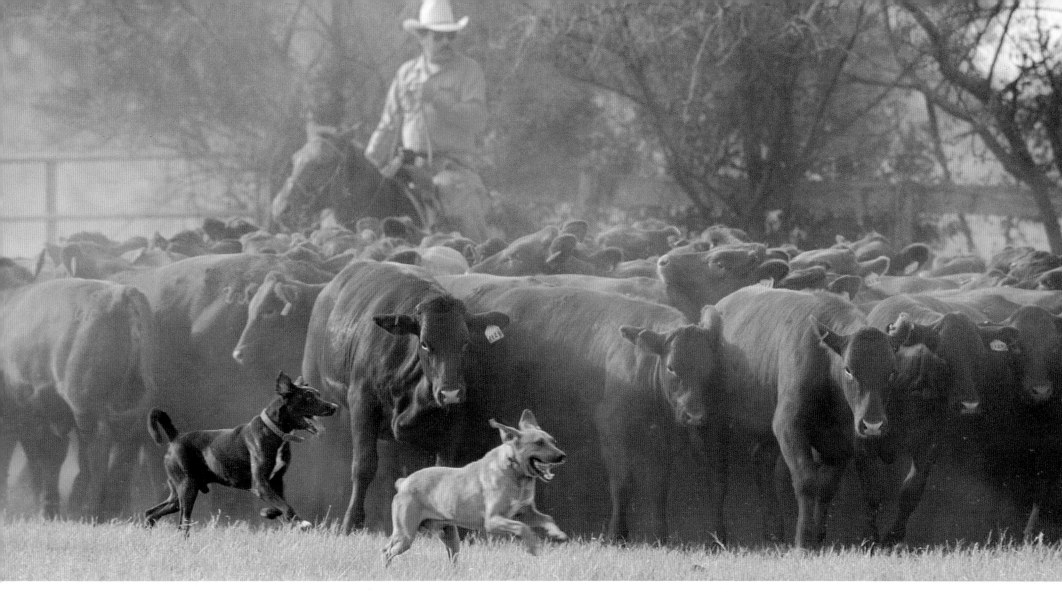

TEXAS HILL COUNTRY

There's no place I'd rather be than on the banks of the Llano, under a live oak tree. . . .

Located in the geographic center of the state is the beautiful Hill Country of Texas, with its rolling, live-oak-covered hills, and its creeks and winding rivers.

This is the most agriculturally diversified area in the state, highly adapted to browsing-type animals such as sheep and goats, as well as good cow and horse country. Hill Country winters are moderate and rainfall averages 21 to 23 inches a year.

In the granite and limestone hills of this country are found more natural springs than anywhere else in Texas. It is also home to the state's largest deer and wild turkey populations.

Cowboying in the Hill Country is an exciting experience, for you never know what may jump out of a white-brush thicket—a cow, maybe, or a goat, white-tailed deer, or bobcat. Riding a green horse sure increases the excitement, and might even get you bucked off if you're not paying close attention.

In the Hill Country, like anywhere else, a cowboy's day starts before light and ends when the owls begin to hoot. A good horse is always the most important tool a cowboy has, and is generally considered his best friend—although, in this country, a cowboy's dog is likely to run a close second. A good dog can do the work of several men, and do it more easily. This is especially true when it comes to handling sheep and goats.

Sheep and goats are hard-headed critters that take undue advantage of a man working in rough country. Coming off a rugged limestone ridge choked with heavy mesquite, white brush, and scattered prickly pear can slow a horseback rider down, and even on their short legs, sheep and goats can outrun most anything on a downhill grade.

A good dog is a necessity under these circumstances. A dog can scoot under that brush, get ahead of the critters you are trying to round up, and hold them up until you and your old pony can get there.

Although the dogs used in the Hill Country vary in breed, most are Australian shepherds, Border collies, or kelpies. These dogs aren't as aggressive as some, but they sure have the right temperament for sheep and goats, and they respond well to voice commands.

Although these dogs do a fair job on cows, Hill Country brush usually isn't so tall that a man riding horseback can't keep a cow in sight. That means a dog isn't as critical in gathering cattle in this part of the state.

As I said earlier, the Hill Country is well watered, with many rivers, creeks, and springs. The Llano, San Saba, Guadalupe, Colorado, Pedernales, and Blanco rivers all run year-round, clear and cool.

Huge live oaks thrive all up and down these rivers and creek banks. These trees can measure 18 to 20 feet around the trunk, and be as much as 800 years old. It's a shame they can't tell stories, for I bet they've seen many of the great herds of longhorns headed north to the Chisholm Trail and on to the railhead in Kansas, from where they were shipped northeast to the multitudes who liked to dine on good beef. I'm sure those trees could also tell many a tale about Comanche Indians camping under their wide branches, roasting venison for supper.

Today, the big trees overhanging these riverbanks invite the modern cowboy to step down for a drink of water while he cools his horse and his dog, letting them help themselves to the crystal-clear water. Scores of pecan trees, Texas's state tree, also frame the banks of these rivers and creek bottoms, and many a cowboy, both past and present, has loaded his pockets before crawling back up onto his mount.

The cowboy is not the only animal who favors these haunts. Deer, turkey, and even feral hogs find these places an oasis where they can feast on acorns and pecans. Needless to say, the pioneers in this country never found grocery shopping a problem. Many a fine meal of venison, pork, or turkey was harvested along these banks and taken home to the family.

The horses used in the Hill Country, mostly quarter horses, are touted as being the best in Texas. Of course, every cowboy is loyal to his home range, and they all claim to raise the best horses. But this country does seem to have an advantage, because the ponies raised on these rough granite and limestone hills have some of the strongest feet and legs to be found on any horse.

WHITE-TAILED DEER
YO Ranch; Mountain Home, Texas

GATE ORNAMENT
YO Ranch; Mountain Home, Texas

92

WINDMILL
YO Ranch; Mountain Home, Texas

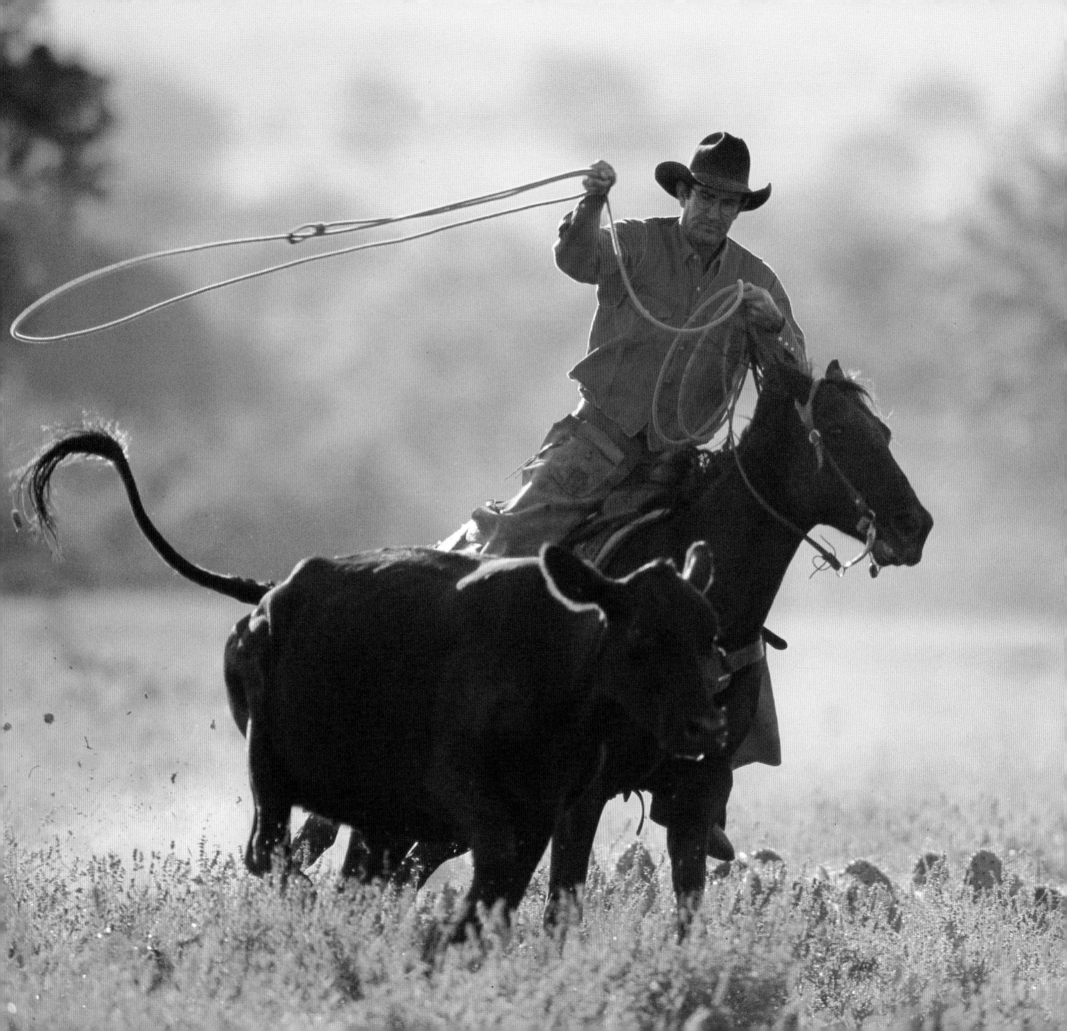

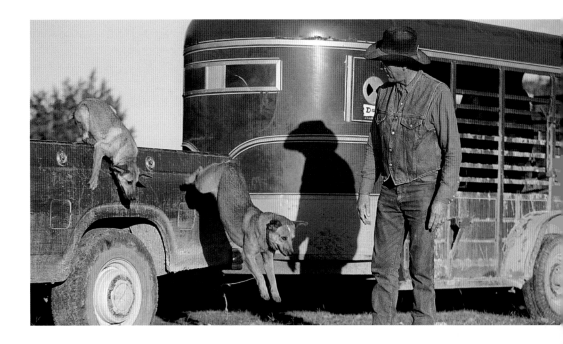

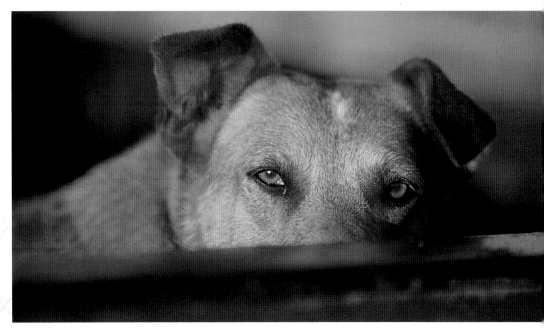

JIM MURFF AND HIS DOGS, FRITO AND CHILI
YO Ranch; Mountain Home, Texas

CHASING A WILD ONE
Jim Murff
YO Ranch; Mountain Home, Texas

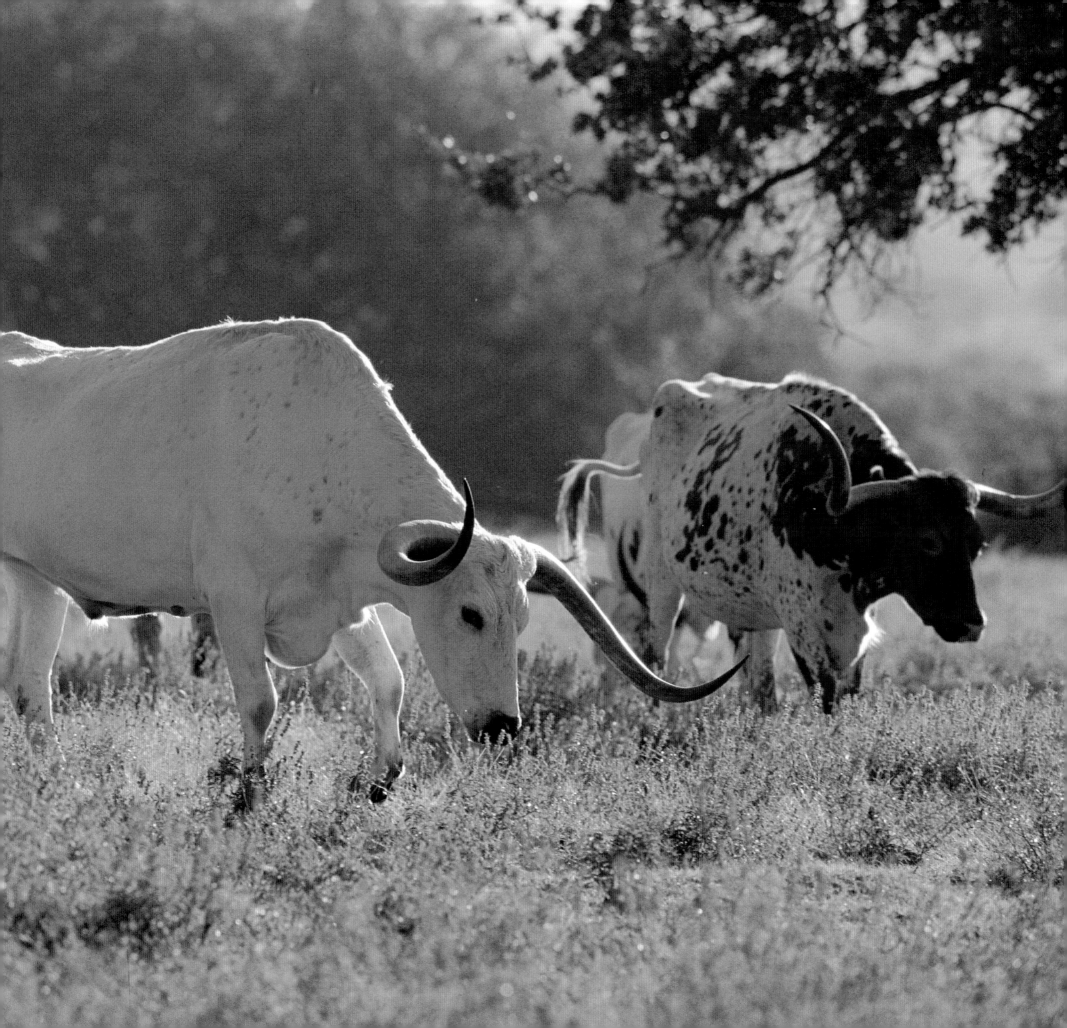

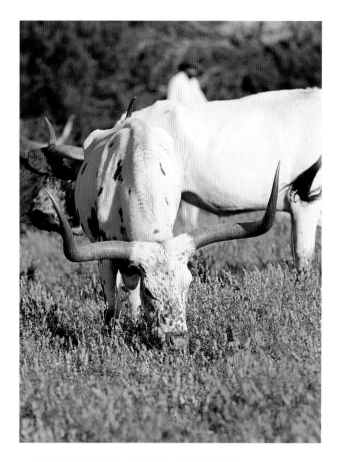

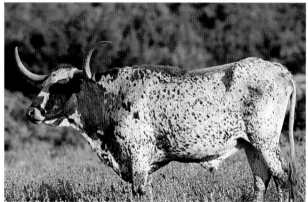

LONGHORN STEERS
YO Ranch; Mountain Home, Texas

GOD'S COUNTRY

There's a place we call God's Country
Where one time everyone should go
And I'm lucky enough to live there
So I think that I should know
It's right square in the middle of Texas
Maybe just a little bit further south
Its beauty is spread far and wide by pictures
But mostly it's spread by word of mouth
It has rolling hills and winding rivers
Plenty of wildflowers, cedars and big oak trees
With many different kinds of cattle and wildlife
For everyone to photograph, enjoy and see
When you finally pass thru our country
And you may not believe all that I've said
But I'll guarantee when you come to visit us
Its beauty will make you light in the head
'Cause you see when God made the Hill Country
He finished on the Eve of the Seventh Day
Then he stopped to rest and look at his work
And decided it was so pretty this is where he'd stay
So ya'll come out to see us sometime
And you'll never regret the time you spent
'Cause I figure if it's good enough for the Man upstairs
It's dang sure good enough for ya'll a space to rent

— © 1996 Jim Murff, used with permission

DETAILS OF THE HILL COUNTRY
YO Ranch; Mountain Home, Texas

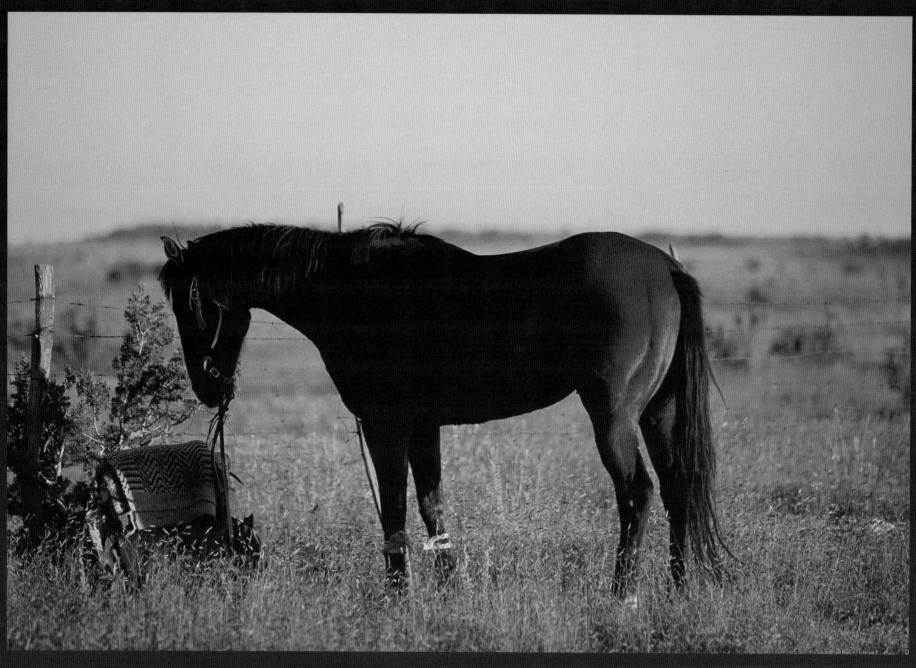

HOBBLED FOR THE DINNER BREAK
06 Ranch; Fort Davis, Texas

TRANS-PECOS

Actually part of the Rocky Mountains, the Trans-Pecos area of Texas is a vast, rugged region of high plateaus and deep canyons in the far western portion of the state. It is bordered on the east by the Pecos River, on the west by the city of El Paso, and on the south by the Rio Grande River.

This area contains the Stockton Plateau, the Diablo Plateau, the Big Bend, the Davis Mountains, and the upper Rio Grande Valley. Guadalupe Peak, the highest point in Texas at 8,749 feet, rests in far west Texas, just south of the New Mexico state line.

The Trans-Pecos area is the driest region of the state, with rainfall averaging only 5 to 10 inches annually. But this is strong grass country, and cattle normally do well unless there is a prolonged drought. In the summer, temperatures may reach the 90s in the higher country, and up to 115 degrees in the lower Rio Grande Valley. In the winter, temperatures can drop to below 0 in the mountains.

Plant life in the plains and Pecos Valley is characteristic of the western deserts of North America, with desert shrubs such as lechugilla, challa, yucca, and ocotillo. The primary grasses of the region are sacaton and taboso in low-lying areas, and black and blue grama in the higher country.

Every cowboy's home range is the most beautiful to him, but most will tell you that the Trans-Pecos and the Davis Mountains area is the prettiest cow country in Texas. Cattle in this country are predominantly English breeds, such as Herefords or Angus, or crosses of the two.

Cowboying in this country is quite different from the way it's done on other ranges in Texas. The ranches may be no larger in size than those found in the high plains or west Texas's rolling plains, but the pastures are bigger. This may be due to the nature of the terrain.

In this rocky, mountainous country, fences are difficult to build and extremely expensive. And in one respect, they are unnecessary. Why bother building fences when natural boundaries have worked for more than a hundred years? Instead of gathering a pasture as others do, these cowboys gather certain areas just as cowboys did in the era of the open range. The hands know what regions constitute the herd's range, and the number of cattle seldom changes.

Most of the ranches put out a wagon or work out of the different camps located over a ranch. The camp cook always has a good meal ready about an hour

DRYING OUT MY CHAPS
O6 Ranch; Fort Davis, Texas

before sunup. Fried beans, tortillas, sow belly and an egg or two, along with strong, hot coffee to wash it down, will get any cowhand ready for a long day in the saddle.

In the mountains, the fog is too thick on some mornings to let the cowboys see down into the canyons. Work is kept slow and methodical until the mist burns off, to avoid having cattle overlooked and the count at the end of the day come up short. Of course, taking it slow is no problem, for there is plenty to keep the men interested. This country abounds with game such as Texas black-tailed deer, antelope, and mountain lion. Even a black bear may amble into view.

By midmorning, the sun has usually burned off the fog and the boys have completed their round of an area, returning the herd to the roundup grounds. Most of the work to be done on the herd is complete in time to catch dinner—the term most Texans use when referring to their midday meal.

Normally, cowboys can look forward to a meal consisting of beefsteak stew, refried beans, tortillas, and hot coffee. Usually there will also be a cobbler or something else sweet to eat if the boys cry up the cooking—and you can bet they do!

After dinner, the hands catch a fresh mount and strike out to gather another area of the pasture. If all goes well, they finish their work with the herd by sundown and head into camp. There they tend their horses and catch the mounts they will need for the next day's work.

Supper is made ready with leftovers from dinner and maybe something added, such as corn, potatoes, or fajitas—whatever is available to get the hands fed. But the boys don't eat as heartily as they do at the other two meals.

This time of day, the boys mostly want to hose down, climb into a bunk, and get some shuteye. Tomorrow comes mighty early in these parts.

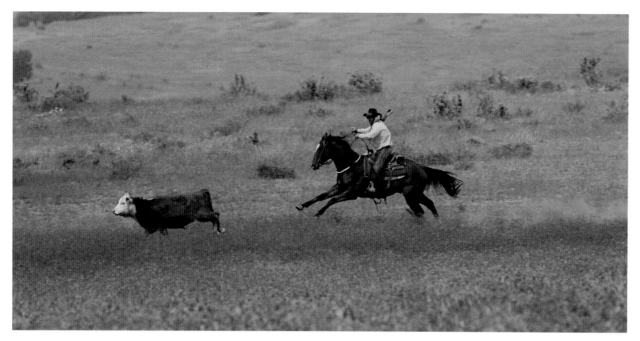

"I'LL GET 'EM!"
Dennis Yadon
O6 Ranch Fall Roundup; Fort Davis, Texas

HOLDING THE HERD
O6 Ranch Fall Roundup; Fort Davis, Texas

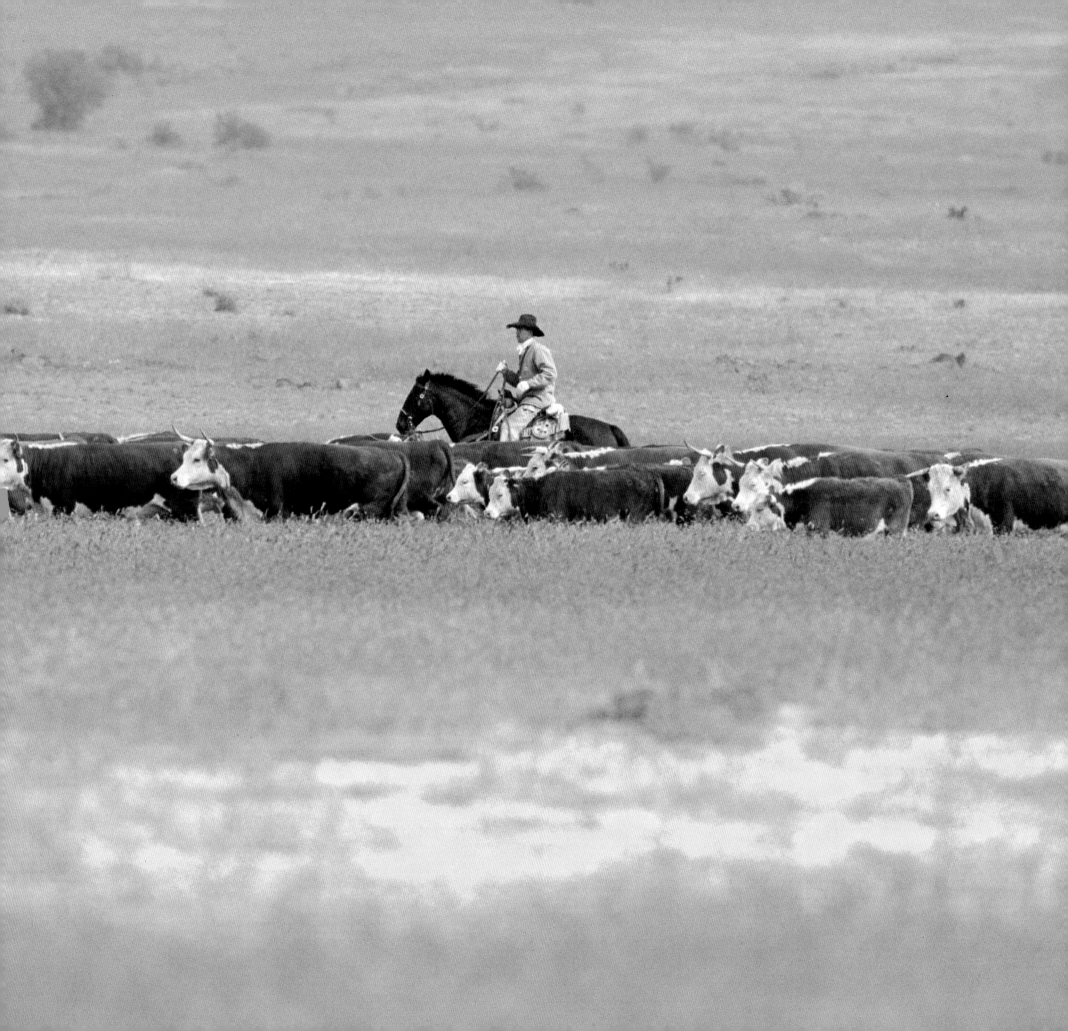

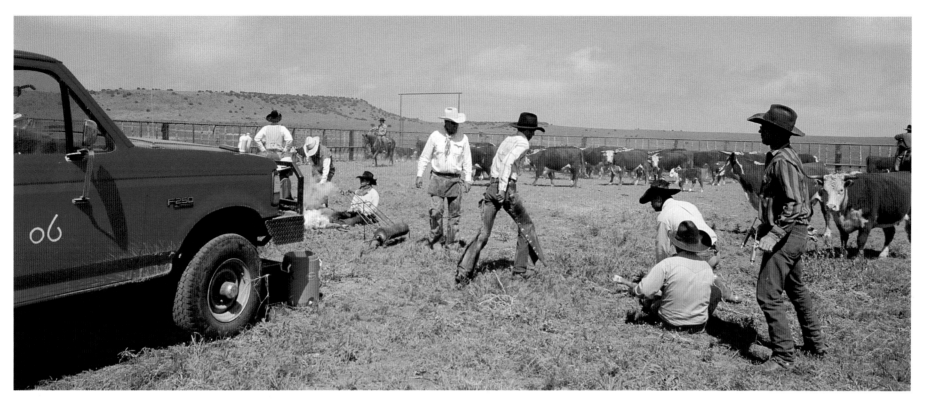

BRANDING TIME AT THE O6 RANCH; FORT DAVIS, TEXAS
Bubba Withers, Chris Lacy, Diane Lacy, Donnie Slover, Jeff Gray, Tommy Dale Vines,
Marc Lang, Dennis Yadon, Shiloh Coleman, and Zol Owens

DONNIE SLOVER
O6 Ranch; Fort Davis, Texas

ZOL OWENS
O6 Ranch; Fort Davis, Texas

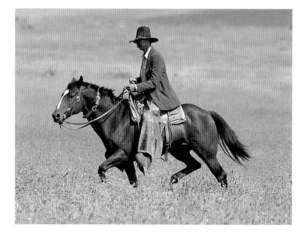

THOMAS VAUGHN
O6 Ranch; Fort Davis, Texas

Previous pages

BRINGING 'EM IN
Chris Lacy
O6 Ranch Fall Roundup; Fort Davis, Texas

COWBOY TEEPEE
O6 Ranch; Fort Davis, Texas

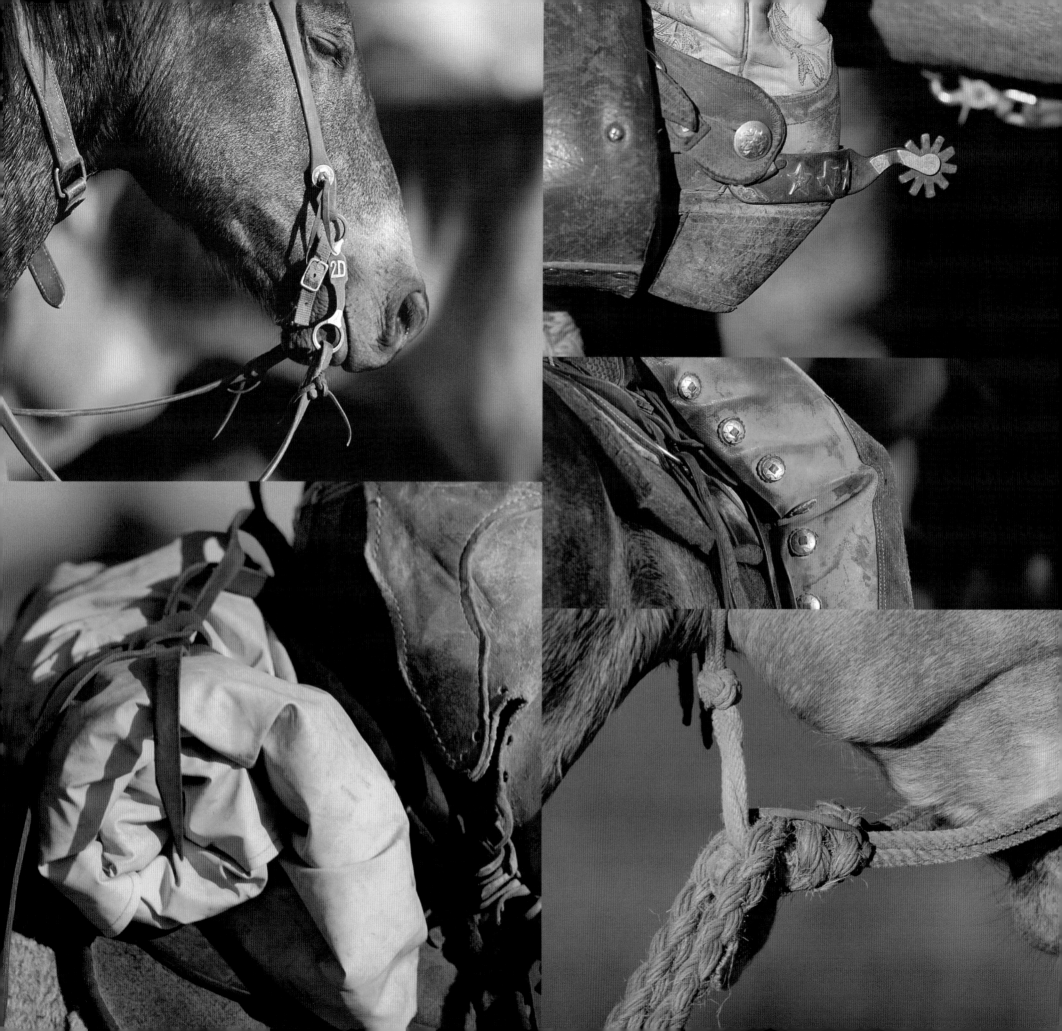

TRAPPINGS OF THE 06 RANCH
Fort Davis, Texas

All Photos 06 Ranch

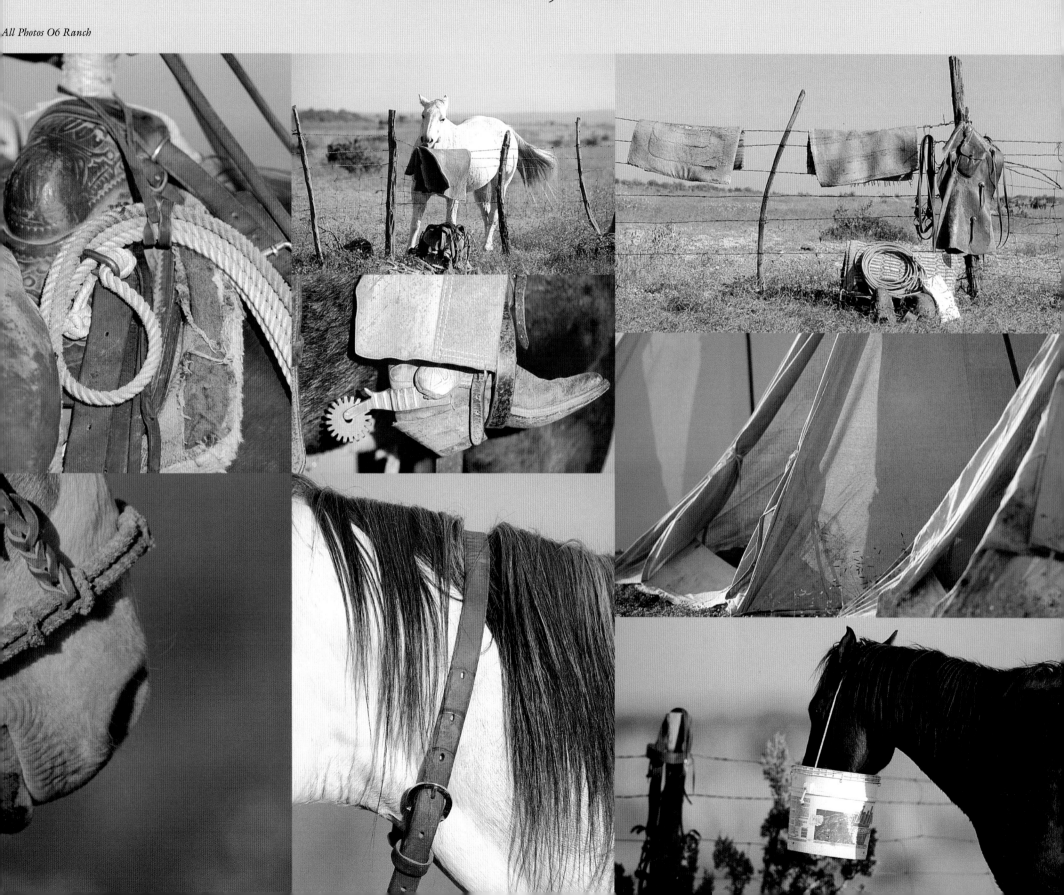

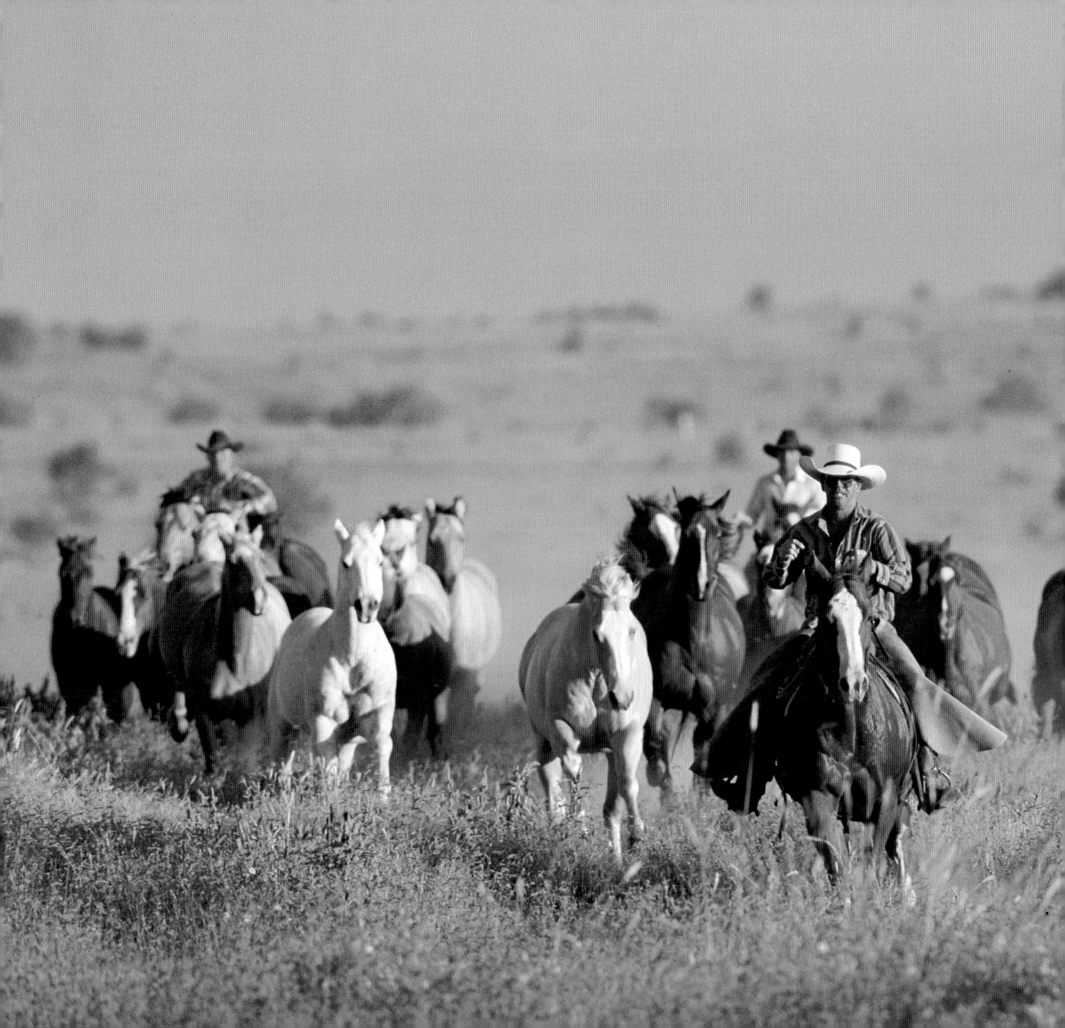

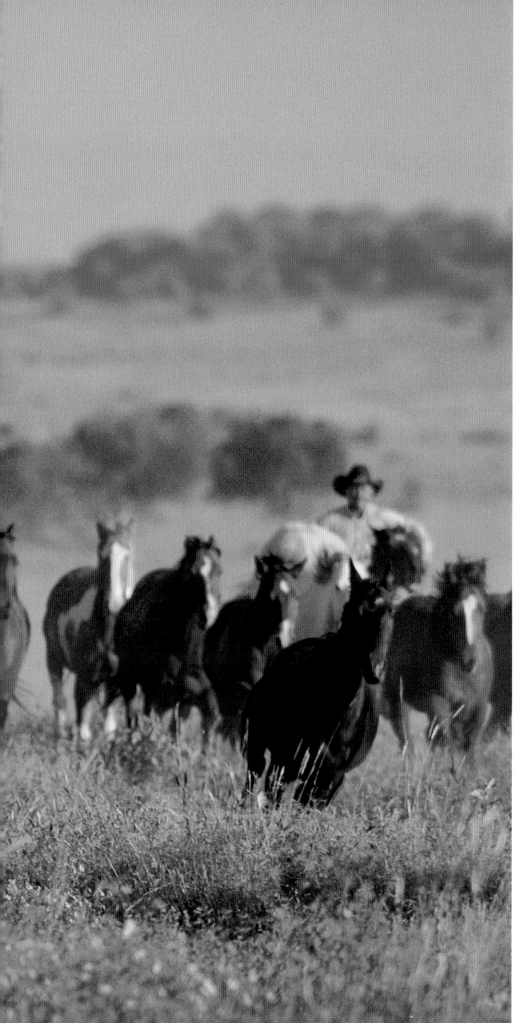

JEFF GRAY
O6 Ranch; Fort Davis, Texas

RANDY WEIGEL
O6 Ranch; Fort Davis, Texas

BRINGING IN THE REMUDA
Bubba Withers, Donnie Slover, Marc Lang, and Jeff Gray
O6 Ranch Fall Roundup; Fort Davis, Texas

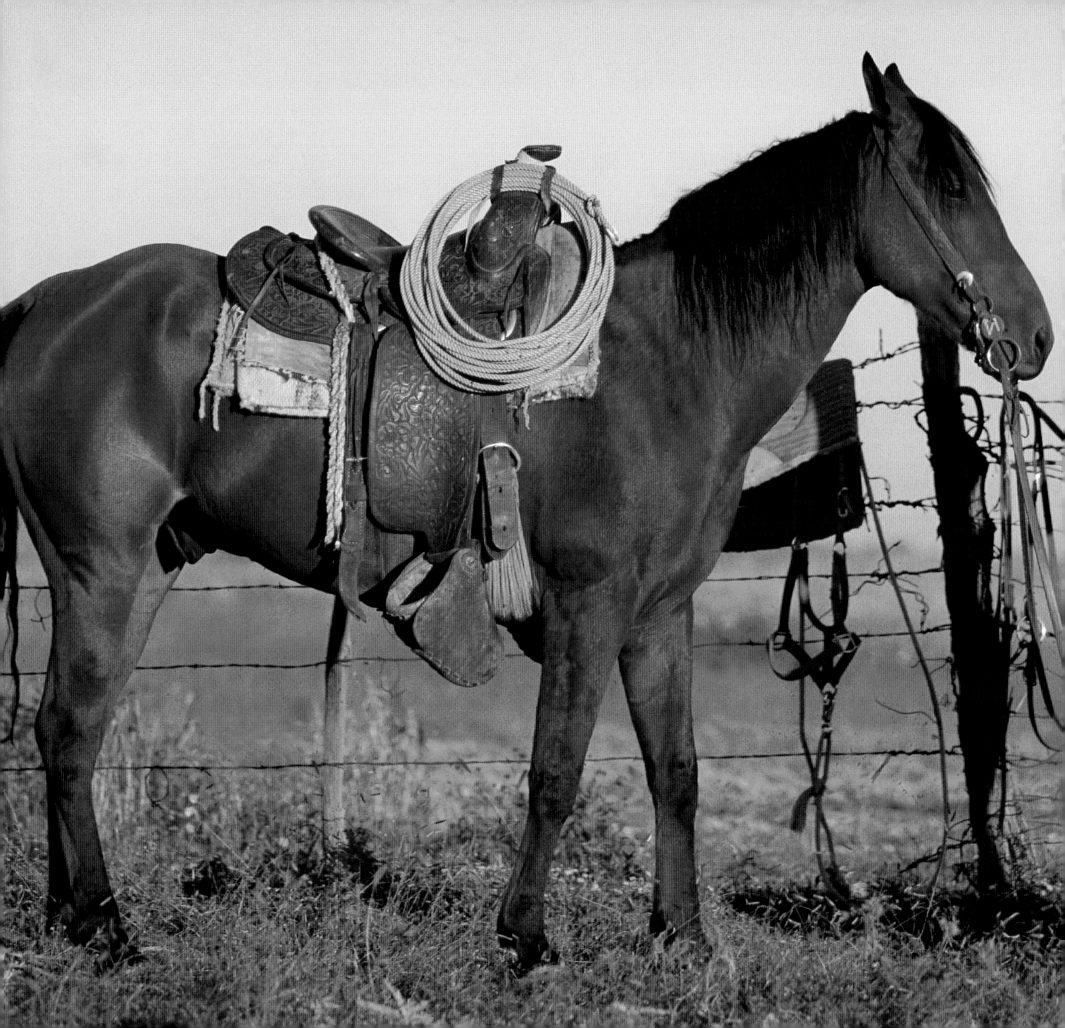

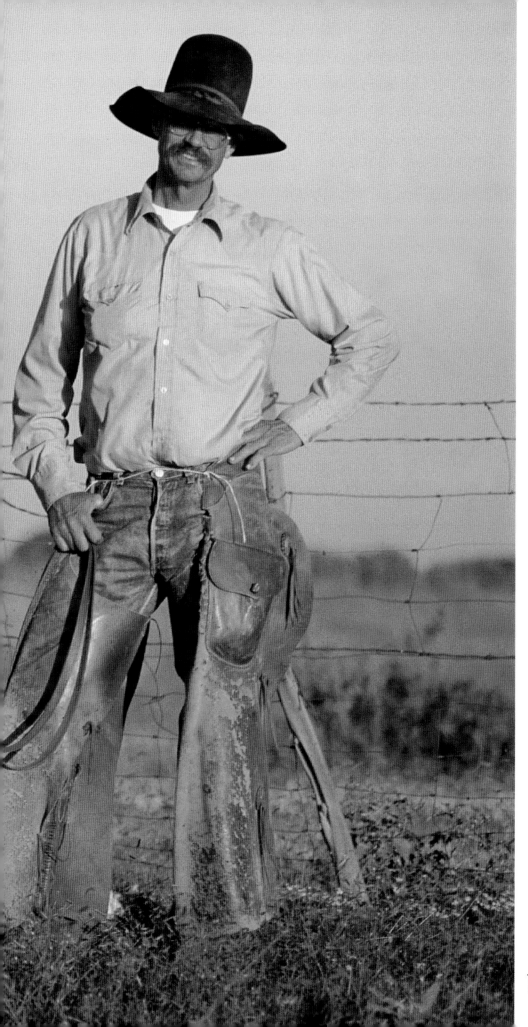

THE KICK
O6 Remuda; Fort Davis, Texas

TOMMY VAUGHN
O6 Ranch Remuda; Fort Davis, Texas

TOM SAUNDERS AND JOHNNY STEWART
Eppenauer Ranch; Toyah, Texas

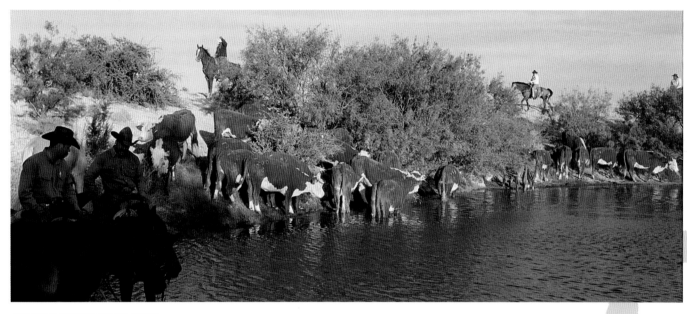

STOPPIN' AT THE WATER HOLE
Doug Seaberry, Johnny Stewart, Henry Mudge, Charley Stanford, and Ray Meadows
Eppenauer Ranch; Toyah, Texas

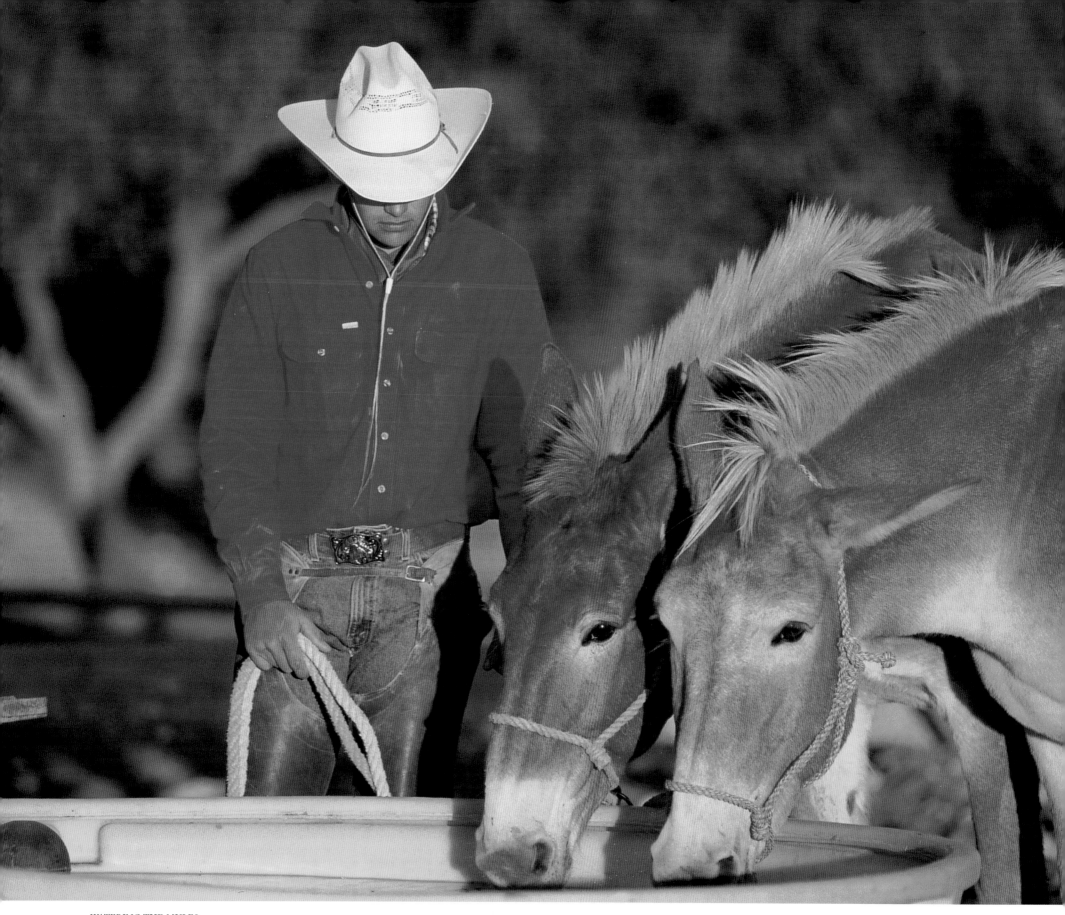

WATERING THE MULES
Henry Mudge
Eppenauer Ranch; Toyah, Texas

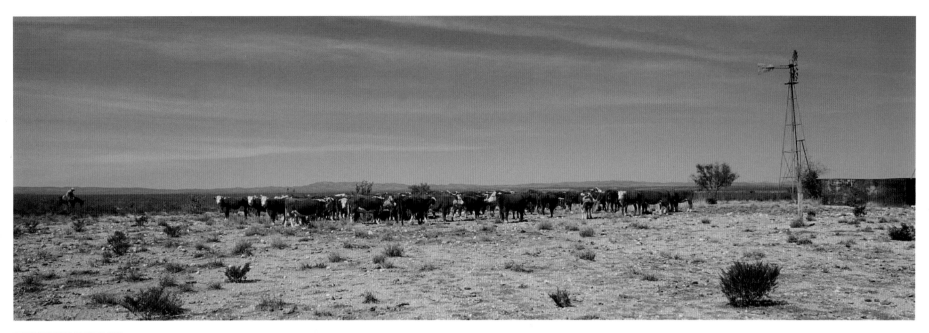

WEST TEXAS WINDMILL
Eppenauer Ranch; Toyah, Texas

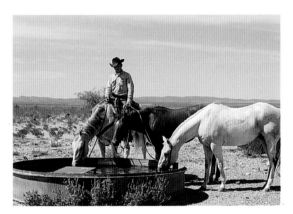

JUST A SMALL DRINK
Cody Mahan
Eppenauer Ranch; Toyah, Texas

Where the grass is our religion,
The Devil pulls the plow,
Our Angels all are Buffalo
Our Saints all Longhorn Cows.

—*Andy Wilkinson*
"The Son of Charlie Goodnight"
©1994 Can't Quit Music (BMI), used with permission

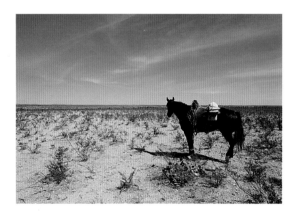

NOTHING TO EAT
Eppenauer Ranch; Toyah, Texas

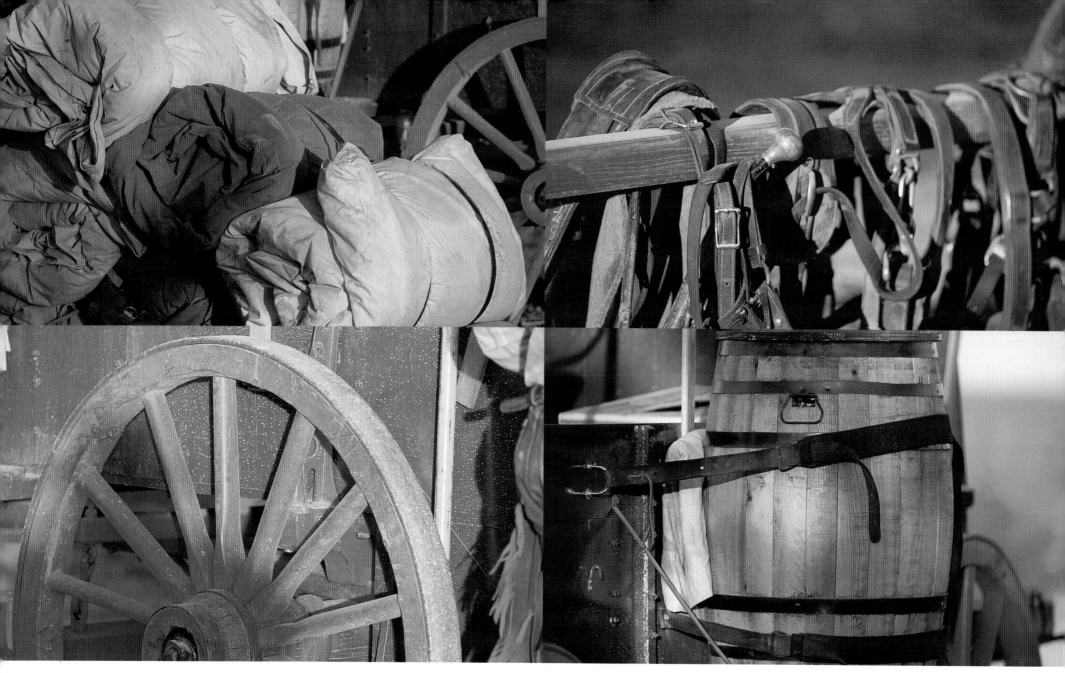

Clockwise from upper right

BEDROLLS, VEALE CHUCK WAGON
Eppenauer Ranch; Toyah, Texas

HARNESSES
Eppenauer Ranch; Toyah, Texas

WAGON WHEEL, VEALE CHUCK WAGON
Eppenauer Ranch; Toyah, Texas

WATER BARREL, VEALE CHUCK WAGON
Eppenauer Ranch; Toyah, Texas

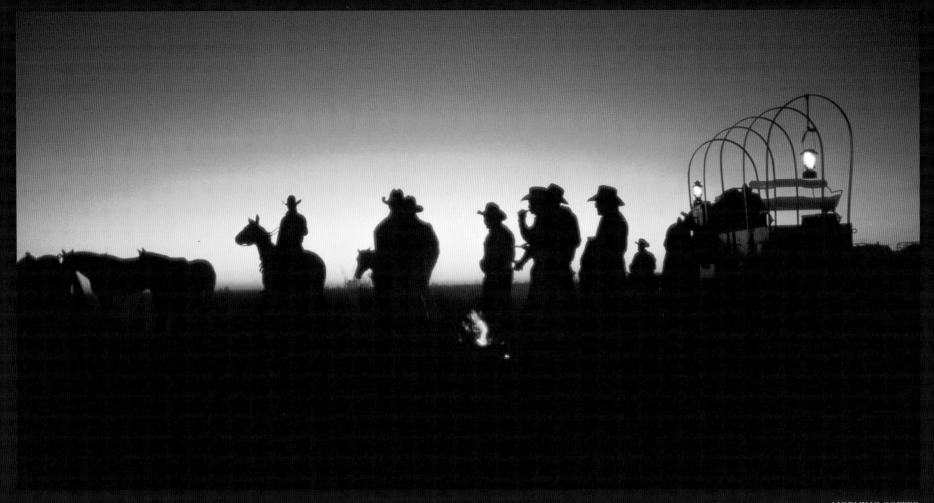

MORNING COFFEE
Tom Saunders, Kevin Bauer, Doug Seaberry, Jim Calhoun, Johnny Stewart,
Joe Wimberly, Cody Mahan, and Ray Meadows
Eppenauer Ranch; Toyah, Texas

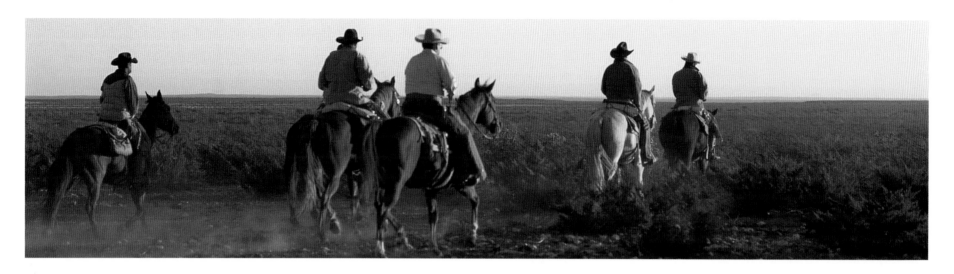

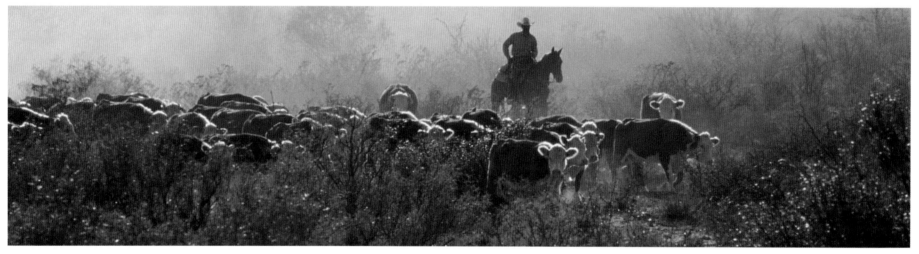

MORNING ROUNDUP
Ward Veale, Jim Calhoun, Doug Seaberry, and Johnny Stewart
Eppenauer Ranch; Toyah, Texas

RIDING IN THE DUST
Tom Saunders
Eppenauer Ranch; Toyah, Texas

"Brave, hospitable, hardy, and adventurous, he
is the grim pioneer of our race;
he prepares the way for the civilization before
whose face he must himself disappear."

—*Theodore Roosevelt*

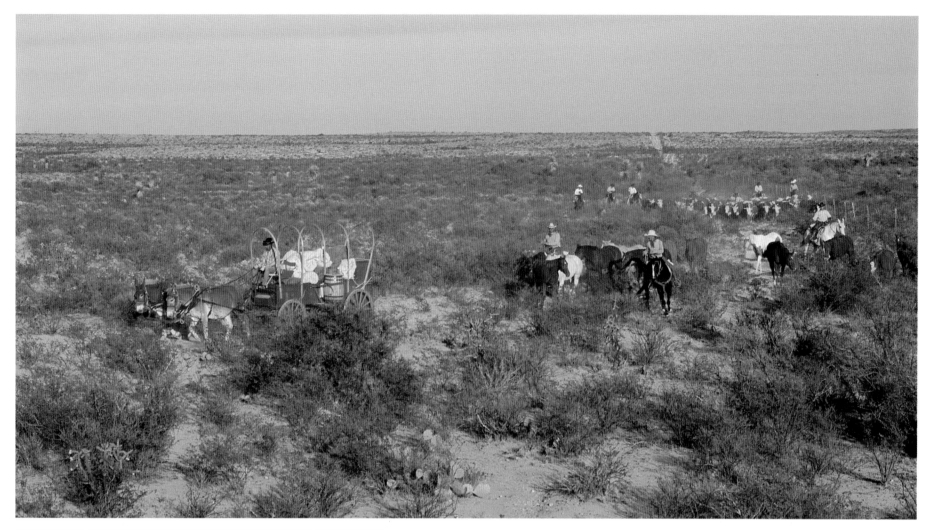

JIM CALHOUN, JOE WIMBERLY, CODY MAHAN, HENRY MUDGE, RAY MEADOWS,
KEVIN BAUER, CHARLEY STANFORD, DOUG SEABERRY, AND JOHNNY STEWART
Eppenauer Ranch; Toyah, Texas

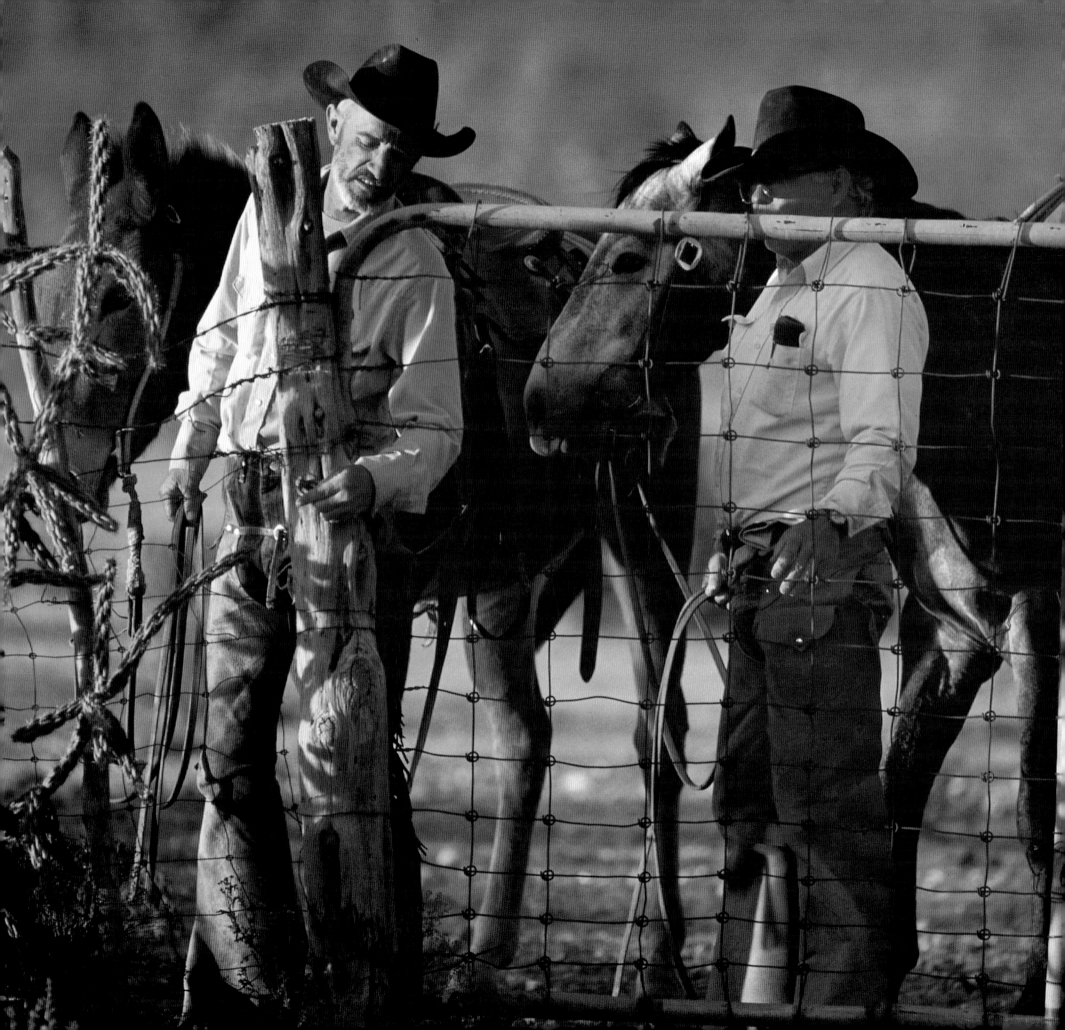

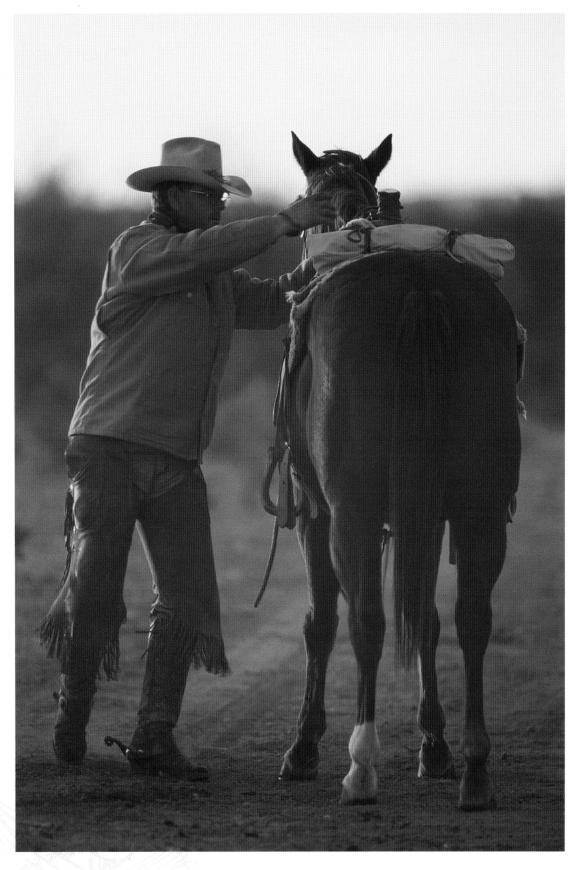

READY TO RIDE
Jim Calhoun
Eppenauer Ranch; Toyah, Texas

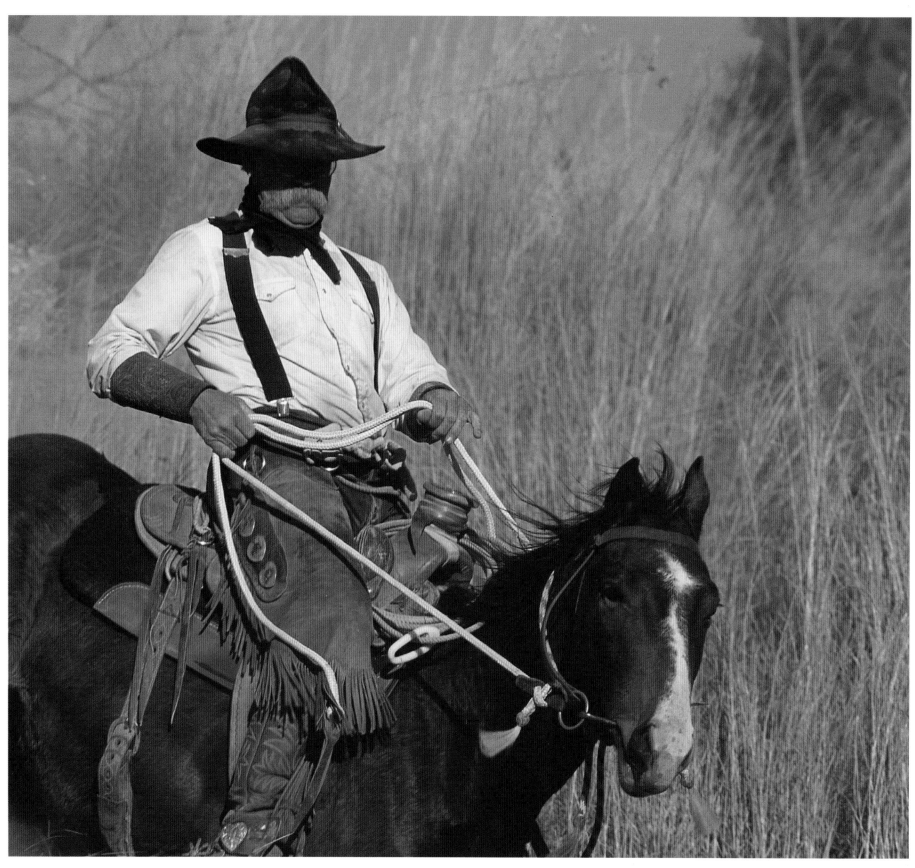

RIDING IN THE BREAKS
David Ross
Pitchfork Ranch; Guthrie, Texas

WEST TEXAS ROLLING PLAINS

The west Texas Rolling Plains encompass a vast area of rolling hills and winding valleys. These hills are covered with native Texas tall grasses, such as big blue and little bluestem, Indian, and switch grasses. The valleys and arroyos are laced with huge cottonwood trees, and mesquite trees are scattered across the flats. Oaks outline the ridges.

The annual rainfall here is around 20 to 23 inches, and the temperature ranges from the single digits in winter, into the upper 90s in the summer.

Comprising approximately 24½ million acres, the west Texas Rolling Plains are bounded on the west by the Cap Rock Escarpment, and on the east by the north-central Cross Timbers and Prairies and the Texas Hill Country. The land is predominantly used for raising cattle and for the production of small grains and cotton.

WHAT'S GOING ON ?
Croton Camp, Pitchfork Ranch; Guthrie, Texas

well-ridden and a little gaunt, and when he's reined to a stop, he will immediately drop one hip and rest a hind leg, an obvious indication that he's made many a mile and expects to make many more.

In this country, horses must have plenty of stamina and heart, as well as a good set of feet and legs. Their hooves have to be hard and tough enough to hold a shoe, because this country is rugged on horses. Without good feet and legs, a horse can't make a living here, and neither can his rider.

Cowboying on the Rolling Plains varies little from the way it's done in other areas in Texas that contain big cattle ranges. Hours are about the same—sunup to sundown—for a man can cover only so much country in a given day.

But the west Texas cowboy has just a little

When one thinks of west Texas cow country, this is the place—the place where the big cattle empires started in the late 1870s and early 1880s. There is probably a greater concentration of 100,000-acre ranches in this area than anywhere else in the state.

The stereotype of the Texas cowboy probably originated in this region. The country over which he rides, the endless miles of red, rolling hills—referred to by some as the "red ripples"—also stereotypes the big ranching country. One can tell a west Texas cowboy from as far away as you can see him. He'll wear a big-brimmed hat, with the brim pulled up high on the sides and not much of a crease on the top. He'll have on a pair of high-top, handmade boots with three-inch heels, and a pair of long-shanked spurs with big-spoke rowels. His pants will be tucked into the tops of his boots.

This cowboy's shirt collar will be buttoned around his neck, and he'll be wearing a neckerchief, or "wild rag," to keep out the fine dust that seems to color everything about him. He is truly today's "red man" of the West.

It's also easy to recognize a West Texas ranch horse at first glance. He'll look

different look and way about him. And even though most of the good cowboys in this area have all worked on most of the big outfits in their country, they all have a favorite place where they like to stay, close to what they call their "home range."

As the old cowboy ballad says:

Once I rode a longhorn cow,
Then I rode a muley,
But when the work's all done this fall,
I'm going back to Buley,
My old home range.

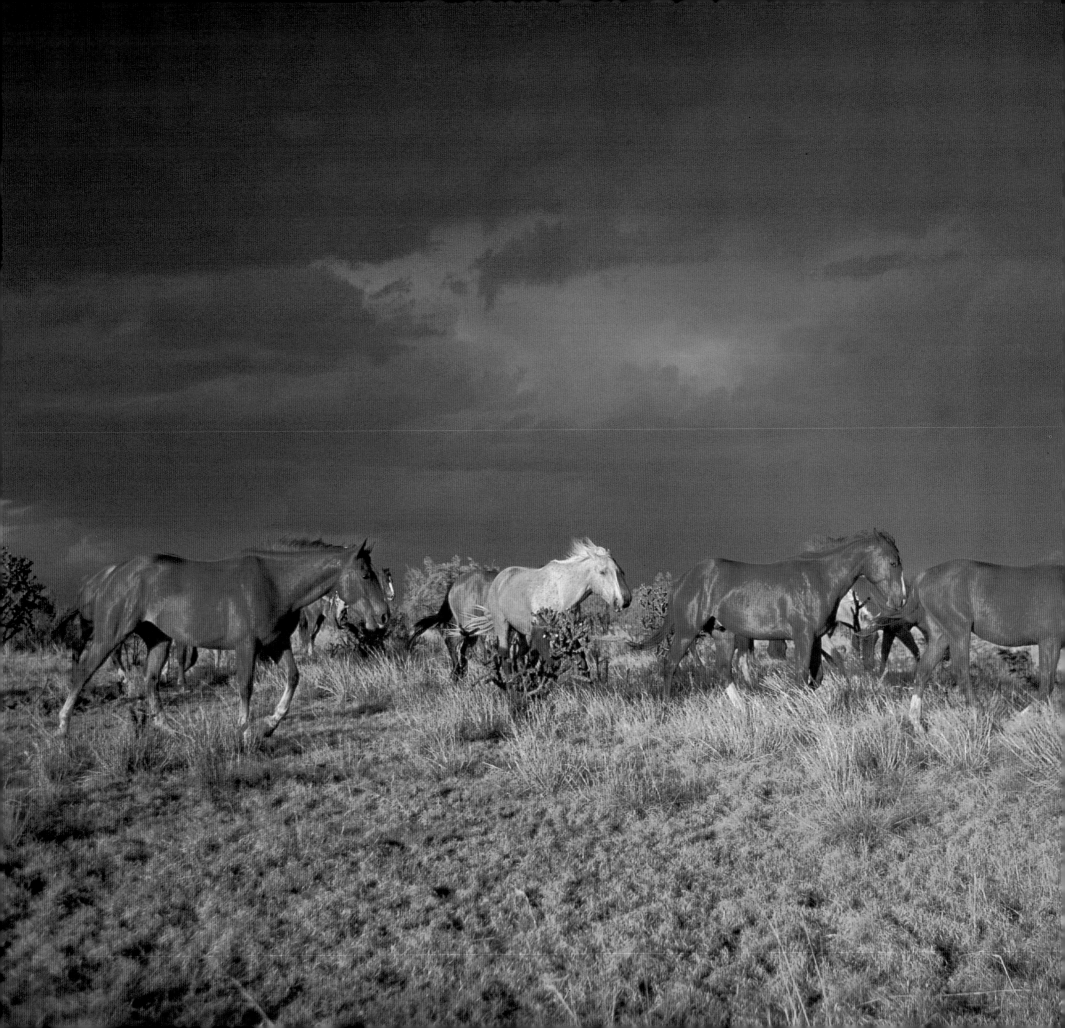

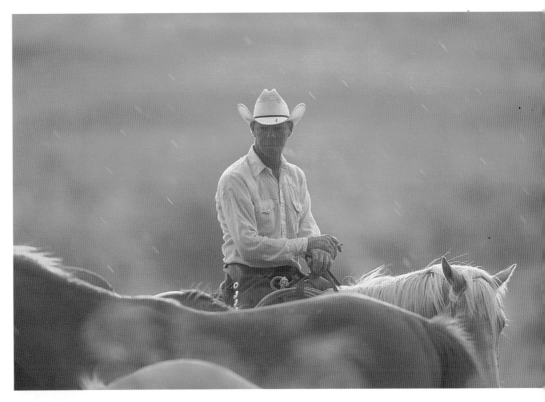

CASEY DANIEL
Beggs Ranch; Post, Texas

The cowboy life is a dreary, dreary life
All out in the midnight rain,
Punchin' cattle from morning 'til night
Way out on the Texas plains.

—*Anonymous, "The Cowboy Life"*

EVENING SHOWER
Casey Daniel
Beggs Ranch; Post, Texas

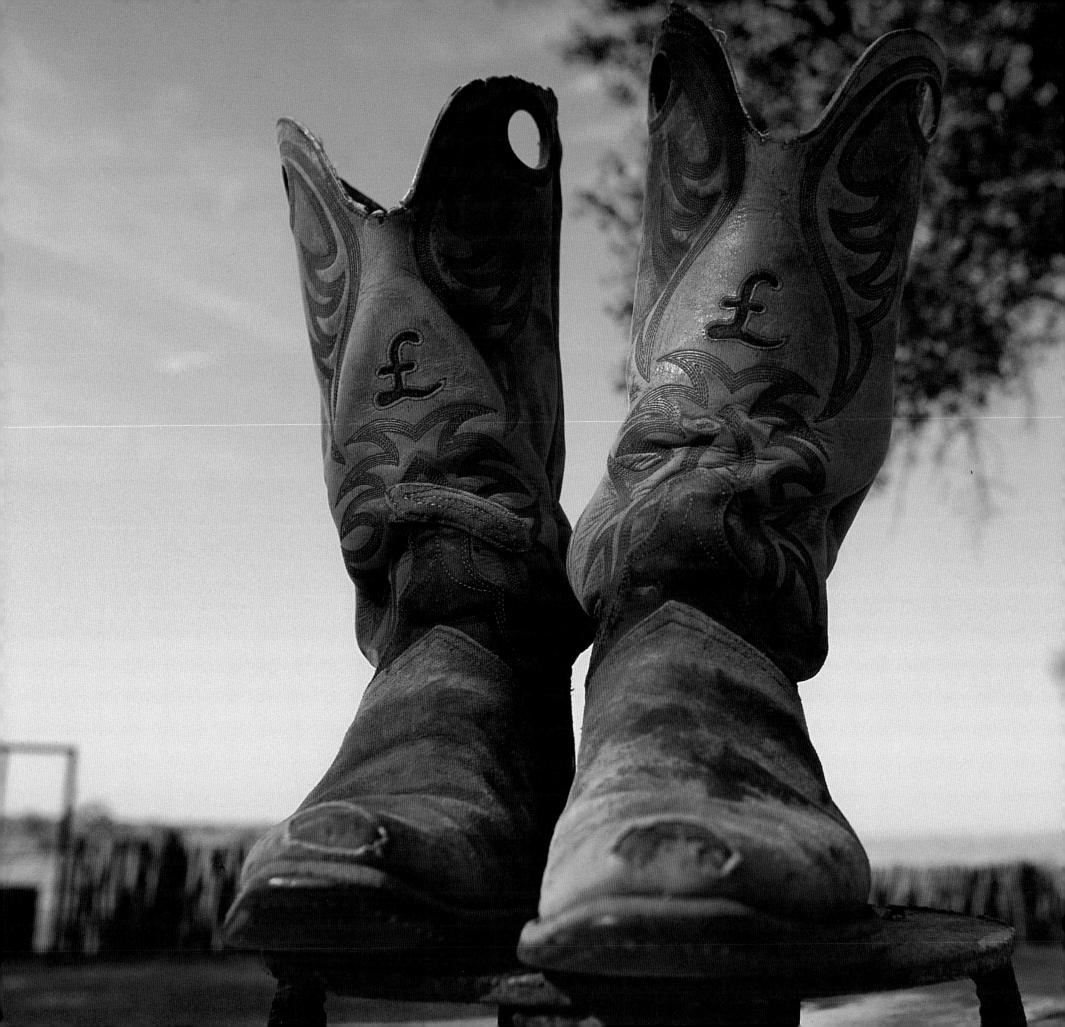

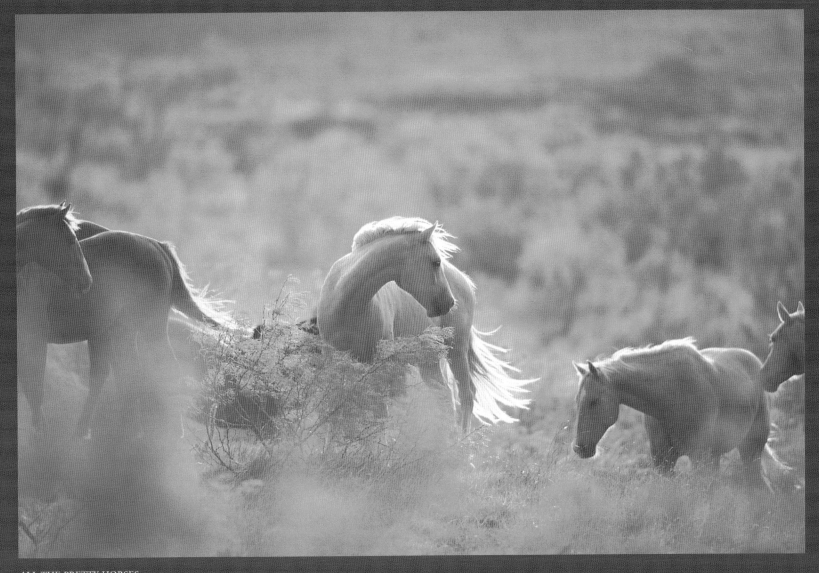

ALL THE PRETTY HORSES
Beggs Ranch; Post, Texas

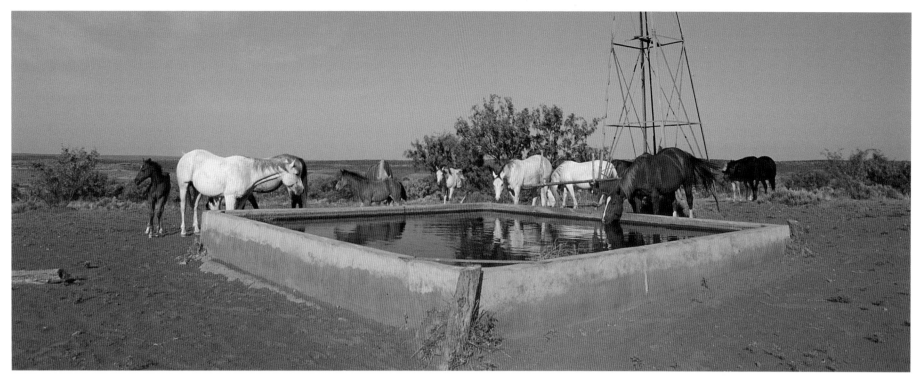

AT THE WATER HOLE
Beggs Ranch; Girard, Texas

Left to right

RANCH HOUSE ON BEGGS RANCH
Girard, Texas

THE BEGGS RANCH GATE
Beggs Ranch; Girard, Texas

GOLDEN CHILD
Beggs Ranch; Girard, Texas

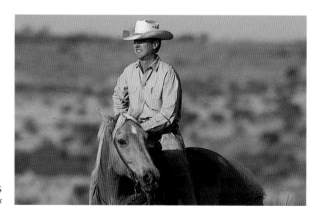

GEORGE BEGGS
Beggs Ranch; Girard, Texas

THE ENGLISH POUND SYMBOL IS THE
BRAND FOR BEGGS RANCH
Post, Texas

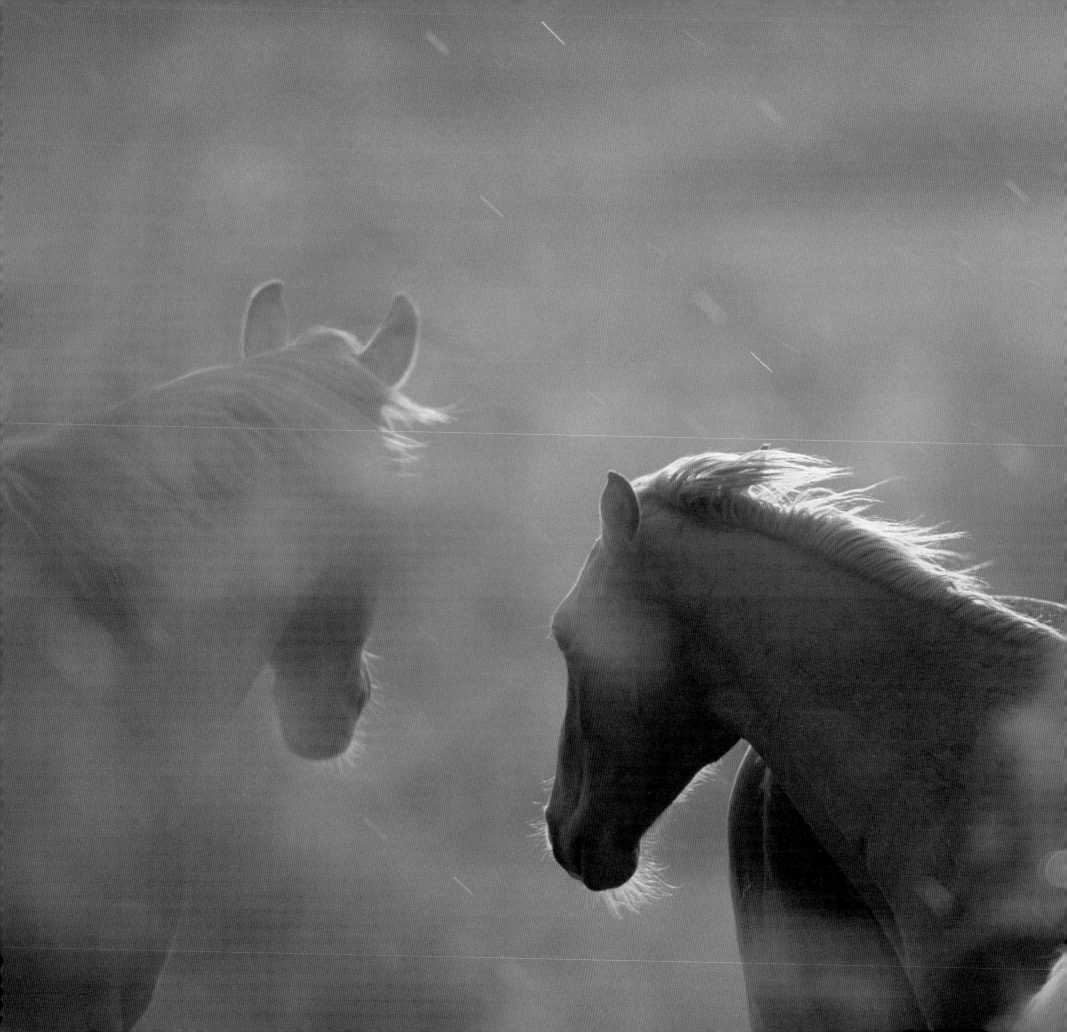

Texas Ranch Horses *Jim Pfluger*

There once was a belief among old-time cowboys that a cow outfit was only as good as its horses. And who was a better judge of horses than a cowboy? After all, the best definition of a cowboy is someone who works from the back of a horse.

That definition, spare in words but to the point—much like the cowboy himself—reflects volumes that could be said about the relationship of man and horse and the nature of the work to be done.

The thought that an ideal cow operation would have the best horses is still true today. The modern Texas ranch is still rooted in traditions established decades, even centuries ago, by horsemen of many cultures and backgrounds.

The image of a horseman, taller than a man walking on the ground, still evokes a feeling of power and freedom few men otherwise have the opportunity to attain. Texas cowboys, because of their place in history and their geographic opportunity, created a legend, a legend and a place in history that could not have happened without the horse.

For centuries, Texas has been strategically important to North America, both geographically and culturally. It has been a crossroads for many cultures and has had an enormous influence on Western history.

First, Native Americans lived on this land. Then Spanish, French, Mexican, Anglo-American, and other European immigrants came to Texas, following dreams of freedom, land and wealth. For many, those dreams included the Western cattle industry, which has fired the imaginations of generations of Americans.

Sometimes myths were created to accompany the dreams. Texas cowboys riding tall in the saddle on a boundless horizon, although real for only a short period of American history, created an image that has endured for generations.

Spaniards were the first Europeans to believe there were riches to be found on the vast plains and in the dense woods of Texas. In 1541, Francisco Vasquez de Coronado entered the southern Great Plains in search of cities of gold. Coronado did not find his riches on the *Llano Estacado*; but, ironically, the land and the rich grasses he rode upon, which now comprise the Texas High Plains, would make fortunes for Anglo-Americans more than three centuries later.

When Coronado explored this area, he brought a valuable commodity with him—the horse. Spanish explorers and settlers in northern Mexico, Texas, and New Mexico completed a circle of sorts by bringing the modern horse back to its prehistoric homeplace. Centuries before, prehistoric horses had wandered into Asia, and their descendants had eventually been brought to Africa and Europe. Those remaining in the Western Hemisphere became extinct.

But once reintroduced to the New World, the Spanish horse had a significant impact upon the future of Texas.

Spain had established a tradition of stock raising centuries before Columbus sailed west. By 1492, cattle were being herded with horses, and roundups, brands, and ropes were being utilized. Those stock-handling traditions and methods were brought to the Western Hemisphere with the first horses and cattle. Virtually all conquistadors and ranchers of New Spain were caballeros—gentlemen of the horse.

The *caballos* brought by the conquistadors and Hispanic settlers were of Andalusian, Arabian, Barb, and Turk bloodlines. Those horses became the breeding and working stock for Mexican cowboys, the vaqueros, whose stock-raising methods and traditions greatly influenced future Anglo-Texan cattlemen.

As Spanish settlements extended north from Mexico City, the horse herds grew in number. Many animals broke free of their domesticated life and ran wild, eventually creating large herds of feral horses. During the Pueblo Revolt of 1680, New Mexican Indians temporarily drove Spanish colonists south and forced them to leave their horses behind. As a result of these events, thousands of *mesteños,* or mustangs, were common in the Southwest and on the southern Great Plains by 1700.

Historians cannot document exactly when it was that Native Americans first acquired horses, but it is easy to show how the horse changed the life and culture of those living on the Great Plains. By 1720, the Comanches had grown strong with the acquisition of horses. They drove other Indian groups out of a territory extending nearly 240,000 square miles, an area that became known by the Spaniards as *Comancheria*. The region included all of western Texas, eastern New Mexico, and the remaining Great Plains south of the Arkansas River.

During the period known by historians as the Horse Culture, Comanches and other tribes of the southern Great Plains served notice to the *Tejanos,* the hated residents of Texas, that the vast grasslands in *Comancheria* would not easily be taken from their control. Texas Rangers and U.S. Cavalry thought twice before entering the Comanches' territory. Few cowmen dared cross it with cattle herds. With the horse, Comanches and Kiowas were able to delay the cattlemen's occupation of west Texas.

Adding to the cattlemen's problems, large numbers of prime Texas ranch horses were stolen in raids that continually took place. By one estimate, more than 100,000 horses and mules were stolen from the Texas frontier by Indian raiders. Some of the stock augmented the warriors' herds, but most was traded to comancheros bringing trade goods from Mexican settlements along the Rio Grande.

From 1836 to 1860, after Texas won its independence from Mexico, the new republic was a destination for western-bound settlers. Citizens of the United States came in droves to claim rich lands in east and south Texas. Many of those immigrants were from the Southern states and had brought with them their own stock-raising traditions, which included some degree of herd control using horses.

Cutting horses, descendants of Colonial Quarter Running Horses, were used in the Southern states to gather and drive cattle in the open range areas. The Southern cowboys didn't use ropes, however. Not until the Anglo stockmen arrived in Texas would they acquire certain equipment and habits from their Mexican neighbors.

Southerners were not the only Americans who came to Texas. Stockmen and farmers from Northern states and territories of the young United States could go no farther west when confronted by the Great Plains, an area described as the Great American Desert. Instead, these hardy pioneers turned south, following the trail blazed by Stephen F. Austin's colonists. What the Great Plains could not provide—rich soil, lush pastures, and ample rain—Texas could.

In 1845, a boy of nine set out with his family from southern Illinois to settle new lands in the Republic of Texas. That boy was Charles Goodnight, born March 5,

1836, only three days after Texican rebels declared their independence from Mexico.

Goodnight rode all the way to Texas bareback and learned to be a horseman. By his twentieth birthday, he was an experienced cowman managing his own and his partner's herds on the open range of the western Cross Timbers of north-central Texas. He knew horses and how necessary they were to the cow work on the frontier. Goodnight would be a significant figure in Texas history as a cattleman and trail blazer.

The Goodnight family's move to Texas was not unusual. Many Americans abandoned farms and homes, and notified anyone who wanted to know of their whereabouts by painting on the doors of their abandoned cabins the letters "GTT"—Gone To Texas.

Like their neighbors from the Southern states, the people coming to Texas from Illinois, Ohio, Kentucky, and Pennsylvania also brought horses—good pacers and runners. For example, Carl Sandburg, in his biography of Abraham Lincoln, described people in Illinois as "horsey" people in a "horsey country." They were people who talked about good horses because they owned and bred good horses.

One such good horse came to Texas hardly more than a year before Charles Goodnight's arrival and contributed immeasurably to the Texas cattle industry. The bay yearling known as Steel Dust was foaled in Kentucky and purchased by Middleton Perry and Jones Greene of Illinois. Steel Dust came from Quarter Running Horse bloodlines tracing all the way back to colonial Virginia. Perry and Greene brought the horse to Texas as they searched for land and opportunity.

In north Texas, Steel Dust found a home and soon became a legend as both a racehorse and a sire. His offspring were in demand as runners and as stock horses. Steel Dust's get were compact, not as tall as the lankier Thoroughbreds but with the strength and weight to pull down a steer at the end of a rope. These same horses could fly through quarter-mile sprints when the cowboys entertained themselves.

Because of those valuable qualities, most stockmen and racehorse owners looked for Steel Dust horses and bred to his offspring, thus creating a "family" or strain of "Steeldusts" that were in demand throughout Texas.

The Steel Dust legend was created even before he died in the early 1870s. Stories were told about Steel Dust and his offspring, and at least one story was put to music by Jack Thorp, an Easterner by birth but a cowboy of Texas and New Mexico by choice.

Thorp remembered hearing one song about Dodgin' Joe, "a Steeldust cuttin' horse, the fastest in Texas." Thorp, a writer and musician, was inspired by this song heard at a chuck wagon campfire one evening in 1889, and decided to collect cowboy songs, gathering them as he traveled. His booklet of 24 songs, published in 1908, was the first collection of cowboy songs obtained first-hand.

Thorp knew horses and cattle, as well as music. He worked as a hand in west Texas and New Mexico, and later bossed his own herd. In his book *Pardner of the Wind*, Thorp devoted several chapters to his horses and others he knew from stories told around campfires. One of Thorp's favorite horses was a Steeldust.

Other horses coming to Texas in the pre-Civil War period also became famous, creating their own enthusiasts. Where possible, breeders made a point to keep records of their good horses' pedigrees. Like Steel Dust's lineage, the bloodlines of many could be traced to Colonial Running Horses. A pair of horses named Shiloh and Billy had their following from the brush country of south Texas to the rolling plains of central Texas. Another important sire was Copper Bottom, brought to Texas from Pennsylvania in 1839 by General Sam Houston.

After the Civil War, the range cattle business began in earnest in Texas. The demand for meat in Northern urban areas and Western mining towns created near-instant gold on the hoof for those hardy enough to "jump" the wild longhorns out of the brush, and bold enough to drive the "critters" hundreds of miles up the trails to the corrals and railheads found north of the Red River.

In 1866, Charles Goodnight, in partnership with Oliver Loving, blazed one of the earliest trails from Texas, driving 2,000 head of longhorns to the gold fields near Denver, Colorado. But Goodnight did not travel the direct route across the *Llano Estacado*—through the heart of *Comancheria*. The Goodnight-Loving herd left the vicinity of Jacksboro in north Texas, headed southwest to Horsehead Crossing on the Pecos River, then turned north up the Pecos into New Mexico. The first herd was sold to the U.S. Army at Fort Sumner, New Mexico, while another herd was taken to Denver, a trip of nearly 1,000 miles.

Goodnight's trail was eventually extended to Wyoming, where Texas cowboys introduced their methods and traditions along with Texas cattle and Texas horses.

Goodnight believed that a successful drive must have good horses and good men. Without an adequate *caballada*, or remuda, of cow-smart horses, his riders could not control a herd crazed by thirst after three waterless days of travel across 80 miles of sunbaked, alkaline flats. And surefooted horses with speed and stamina were needed to keep up with a stampeding herd on a moonless night.

J. Evetts Haley, in his biography *Charles Goodnight, Cowman and Plainsman*, wrote of some of Goodnight's special horses from his trail-driving days. One was a blue roan that Goodnight thought at first "too chunky," but soon found out was strong and agile enough to withstand the rigors of the trail. Another horse, known as Charlie, was considered by Goodnight to be "powerful, fast, and the best-trained horse I ever rode in a stampede."

Once, while tied to the chuck wagon, Charlie was virtually run over by stampeding steers. After the herd passed, Goodnight cut the horse's rope and jumped on Charlie, who at once "struck out at full speed with the herd."

Each year, as the grass "greened up" with the warm breath of spring, the chuck wagons, with the remudas following, rolled out from ranch headquarters. Another spring roundup was beginning. Spring roundup was the most important activity on the open range more than a century ago, and it's still important on today's ranches. During roundup, the cowman learned of his herd's condition and its increase since the previous fall's work. This was harvest time in cow country.

The roundup required special preparation, including getting the horses in condition after a winter of limited work. Before the open ranges were fenced, roundup crews from several ranches could be out for months working hundreds of square miles. A rider might have six or more horses, and he was responsible for their conditioning, training and care. Continued abuse of his string could lose a hand his job. No one, not even the wagon boss, could ride one of a cowboy's "hosses" without permission. If the boss took a horse from the rider's string, it was the same as telling him he was fired.

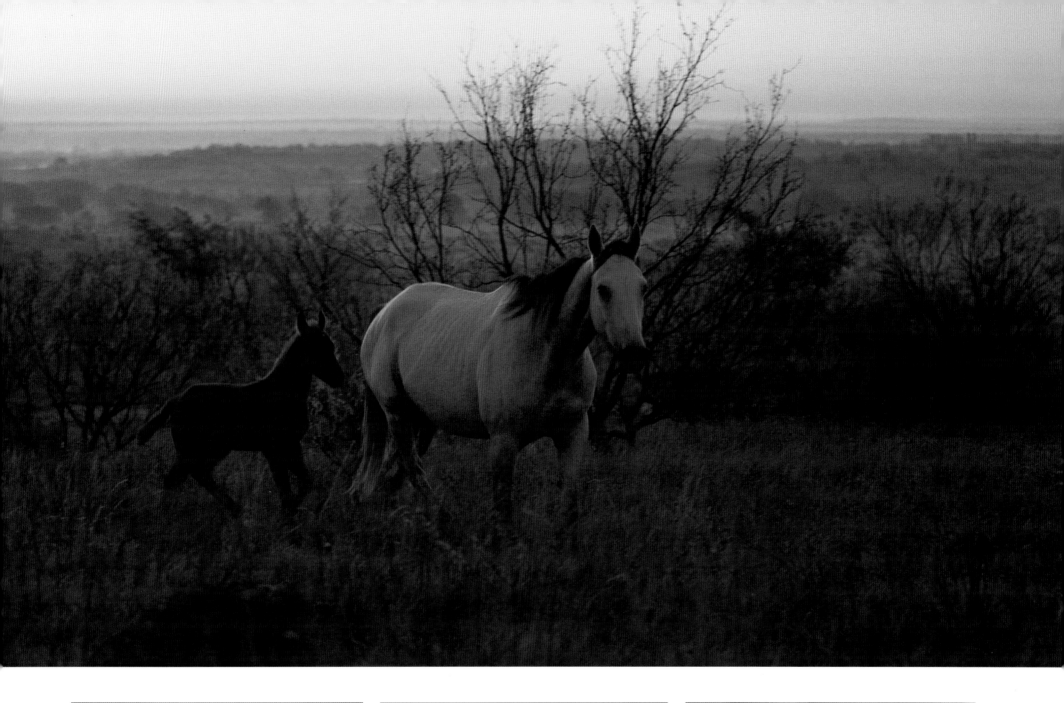

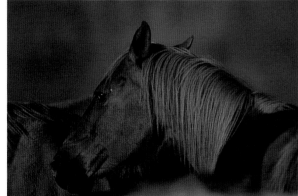

SORREL
R. A. Brown Ranch; Throckmorton, Texas

SALT & BREEZE
R. A. Brown Ranch; Throckmorton, Texas

MARE MANES
R. A. Brown Ranch; Throckmorton, Texas

Above

MARE AND HER COLT
R. A. Brown Ranch; Throckmorton, Texas

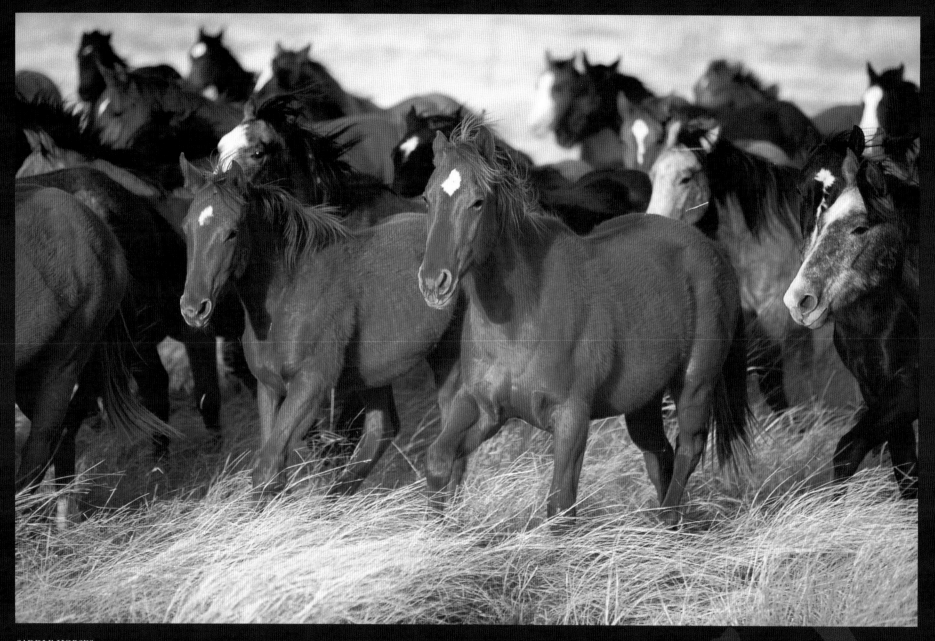

SADDLE HORSES
Pitchfork Ranch; Guthrie, Texas

Jack Thorp tells the story in *Pardner of the Wind* of a ranch owner whose friend from the East was coming to visit. The owner wanted his friend to ride one of his cowboy's horses. The cowboy agreed, replying, "Sure, cut him out. While you're at it, cut out the whole mount—an' make out my paycheck."

When a new hand was assigned his string, he was not told anything about the character of his horses. He was considered a good enough hand to learn about his horses on his own. The bronc buster topped out the unbroken colts and fillies brought in from the range, but each cowboy worked the "cavvy-broke" (broke to ride) horses in his string.

Good cow outfits had horses with cow sense, the ability to anticipate what a cow will do in any situation and not be intimidated by a bull on the prod or a "mama cow" looking after her newborn calf. There was a pecking order among cowboys in an outfit. The wagon boss got first choice of horses, and then the best riders, if not allowed to choose their own, were assigned the best horses. Experienced hands got the best cutting horses and the top ropers had the steadiest rope horses in their strings. The horses in a cowboy's string determined his value to the outfit.

Nearly all hands received at least one or two "green-broke" broncs and were expected to continue training them to be useful to the outfit. According to some old hands, it took several years, perhaps six or more, for a horse to be a top roper or cutter.

"Circle horses," those younger, stronger horses without special skills, were the first to be called into action at a roundup. "Telling off the riders," the roundup captain assigned the cowboys over the perimeter of a gather. They were to drive cattle to a holding point for sorting and branding. It was hard work, requiring a thorough inspection of every canyon and arroyo, a look behind every hill and in each motte.

The size of the area assigned could require a cowboy and his horse to be out most of the day. Therefore, all circle horses required stamina or "bottom" for their day's work.

But the cowboy's work was only beginning when the cattle reached the holding point. There, each rider would change his saddle to a fresh horse. Depending upon the cowboy's skills and his assignment, a cutting horse or a roping horse might be needed. The younger hands, who would not get the chance to cut or rope, would be mounted on a herd horse, one that would not spook easily at the dust and noise while the hand kept the herd close or the cuts separated. This was also was a good time to work a green horse, giving it the experience of working close to the herd.

Most likely, all except the wagon boss and top hand took a turn at flanking and branding, the less desirable work that required cowboys to dismount. Ranch horses respected the "catch rope" and the roundup's rope corrals. All were taught to "work easy" around cattle and to tolerate a rope thrown by their riders. The rope, a simple extension of the cowboy, was essential to cattle work. Two cowboys heading and heeling on trained horses could easily doctor a 600-pound steer. However, according to John H. Culley in his classic book, *Cattle, Horses & Men of the Western Range*, horses were trained to be "tetchy about the rope around their legs and tail. It made them leery about stepping into the slack of the lariat when roping. . . ." It also kept the horses from "crowding up" against the rope corral.

Horses' abilities were as varied as those of the cowboys who rode them. Its natural disposition plus its training determined whether a horse became a top roping or cutting horse, or a favored night-herding or river-crossing horse. Cutting horses, for example, were considered a second set of brains for a rider at a roundup and were a source of pride for their owners. One horse said to be a natural cutter was Powderhorn, a sorrel owned by world champion cowboy Bob Crosby. According to witnesses, Bob would draw a brand in the sand for Powderhorn, and the horse would cut out the cattle wearing that brand.

Good ranch horses never lose their instinctive "cow." There is a story told by Jack Culley in his book of a horse he sold to a "nester" who had recently moved into the area. It was a steady cow horse showing some cutting ability.

Culley, riding by the farmer's place some months later, stopped to visit. Asked whether he still had the horse he'd bought, the farmer replied, "O, yes, we wouldn't part with Ruby. The only thing is that we don't have enough work for him here, so every once in a while he rounds up the milk cows down in the pasture on his own hook and brings 'em up and puts 'em in the corral in the middle of the afternoon."

Most horses did not distinguish themselves beyond their careers as ranch horses. However, some gained fame beyond their own outfits. One of the best-known cutting horses in west Texas was a bay gelding called Hub. Foaled in 1876 on the Keechi Range near Jacksboro, Hub was trained as a cutting horse by Sam Graves, a hand for the 8 Ranch in King County. Hub gained a reputation as the best cutting horse on the ranch, and even won bets for his owner by cutting steers from the herd with his bridle removed, or so the story goes.

In 1898, a cowboy reunion and rodeo was held in Haskell. In addition to the

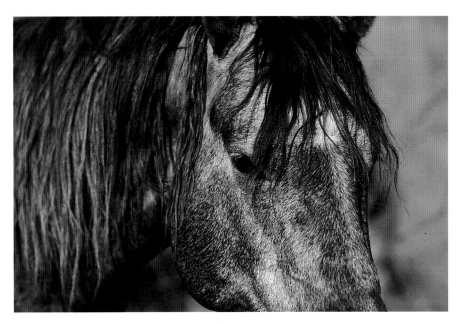

ROB BROWN'S BLUE STALLION, HESA EDDIE HANCOCK
R.A. Brown Ranch; Throckmorton, Texas

horse races and other events, a cutting contest was scheduled. A $150 prize was to be awarded to the horse that cut out the most cows within five minutes. At the age of 22 and retired to the pasture, Hub, with Graves aboard, won the contest by cutting out eight head, beating much younger horses. Later that day, Hub performed a second time, cutting two more steers without his bridle.

But sometimes a horse's intelligence was more than the cowboy considered possible. In *Pardner of the Wind*, Jack Thorp told the story of two horses, top rope horses in their day but getting on in age:

"When a big steer, or a cow, or a bull was roped, the roping horse kept his head to the animal and the rope tight, not only because that was what he was taught to do, but also because anything else was likely to result in his getting snarled up in the rope and thrown. The strain came just behind the horse's shoulders, and at this point he was apt to get tender and sore. Also, holding heavy cattle was hard on the front legs. Some old rope horses were 'cute enough to be mighty careful not to run within roping distance of a heavy animal. I once knew two rope horses that grew up together and were pals, and in their prime they were top roping horses. But as they got older, while they would always make a great show of willingness to overtake a steer, they would never carry the rider quite close enough for a throw. One spring, come roundup time, these two old-timers were not to be found at all. Don't tell me they didn't know! For, within a week after the crew left for the lower end of the range and the roundup, the two old bums showed up all right at the home watering. The same thing happened the two following years, and the head man told the foreman to let them have their liberty, for they had earned it—both were more than eighteen years old."

Ranch owners continually evaluated both their cattle and their horses and "bred up" their stock. Cowmen had their own ideas of what combinations of breeds worked best for the demands made on their horses. Conformation of the horses varied somewhat, but all hands wanted a horse with strength enough to handle a 1,000-pound steer, the speed to sprint after a "bunch quitter" bolting from the herd, and the ability to "turn on a dime." According to several contemporary accounts, cowmen and cowboys preferred dark, solid-colored horses; paints and palominos were rarely seen on the ranch.

W. B. Mitchell, who ranched near Marfa, Texas, described his saddle band of the 1880s as mainly quarter horses mixed with Spanish blood to provide the best cow horses. According to Mitchell, the typical cow horse weighed from 950 to 1,150 pounds, and stood 14.3 to 15.2 hands high (a "hand" equaling 4 inches). This horse was the result of breeding up from shorter and lighter Spanish or mustang horses.

The Bell Ranch of northeastern New Mexico continued to upgrade its ranch horses by importing Texas stallions. John Culley recalled in *Cattle, Horses & Men* that ". . . we replaced the Thoroughbreds with some useful range-bred studs from the JA ranch in Texas." The JA was Charles Goodnight and John Adair's legendary ranch in the Texas Panhandle. Culley noted that "the semi-legendary Steeldust or Quarter horses, appearing to be more a type than a family or breed, was a byword throughout the range. . . ."

Texas cow horses, nearly always from a quarter horse blood line, were exported to virtually every Western state for cattle ranching prior to World War II. It is estimated that nearly a million horses were taken from Texas. As shown in the 1890 census, the horse population of Texas nearly equaled the number of horses in the eleven western states of the Great Basin and Pacific Coast. However, in only twenty years, the greater number of horses would be in the central and northern Great Plains states, and west into the Inter-Mountain region. This shift occurred when Texas ranges were fenced, meaning fewer horses were needed compared to the demands of the relatively open ranges farther north.

The famous Western artist and writer Will James, always an admirer of good cow horses through his art and stories of cowboy life on the Northern Plains, once noted in his book *Horses I've Known*, "Some of our best cow horses was from the south, Steeldusts and Comets, the first strain of our American horse brought over from Spain, and the breed kept alive and carefully strained from that stock by the first cattlemen of Texas."

Even in the early 20th century, there were still large cow operations in Texas—fenced, but large. Those ranches required remudas of skilled cow horses with an ability to do many jobs well. For example, King Ranch, Waggoner, 6666, JA, Pitchfork, 06 (Kokernot), and SMS ranched tens of

Quarter horse colts of the 6666 Ranch Guthrie, Texas

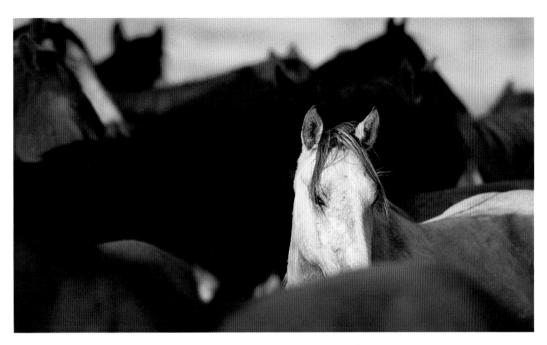

SADDLE HORSES
Pitchfork Ranch; Guthrie, Texas

silken thread. King Ranch horses fear neither man nor rope, and can be caught from the remuda without the use of rope or corral."

Other ranch owners were good judges of horses for their operations. W. T. Waggoner and his son E. Paul of the W. T. Waggoner Estate Ranch, Burk Burnett of the 6666 and Triangle ranches, M. H. W. Ritchie of the JA, R. A. Brown Sr., as well as many others, understood the necessity for good ranch horses. Their intent was to cross the best bloodlines to improve their horses' quality. Horses such as Joe Hancock, Poco Bueno, Hollywood Gold, and Blue Gold produced good working horses for the saddle bands of today's ranches.

Raised under the guidance of his father, R. A. Brown Sr., to be both a cattleman and a horseman, Rob Brown reflects the belief of many current ranch horse breeders. In a 1995 interview with Jim Jennings of *The Quarter Horse Journal*, Rob, a past president of the American Quarter Horse Association, described his ideal ranch horse: "We may ride a horse 30 or 40 miles a day, and think nothing of it. We've kept a little more bone, a little more size under our horses, but there's a reason for it. We do feel like the ideal horse should be a super cutting horse, but we want him big enough that if we need to go catch something, even if it's pretty big, we can catch it and handle it."

Perhaps it is no coincidence that Brown's Throckmorton ranch includes some of the original range from which Charles Goodnight gathered his first trail herds.

Times have changed, but perhaps not that much. The price of beef and the cost of labor and horses has changed ranching. But no matter what technology has been incorporated into ranch work to make the operation more profitable, a cowboy with a horse is still necessary.

Pickups, horse trailers, and cattle haulers have made the chuck wagon and cow camps obsolete, except in those operations that want to continue at least some of the old traditions. Butane-heated branding irons and freeze brands have replaced many a mesquite-fueled fire at roundup time, but there is still a roundup.

Today, the demand for good ranch horses, and the average price, continue to increase at sales. Some of the best-attended sales are the ranch horse sales offering geldings from the Pitchfork, 6666, R. A. Brown, 06 and Waggoner ranches. It is not just cowboys who want trained cow horses. Now, professional and amateur ropers, cutters, and team penners also want trained ranch horses with cow sense.

Many ranches still have a contingent of full-time hired hands. Other cowboys day-work around the country, providing their own horses. Those hands "riding for the brand" full time are usually provided a string of four or more horses. The riders are still responsible for the training and welfare of their saddle horses.

After training their horses, some cowboys, such as those on the R. A. Brown Ranch, have the option to have a horse sold in the annual sale and receive 25 percent of what the horse brings.

"I think that's why we have some of the best cowboys in the country," Brown said. "They've got the pride of riding some sure 'nuff good horses."

Just how important is a horse to a cowboy? As Texas cowboys have believed since the first roundup more than a century ago, "A man afoot is no man a'tall."

thousands of acres of rough country. Very little had changed on these ranches when compared to what cowboys and horses were doing decades earlier. And the value of the average ranch horse had not changed much. An inventory of the JA's saddle band in the mid-1920s indicated that the geldings were valued at $15 each. Many ranches still maintained their own broodmare bands, and the JA's mares were valued at $30 each.

Ranchers became more knowledgeable about genetics and "breeding up" to improve their saddle horses and broodmares. The legendary King Ranch of south Texas is a good example. Robert J. Kleberg Jr. established a successful breeding program, creating the ranch's own strain of American quarter horses with the foundation sire Old Sorrel. Later, Kleberg's nephew, Richard M. Kleberg Jr., continued improving the quality of their ranch horses. Wimpy, a grandson of Old Sorrel, was awarded registration number 1 with the American Quarter Horse Association.

King Ranch horses destined for the remuda were broken and trained without the harsh methods used on some other ranches. According to John Hendrix in his 1964 classic *If I Can Do It Horseback*, the young sons (perhaps as young as six years of age) of the vaqueros were assigned weaned colts to play with, getting them used to humans and soft ropes. Within a few months, the young horsebreakers were riding bareback and reining with hackamores. At two years of age, the colts were sent to the remuda for experience under saddle and additional training with the hackamore. Three-year-olds began doing light work with a "limber bit." By the horse's fifth year, he was considered ready to handle heavy cow work and might even replace an older horse.

Hendrix described King Ranch horses, writing, "There is no such thing as cold-jawed or dead-headed horses on the King Ranch. So perfect are the horses' mouths and so light the touch of the vaquero that they well might be ridden with reins of

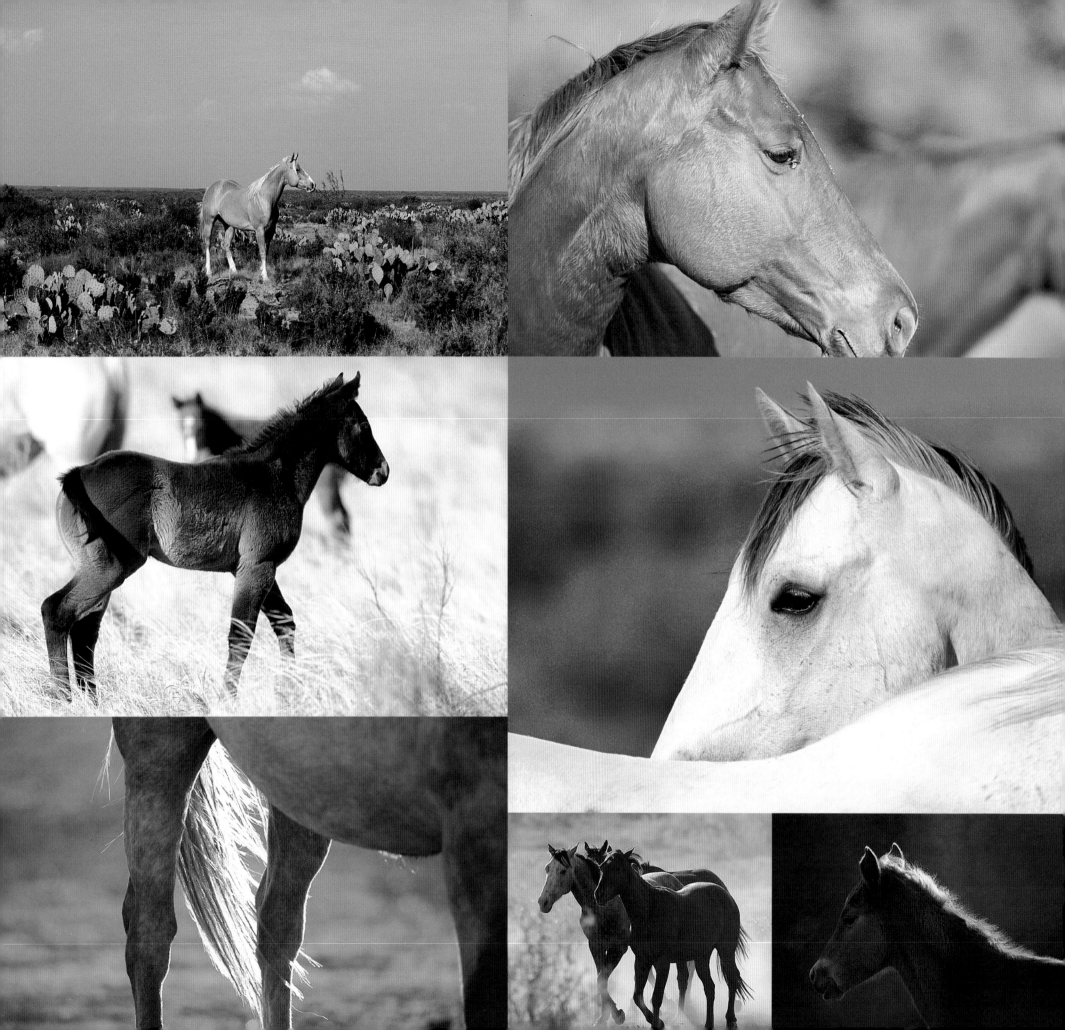

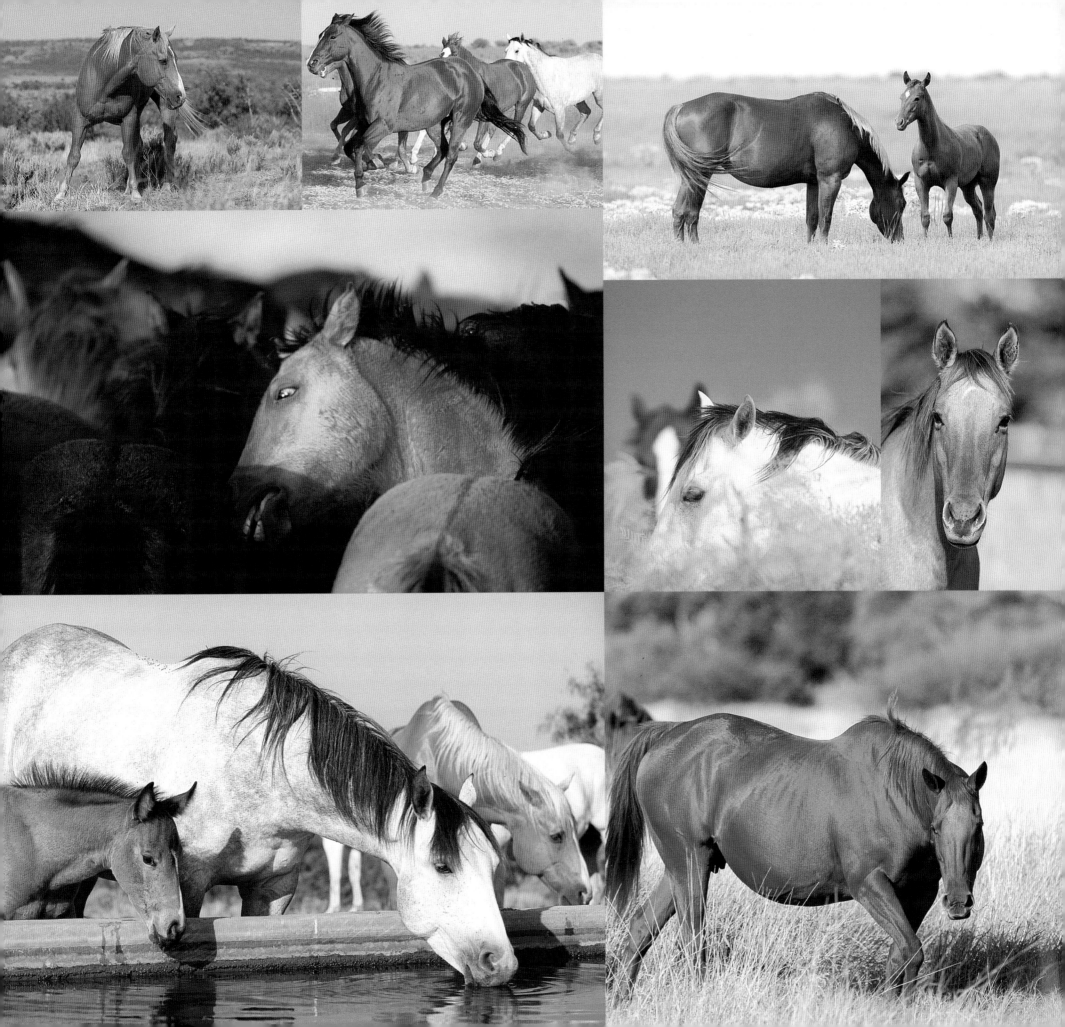

Burnett quarter horses still wear an "L" brand in honor of Burk Burnett's father-in-law, Captain M. B. Loyd. Although these horses are raised mainly for use on Burnett ranches, surplus horses are sold throughout the world. Developed from three of the most famous sires in quarter horse history—Joe Hancock, Hollywood Gold, and Gray Badger—the 6666's horses are bred with cow sense, speed, gentleness, and good looks.

DIRECTOR'S CHAIR
6666 Ranch; Guthrie, Texas

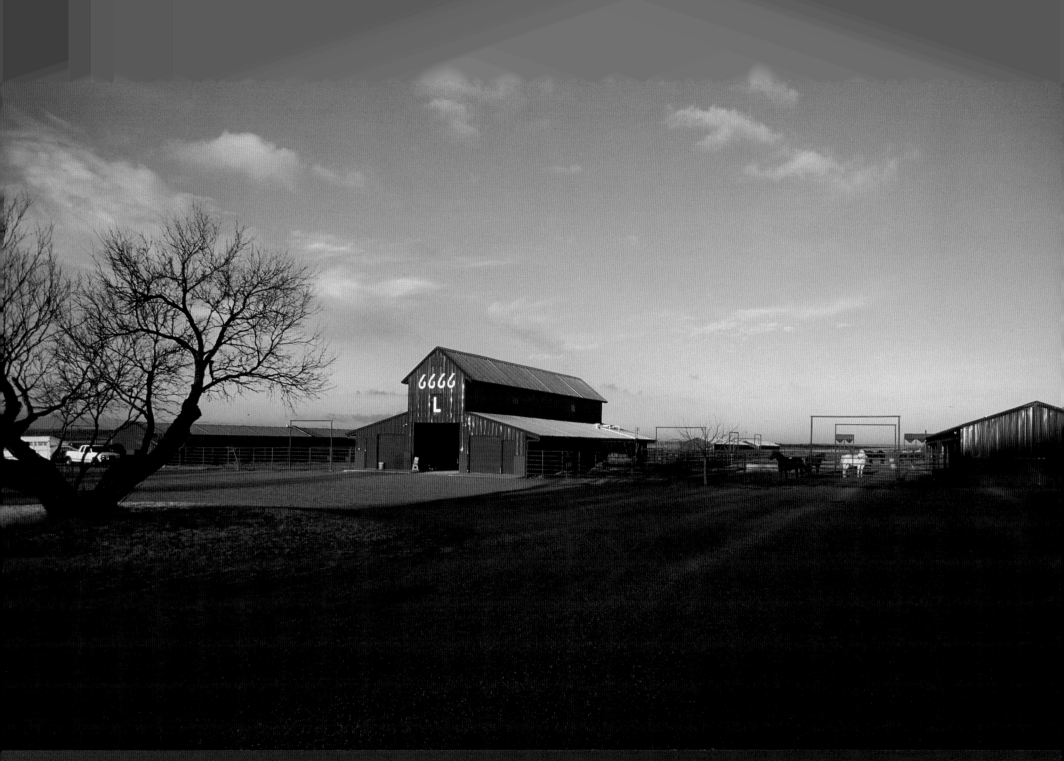

THE BARN AT THE 6666 RANCH IN GUTHRIE IS ONE OF THE MOST FAMOUS RANCH STRUCTURES IN THE WEST.

Contrary to the myth that Samuel "Burk" Burnett won the original 6666 Ranch in a poker game with a hand containing four sixes, Burnett actually purchased one hundred head of cattle near Denton,

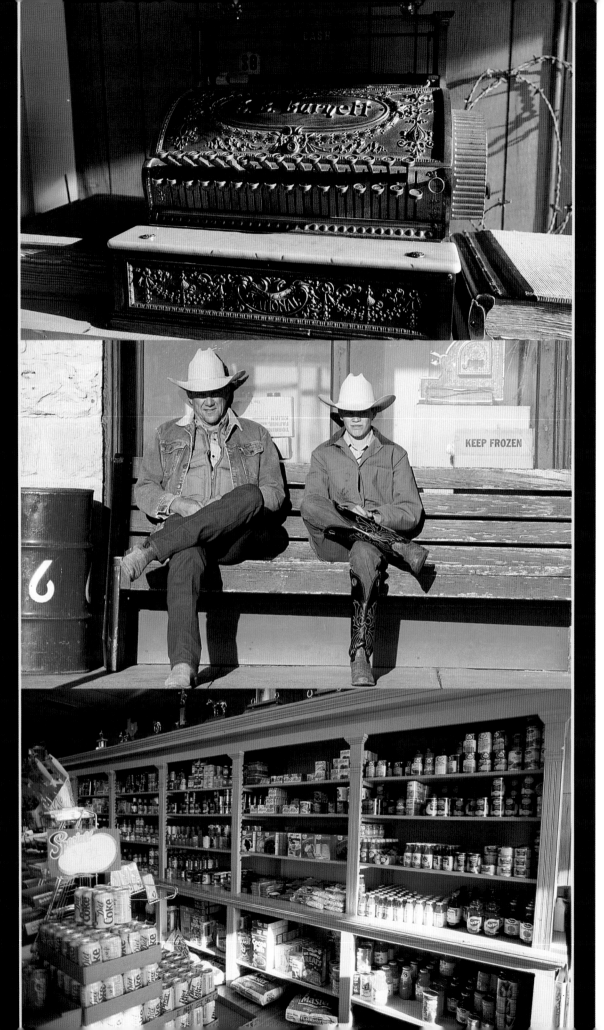

CASH REGISTER
6666 SUPPLY HOUSE
Guthrie, Texas

TERRY LAMBETH AND SON, BRAD
LAMBETH
6666 Ranch; Guthrie, Texas

SUPPLY HOUSE
6666 Ranch; Guthrie, Texas

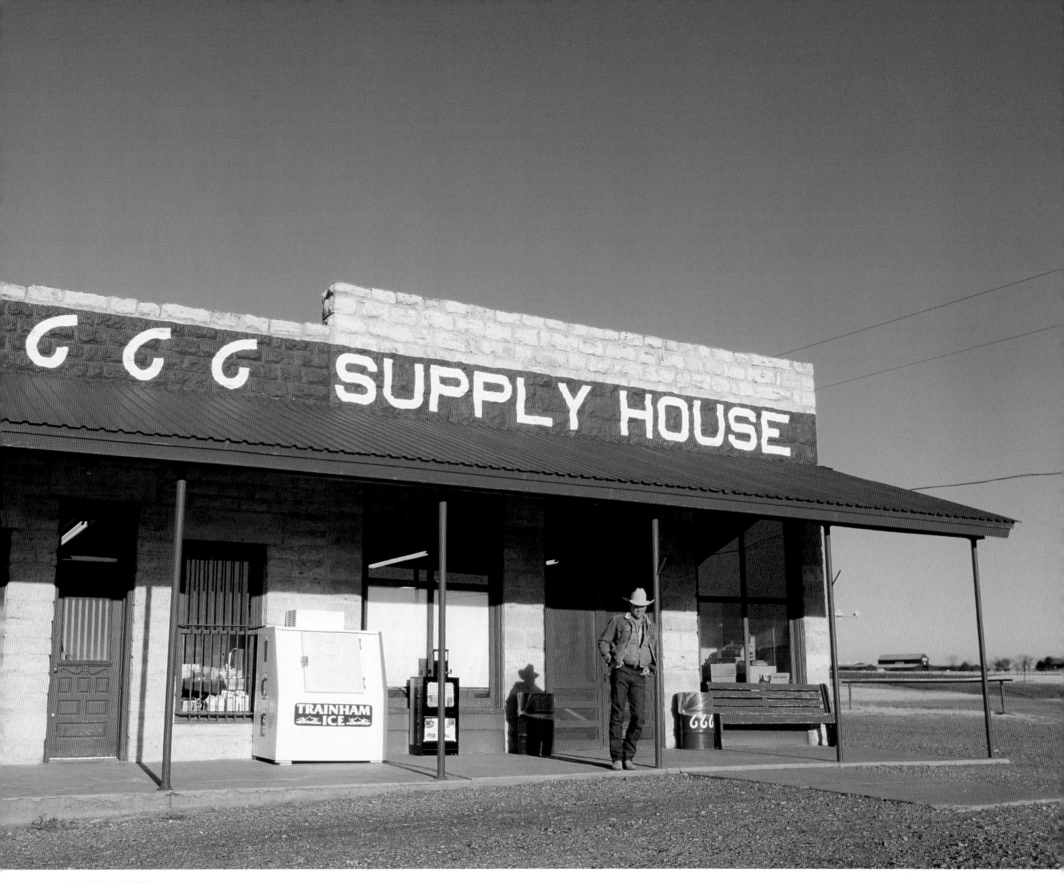

TERRY LAMBETH
6666 Ranch Supply House; Guthrie, Texas

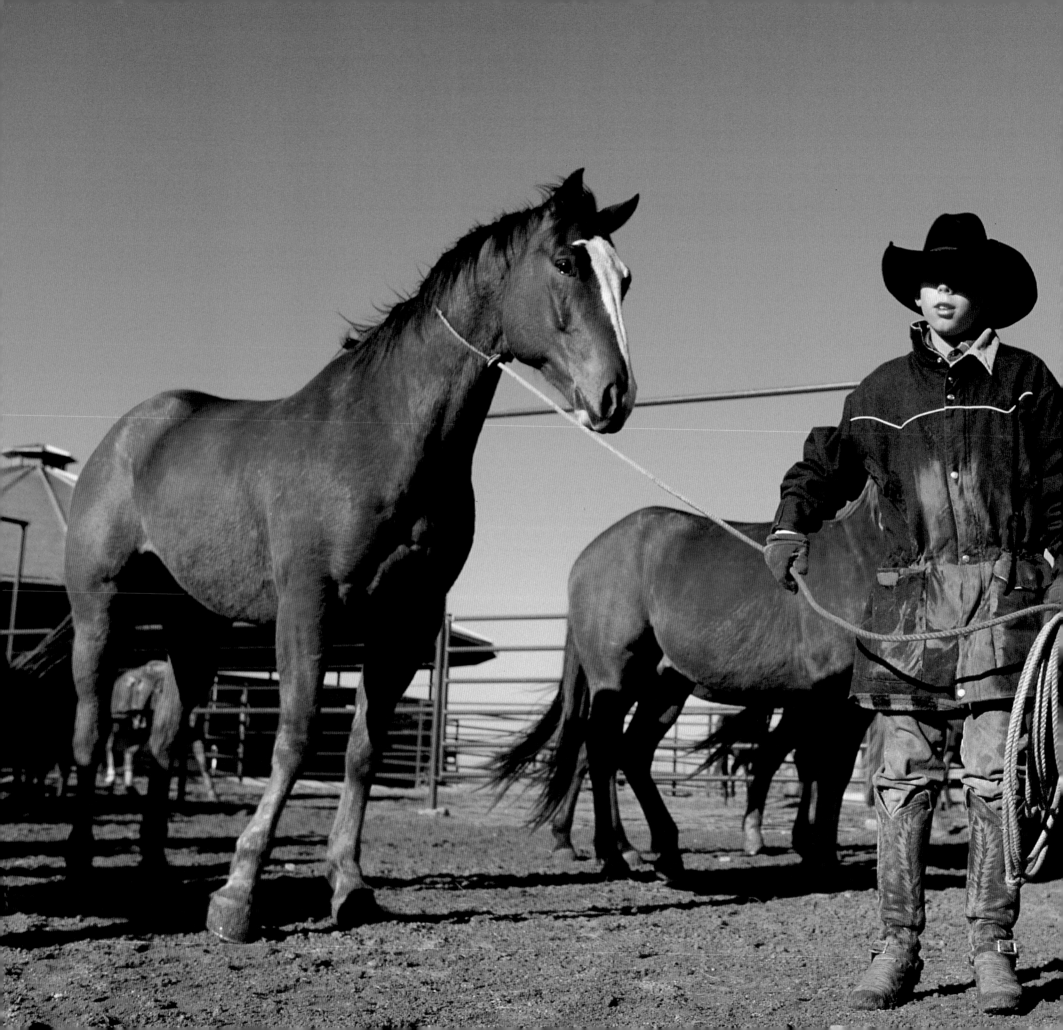

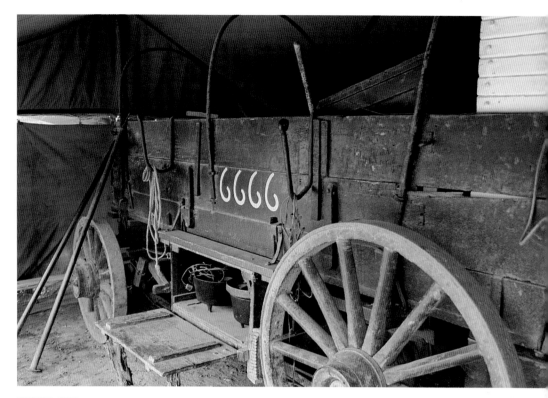

THE WAGON
6666 Ranch; Guthrie, Texas

SHANNON VINSON
6666 Ranch; Guthrie, Texas

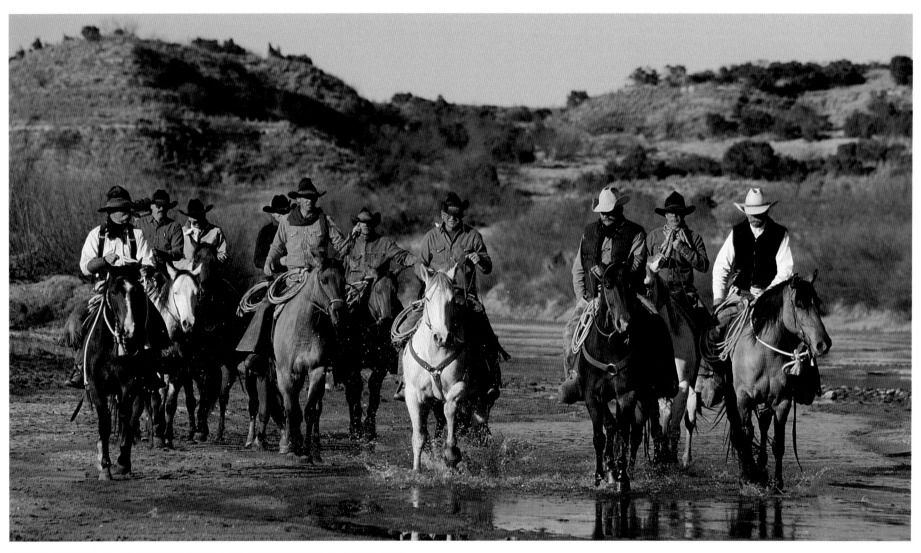

BOB MOORHOUSE, JAMES GHOLSON, DAVID ROSS, CLAY TIMMONS, AL SMITH, ANDY
FALCON, RICHARD BUMPUS, DICK SAYERS, THOMAS SAUNDERS, AND CRAIG CAMERON
A quiet ride down Croton Creek on Pitchfork Ranch; Guthrie, Texas

Only five managers have filled the vacancy of the first manager, Daniel Baldwin Gardner, since the Pitchfork Land & Cattle Company was formed in 1893. These included O.A. "Red Mud" Lambert, Dee Burns, and Jim Humphreys. Today, the ranch is managed by Bob Moorhouse, son of Togo Moorhouse, another prominent west Texas rancher.

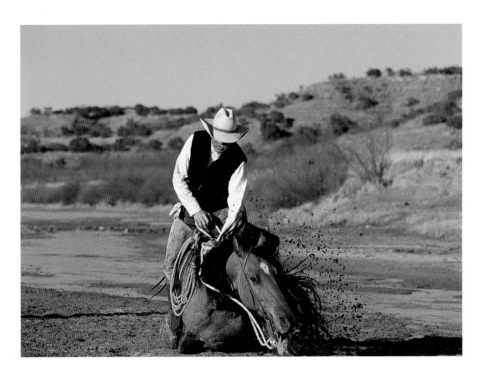
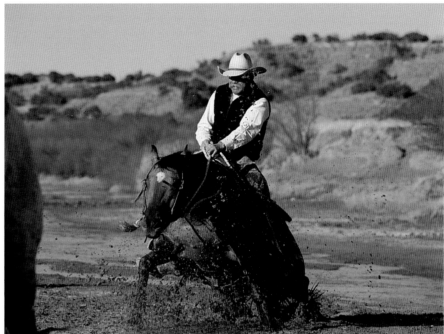
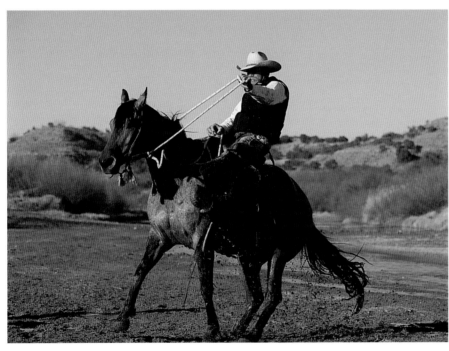
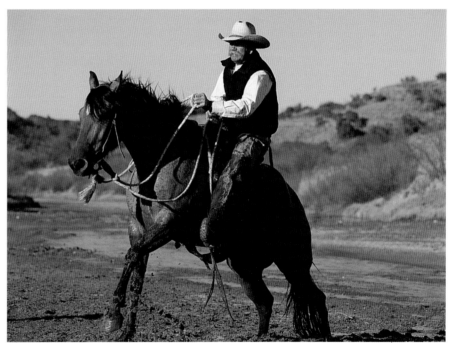

A PEACEFUL RIDE TURNS INTO NEAR DISASTER WHEN BOB MOORHOUSE'S HORSE DROPS
INTO QUICKSAND!
Pitchfork Ranch; Guthrie, Texas

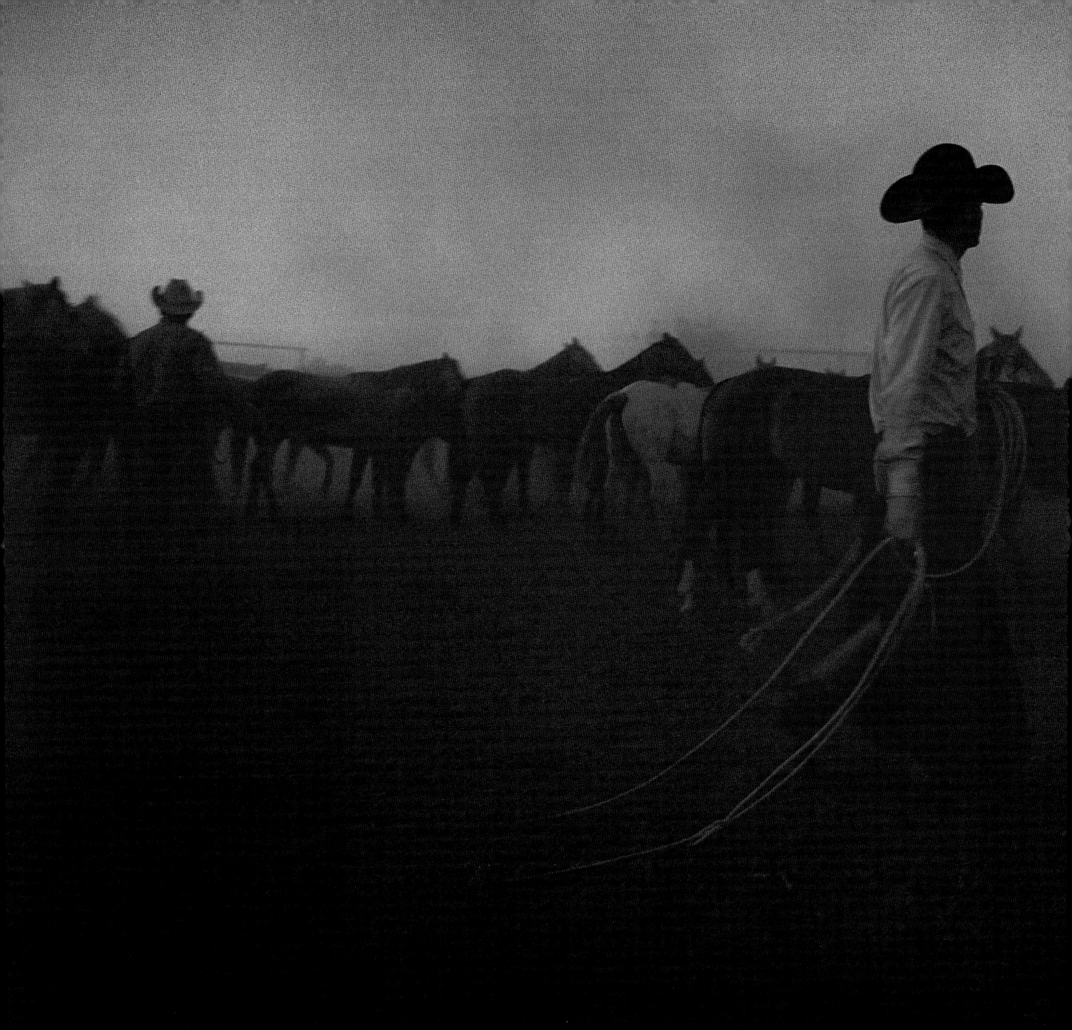

"The cowpuncher was a totally different class from these other fellows on the frontier. We was the salt of the earth, anyway in our own estimation, and we had the pride that went with it."

—E.C. "Teddy Blue" Abbott &
Helena Huntington Smith
We Pointed Them North:
Recollections of a Cowpuncher
©1955, University of Oklahoma Press

THE WRANGLER
Bubba Smith
5 a.m. at Pitchfork Ranch; Guthrie, Texas

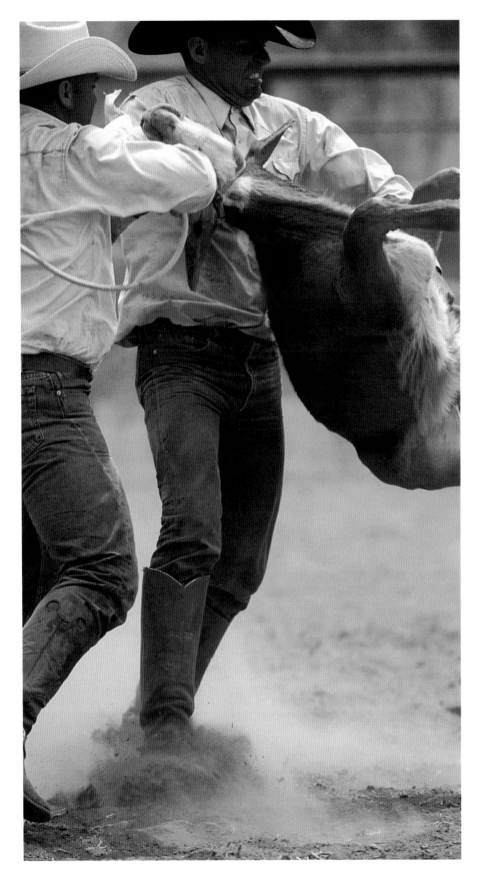
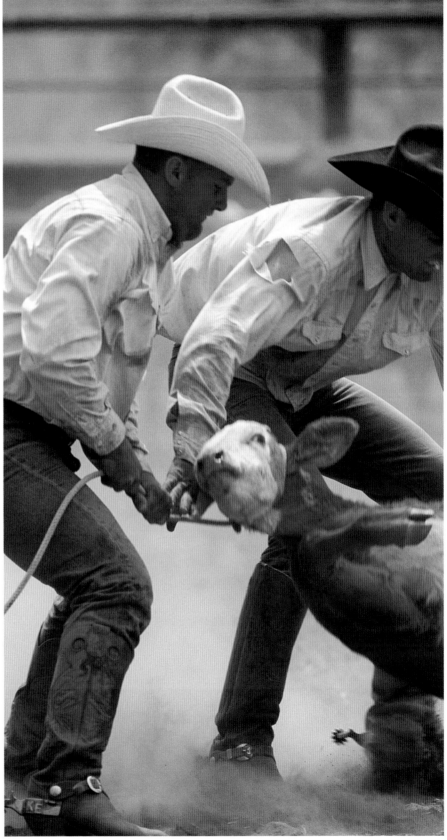

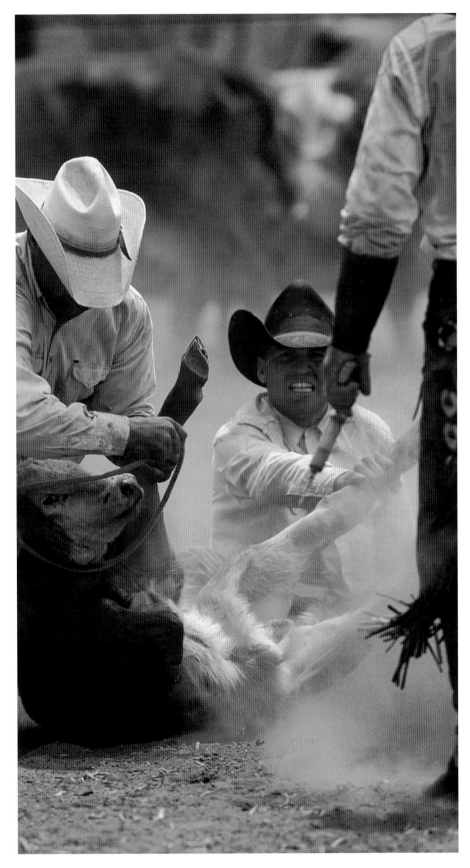

GROUND WORK
Kyle Everson and Bubba Smith
Pitchfork Ranch; Guthrie, Texas

They ride into the branding pen
A rope within their hands
They catch them by each forefoot
And bring them to the sands.

—*The Texas Cowboys*

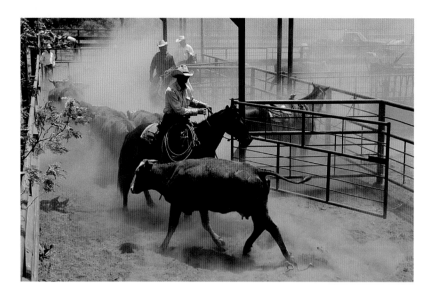

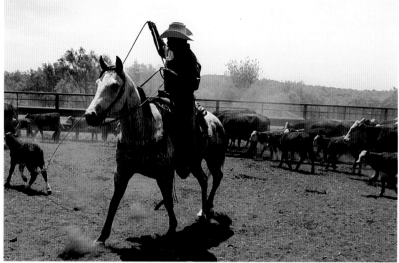

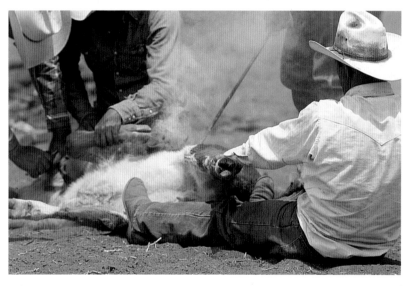

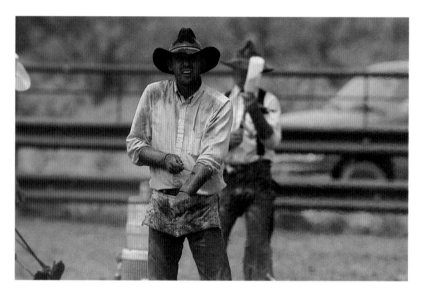

Clockwise from upper left

CLAY TIMMONS, JAMES GHOLSON, CARL GHOLSON, AND JOE LEATHERS
Pitchfork Ranch; Guthrie, Texas

JAMES GHOLSON, WAGON BOSS
Pitchfork Ranch; Guthrie, Texas

The wagon boss is the liaison between the ranch manager and the cowboys. As part of the chain of command, management tells the wagon boss what to do, and the wagon boss sees that it gets done.

BUSTER McLAURY
Pitchfork Ranch; Guthrie, Texas

DICK SAYERS
Pitchfork Ranch; Guthrie, Texas

THE TEXAS COWBOYS — WEST TEXAS ROLLING PLAINS

DAVID ROSS
Pitchfork Ranch; Guthrie, Texas

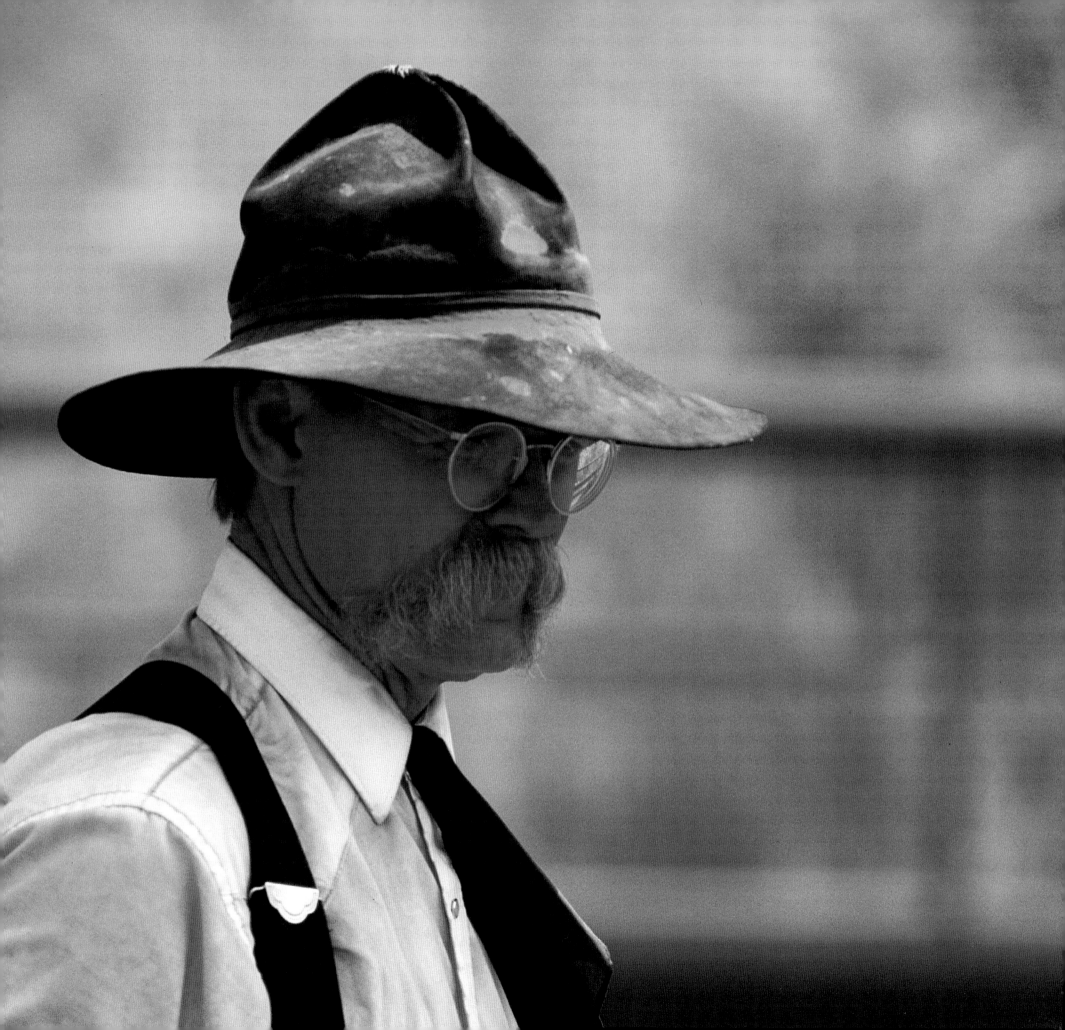

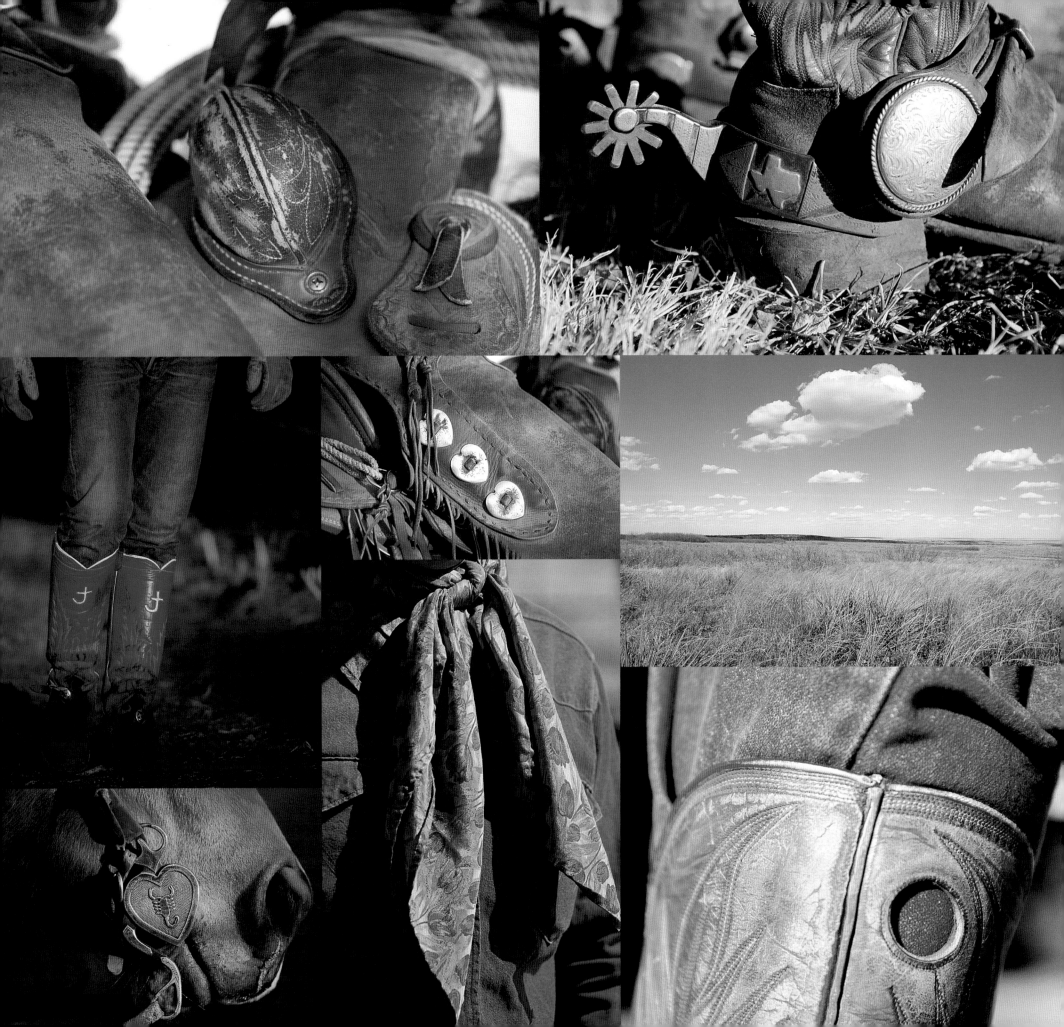

TRAPPINGS OF THE PITCHFORK RANCH
Guthrie, Texas

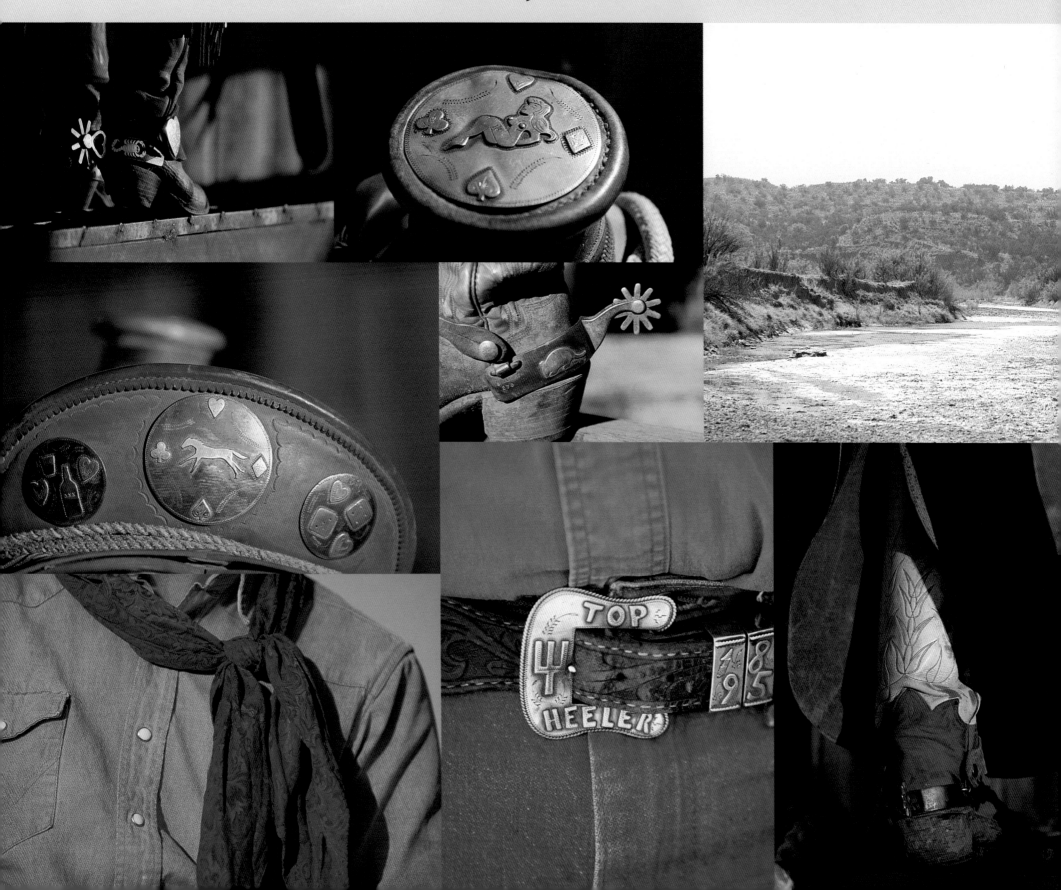

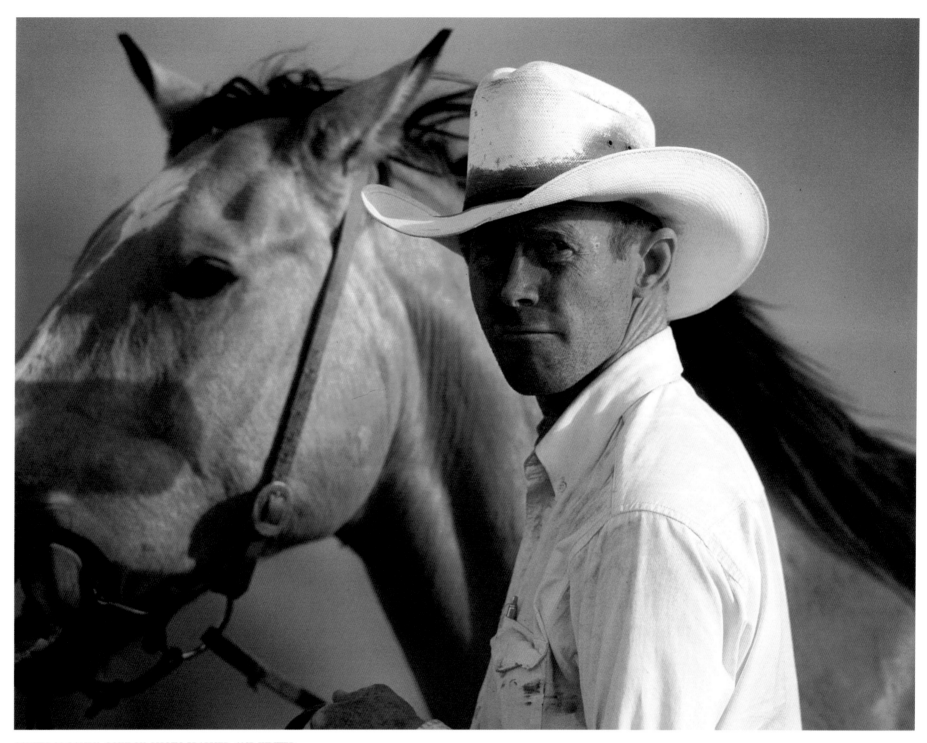

BUSTER McLAURY: COWBOY, PHOTOGRAPHER, AND WRITER
West Texas

THE TEXAS COWBOYS — WEST TEXAS ROLLING PLAINS

West Texas Cowboy

Buster McLaury

I have been fortunate enough to get to cowboy a little bit in lots of different parts of the country—the Great Plains, the high-desert country of northern Nevada, the rocky Davis Mountains in the Big Bend country of Texas—but I've spent the biggest part of my life trying to get out cattle held up in the rough, brushy country between the Red and Brazos rivers of west Texas.

I heap savvy the leather- and ducking-clad hombres who inhabit this part of the country, and who don't mind turning a limb back to get in front of a cow. It's them that I'd like to tell you all about.

I don't guess there's any such thing as a "typical" cowboy. As much as they might look alike to the untrained eye, they're all somewhat different. The same can be said of the ranches they work for. Two outfits with nothing but a barbed-wire fence between them can be as different as daylight and darkness. But here are some generalizations.

Cowboys in this country usually ride a double-rigged, swell-forked saddle with a three- or four-inch cantle. Oxbows or narrow bell-bottomed stirrups are the most common, and are often covered by short "bulldog" tapaderos. Split reins are used almost exclusively because of the brush, and leather split-ear headstalls are the most customary.

Long leggings are a must, with "shotguns" being the most common, along with a scattering of batwings. Ropes are mostly nylon or poly, ranging from 28 to 33 feet in length. I'd guess that 99 percent of these cowpunchers tie "hard 'n fast." Levi or ducking jackets are worn—even in the summer—as protection from the brush. These hands wear a felt hat in winter and a straw hat in the heat of summer, usually with about a four-inch brim. A wild rag, vest, and longhandles usually round out a cowboy's winter attire.

These cowpunchers go for functional, rather than fancy. Fancy doesn't seem to hold up in the brush real well. These fellows' intense pride lies not so much in what they might look like—few people ever see them—but in their ability to gather cattle that most people couldn't even find.

Because the country dictates the kind of cowboys who inhabit it, perhaps it should be described first. The country between the Prairie Dog Town Fork of the Red River and the Clear Fork of the Brazos River varies from big flats and rolling mesquite-brush-covered hills, to rugged canyons and boggy creeks. The creeks are covered with thick stands of cedar, hence the term "cedar breaks."

This is arid country. The annual rainfall is 16 to 18 inches. The temperature variations are extreme—100-plus degrees in the summer, down to the 20s and teens with bitter wind-chill factors in the winter. But the trees and canyons provide shade and windbreaks, so it is considered prime cow country.

The cattle in this country range from Hereford and Angus, to crossbred "Brahmers." The crossbred cows do well in the rougher country, as they will climb in and out of the canyons to grass, and walk a long way to water.

Cattle in this part of Texas "winter out," or run out in the same big pastures year-round, as opposed to the way it's done by outfits farther north, where cattle are kept up in small traps and fed hay all winter. Cattle kept up like that tend to get real gentle because they are around people a lot. Texas cattle usually don't get that much attention.

These cattle are, for the most part, expected to make their own living, and some of them develop a real sense of independence. They seem to resent a cowboy riding into their business, and so try to avoid him as much as possible. These old sisters may be referred to as "trotty," meaning they are liable to strike a trot for somewhere else if they see or hear a man ahorseback.

This is where a crew of real brush hands really shines. Through years of experience, these cowpunchers have developed a sixth sense about where the cattle and other men on the drive are, and where they are likely headed. There's no better example of precision teamwork anywhere than a good crew of cowpunchers working in the brush and rough country of west Texas. To describe all the intricacies and variables of working trotty cattle in this country would be next to impossible.

Knowing the country is all-important. The better a feller knows the trails, waterholes, how the canyons tie together, where the holdup grounds are, and where the crossings are, the better a hand he can make on a drive. Learning the crossings is most important to a puncher in this country. Many of the canyons are so deep and rough that crossings are few and far between.

Any creek or river that has water in it will "bog a saddle blanket" in most places. I've seen fellers miss a trail by three feet and bog a horse plumb down.

A friend of mine from the Panhandle came down to the Triangle Ranch to work. After three days of coming in behind the drive, bogging a horse down and losing a pair of glasses, he throwed a cussin' fit and declared, "I don't know why in the hell anybody would want to work in this damned country. You spend 90 percent of your time fightin' limbs outta your face, and the other 10 percent hunting a damned crossing!"

One cowboy swears he's seen buzzards on the middle prong of the Wichita, circling and hunting a crossing. No one who ever tried to cross it ahorseback would argue with him.

Pastures usually run from 5,000 to 20,000 acres on the bigger outfits. When I was a kid, it wasn't unusual to see 18 or 20 men in a crew. But the economics of the cow business are such that crews of 10 to 12 are much more common today. These fellers still work the same country, they just make shorter "welties," circles, that don't cover as much country at one time. They make these little overlapping drives until all the pasture has been worked. Depending on the circumstances, cattle picked up on these little circles are either put in a trap, a small pasture of from one to three sections, or held in a "holdup" while another drive is made.

The crew will probably sit and hold these cattle a little while if the animals act nervous. Then the wagon boss will pick a few men to stay with the holdup, while the rest of the crew makes another welty nearby.

When I was little, they would always leave me at the holdup after that first drive. Oh, man, I wanted to go with those guys to make another circle. They'd come in with horses and wild stories of cattle lost and gathered.

Usually, after the cattle were held a little while, they didn't give much trouble

unless we had to move them. Then, I was always sent around the cattle so I'd be behind them when we started.

One time when I was about ten or eleven years old, Daddy carried me down to the 6666 wagon. We made a drive one morning, and Bigun (Bradley) had left five or six men and me at the holdup. He told Lath (Withers) to move the cattle somewhere whenever he thought they'd drive. When Lath finally got ready to go—it seemed to me like we'd sit there half a day and I was craving some action—he told us how and where he wanted to move the cattle. A younger feller (showing his ignorance of several subjects) said, "Well, Lath, don't you think we ought to do such and such?"

Even at my tender age, I fully expected lightning to strike someone who questioned the authority, intelligence and judgment of ol' Lath.

"By God, you just make them follow this dun horse I'm riding, and don't worry about nothing else," said Lath. "I've seen more cattle get away than you've ever seen put in a pen!"

Sitting around those holdups, I'd strain my ears to try to be the first one to hear that next drive coming. I soon learned that if I'd watch the cattle and horses I was close to, they'd usually know it before I could detect it. But directly, a limb would crack or you could hear rocks rolling, and you knew things were fixin' to happen.

Those older fellers would start putting out their cigarettes or straightening out the coils of their ropes, which had been hung over their saddle horns. As much as I wanted to watch the brush in the direction the cattle were coming from, I kept a close eye on our holdup. I'd already learned that that was when an old cow could get away—when she caught someone lookin' off. So I tried to watch close and only cast an occasional glance out in the brush. Those old fellers had me tuned up.

Usually, after making two or three of these fast little welties, everyone would be needing a fresh horse. Sometimes a man or two was sent to bring the remuda to the holdup, but more often the cattle would be driven out to a trap near the wagon, and fresh horses were waiting there.

Funny what impresses a kid and sticks in his mind. I probably saw what I'm about to tell you thirty years ago, but I can see it in my mind's eye like it happened this morning.

We were on the Triangles, and had a little bunch of cattle held up, and they were

BUSTER McLAURY: COWBOY, PHOTOGRAPHER, AND WRITER
West Texas

ringy. We were off in a deep old canyon, where the brush was thick. When Daddy finally decided to move them, I thought for sure those cattle were all gonna get away. They'd barely get started and the leaders would try to run off, so the cowboys would have to turn them back, which would mill the whole bunch. After that we'd have to stop and then start all over.

We finally got them movin' a little, but directly we struck a dim little road. Daddy and Bigun were in front of these cattle in the road, and I was straight behind them. Every cow and cowboy was tiptoeing along on eggshells. If a feller had blinked his eyes too loud, the whole bunch would'a run off.

Everyone but me had their ropes down. I didn't have a rope. Daddy and Bigun were easing along in front of those cattle with a little three-foot loop built. Daddy was on the right and was sitting cocked to the right in his saddle, lookin' back over his right shoulder. Bigun was cocked to the left, lookin' over his left shoulder. They never had to look around at one another. Each knew the other was there. Occasionally, their inside stirrups would brush together. I remember thinkin', "Now, that's punchy!" I immediately set a conscious goal to someday be a good-enough hand that they'd let me help lead one of those holdups outta the brush.

Workin' and movin' that kind of cattle in that kind of country is what makes real top hands. They have to learn to be ever-alert, conscious of where the other men and the cattle are, and what they're doing.

A brush hand really learns to "read" cattle—be able to tell what they're going to do before they do it. No tellin' how many times, after I'd let something get away, I've heard Daddy say, "Hell, she was tellin' ya she was fixin' to run off 30 minutes ago. You never seen it 'til she's already gone, then it's too late." Then he'd add, "Most cows can be turned before they ever run off."

These cowpunchers learn early on to work together, as a crew. They see the results of someone not being in the right place at the right time. They learn to work together and, importantly, back one another up.

When moving cattle in this country, whether it's 15 head or 300, there'll always be at least one, and maybe two men in front, leading the way. Everyone else's job is to make those cattle follow the leaders. The men on the point (another very important position) try to keep the lead cattles' heads pointed right behind those lead horses' tails, and not let them come out on either side, 'cause that's when cattle can run off.

The men behind the point men try to keep the rest of the cattle following the leaders, and not let them widen out and get scattered. Lots of cowboys never learn that big bunches of cattle are best driven from the sides, not from behind.

The trottiest, wildest cattle always work their way to the front and sides, but mostly toward the front, because they're leaders. They're hunting somewhere to go. Knowing this, a cowpuncher's main job moving cattle is to "back up" the men in front of him—not let anything come out between him and the feller he's following. That's not to say he shouldn't look behind him, too, and be ready to turn around and go back a little if necessary, but his main concern is in front of him.

Experiences like these are why, to me, the cowpunchers in this country—or in any rough, brushy country—are way ahead of cowboys who live and work out in open, flatter country.

These fellers know that being in the wrong place for two seconds, or maybe going on the wrong side of a tree, will let a cow get away and maybe cause the whole holdup to run off. And that's what's hard for someone who hasn't experienced it to grasp—when a cow runs off down here, she's gone! The chances of ever getting her back are against you. Not that it can't be done, and there's lots of fellers down here who can do it, but it's hard on men and horses.

Because some cattle around here do get wild and smart, and learn to get away, I shouldn't quit without talking a little about ropin'. When cattle get to where they won't hold up and respect a horse, they have to be caught and led out.

I've heard it said that all it takes to have a good brush roper is a damned fool and a racehorse. That pretty well sums it up. Ropin' in this country is reckless and dangerous at best. A feller can't be bashful about runnin' over trees and slidin' off bluffs if he ever expects to get a loop. Then, after a helluva chase, you have to hit an openin' big enough to swing a loop in. A lot of brush ropin' amounts to crankin' it a couple of times and mailin' it to 'em. There's no telling how many cattle have been roped and then been out of sight again by the time they hit the end of the rope.

The methods of gettin' cattle led or driven back out to civilization after getting them captured would fill a good book. Suffice it to say, those methods are ingenious at least.

Cowpunchers in this country work hard, suffer a lot of abuse from the trees, and use up a lot of horses doing it. Fellers who enter the thickets and canyons and consistently come out driving cattle are an elite group. A man who can make a hand in this country can go anywhere in the world and punch cows with anybody. The reverse isn't always true.

Just knowing the names of some of the pastures, places, creeks, and canyons should tell you a little about the men who work there. There's Poji Corner, Dark Canyon, Brushy Creek, Maverick Flat, Boggy Creek, Ignorant Ridge, Scatter Branch, Cow Holler, Cedar Mountain, Mad Bull Draw, Prickly Pear Ridge, Witch Mill . . . and the list goes on. There's a pasture about half a mile north of my house aptly named The Getaways.

I can think of several compliments said of a cowpuncher by his peers that show they think of him as *muy primo*:

"When things go to happenin', you don't have to wonder if he's back there. He'll be a-knockin' your tracks out."

"He's one o' them fellers that knows what a cow tells her calf."

"He's a hand. If he ever sees the color of a cow's hide, damn the brush an' damn the country—she's a caught cow!"

I can assure you that I personally do not throw those compliments around freely. But I'll guarantee you that they'll fit quite a few cowpunchers within a hundred miles of Guthrie, Texas.

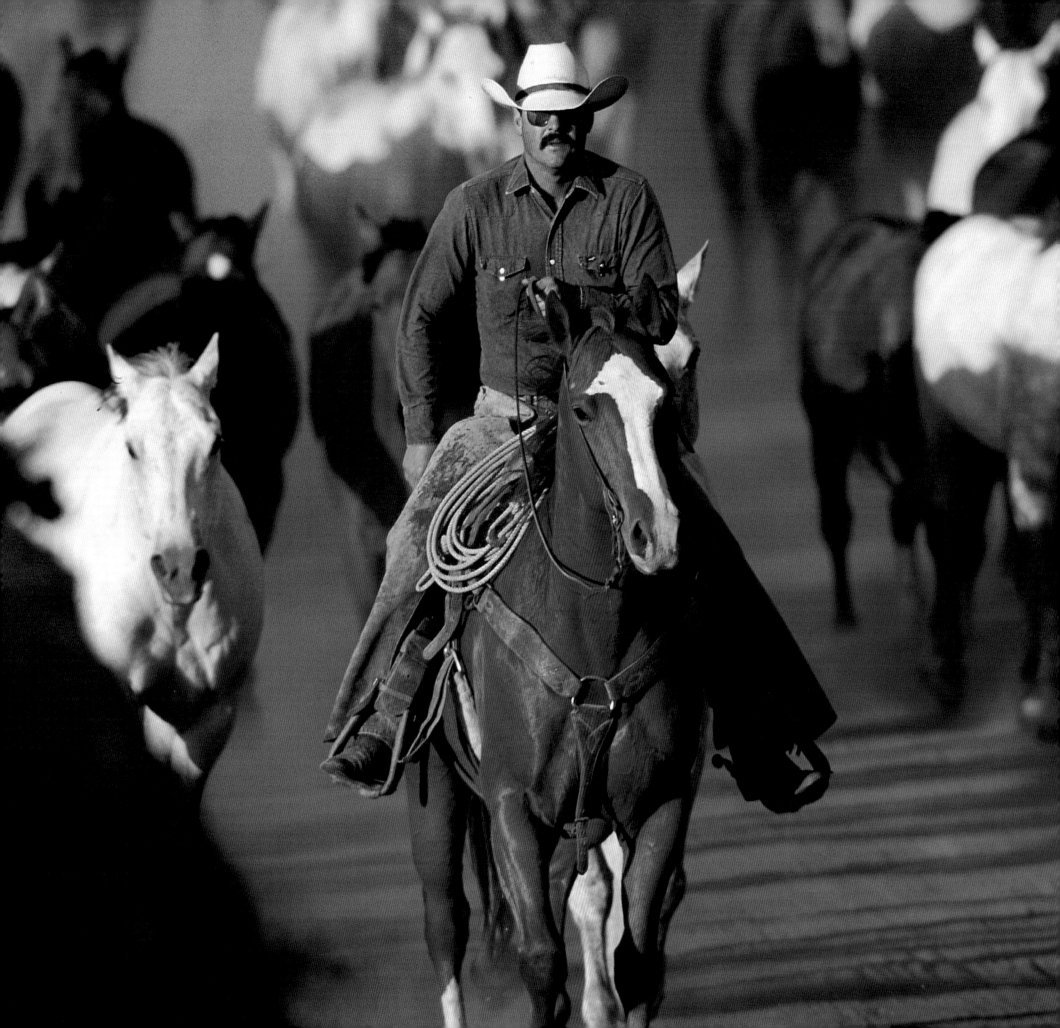

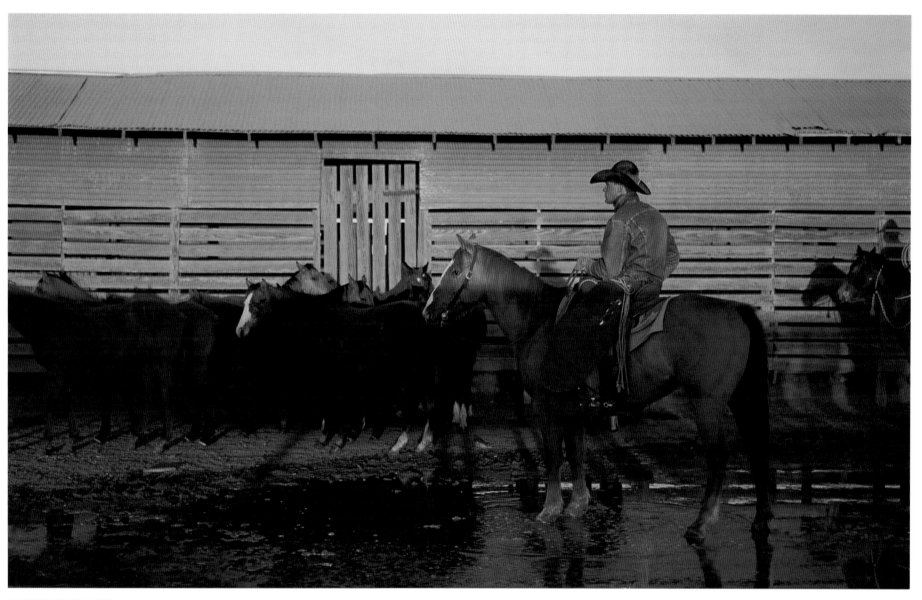

SETTLING THE COLTS
Bubba Smith
Pitchfork Ranch; Guthrie, Texas

COOKSHACK
Pitchfork Ranch; Guthrie, Texas

5 A.M. AT THE COOKSHACK
Pitchfork Ranch; Guthrie, Texas

The first bell rings fifteen minutes before mealtime, alerting the cowboys that it's just about time to come and get it. When the second bell rings, the cowboys rush to the table to sit down and eat. Hardly a word is spoken as hot coffee, bacon, eggs, biscuits, and gravy are consumed before 5:30 a.m. The cookshack is not a meeting place, but rather a place to eat in peace.

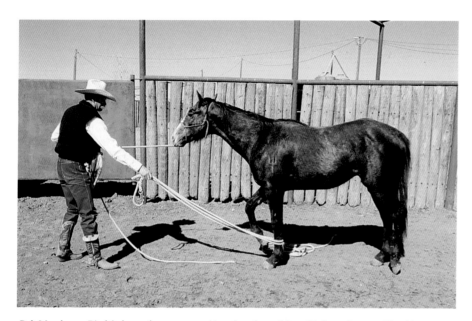

Bob Moorhouse, Pitchfork ranch manager, asking the colt to pick up his front foot, teaching him to yield to pressure.

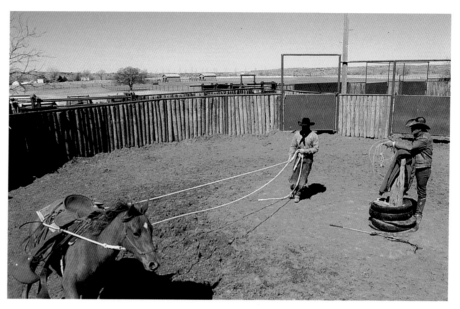

Thomas "Peeler" Saunders drives a Pitchfork colt named Fargo, for his first time. Bubba Smith stands by in assistance.

MAKIN' A HORSE

Thomas "Peeler" Saunders V

Although the horse has evolved through the centuries, he still remains one of the most treasured tools of the cowboy trade, and good hands ride good horses.

I think Texas outfits have a strong history of producing outstanding horseflesh, and most of the cowboys who are sure mounted wouldn't be bashful in backing me up on that, either. If you don't believe me, just ask him what he's riding someday, and in a little bit you'll know more about that horse's family, mother, brother, sire, and every half-sister he has than you will know about that cowboy's own family.

Horses are taken as seriously as the cowboys who make them.

When I was 14 years old, my grandmother gave me the pick of her colt crop that year, and I didn't know anything more than that I wanted to ride a horse that could run fast enough to turn a cow. There were a lot of good horses to choose from, and I was getting a lot of advice from the ranch hands.

My uncle, Jim Calhoun, the man who rode and trained World Champion King's Pistol, was leaning on the corral looking over the herd. He noticed I was getting lots of "biased" advice, so he motioned me over to the side and asked, "Thomas, what do you want in a horse?"

"I want to be able to turn a cow like Ed Hamm," I said, referring to one of the ranch's best hands with a horse.

"So you want a cowhorse?" Uncle Jim asked.

"Yes, sir, I sure do!" I replied.

"Then he needs to have a good foot, doesn't he?" Jim asked.

"Yes, sir, he sure does," I said.

"If you need to go fast," Uncle Jim continued, "then don't you need some daylight under him, and a good set of hindquarters that run down his legs far enough to help him stop when you get there?"

"Yes, sir, that's right," I said.

"Well, where are you gonna put your saddle?" was Jim's next question. "I'd think you'd need a good set of withers and a short back you can build your house on. I'd want a long, thin neck that goes to a neat throatlatch that's got a head full of cow hung on it.

"Now, look that bunch over and tell me . . . which horse is yours, son?"

I knew which horse was mine, and it didn't take long for me to choose, either. I knew my choice must have been a good one, too, because I could've traded him ten times before we got started working with him the next day.

To this day, my idea of a good ranch horse hasn't changed, and the horse I picked that day is 25 years old, still in good flesh, and doesn't need a shoe. That's the first horse I ever broke, and ten years later I gave him to the man who helped me start him.

The men who shaped me and that horse are what made me want to become a horseman. I started 98 head of colts in 1996, and I'm still working at becoming what those men are—top horsemen, top hands, and top cowmen.

I'll never get too old to enjoy seeing good horses work and good cowboys work them, but making a good horse doesn't come easy. The stages of development are pretty standard, and a good hand doesn't venture very far from the norm.

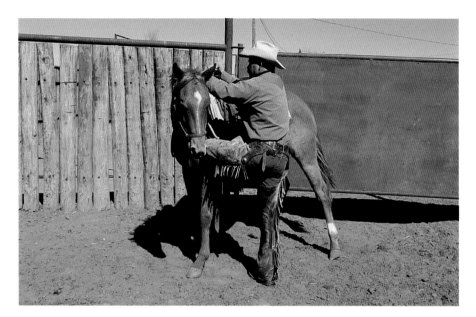

James Gholson, the wagon boss at Pitchfork Ranch, prepares the colt to be mounted for the first time.

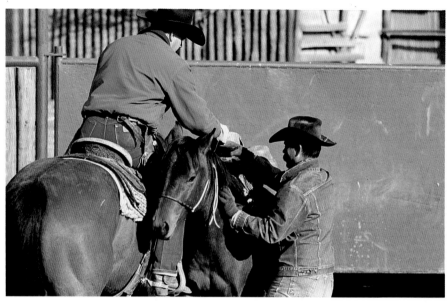

Thomas Saunders snubs the colt while Andy Falcon saddles him up for the first time.

I believe you need to prepare a horse to learn, and train under that premise—not advancing to the next phase until the previous one has been achieved. You cannot teach a horse something before he is ready to learn it. Preparation makes things harmonious between the man and the horse.

You train through repetition. You train with patience, offering until it is finally accepted and absorbed. Some horses are tougher to teach than others, but most all have something good to offer. It's your place to capitalize on the positives, cover up the negatives, and find what that horse can do best. This builds your horse's confidence in you, and as his confidence grows, you develop a bond that allows that horse to think on his own, to truly be able to help him help you.

At the Pitchfork, I rope each colt and start him yielding to pressure, leading, learning to side-pass, backing, taking the "brace" out of both sides. Once I have a colt softened up and have his confidence, he is ready for his rider to saddle him. We go through these colts until all are saddled and turned out of the round pen into a bigger pen.

The first day, all these colts do is pack a saddle; then they are driven using driving lines. Finally, they are mounted. We don't ask for direction once we're boarded, only movement. We call this "controlled chaos." Wherever the colt wishes to go is all right, as long as he takes his cowboy with him.

On day three, we go out into a big arena and ask the colt to flex his neck in, and to the left and right. These Pitchfork horses are bright and have good recall.

There's not a lot of buck in these colts, which I credit to the horses as well as the hands. I'm partial to these Pitchfork horses, as well as the Browns' horses. There, cowhorses are made out of iron. That's breeding—a good blend of horse for big country.

These days, big ranches are adopting a new philosophy on starting their young horses. They bring in outside horsemen to help the cowboys start their colts and develop good horsemanship. The introduction of natural horsemanship through Tom Dorrance's disciples Ray Hunt, Pat Parelli, and Craig Cameron has given hands like myself an opportunity to offer big outfits a service their horses and their hands have responded to.

The Pitchfork, Brown's, 6666, Moorhouse, and other big ranches have found that they can produce more finished horses more quickly, and improve their hands' quality of horsemanship if they create a "schooling" atmosphere when they start each year's new set of colts. Not only does this atmosphere serve as a motivator, but it also creates some healthy competition among the cowboys.

Regardless of the method used, everyone has the same goal—producing the best possible horse. This is a good incentive for both the ranch and the hand.

To be able to communicate with and help a horse help you, until you both react as one, is true harmony. Your horse will only know you as well as you know him.

None of this is new. Anyone who aspires to and works at this trade knows exactly what I'm talking about.

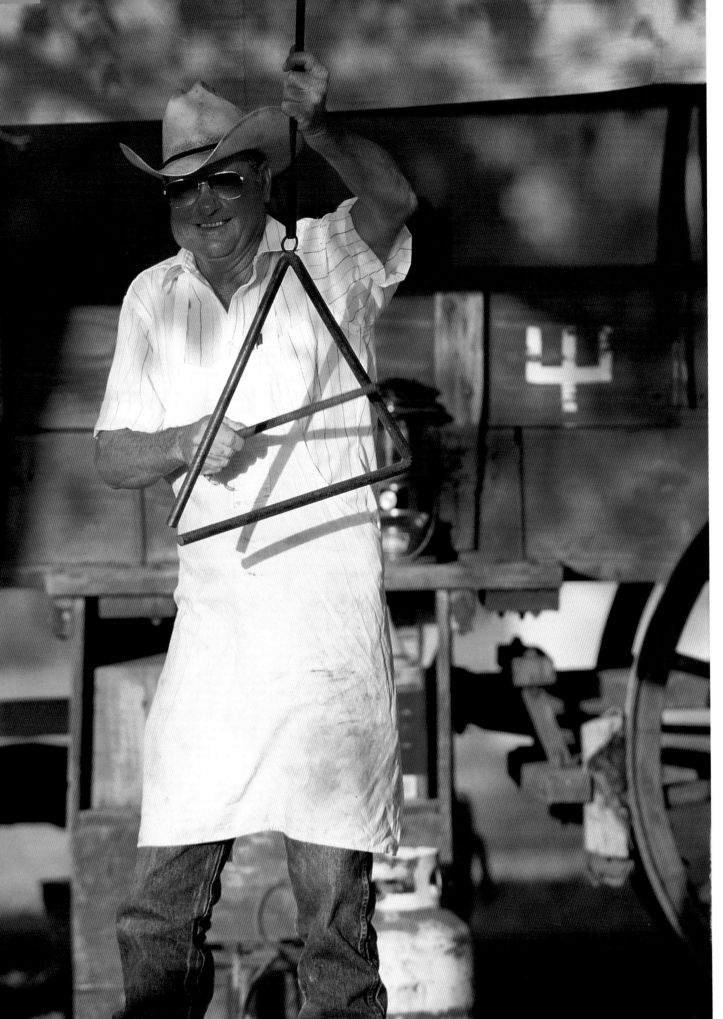

COME AND GET IT!
Elmo Adams, the cook at Pitchfork Ranch; Guthrie, Texas

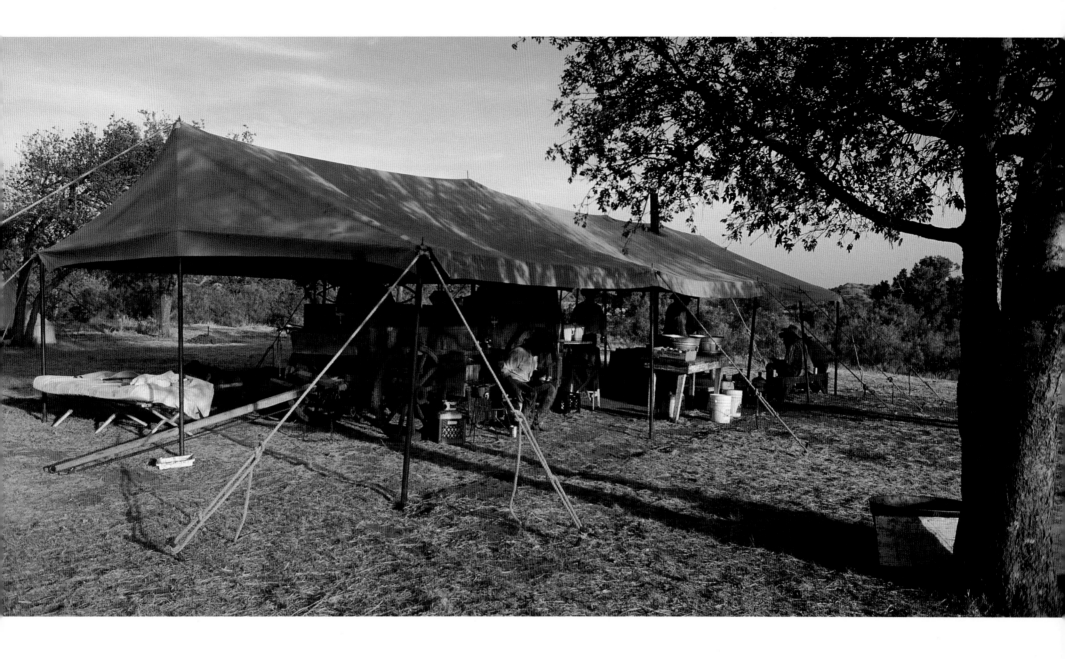

"The Pitchfork Ranch carries on the great tradition of the wooden-wheeled chuck wagon that was started 140 years ago by Charlie Goodnight. Lots of ranches still use chuck wagons, but the Pitchfork is one of the few I have found that still pulls a wooden-wheeled wagon to the branding camp."

—*David R. Stoecklein*

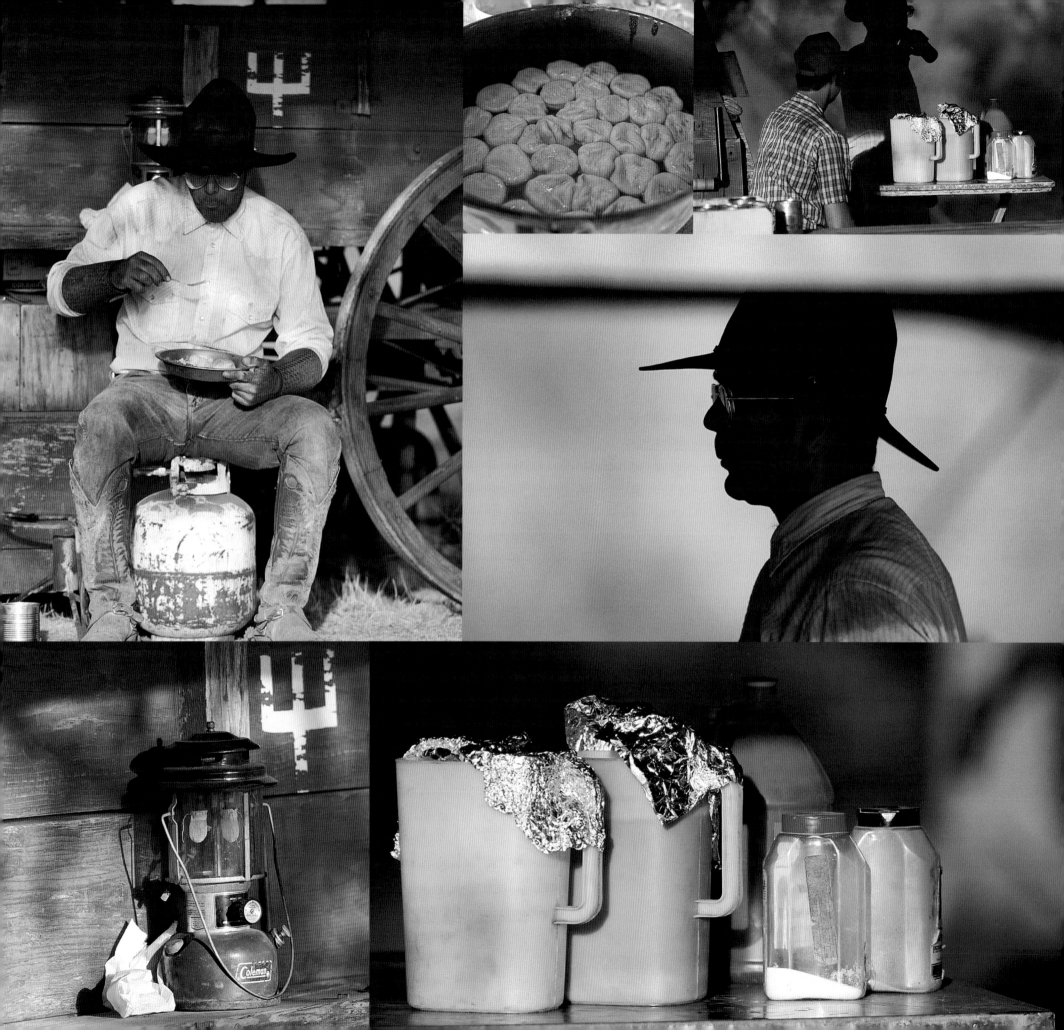

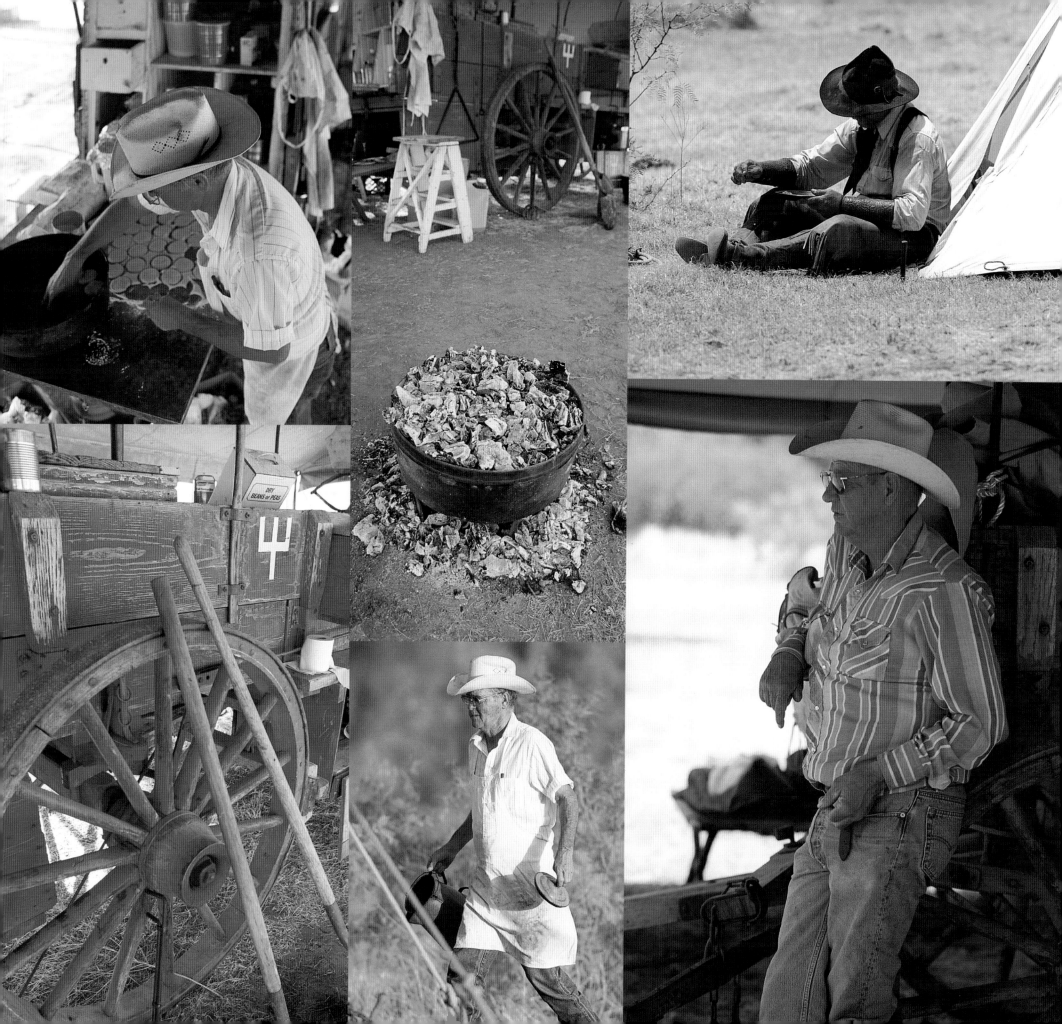

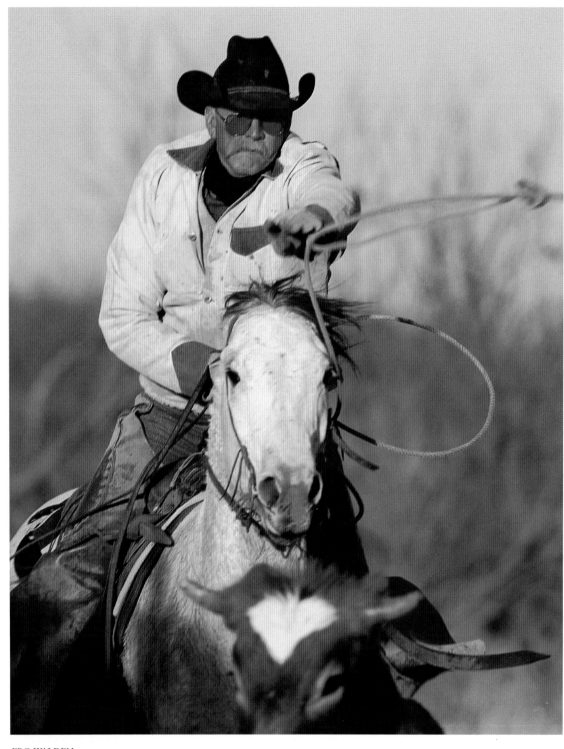

FRO WALDEN
Moorhouse Ranch; Benjamin, Texas

THE TEXAS COWBOYS — WEST TEXAS ROLLING PLAINS

TOM MOORHOUSE AND FRO WALDEN
Moorhouse Ranch; Benjamin, Texas

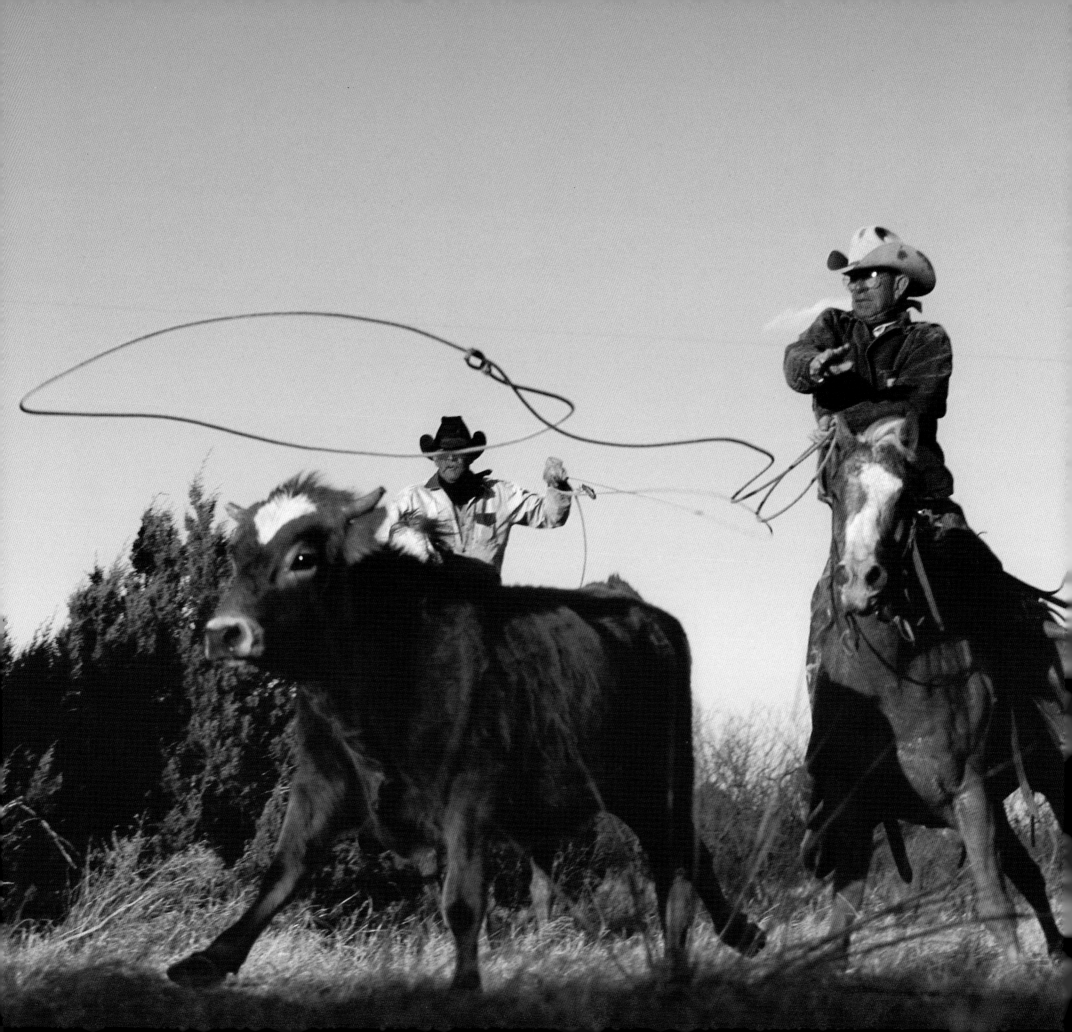

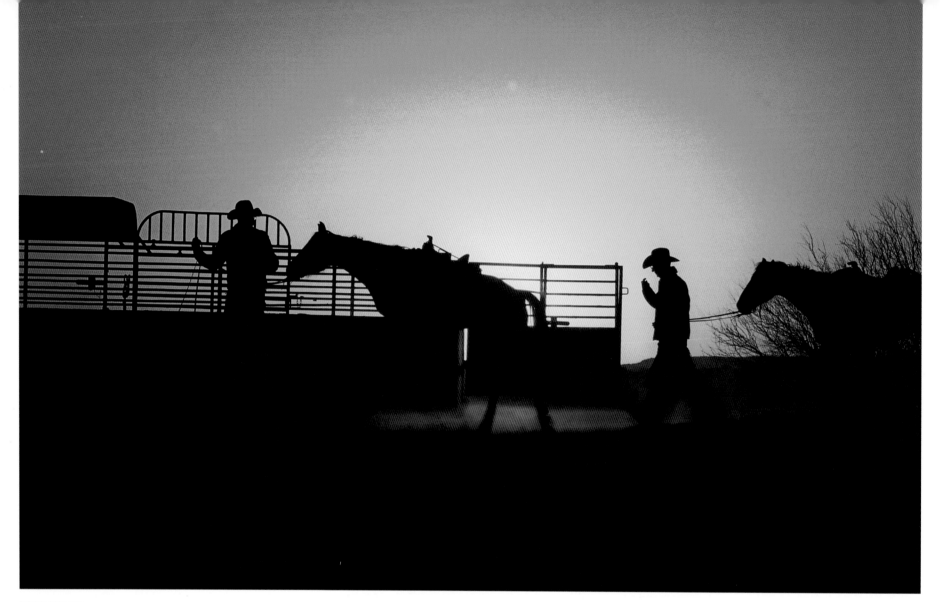

LOAD 'EM UP
Tom Moorhouse and Fro Walden
Moorhouse Ranch; Benjamin, Texas

As for saddle and bridle
I have no more use,
I'll ride to the home ranch
And turn my bronc loose.

—Anonymous, "The Pecos Puncher"

THE OLD WAY
Tom Moorhouse

I have been asked why we do things the "old way," which I assume means using horses every day, keeping the wagon out while we are working, driving the remuda instead of hauling it, dragging calves to the fire, and so on.

Although I know it really *is* the old way, judging from my childhood experiences and listening to the old-timers talk, I don't really consider this the old way. I don't even consider it out-of-date or behind the times.

When the cattle market turns south, we hear and read a lot about low-margin or low-overhead operators. They are the ones who stay in business. *That* is the main reason we do things the old way!

For our operation, it is a financial burden, or luxury, to lean more on mechanics. We use computers, faxes, EPDs (Expected Progeny Differences) and call-waiting, but those things have very little to do with branding the calves in the spring or weaning in the fall. Although we must use any technological advantage we have available that is feasible, that doesn't replace hours upon hours of prowling horseback for sick yearlings, or foot-rot or cancer-eyed cows.

We watch the commodity board every day, but that doesn't eliminate the need for breaking the broncs in the spring, or hiring employees who are able to ride them. We use the most advanced medicines available for our cattle, but it takes a fast horse and a cowboy with a swinging rope to get the medicine in the animal.

This kind of man is not just working for his wages. It is his way of life—his lifestyle—one that he chooses. He is proud to be a part of it. He is not looking for something easy or warm or sheltered. He likes sitting on leather with his legs hanging down. He's a cowboy.

TOM MOORHOUSE, MANAGER OF THE MOORHOUSE RANCH
Benjamin, Texas

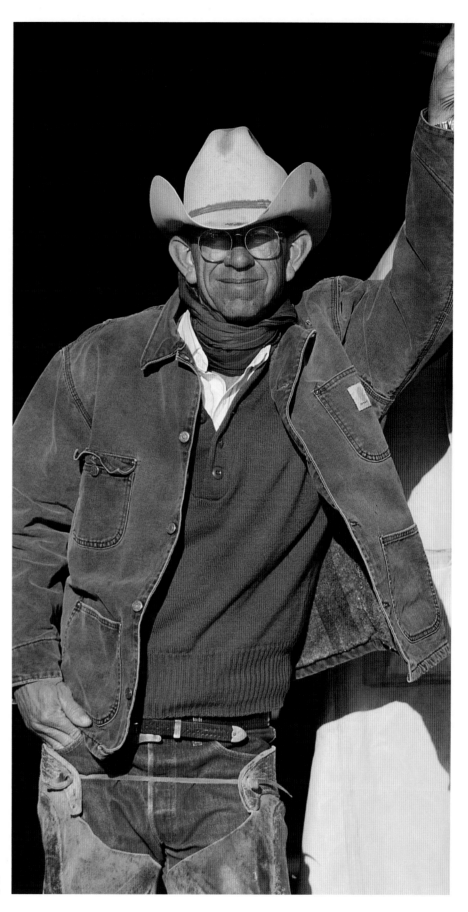

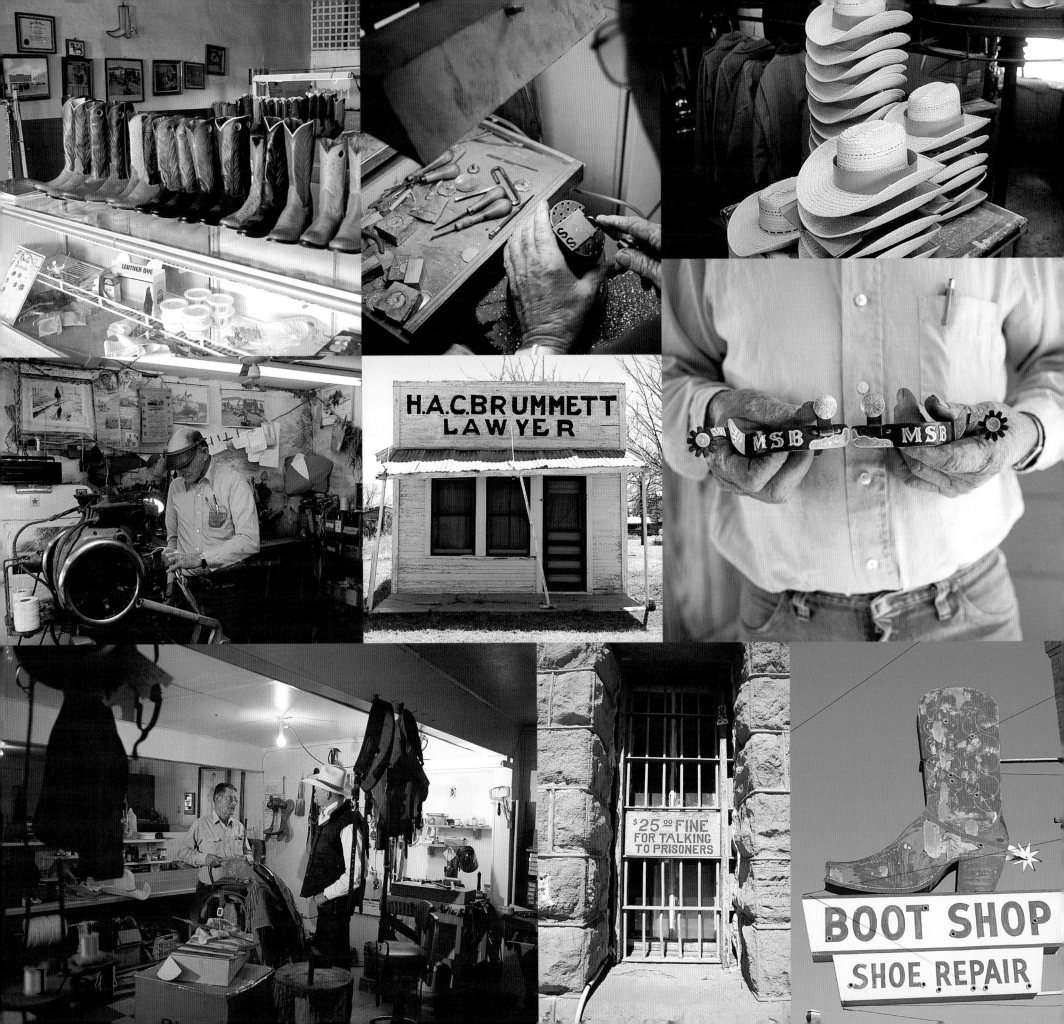

H.A.C. BRUMMETT
LAWYER

MSB MSB

$25.00 FINE
FOR TALKING
TO PRISONERS

LEATHER DYE

BOOT SHOP
SHOE REPAIR

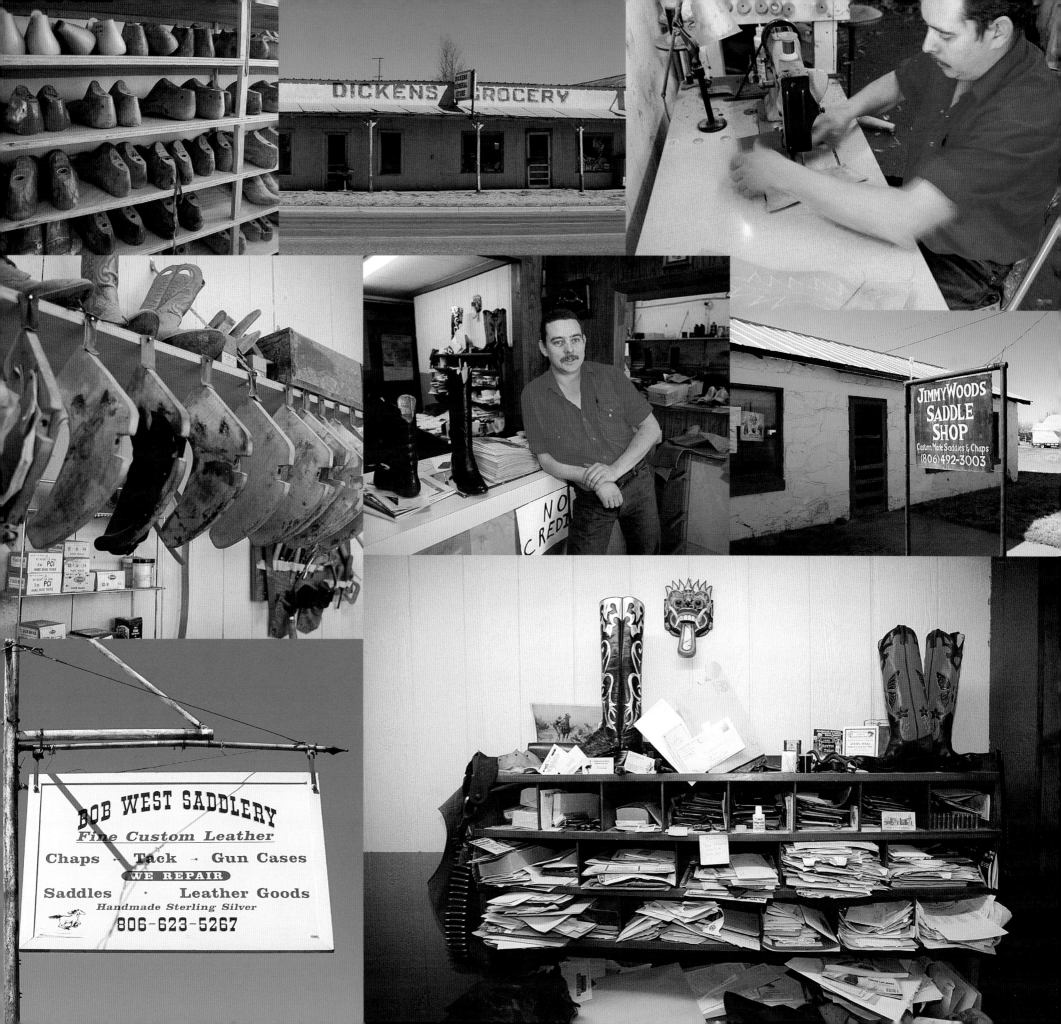

DICKENS GROCERY

JIMMY WOODS
SADDLE
SHOP
Custom Made Saddles & Chaps
(806)492-3003

NO
CREDIT

BOB WEST SADDLERY
Fine Custom Leather

Chaps · Tack · Gun Cases
WE REPAIR
Saddles · Leather Goods
Handmade Sterling Silver
806-623-5267

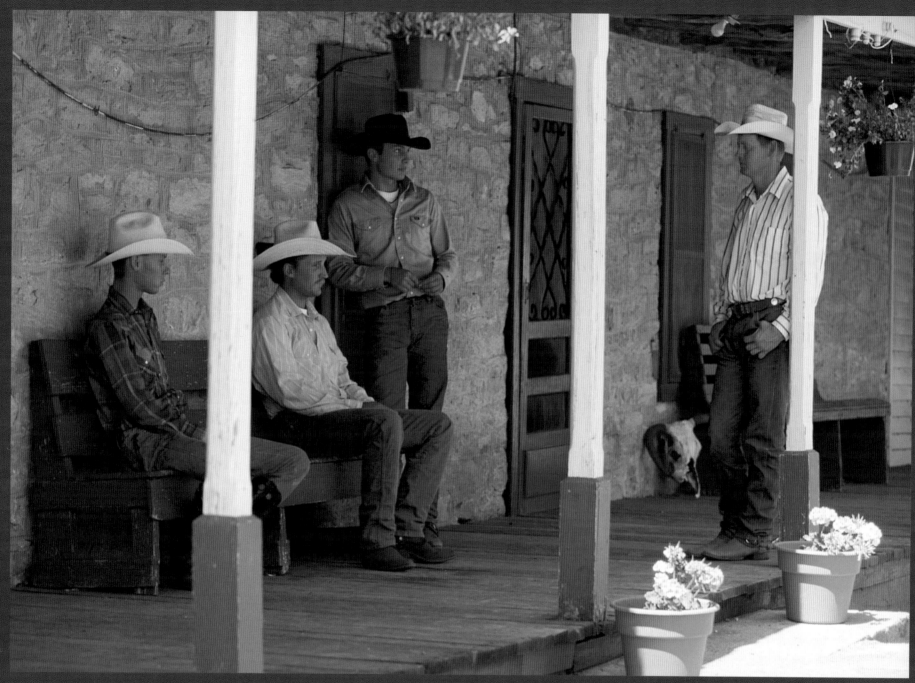

RESTING ON THE PORCH AT THE JA RANCH
Powder Horn, Carroll Jack Lewis, Fredrik Holgerman, and Billy Hollowell
Clarendon, Texas

PANHANDLE HIGH PLAINS

The short-grass country of the Llano Estacado, in the far northwest corner of Texas, was originally the home range of the southern buffalo herd and the people who were dependent upon that herd for their religion, shelter, clothing and sustenance—the Comanche Indians.

In this vast, treeless region, comprising some 21 million acres, the early Mexicans, or "Comancheros," who traded with the Comanche, had a difficult time finding their direction in the flat, endless sea of grass. Having no natural landmarks to go by, they erected poles or stakes in the ground by which to navigate. Thus the origin of the region's name—the Spanish words llano, meaning "plain," and estacado, meaning "staked"—or Staked Plain.

Some refer to this area as being "on top of the Cap Rock." The Cap Rock Escarpment actually borders the Panhandle High Plains on the east, with New Mexico on the plains' west side.

Rainfall in this area averages 15 to 20 inches annually, and the winter temperatures are usually the coldest in Texas, ranging into the single digits or below. In the summer, temperatures climb into the high 80s or 90s.

Although this region is primarily cow country, the state's largest wheat, cotton, and grain sorghum crops are raised on these plains. The area is also home to the state's largest concentration of feedyards where, every year, hundreds of thousands of cattle are fattened for consumption.

This region contains the largest canyon in Texas, as well. The Palo Duro Canyon, located at the headwaters of the Red River and just south of the city of Amarillo, is some 60 miles long and 20 miles wide at its mouth. One of the area's first ranches was established in the canyon in 1876, after the last major battle with the Comanches was fought here in 1874.

Cowboying in this country can be tough in the wintertime, with nothing to stop the North Wind but a barbed-wire fence. There have been times that the snow would completely cover the fences in a heavy blizzard, and cattle would drift before the wind for miles, seeking a windbreak. Many times, they would wind up in the canyons, or even drift as far as the edge of the Cap Rock and down and under its ledges seeking shelter from the storm. Many of these cattle would not be recovered and returned to their home ranges until after the spring thaw.

Cowboying on top of the Cap Rock can be tough in the winter, unless your home country is in the canyons or along the river breaks. But in the summer it's a pleasant task, for there is generally a cool breeze blowing and the big cottonwood trees along the creeks provide plenty of shade.

Wildlife is abundant, with a profusion of white-tailed deer, antelope, and wild turkey. Antelope are plains animals, and range out into open country, while the white-tailed deer and wild turkey stay near the wooded creeks and river bottoms. During the heat of day, the cattle also favor these cooler bottoms.

Ranch work here on the Panhandle High Plains is no different from anywhere else. Long hours and plenty of wet saddle blankets tell the true tale. It takes a good horse to make it in this country, for the pastures are large and it's a long way between waterholes. Even though a cowboy can see for miles, he still has to *get* there, and a big, stout horse with lots of grit is what it takes to make the trip.

It doesn't take as many cowboys to work the high plains as it does the cedar break country or the brush country of south Texas. The visibility is so good on the plains, one can see every cow and every other cowboy within a mile.

Regardless of the work, any cowboy from this part of the country will say that the shank of the evening is the best time of day. When the sun's final light glows soft in the west, and he can hear the sounds of turkeys flying along the creek to their roost in the cottonwoods, the hoot of the great horned owl, and the lonesome cry of the coyote upon the ridge, then the cowboy will be the first to boast that this land is, indeed, special.

Even his horse will nod and nicker, as if to say, "Yes, partner, we're in God's country!"

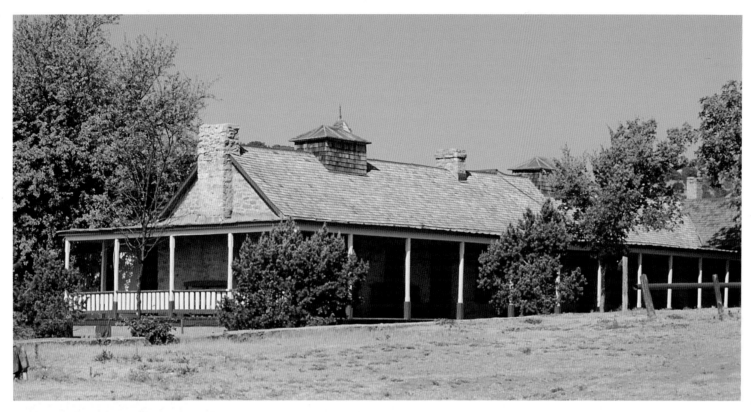

BUNKHOUSE AND COOKSHACK
JA Ranch; Clarendon, Texas

THE OFFICE AND POST OFFICE AT THE
JA RANCH
Clarendon, Texas

GRANARY DOOR
JA Ranch; Clarendon, Texas

The JA Ranch was a partnership formed between Charles Goodnight, a trail driver and Texas Ranger, and John Adair, from Bathdair, Ireland, owner of a brokerage firm in Denver, Colorado. The ranch was established in the Palo Duro Canyon in 1876. Adair financed the operation, and Goodnight furnished the foundation herd and managed the ranch.

THE TEXAS COWBOYS—PANHANDLE HIGH PLAINS

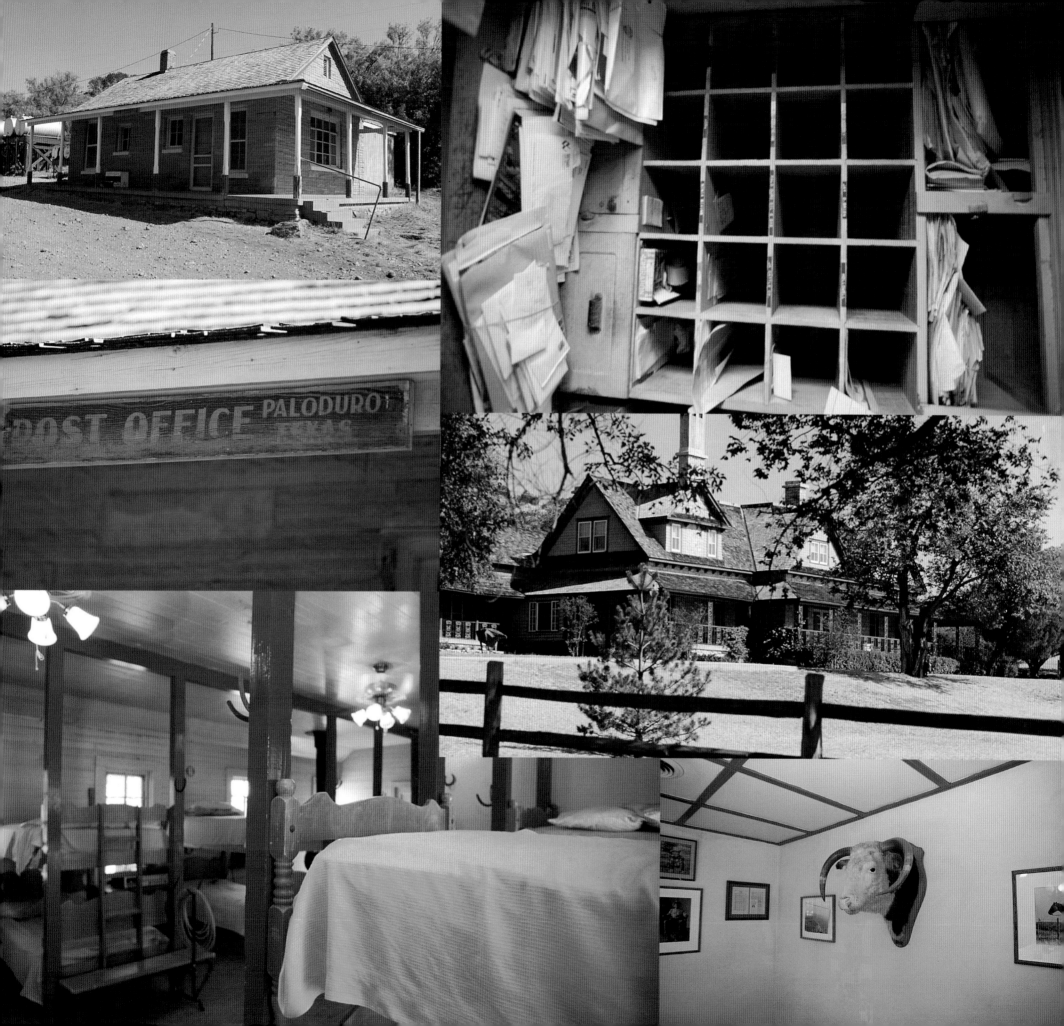

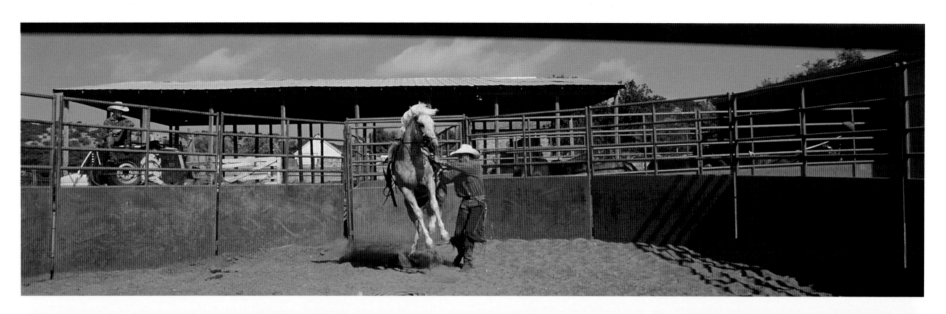

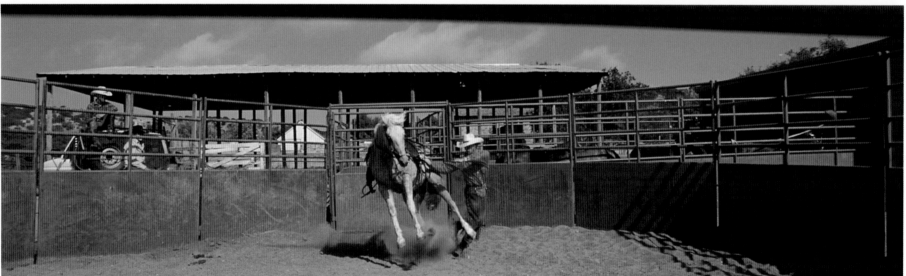

CARROLL JACK LEWIS SETTING UP FOR THE KICK
JA Ranch; Clarendon, Texas

CARROLL JACK LEWIS TAKING A BIG KICK IN THE LEG
WHILE BREAKING COLTS
JA Ranch; Clarendon, Texas

ONE HOUR LATER . . . CARROLL JACK
LEWIS, FLAT ON HIS BACK AFTER HIS
ROUGH DAY IN THE BREAKING PEN
JA Ranch; Clarendon, Texas

CARROLL JACK LEWIS RIDES THE BRONC
JA Ranch; Clarendon, Texas

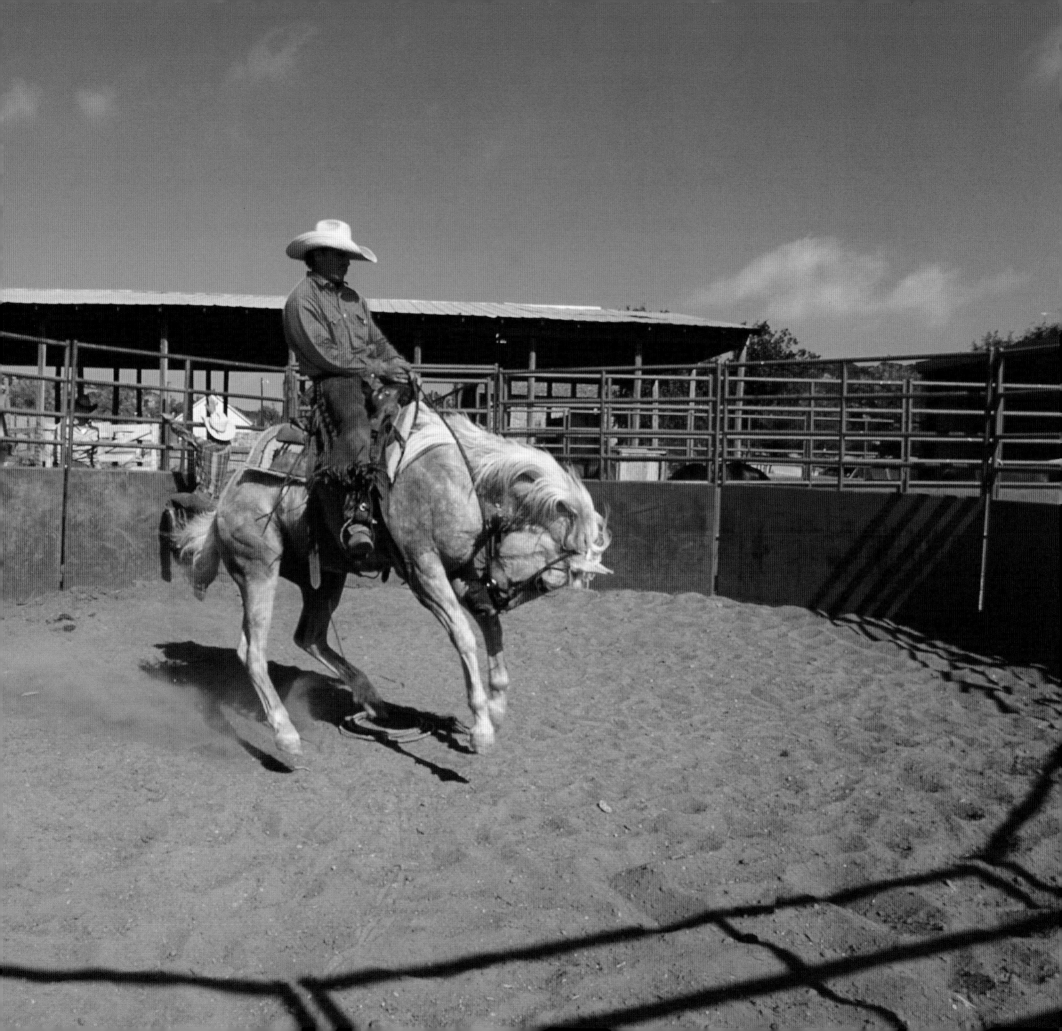

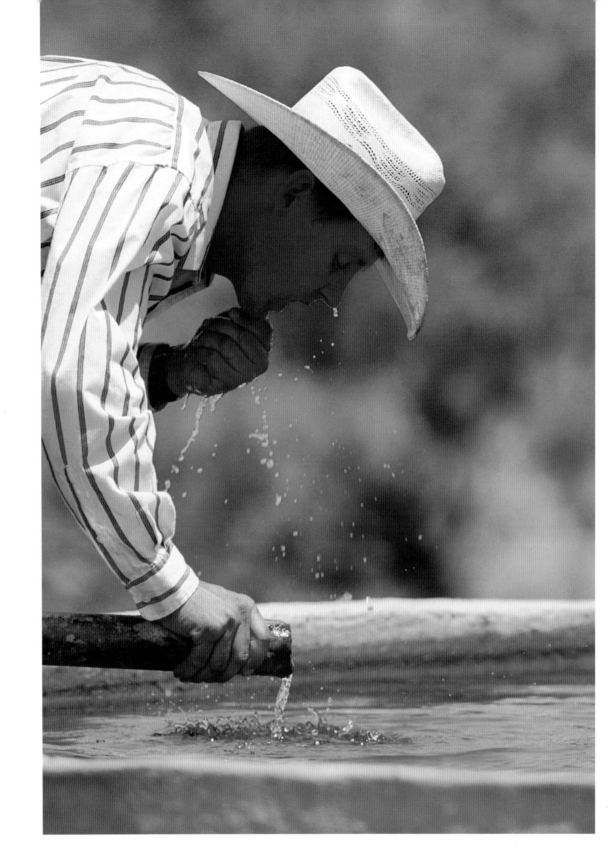

GETTIN' A DRINK
Billy Hollowell, Ranch Foreman
JA Ranch; Clarendon, Texas

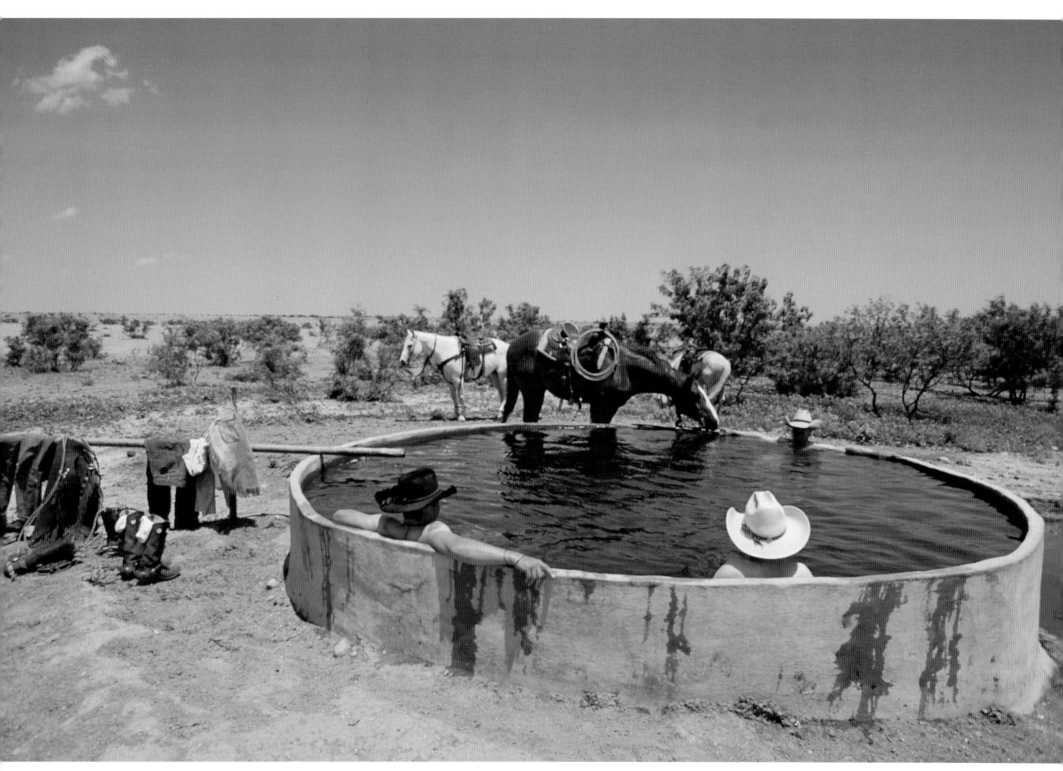

COWBOY SWIMMING POOL
Fredrik Holgerman, Carroll Jack Lewis, and Powder Horn
JA Ranch; Clarendon, Texas

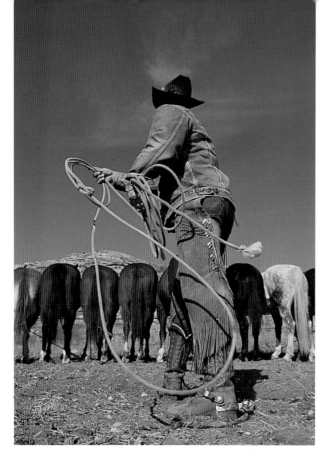

HOOLIHAN LOOP
Dave Anderson
LX Ranch; Amarillo, Texas

LX SADDLE HORSES
LX Ranch; Amarillo, Texas

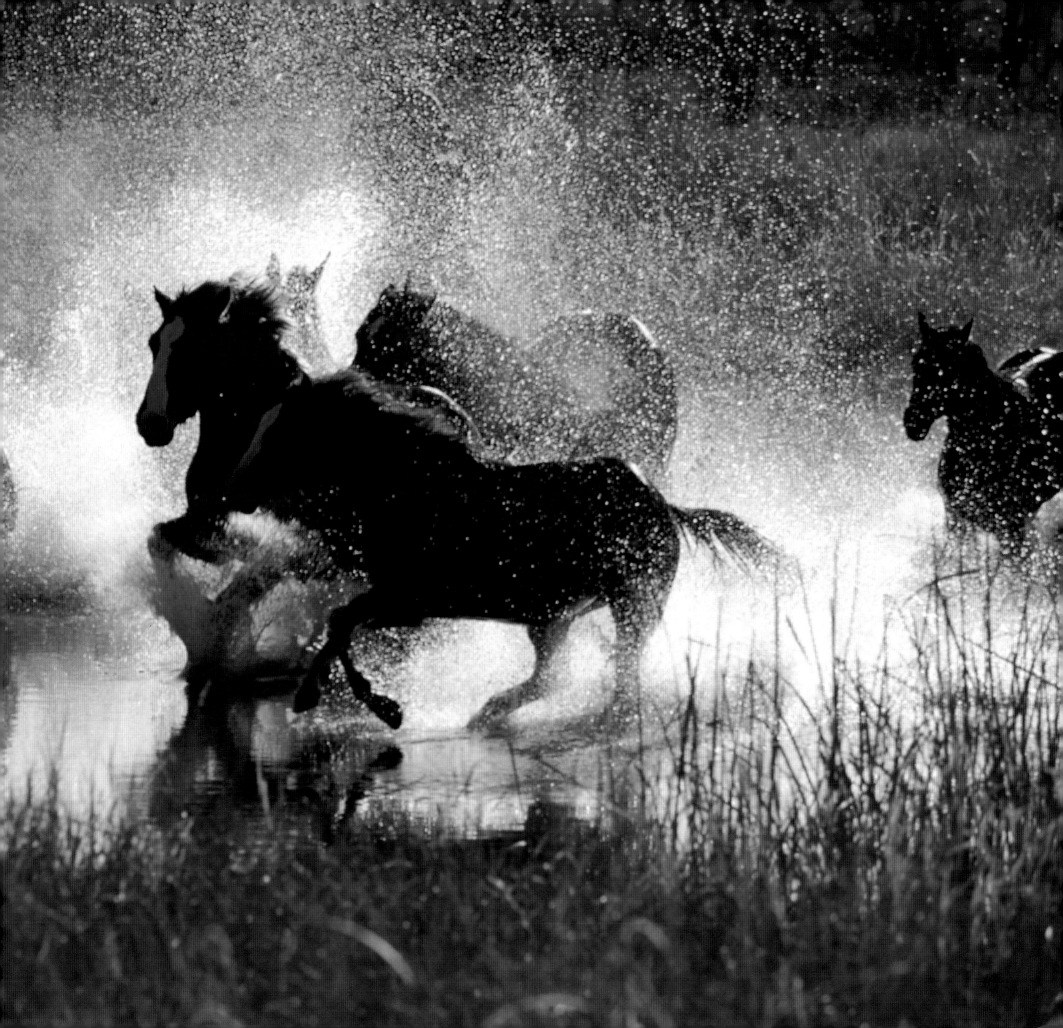

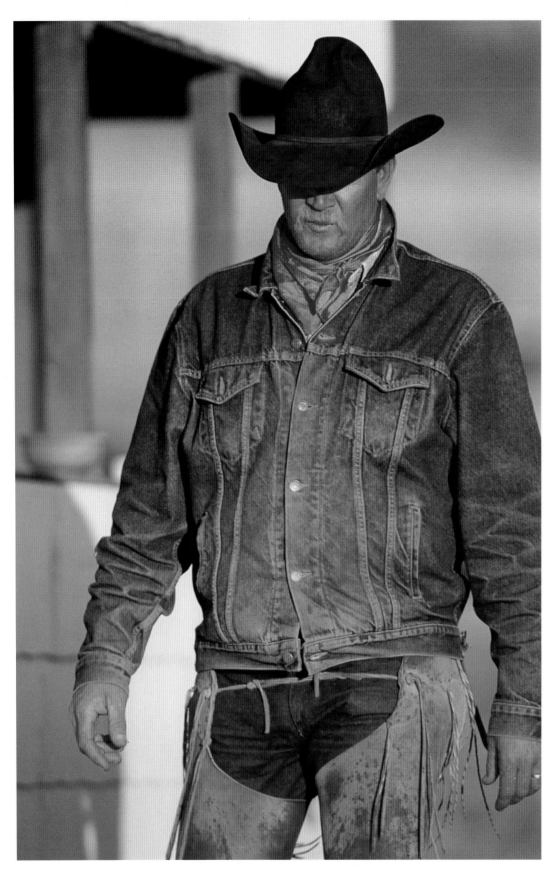

JIM BOB WALDEN
LX Ranch; Amarillo, Texas

THE TEXAS COWBOYS—PANHANDLE HIGH PLAINS

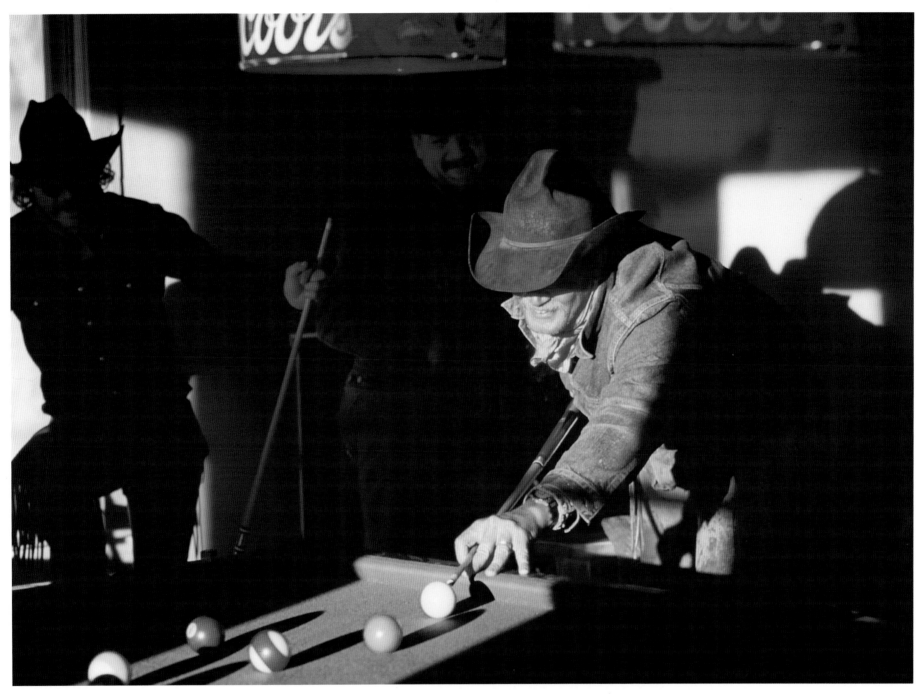

SHOOTIN' POOL
Vance Molesworth, Dave Anderson, and Jim Bob Walden
LX Ranch; Amarillo, Texas

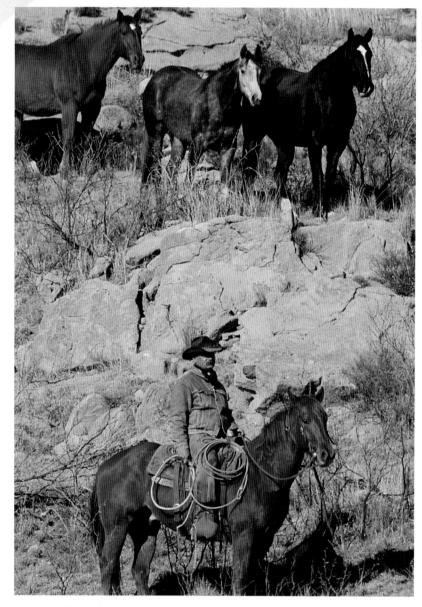

DAVE ANDERSON, RANCH FOREMAN
LX Ranch; Amarillo, Texas

CHECKING THE MILL
*Ed Harrell and Jim Detten
Harrell Cattle Company; Claude, Texas*

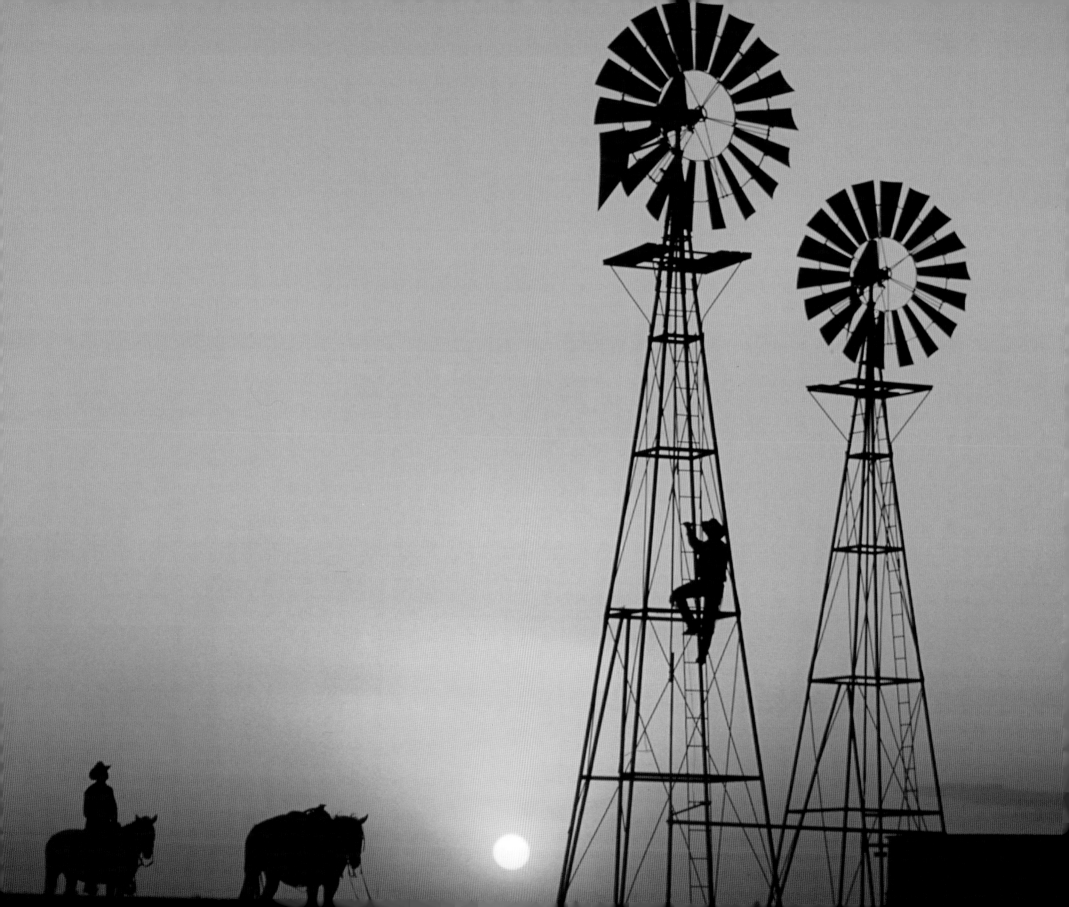

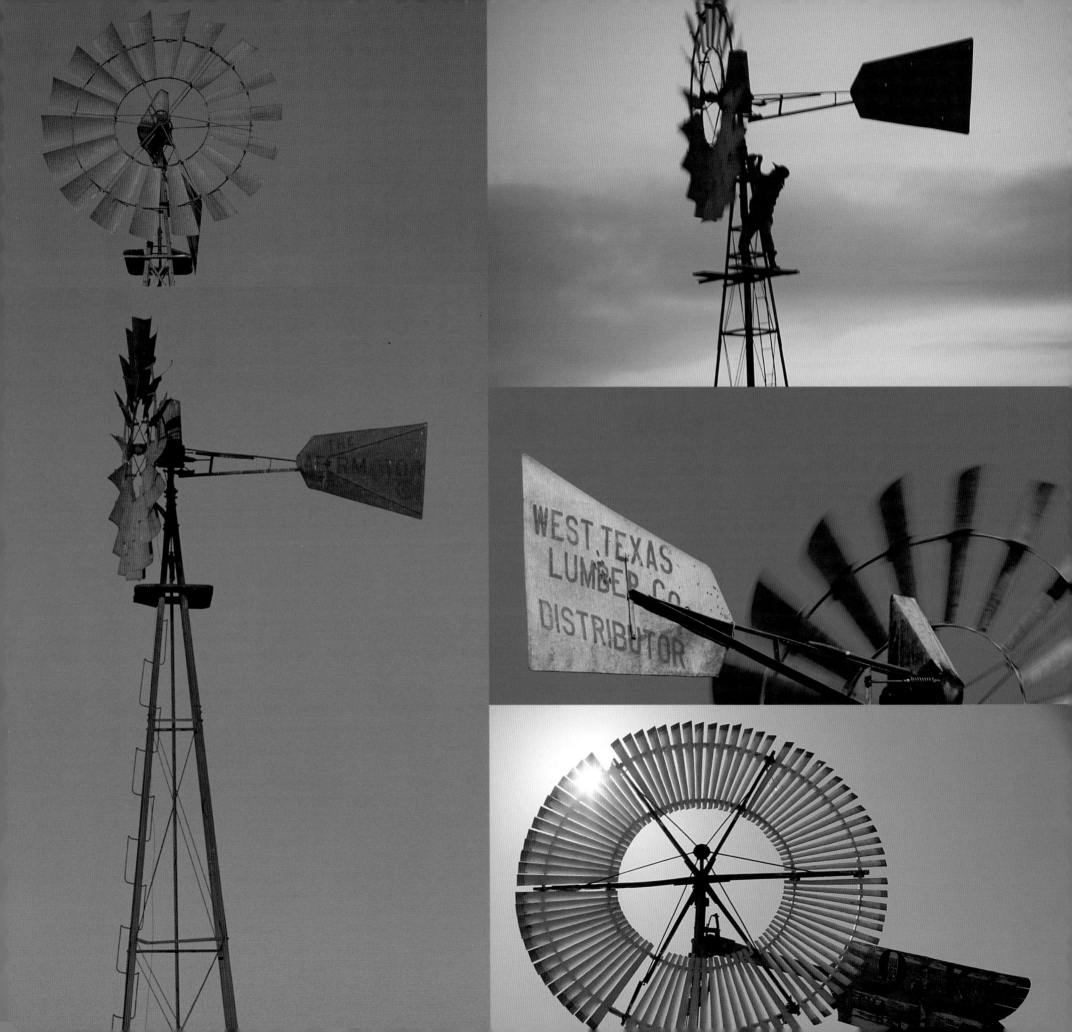

The feedlot rider may be the most honored man left on the great western prairies. He just may be the last cowboy.

—*Caleb Pirtle, "The American Cowboy"*

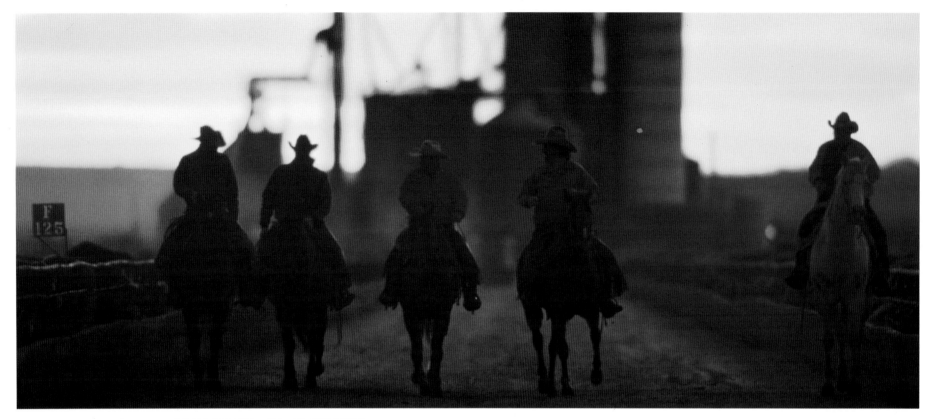

RANDALL COUNTY FEEDYARD, BETWEEN AMARILLO AND CANYON, TEXAS
Carl Avant, Cecil Blasingame, Walt Donais, James Welch, and Ed Harland
Cattle are shipped from all over Texas to be fed in the Panhandle feedlots;
the Randall County Feedyard feeds a capacity of 60,000 cattle every year.

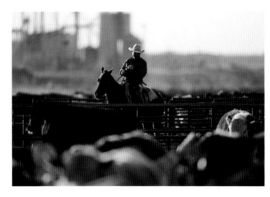

LEAVING THE FEEDLOT
Randall County Feedyard

CHECKING THE PENS
Randall County Feedyard

CATTLE TRUCK
Randall County Feedyard

Previous Spread
WINDMILLS OF THE PANHANDLE
Without the windmill, the Panhandle never would have been settled.

CATTLE PENS
Randall County Feedyard

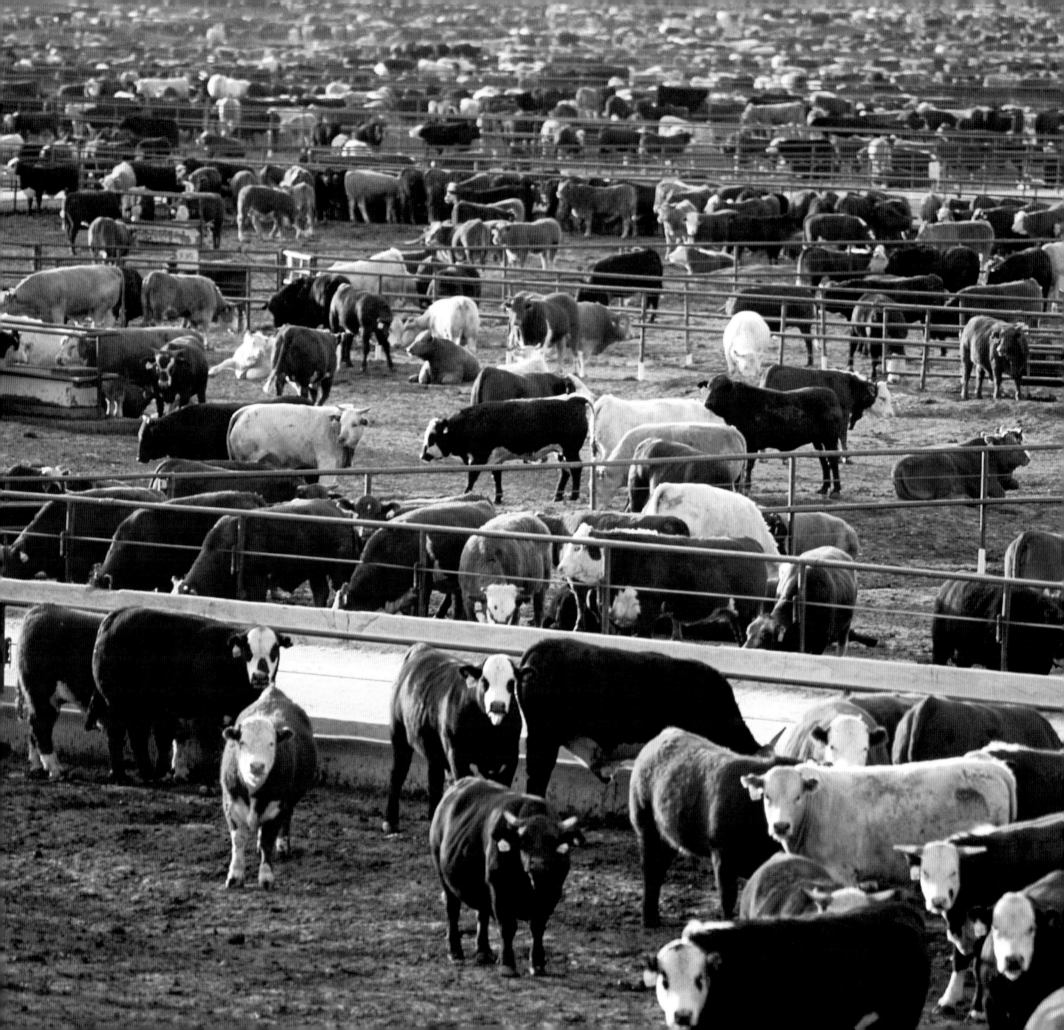

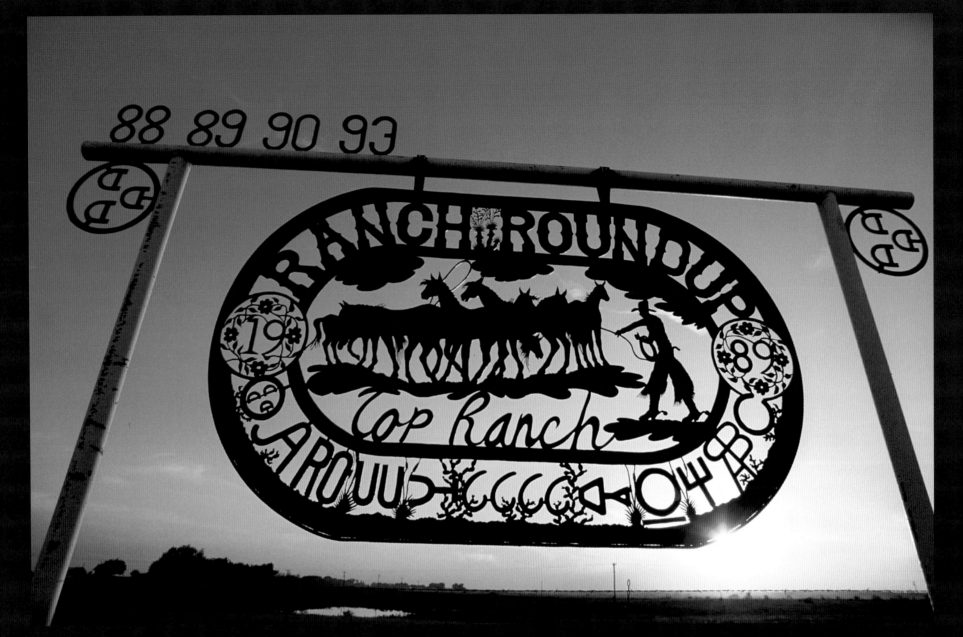

PROUD MARKER
Waggoner Ranch; Vernon, Texas

North-Central Cross Timbers and Prairies

South of the Red River at the Oklahoma border lie the Grand Prairie and the western Cross Timbers. These areas contain some 14 million acres and enjoy the reputation of being among the most picturesque sections of the state.

A large variety of native Texas grasses can be found in north-central Texas. The rolling prairie country is made up of tall prairie grasses in the flats and bottoms, while short grasses, such as buffalo and side oats grama, grow atop the limestone ridges. The ridges are spotted with live oak and red oak mottes, and the bottoms are covered with large pecan, cottonwood, burr oak, and elm trees. On the flats, live oak, post oak, and mesquite trees thrive.

The rainfall in this area runs from 25 inches on the western side to 40 inches in the east. Temperatures can vary from the low teens in winter to the high 90s, sometimes reaching the century mark in the summer.

With this kind of rainfall, spring is sure to bring an array of colors to the countryside as the famous Texas wildflowers come to life. Texas bluebonnets, Indian paintbrush, black-eyed Susans, wild buttercups, verbenas, purple thistles—and even goldenrod, which is renowned for getting the allergies in gear—have occupied many an artist's canvas.

Two major rivers serve the area, the Trinity in the eastern portion, and the Brazos, which winds through the middle, its length second only to the Rio Grande.

Primarily adapted to grazing livestock, this region also produces wheat, oats, grain sorghum, peaches, watermelons, canteloupes, and pecans. It is also the location of one of the largest metropolitan areas in Texas, the Dallas/Fort Worth metroplex.

Cowboying here differs somewhat, in that the ranches are not as large and the pastures are smaller than they are in the southern or western parts of the state, with easy access along farm-to-market roads. The boys are able to load up their ponies and trailer to most any pasture they need to ride.

There are no line camps or chuck wagons used in this part of the country. The ranches all neighbor with each other, so there is lots of help; and the crew can run to the local cafe and catch a hot plate lunch at mealtime. It is customary for the boss of the ranch where the work is being done to pick up the tab. Also, it's not uncommon for some outfits to have a soda pop and candy bar break around ten in the morning, or as the work permits. That sure beats the gyp of a water-and-biscuit break that the west Texas boys get.

Some parts of the job may be a little easier here than elsewhere, but the work remains the same, and at certain times of the year, the hours are just as long. The cowboys here always have a large variety of work to do, such as carpentering, plumbing, welding, fencing, ditch-digging, and farming, which means having to ride a tractor.

Cowboys here maybe don't spend as much time in the saddle as do the hands in the other regions, but these cowboys are certainly more versatile, and they are just as proud as any cowboy out on the Texas range. I know of one outfit in this area that farms more than 3,000 acres of land and handles 9,000 head of yearlings a year. The cowboys get all the riding and roping they want—and a little more!

Cowboys from this part of the state dress about the same as all the rest, but a little nicer because they go to town more. When you see one of these boys, you'll know right off that he's all cowboy, for his hide is tanned and his legs are bowed. If there is any doubt, just ask him, and he'll tell you, "Yep, I'm a bronc rider, a pretty good windmill man, and I can even overhaul your tractor, weld up your fence, or dig you a ditch. But I'm a true Texas cowboy plumb through, and damn proud of it!"

What makes cowboying worthwhile is when your old pony can jump over and head a wild cow and stick her back in the herd before she even knows she had the notion to leave, or when you jump out and lace your rope around a calf's neck just as it leaves the herd. The boys all grin and one says, "Say, that old pony is shore coming around. How long you say you've been ridin' him?"

And you swell with pride and say, "Aw, not long. He's shore gonna make one, ain't he?"

The boys all nod their heads, and one says, "Yep, he shore is."

And another says, "Naw . . . Hell, boys, he's already there!"

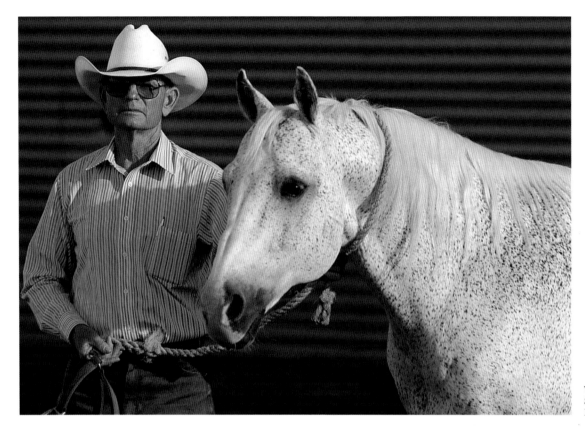

Waggoner Ranch is a breeder of performance and good ranch horses. Their horses have performed magnificently wherever asked to work: in the arena or the show ring, or on the ranch. The Waggoner Ranch is a charter member of the American Quarter Horse Association, and was honored in March of 1997 at the AQHA Convention with the Legacy Award for breeding quarter horses for over fifty years. Just recently, they have won the AQHA Best Remuda award; Top Horse at the Texas Ranch Roundup at Wichita Falls, Texas; and, in 1996, had the champion ranch gelding at the Texas Cowboy Reunion at Stamford, Texas. Their horses are in great demand today, and it has been said that the D brand on a horse's left shoulder is like sterling silver.

—*Wes O'Neal, Waggoner Ranch; Vernon, Texas*

WES O'NEAL WITH TEE J JACK STEEL, GRAY STALLION AND AQHA CHAMPION WITH POINTS IN SEVEN AQHA EVENTS

Waggoner Ranch horses have been considered some of the best ranch horses in Texas. Poco Bueno especially made his mark, as a cutting horse champion, winner of numerous performance and halter classes in American Quarter Horse Association competition, and as a sire. In 1990, Poco Bueno was inducted into the American Quarter Horse Hall of Fame.

—*Jim Pfluger*
American Quarter Horse Museum

RESTING PLACE OF A LEGEND, POCO BUENO
Waggoner Ranch; Vernon, Texas

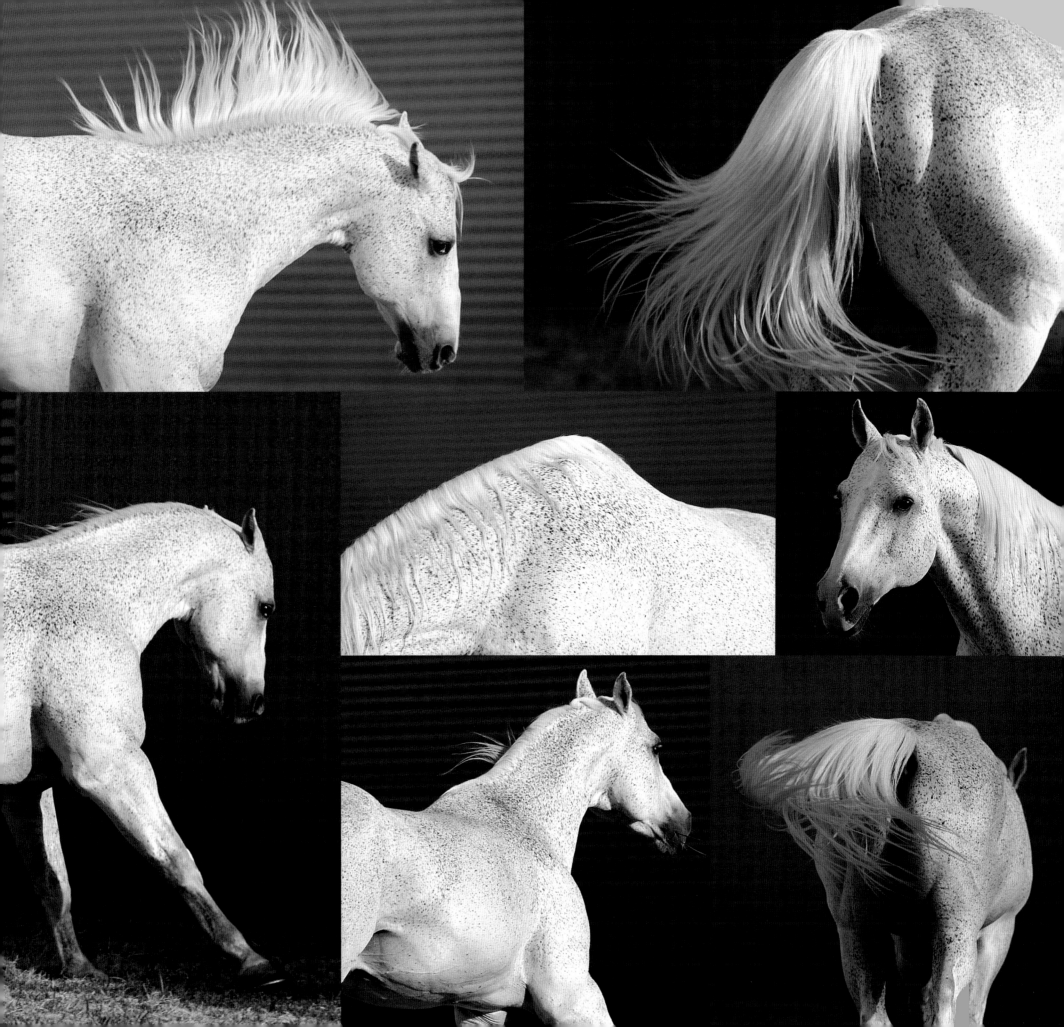

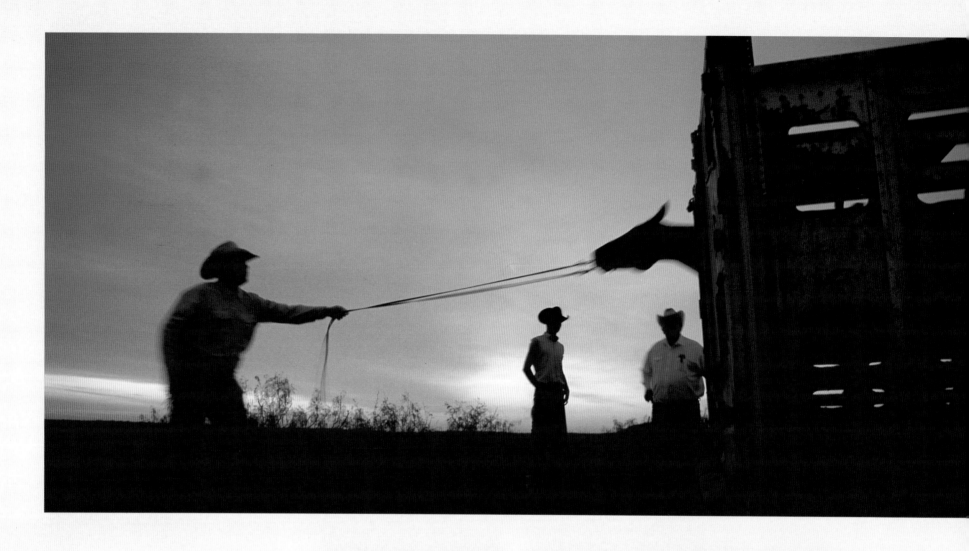

TED DUCKWORTH, TREY STONE, AND RICHARD KELLEY
Waggoner Ranch; Vernon, Texas

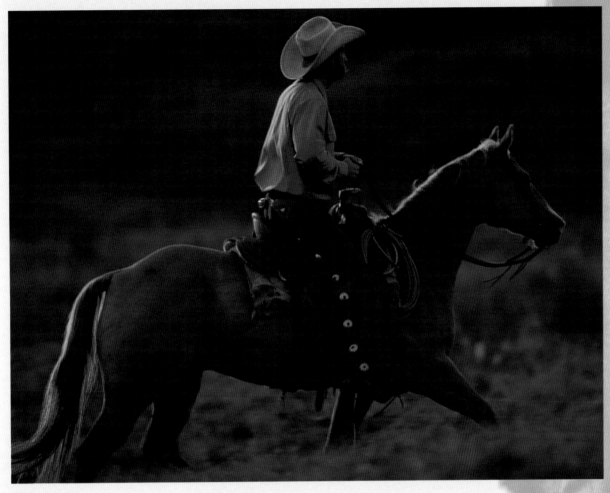

BLAKE ESTRIDGE
Waggoner Ranch; Vernon, Texas

5 a.m.: Work starts in the dark so the cowboys can catch the cattle while they're still asleep.

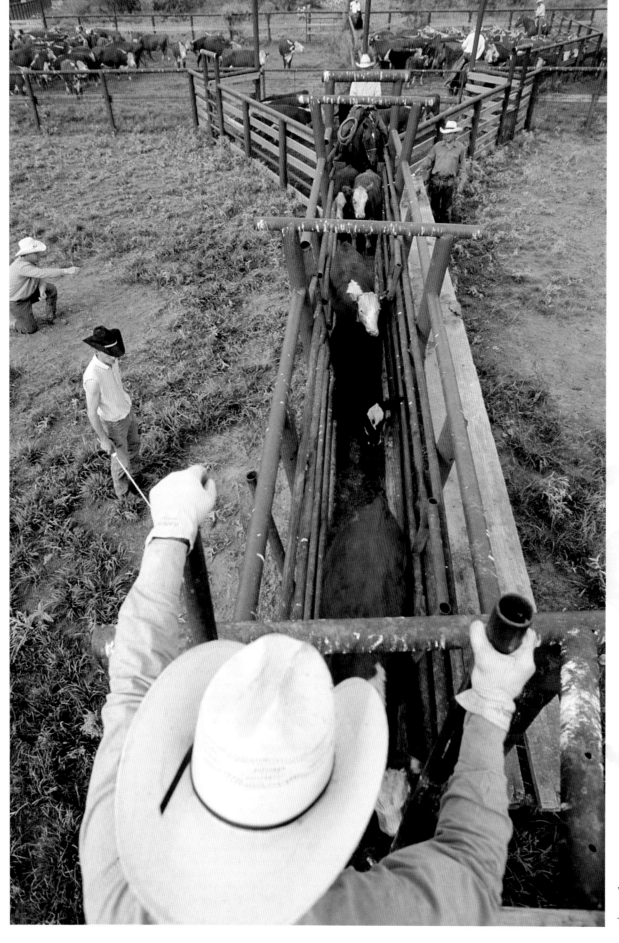

WORKING THE CHUTE
Ted Duckworth, Trey Stone, and
Jimbo Glover, the wagon boss
Waggoner Ranch; Vernon, Texas

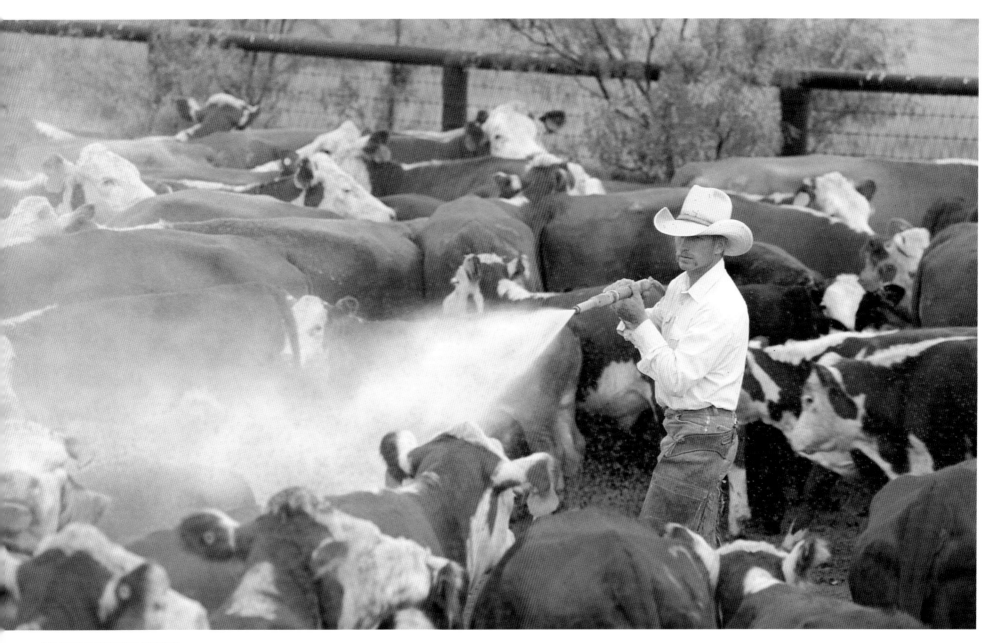

SPRAYIN' DOWN THE CATTLE
Calvin Robinson
Waggoner Ranch; Vernon, Texas

Ranchers spray their cattle to control the insects and parasites—such as ticks, lice, and horn flies—that prey on them. Infestations, if they become severe enough, can cause weight loss and even death. Ranchers spray cattle each fall, in late February or March, and then again in the summer months as needed.

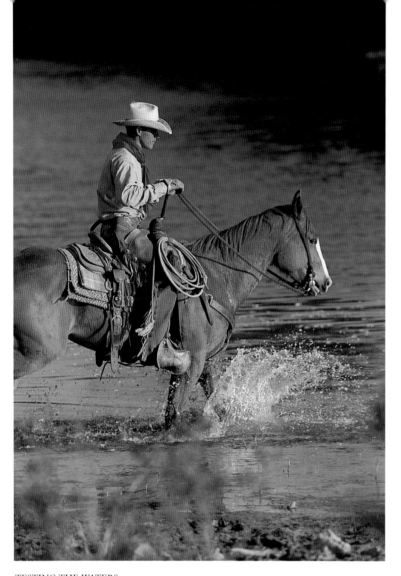

TESTING THE WATERS
Todd McCartney
R.A. Brown Ranch; Throckmorton, Texas

Previous page

GATHERING THE MARES
R.A. Brown, Rob A. Brown, Jody Bellah, Todd McCartney,
and Donnell Brown
R.A. Brown Ranch; Throckmorton, Texas

In tradition, the cutting horse comes in proud over all other range horses. He has *cow sense*, as well as horse sense; he keeps calm, never excites the cattle. *As smart as a cutting horse* runs an old phrase of the range, meaning *smart as a Philadelphia lawyer and a little smarter than a steel trap.*

—J. Frank Dobie

Cow People

IN TEXAS, CUTTING HORSES ARE USED EVERY DAY FOR WORK
Rob A. Brown
R.A. Brown Ranch; Throckmorton, Texas

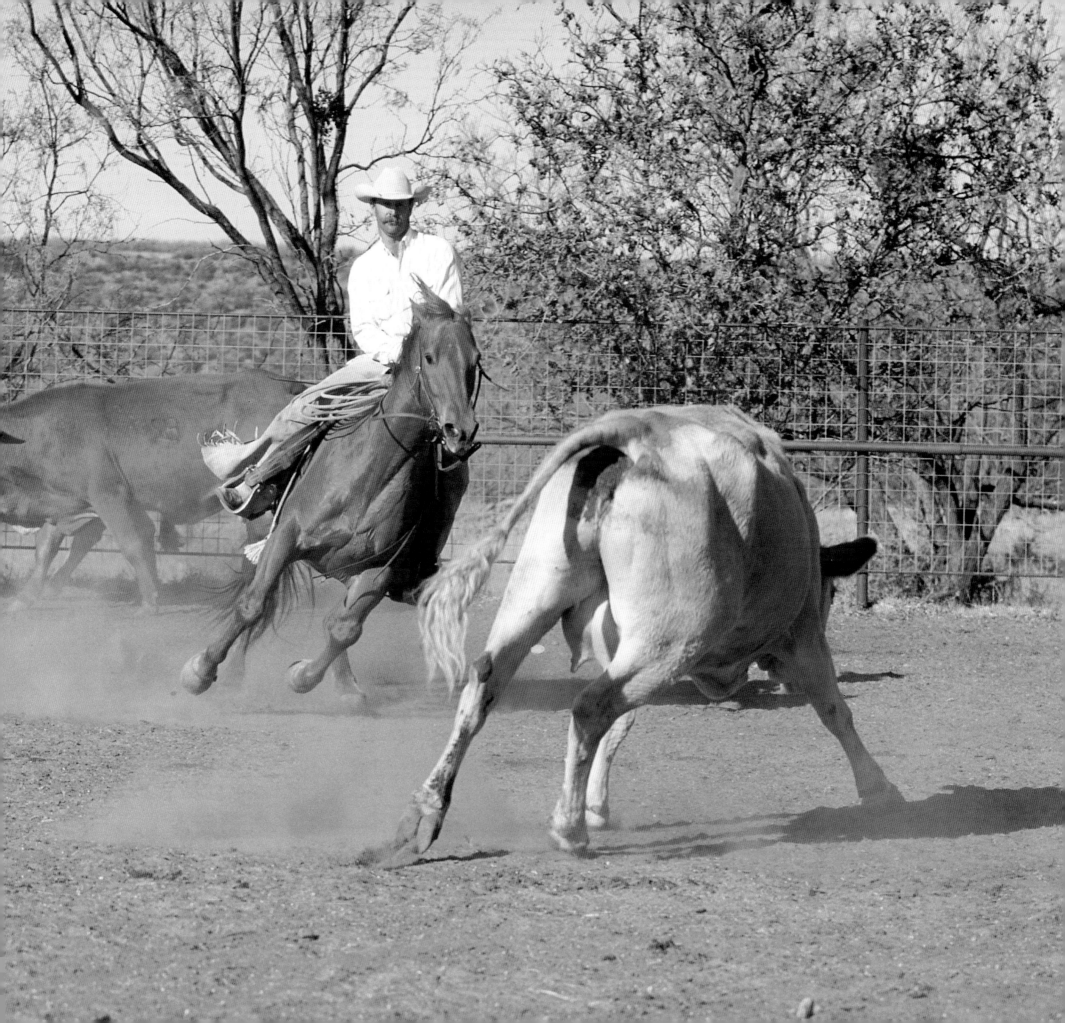

R. A. Brown Sale

The first bull sale at the R.A. Brown Ranch was held in October of 1975, and the following October, the ranch has its first production and horse sale, in addition to the bull sale. At this second sale, they auctioned 25 Quarter Horses and 120 cows to 27 buyers, and sold 100 bulls to 35 buyers.

In 1980, the Brown Ranch offered 25 Simbrah bulls, which were the result of a new breeding program started by the ranch in 1975. By 1991, the beef operation consisted of five breeds of cattle:Simmental, Simbrah, Angus, Senepol, and Red Angus. The 1991 sale offered all these breeds, as well as their crosses.

Through the years, the sale has also offered exceptional bird dog pups. Mrs. Valda Brown, the matriarch of the Brown Ranch and a strong supporter of the West Texas Rehabilitation Center, has always donated the proceeds from this sale to the Center.

In 1991, the Brown Ranch began developing a four-breed composite of Simmental, Brahman, Senepol, and Red Angus, called Hotlander, a heat-resistant, early-maturing breed that is well adapted to the climates of southern and south-western parts of the United States and of Mexico. These cattle were offered to the public for the first time in 1995.

The R.A. Brown Ranch is a true family operation, with all four of Peggy and Rob's children playing a vital role in its operation. The Ranch has continued to improve its cattle efficiency, and through the Browns' long-term experience and modern-day technology, they offer some of the best cattle and horses available to the ranching public.

Above
PEGGY BROWN, GREGG CLIFTON,
AND DONNELL BROWN;
R.A. BROWN RANCH ANNUAL
BULL & QUARTER HORSE SALE
Throckmorton, Texas

BILL BREWER, EXECUTIVE VICE PRESIDENT OF
THE AMERICAN QUARTER HORSE ASSOCIATION

ALL PHOTOS
R.A. Brown Ranch; Throckmorton, Texas

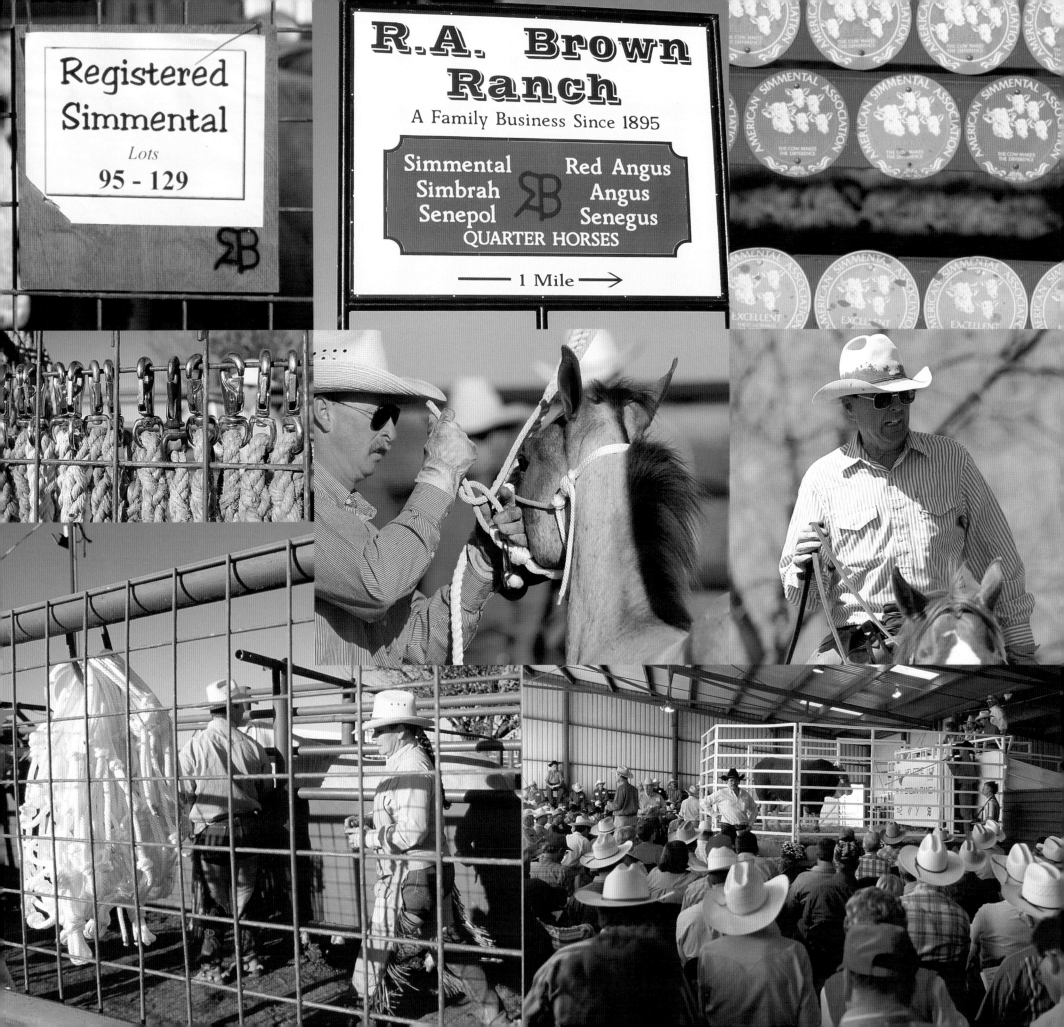

Registered Simmental
Lots 95 - 129

R.A. Brown Ranch
A Family Business Since 1895

Simmental Red Angus
Simbrah Angus
Senepol Senegus
QUARTER HORSES

← 1 Mile →

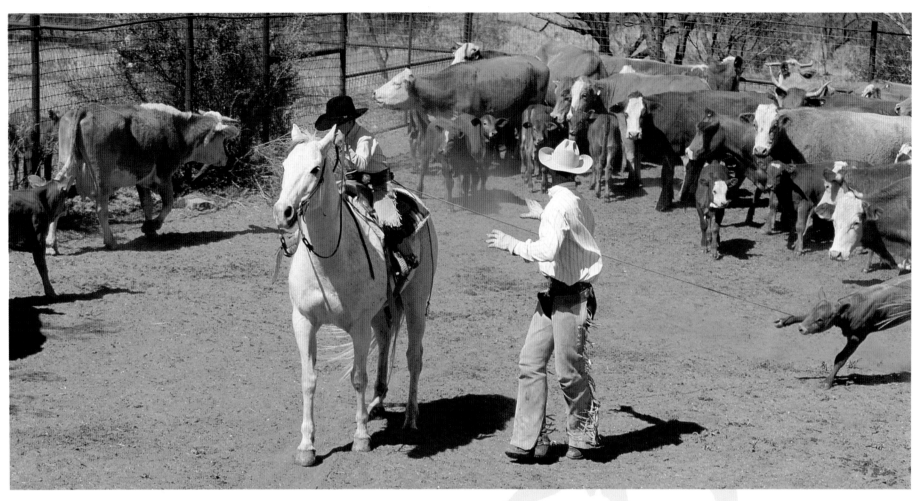

TAKE HER SLOW
R.A. Brown II and Rob A. Brown
R.A. Brown Ranch; Throckmorton, Texas

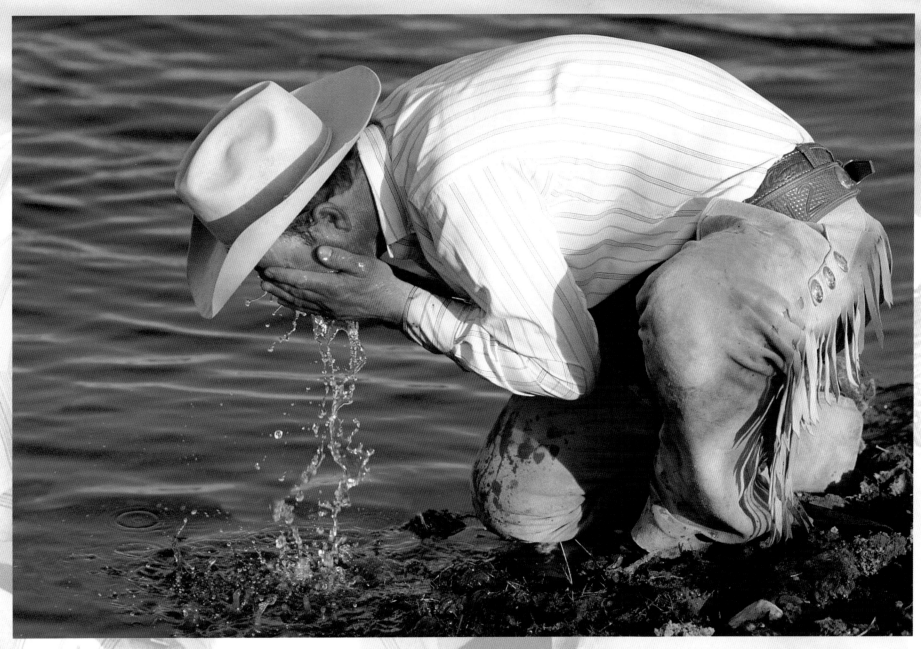

WASHING OFF
Rob A. Brown
R.A. Brown Ranch; Throckmorton, Texas

CLEAR FORK OF THE BRAZOS
Lambshead Ranch; Albany, Texas

GRAVEYARD
Lambshead Ranch; Albany, Texas

REYNOLDS BEND

BUTTERFIELD GAP
BUTTERFIELD
OVERLAND MAIL
PASSED THROUGH
THIS GAP
1858—1861

THE STONE RANCH
BUILT BY CAPT. NEWTON C. GIVENS IN 1856
RESTORED IN 1983 BY REYNOLDS
GRANDCHILDREN AND GREAT-GRANDCHILDREN
IN LOVING MEMORY OF
ANNE MARIA CAMPBELL
1818-1909
AND
BARBER WATKINS REYNOLDS
1819-1882
AND THEIR CHILDREN
GEORGE THOMAS
1844-1925
WILLIAM DAVID
1846-1929
SUSAN EMILY
1848-1921
BENJAMIN FRANKLIN
1851-1946
GLENN
1854-1889
PHINEAS WATKINS
1857-1952
SALLIE ANN
1861-1938
WHO OCCUPIED THIS PLACE
FROM EARLY 1866 TO LATE 1867

BLACK COWBOYS

Some of the Black cowboys who worked on Texas ranches had been born and raised in the state, while others were young men who came from the Southeastern states to avoid the hard times following the Civil War.

Black cowboys have always been an important part of ranching in Texas, especially in the eastern and coastal regions. Men like Bill Pickett and Bose Ikard left indelible marks in history. Bose Ikard died in 1929, and was buried in Weatherford, Texas. Inscribed upon his marker were words written by Charles Goodnight: "Served with me four years on the Goodnight-Loving Trail, never shirked a duty or disobeyed an order, rode with me in many stampedes, participated in three engagements with Comanches, splendid behavior."

GRAVE MARKER
Lambshead Ranch; Albany, Texas

The activities of Black cowboys took place in various states both east and west of the Mississippi River. However, the largest concentration of Blacks, either wholly or partially devoted to tending and driving cattle, was in Texas. In 1860, African-Americans, both slave and free, were 183,000 and exceeded 30 percent of the population. Following the end of slavery, the African-American population of Texas continued to grow while steadily declining as a percentage of the total population.

A substantial number of slaves crossing the Red and Sabine Rivers were put into direct contact with cattle. In some cases, it was the first time these men worked with cattle, but in others it was a continuation of a tradition extending from Africa.

Many Blacks in east Texas, during and following slavery, held a variety of jobs over time and were not steadily employed in any given occupation. Some found work in farming, cattle and sheep raising, horse handling, service jobs, skilled crafts, factories, railroad, numerous odd jobs, as soldiers, and as small entrepreneurs. Although the vicissitudes of life and their lower socio-economic status kept the black cowboys nearly invisible in the pages of history, many accounts exist which not only indicate that black men played a role in the promotion of the cattle kingdom of Texas; their stories of adventures along the trail rank with those told by their white counterparts.

—Michael N. Searles

Right
CHESTER STIDHAM
Saunders Twin V Ranch; Weatherford, Texas

CHESTER L. STIDHAM

I was born in Carthage, Texas, in 1941, but grew up near the Stockyards in Fort Worth.

Through high school, I worked for Steve Kemp at the North Fort Worth Horse and Mule Sale Barn. While working there, I met rodeo clown John Lindsay. There was no animal that John Lindsay couldn't train. He took me under his wing and I learned a lot about training.

I also met Rex Keith, who had managed the broodmare band for the Triangle Ranch in Paducah, Texas, in his younger days. I worked with Rex at Tadlock Ranch in Saginaw, Texas, working horses. He taught me how to appreciate good horses.

I went to college at Eastern Oklahoma State and Southeastern Oklahoma State, and got a teacher's degree. I taught U.S. History, and since I had played football through high school and college, I coached football. But the call of the cowboy life won out over teaching, so I quit teaching and became a self-made cowboy.

I worked at the Jenkins Ranch in Saginaw, the 77 Ranch in Wichita Falls, and did day-work for area ranches. I also trained horses for thirty-some-odd years, and got a name for being able to get something out of horses other people had given up on.

There were a lot of cowboys who influenced my life—Rex and John, George Tyler, J. T. Walters, Matlock Rose, Jimmy Snow, Joe Denmon, Jack Wilson, and Sonny Thompson. Steve Kemp put me on my first horse. Windy Ryon gave me my first saddle. George Murray, a saddlemaker, gave me my first bridle. Billy Cook kept me in saddles for years.

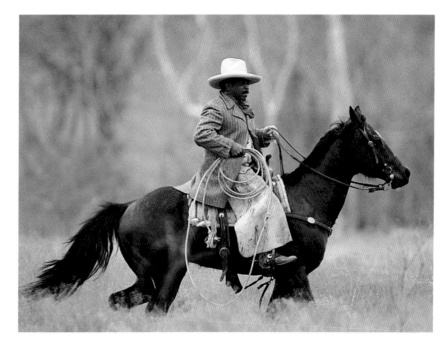

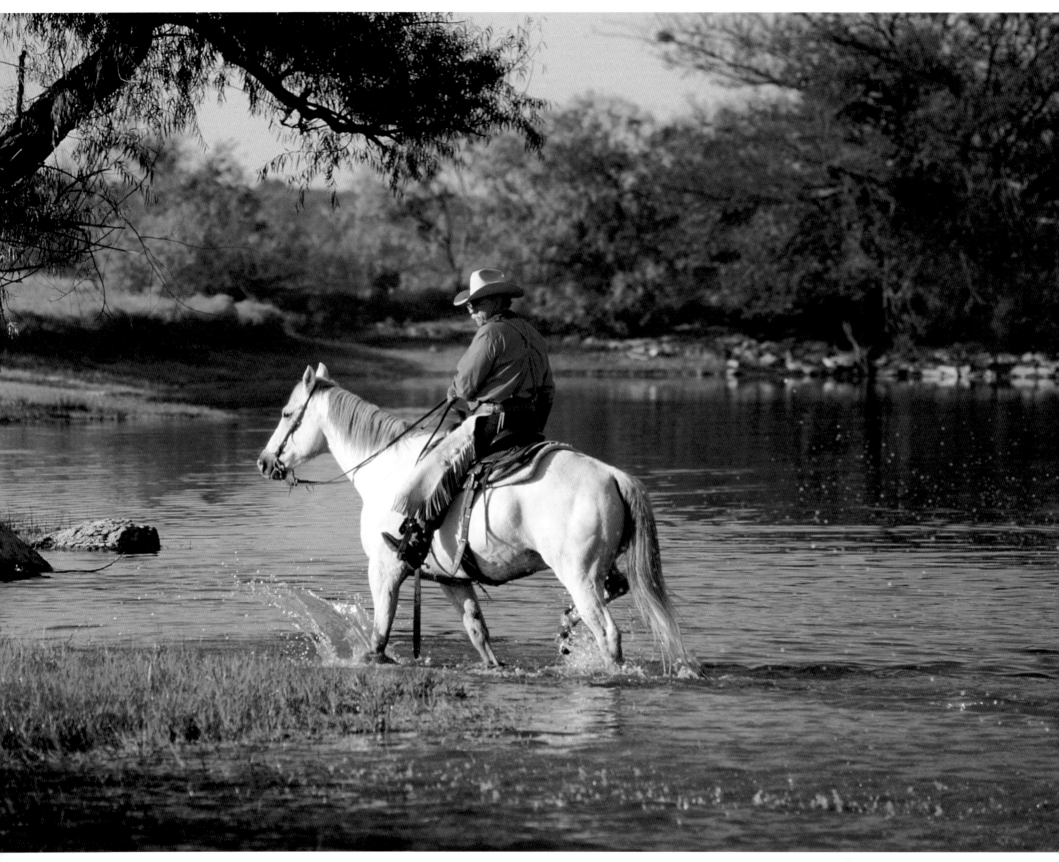

LOOKIN' FOR STRAYS
Tom B. Saunders IV
Saunders Twin V Ranch; Weatherford, Texas

FIRST LIGHT
Bo Wilson
Saunders Twin V Ranch; Weatherford, Texas

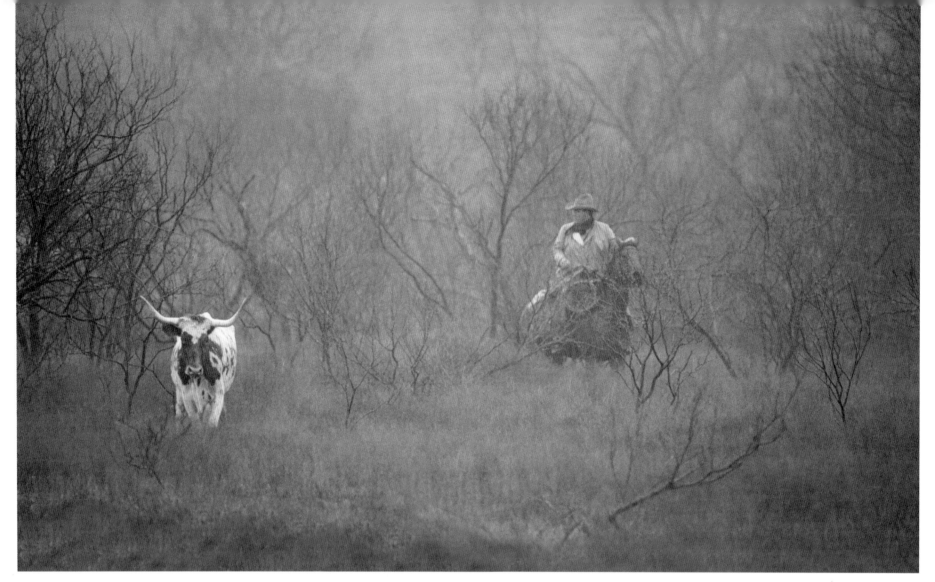

GETTIN' THEM OUT OF THE BRUSH
Perry Williams
Saunders Twin V Ranch; Weatherford, Texas

Oh, I'm a Texas cowboy so far away from home
If I get back to Texas, I never more shall roam.
Montana is too cold for me, the winters are too long,
Before the roundups do begin, our money will be gone.

—*Anonymous, "The Texas Cowboy"*

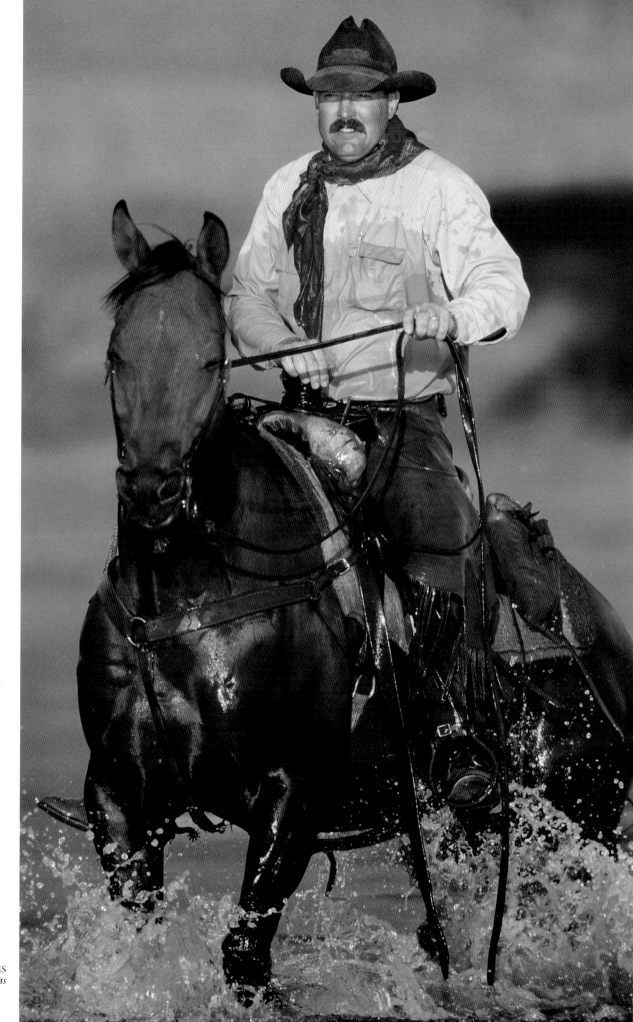

PERRY WILLIAMS
Saunders Twin V Ranch; Weatherford, Texas

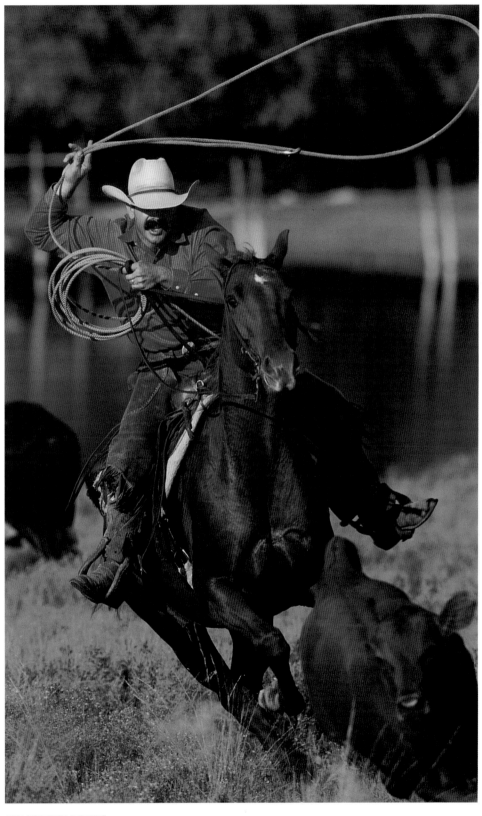

CHASIN' THE DOGIES
Thomas Saunders V
Saunders Twin V Ranch; Weatherford, Texas

FORT WORTH

The city of Fort Worth and the Fort Worth Stockyards could be said to be one and the same. In fact, local people refer to Fort Worth as "Cowtown—Where the West Begins."

During the trail-driving period in Texas, Fort Worth was along the route of the great herds that went north to Kansas. At the end of the trail-driving period, in 1902, the Fort Worth Stockyards were established when the railroads came to town and two major packing companies—Armour and Swift—opened.

The Stockyards became the major livestock market in Texas. In 1903, 732,721 head of livestock sold there, and progressively larger numbers sold during later years. In 1945, 4,850,991 head of livestock sold through the Stockyards.

This area continued to be a major market until the early 1980s. It remains a landmark in the history of Fort Worth and of Texas.

Fort Worth, Texas

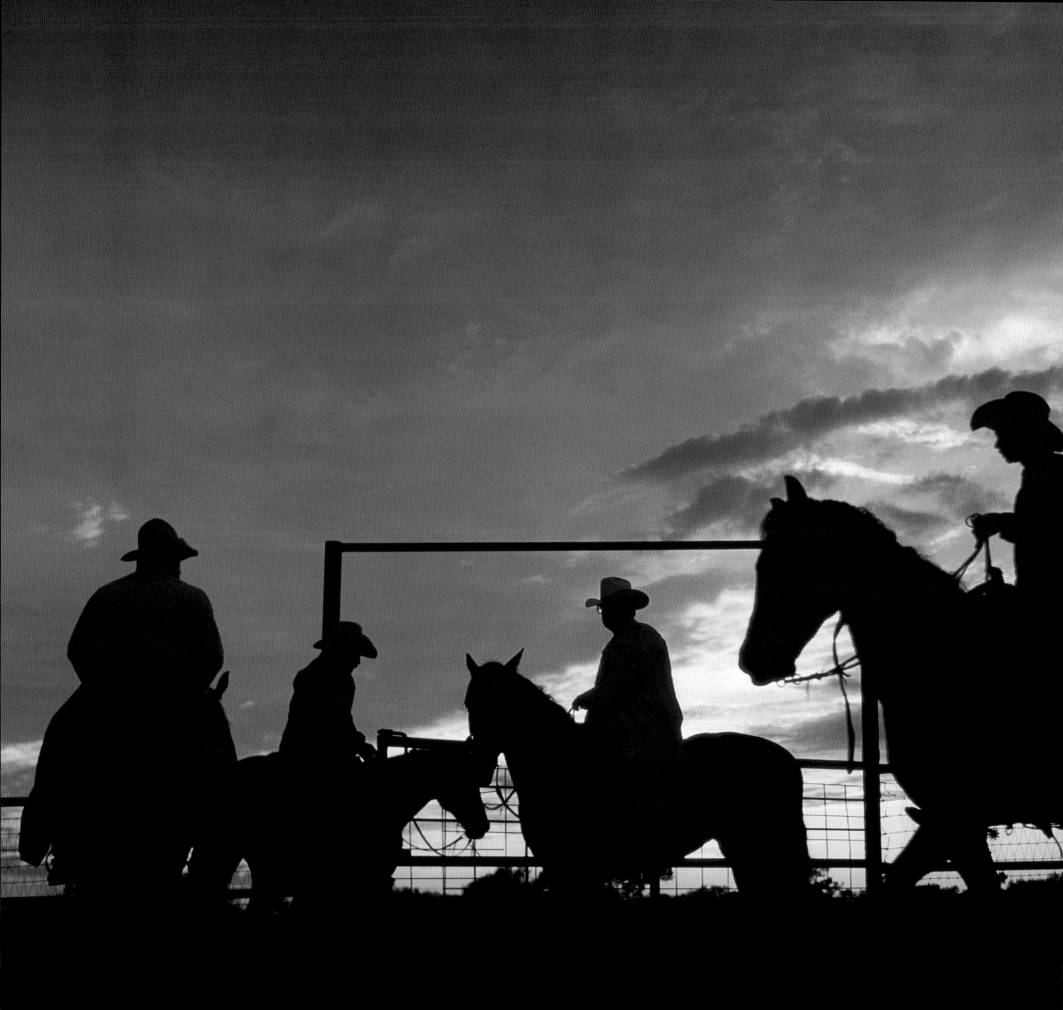

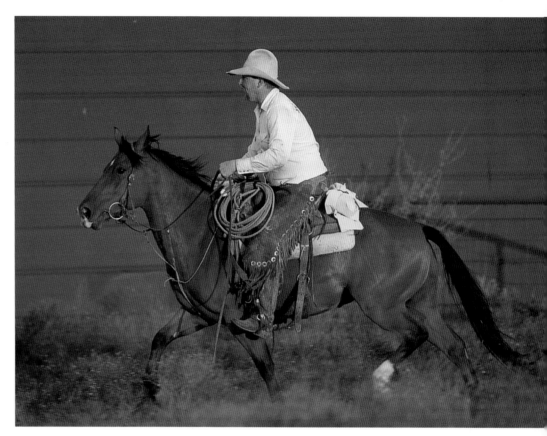

WES FARLEY
Veale Ranch; Breckenridge, Texas

Chopo, my pony, Chopo, my pride,
Chopo, mi amigo, Chopo, I'll ride
from Mexico's border across Texas Llanos
to the Salt Pecos River, I ride you, Chopo.

—*N. Howard "Jack" Thorp, "Chopo"*

JODY EDWARDS, JIM CALHOUN, AND JOHNNY STEWART
Veale Ranch; Breckenridge, Texas

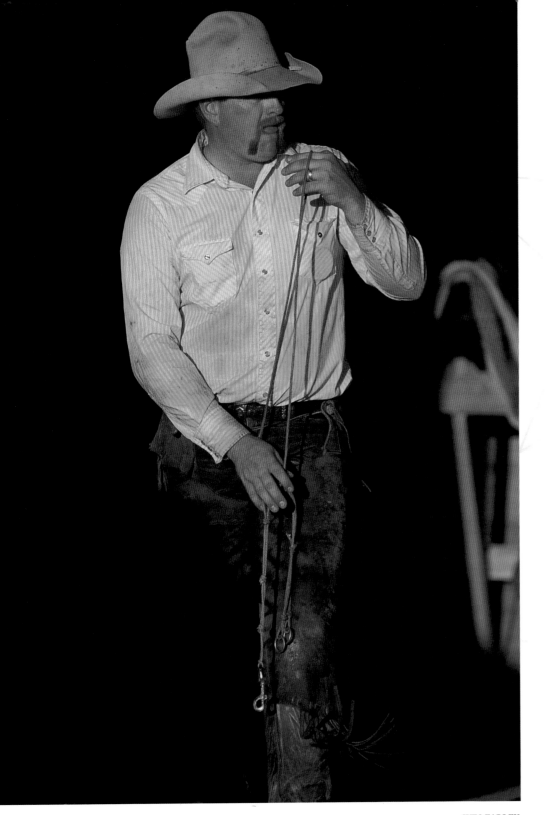

WES FARLEY
Veale Ranch; Breckenridge, Texas

RAY MEADOWS
Veale Ranch; Breckenridge, Texas

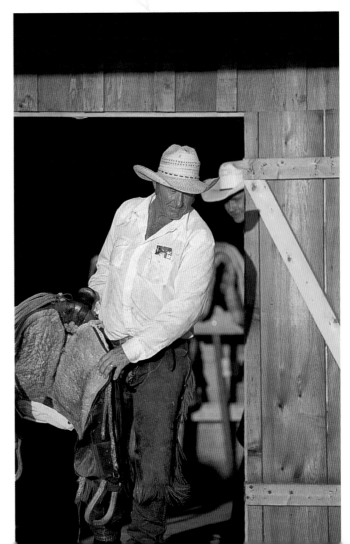

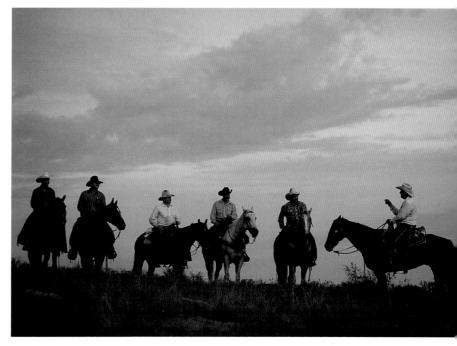

MORNING ORDERS
Ray Meadows, Johnny Stewart, Doug Seaberry, Wes Farley, Smoky Eppler, and Jody Edwards
Veale Ranch; Breckenridge, Texas

DOUG SEABERRY
Veale Ranch; Breckenridge, Texas

"One man's opinion is as good as another's in a strange country, and while there wasn't a man in the outfit who cared to suggest it, I know the majority of us would have endorsed turning Northeast."

—*Andy Adams*
"The Log of a Cowboy"

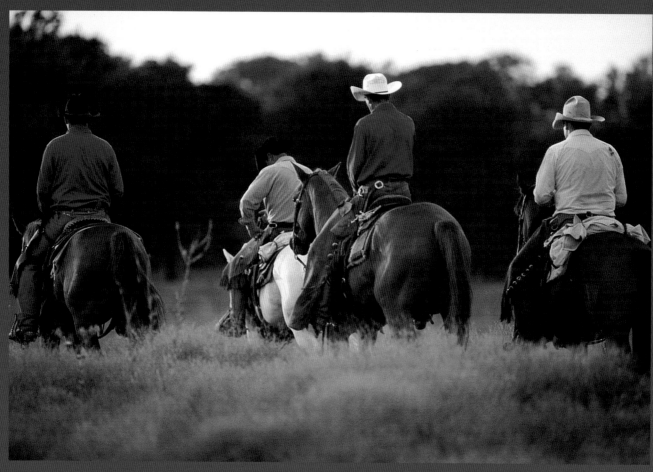

SMOKY EPPLER, WES FARLEY, JODY EDWARDS, AND JOHNNY STEWART
Veale Ranch; Breckenridge, Texas

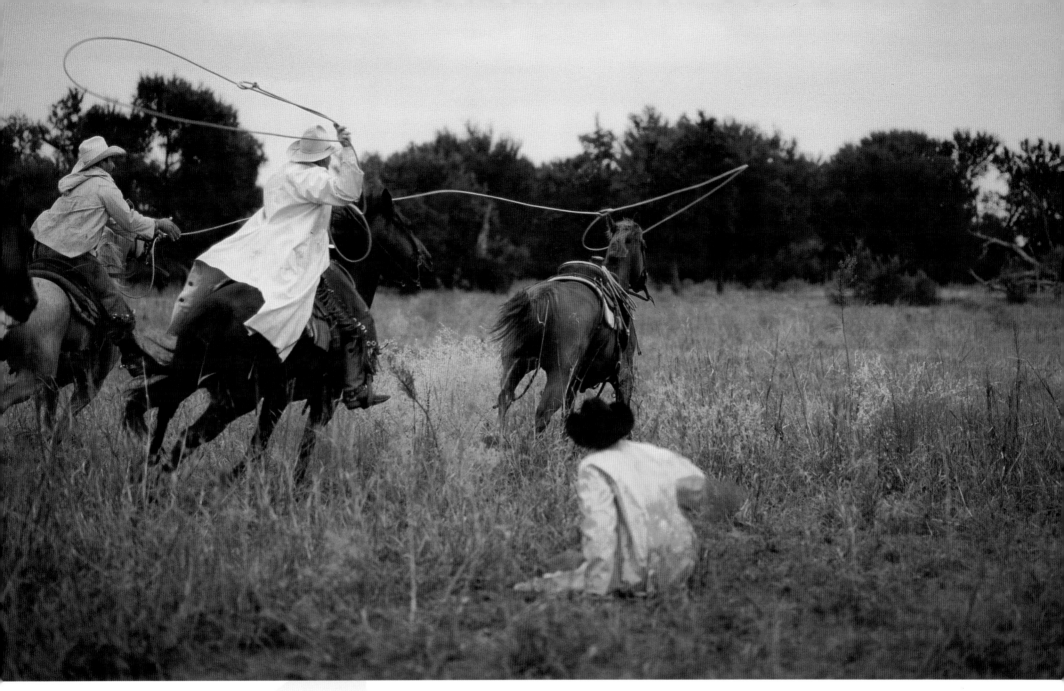

JOHNNY ROPES THE RUNAWAY!
Johnny Stewart, Wes Farley, and Jody Edwards
Veale Ranch; Breckenridge, Texas

There was only two things the old-time cow puncher
was afraid of: a decent woman and being set afoot.

—*Teddy Blue Abbott, "We Pointed Them North"*

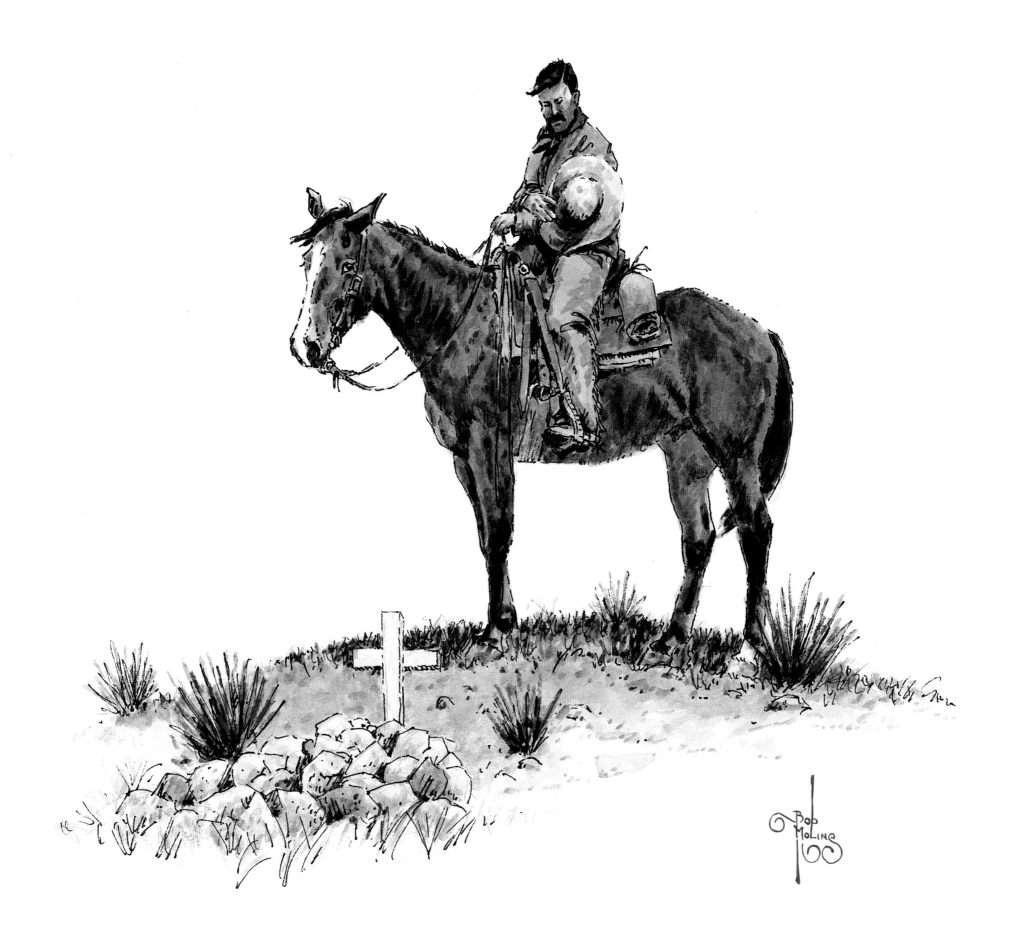

WHEN THE WORK'S ALL DONE THIS FALL

by D.J. O'Malley

A group of jolly cowboys discussing plans at ease
Says one, "I'll tell you something, boys, if you will listen please
I'm an old cowpuncher and here I'm dressed in rags
I used to be a tough one and go out on big jags."

"But I have got a home, boys, a good one you all know
Although I haven't seen it since long, long ago
But I'm going back to Texas once more to see them all
I'm going to see my mother when the work's all done this fall."

That very night this cowboy went out to stand his guard
The night was dark and cloudy and storming very hard
The cattle, they got frightened and rushed in wild stampede
The cowboys tried to head them while riding at full speed.

While riding in the darkness, so loudly he did shout
He tried his best to head them and to turn the herd about
But his saddle horse did stumble and on him he did fall
Now he won't see his mother when the work's all done this fall.

"Send my mother my wages, the wages I have earned
For I am so afraid, boys, the last steer I have turned
I'm going to a new range, I hear my Master's call
And I'll not see my mother when the work's all done this fall."

"Steve, you take my saddle, Bob, you take my bed
Paul, you take my pistol after I am dead
Please think of me kindly when you look upon them all
For I'll not see my mother when the work's all done this fall."

The cowboy was buried at sunrise, no tombstone for his head
Nothin' but a little board and this is what it read:
Charlie died at daybreak, he died from a fall
And he'll not see his mother when the work's all done this fall.

East Texas Piney Woods

Arnold Ranch Crockett, Texas
Owner/operator: Butch Arnold

James Madison Arnold was born in Georgia in 1850, and at the age of 25 brought his family to east Texas in an oxen-drawn covered wagon. In 1875, he settled on Camp Creek in Houston County and built a cabin, cleared some bottomland, and started raising cattle and kids. Because there were no markets in Texas, the Arnolds traded cattle locally.

There were some natural clearings in the bottoms along the creeks and the family farmed these, raising vegetables, corn for their livestock, and cotton for a cash crop. They raised horses and mules and, along with their cotton, traded them in Nacogdoches, one of the first settlements in Texas.

The Arnolds fenced their fields with pine rails so the cattle and hogs would not graze their crops. These animals had to make their living by grazing the timber country, which supplied an abundance of grass, browse, and nuts. In January and February, the family would burn off the underbrush to encourage grass production.

James Butch Arnold's grandfather lived to be 101 years old and fathered eleven children. His sons raised cattle and farmed cotton. In the late 1950s, Butch and his sons, Tim and Tye Arnold, started working for area ranches. Known for his outstanding cowdogs, which had been bred and used by his family for generations, Butch was called on by his neighbors to catch wild cattle and hogs.

Arnold found himself in such demand that he made rounding up these hard-to-catch critters his business. His black-mouth cur dogs are some of the best in the state, and, as Butch says, "Without a good pack of dogs and a good horse, a man in the Piney Woods country might as well stay at the house."

"Way back, we ran English-type cattle," Arnold says. "They were bred up from the longhorns, with Hereford and Angus cattle. We called them 'Woods cows.' Then, in the 1940s, we found that Brahman-type cattle would do a lot better in this high-humidity, thick-timbered country because they are better browsers and tolerate insects better than long-haired cattle.

"The Brahmans' dispositions might not be as good, but once they are 'dog-broke,' they handle easy enough. Back in the screwworm days, we had to muzzle our dogs so they wouldn't bite the cows on their ears and noses. The cows knew the dogs couldn't bite, and gave us a lot more trouble. But now it doesn't take long to bay up a bunch, especially if they are dog-broke."

After 122 years and seven generations, the Arnold family is still in Houston County on Camp Creek, still punching cows, and raising kids and black-mouth cur dogs.

Bauer Ranch, Alto, Texas
Owner/operator: Kevin Bauer

The Bauer Ranch occupies a piece of land known as "the Old Berryman Ranch," belonging to the family of Kevin Bauer's wife, Holly. Kevin Bauer currently leases this land from Holly's family, and this is where he runs his own Brahman-cross cattle.

Miss Helena Dill was born in what became Nacogdoches County in 1804, and

was the first Anglo child to be born in Texas. She later married a Berryman, and in 1847 moved to Angelina County, where they established a ranch and built a two-story cabin, which is still in livable condition today.

So, in truth, after 150 years, this ranch is still being operated by the family, and Kevin plans to continue this tradition for many years to come.

South Texas

Briscoe Ranch Fowlerton, Texas
Owner: Dolph Briscoe; Operator: Chip Briscoe

Dolph Briscoe will be remembered for two things. First, he was governor of Texas from 1973 to 1979. Second, according to longtime friend and partner Red Nunnley, "Dolph Briscoe eradicated the screwworm. People in the ranching business don't think anything about it anymore. They have no idea of the hardships we went through."

In addition to being one of Uvalde's most respected citizens, Dolph Briscoe is probably the largest individual landowner in the state. He pioneered chain-clearing methods that turned the brush country into excellent pasture land.

The Briscoe story began when a distant relative, Andrew Briscoe, obtained a grant of land on the Brazos River, in what is now Fort Bend County, from the Mexican government. He had come from Mississippi, and registered as a citizen of Coahuila and Texas in 1833.

Andrew opened a general merchandise store in Anahuac in 1835, but when the Mexican government raised his taxes, he refused to pay and they put him in jail.

Once out of jail, Briscoe joined W. B. Travis's volunteer army to drive Antonio Delorio Velasco out of office. Briscoe was captain of the army that fought at the Battle of Concepcion, and he followed Ben Milam at the Siege of Bexar, both important events in the battle for independence from Mexico.

Briscoe attended the Convention of 1836, and signed the Texas Declaration of Independence. He served under Sam Houston at the Battle of San Jacinto, and was later named by Houston to become the first county judge of Harris County.

Dolph Briscoe's father left Fort Bend County in 1911 and came to Uvalde, where he traded horses. The market in Uvalde was good, so he decided to settle there. He worked for Ross Sterling, the founder of Humble Oil, and later became his partner in a cattle operation.

In 1930, when the Depression hit, Sterling lost his land; but Dolph's father had access to some lease land known as the Old Catarina Ranch, and he moved there to start over. He had lost everything he had, and it wasn't until 1939 that he was financially in a position to start again. With the help of a federal land loan, he was able to purchase 10,000 acres at the Catarina Ranch. That was the beginning of what Dolph Briscoe owns today.

As mentioned earlier, Dolph Briscoe was the driving force behind a program to eradicate the screwworm in Texas cattle. The main infestation of this parasite came from Mexico, and the U.S. Department of Agriculture took the position that Briscoe's program wouldn't work because of a continual danger of reinfestation from Mexico.

One has to admit that the method proposed by Briscoe and his researchers sounded strange. They had found that the female screwworm fly mated only one time in her life; therefore, if she mated with a sterile male, she would never produce eggs. Researchers raised sterile males at a facility located at Moore Air Force Base in Mission, and these males were dropped from airplanes in small boxes with lids that opened when they were released.

Later, the facility raising the sterile flies was moved to Mexico, where the project became a joint effort between the United States and Mexico.

No one knew for sure whether the program would work, but it did, and ranchers today can thank Dolph Briscoe for the absence of a pest that at one time caused untold damage to the state's herds.

Donnell Ranch Fowlerton, Texas
Owner/operator: Jim Donnell

The Donnell Ranch is located more than 80 miles south of San Antonio in McMullen County, "Brush Capitol of the Country" and one of the least-populated counties in Texas. Tilden, the county seat, boasts a population of approximately 400 people. The Spanish called this country "La Brasada"—a place "like burning embers." Anyone visiting this part of the state would find the name appropriate.

James L. Donnell and his son, Jamie, are fifth- and sixth-generation McMullen County ranchers. Their ancestry dates back to 1850, when James "Jim" Lowe and his wife, Melissa Jane York Lowe, moved from North Carolina to Texas. After first settling on the Atascosa River in present-day Atascosa County, they moved in 1856 and settled at "Rio Frio," later called Dogtown, and now called Tilden.

The Lowes were among the first three or four families to settle in this area. Jim Lowe operated on open range, and is reputed to have owned cattle running in more brands than anyone else in the state. Jim trusted the people he dealt with, and initiated the custom of accepting paper as payment rather than gold in south Texas. Unfortunately, this practice left him broke, and for a time he served as Sheriff of McMullen County.

Lowe's son, W. A. "Dolphus" Lowe, and his wife, May Ellen Beall Lowe, founded the Lowe Ranch in McMullen County between the Frio and Nueces rivers. Most of the original ranch is still owned by their descendants. Their sons, Guy, Dolph, and Roy, owned and operated large-scale ranches in McMullen, LaSalle, Duval, and other south Texas counties. Roy's daughter, Beryl Lowe, and her husband, J. W. (Jim) Donnell, operated in the same area and lived at the Dull Ranch in LaSalle County.

The Dull Ranch was settled in 1856, and was the first ranch to be enclosed by fence in this part of the country. Owned by the Dull brothers, who were steel makers from Harrisburg, Pennsylvania, part of the ranch was comprised of land acquired from the railroads in exchange for steel for rails. Ranching was an unfamiliar occupation for the brothers, so they hired a seasoned ranchman to manage. Captain Lee Hall, a former Texas Ranger, knew the country and also knew the law. The combination of his legal expertise and his ranching ability made him perfect for the job. Using mesquite posts and barbed wire, the Dull brothers fenced in 240,000 acres of previously open range. Not everyone in the county supported this decision. Hall dealt with those who did not.

The short-story writer Sidney Porter, better known by his pen name, "O'Henry," lived on the Dull Ranch as a youth, and used this background for many of his stories.

In 1901, the Dull brothers sold out to L. Naylor and A. H. Jones. In 1911, when the railroad came through, Charles and James Fowler subdivided 100,000 acres of the land, and founded the town of Fowlerton. They promoted their "Frio Valley Winter Garden" as a healthy dream and "truck farming" community. Salesmen from Fowlerton traveled all over the United States, to mining communities in West Virginia, Tennessee, Nevada, and Colorado, selling 10-acre tracts. When a tract was paid for, the buyer received a deed.

Fowlerton grew to a population of more than 2,000, but it was impossible to make a living farming a 10-acre tract, and the drought of 1917 wiped out any remaining hopes these small farmers had. Roy Lowe, Jim Donnell's grandfather, began buying up portions of the Dull Ranch, and blocking it up to create the nucleus of the ranch Jim owns today. Later, J. W. Donnell, Jim's father, continued to purchase and rebuild the ranch.

Today the Donnell Ranch runs crossbred cattle and a stocker operation.

King Ranch Kingsville, Texas
Owner: Kleberg Family; Vice President: Stephen J. "Tio" Kleberg

Wild Horse Desert. The name conjures up visions of desolation, yet this is the area Captain Richard King selected to begin one of the greatest ranches in Texas history.

A steamboat pilot and captain, King arrived in Texas in 1847, during the Mexican War. Commanding the steamboat *Colonel Cross*, he served for the duration of the war transporting troops and supplies for the United States Army. Afterwards, King remained on the border, and became one of the principal partners in two steamboat companies.

These companies enjoyed a near-monopoly in the steamboat trade for more than two decades. With the profits from this venture, King and his partners began purchasing land in the bandit-infested Nueces Strip, where King established his first headquarters on Santa Gertrudis Creek, 45 miles from the nearest town.

In 1854, on a trip to Mexico to purchase cattle, King moved an entire village of impoverished Mexican men, women and children to his property in Texas. These people came to be known as *Kinenos* (King's men), and have formed the core of his work force ever since.

In late 1860, Captain King moved off the Rio Grande to the Nueces ranch with his family, to live and fully develop the ranching business. The ranch survived its early years in spite of bandits, outlaws, raiding Indians, ruffians, and the Civil War.

A man of vision, King saw railroads and town development as ways to both protect and enrich his ever-growing land and livestock holdings. He invested heavily in the building of railroads, packing houses, ice plants, and harbor improvements at Corpus Christi.

King died on April 14, 1885. He left his wife, Henrietta, an estate of some 614,000 acres, 40,000 cattle, 12,000 sheep, 6,600 horses and 500 mules. His final instructions to his principal lawyer, James Wells were "not to let a foot of dear old Santa Gertrudis get away."

Earlier, in 1881, a young lawyer named Robert J. Kleberg had begun assisting Wells with some of King's legal work. Kleberg quickly became an indispensable part of the ranch, and was named full-time manager on January 1, 1886. Six months later, he became part of the family when he married the youngest King daughter, Alice.

Under the management of Mrs. King and Kleberg, operations at the ranch were streamlined and made more efficient. They cross-fenced the sprawling acres, creating more manageable pastures. He upgraded the ranch's breeding stock, removed the annoying wild donkeys and mustangs, and assigned crews to clear land and slow the ever-encroaching mesquite.

So many "firsts" have been attributed to this management team and their heirs that it is difficult to name them all. They include the first artesian well, more than 500 feet deep, dug in 1899; development of the Santa Gertrudis breed of cattle, named after Captain King's home ranch; and production of the superior Old Sorrel line of quarter horses. Assault, a King Ranch thoroughbred, won the coveted "Triple Crown" in 1946, the same year the King Ranch established its horse farm in Lexington, Kentucky.

Today, Stephen J. "Tio" Kleberg manages the ranch assets, aided by the latest in technology. Under his leadership, the company has continued to update its cattle, horses, and farming operations. More and more emphasis is being placed on the application of modern business principles to tradition-bound endeavors.

As an outgrowth of its quarter horse program, the ranch has become involved in the sport of competitive cutting—an event in which horses try to separate individual cattle from a herd. Within a decade, through a combination of strategic horse purchases and successful breeding techniques, King Ranch established a near-dynasty of champion cutting horses, led by the stallions Mr San Peppy and Peppy San Badger.

McAllen Ranch Linn, Texas;
Owner/operator: James A. McAllen

Dian Leatherberry Malouf, in her book *Cattle Kings of Texas*, says that Jimmy McAllen told her, "When I was a sassy little kid, some other sassy little upstart bragged to me about his family coming from the East with the Pilgrims. His other relatives came to Texas with Stephen F. Austin. I responded the way a kid would, and said, 'Yeah, and when they finally got down here, my family was already here to meet them.' "

At an early age, Jimmy reflected the well-known McAllen independence, a commodity the family has never been short on. Jimmy's father, Argyle McAllen, refuses to set his watch to daylight-savings time.

"The cows aren't on daylight-savings time," says Argyle. "Why should we be?"

Jimmy McAllen's earliest recorded ancestor, Juan Jose de Hinojosa, was a descendant of Spanish nobility. He left Spain in 1749, moving his family to the village of Camargo on the south banks of the Rio Grande River. Hinojosa was appointed mayor of Reynosa, a village downriver from Camargo.

To protect from the French their claim to the land adjoining the Gulf of Mexico, Spain was forced to begin colonization of the *Seno Mexicano*. As a result, numerous towns were established along the Rio Grande by colonists under the leadership of Jose de Escandon.

Soon, inhabitants of Reynosa protested that they did not have enough land for

their livestock. A system of allocating land was devised, creating *porciones* along the riverfront, with larger grants north of these narrow strips. Manuel Gomez, a successful rancher and merchant in Reynosa, applied for the lands named Santa Anita, and the grant was approved by the Viceroy of Spain.

Gomez died a short time later, and his estate passed to his wife, Ma. Gregoria Balli de Dominguez, and his father, Don Antonio Gomez. Don Antonio sold his share, but Ma. Gregoria's sons lived on and operated the Santa Anita Ranch.

As a result of the Mexican War in 1846, the Rio Grande River became the boundary between Texas and Mexico, and the Santa Anita became part of the United States. In 1850, the grant was confirmed to Manuel Gomez and his heirs by Texas Governor O. M. Roberts.

By inheritance and transfer, the Santa Anita soon passed to Salome Balli, daughter of Francisco Balli, a pioneer settler.

In 1853, Salomé married John Young. Born in Scotland, Young had become a successful businessman in this country. John J. Young was their only child. After her husband's death, Salomé Balli de Young married John McAllen. McAllen had left Ireland in 1845 and settled in Brownsville, where he worked for various merchants and later assisted Salomé in operating her properties. Salomé and McAllen had one son, James Balli McAllen.

In 1896, the ranch was divided between the Youngs and McAllens, with the Youngs taking the eastern half and the McAllens taking the western half, known as San Juanito.

Today, the descendants of the pioneers who loved this land continue on in the rich heritage and traditions that began so long ago. From the early longhorns to the present-day Beefmaster-type cattle, the owners have been proud of the quality of their livestock and are well known for their conservation of land and wildlife.

For eight generations, the McAllens have "tended the changes," surviving bandits, droughts, depressions, hurricanes, epidemics, and interfering governments. But with the aid of faithful employees such as Juan Luis Longoria, Caporal of the San Juanito, they survive.

San Vicente Ranch Linn, Texas
Owner/operator: Enrique E. Guerra

The San Vicente Ranch, owned by Enrique E. Guerra, shares the same rich history as the McAllen Ranch. Both stem from the original Spanish land grant known as Santa Anita.

The original land grant from Spain was for 21.5 leagues, or 95,000 acres. The ranch was passed from generation to generation through the family lineage, and was finally partitioned off to various owners. One of these portions became the San Vicente Ranch, now owned by Guerra, a direct descendant—through his grandmother—of Don Manuel Gomez, the original grantee.

Guerra and his family have continued on in the rich ranching traditions of this land, and are proud to have maintained an operation notable for its historic husbandry. The centerpiece of the ranch is a standing well dating to 1790, when Don Manuel began construction of the infrastructure neccessary to support a thriving ranch. Though no longer a working well, its sound structure is a tribute to the hard

work and determination of a family that had the visison to recognize the opportunity this forlorn, rugged country had to offer.

In addition to his other ranching activites, Guerra maintains one of the largest purebred Texas longhorn herds in the world. He says his cattle are not intermingled with the so-called English longhorns that were crossed with some cattle in Texas. Cattle from his ranch stocked the famous herd located in Fort Sill, Oklahoma.

Citrus groves dot the ranch, and the large Guerra hacienda is surrounded by a rock wall that forms a "U." Within the wall are smaller buildings that house craftsmen who use mesquite wood grown on the ranch to make furniture and flooring. These craftsmen also manufacture leather goods, such as riatas, headstalls, and other cowboy gear, using true Texas longhorn hides that are tanned on the ranch.

Guerra is a collector of early Texas artifacts, and is considered an authority on his collection of museum-quality pieces. The family is committed to preserving the natural beauty and historical integrity of this magnificent ranch. It was, therefore, a most fitting site for the 1996 Heritage Ranch Gala, benefitting the Hidalgo County Historical Museum.

HILL COUNTY

Hay Ranch Waco, Texas
Owner: Ed Hay; Operator: Lee Hay

The HH (Double H) Hay Ranch, located in Falls County, Texas, was first established by Lester Hay in 1936 on 525 acres. The ranching operation originally consisted of raising stocker calves, along with farming a small number of row-crop acres. Edward Lee Hay Sr., the second of Lester's three sons, acquired the original tract of land, and has increased the size of the operation to approximately 3,200 acres.

The ranch's location on choice Brazos River bottom land, along with an exceptional climate, makes for some of the most fertile farming and ranching land in central Texas.

Today's operation is still owned by Edward Hay, and is operated by his son and partner, Lee Hay. Lee oversees and works on all aspects of the ranching operation, with the help of one full-time employee. Their horses are American quarter horses of the Doc Bar and Poco Bueno bloodlines.

The operation has expanded to approximately 600 acres of corn and milo, Brangus and Hereford cows and calves now make up the cattle herd, and a large deposit of mined gravel adds to the income of the ranch. This diversification keeps Lee busy.

Stocker calves are run year-round. They graze on coastal pastures during the summer months, and rye and oat pastures during the winter. The cattle are pastured until they reach the desired weight, after which they are gathered and shipped to feedlots.

Within a year's time, roughly 5,400 head of stocker cattle will pass through the gates of the Hay Ranch. There is no "down time" on this spread, where there are horses to be ridden, cattle to be fed and tended to, fields of hay to be cut and baled, and row crops to be tilled and planted—plus a hundred other jobs that seem to materialize out of nowhere. The question is never "What will I do today?" but rather "How much can I get done?"

Lee Hay and his two sisters, Lynn Hay Saunders and Leslie Hay Jackson, come from a long line of ranching families. Their mother, Elise Waggoner, was the daughter of William Thomas Waggoner Jr. of the Waggoner Ranch family. Lynn is married to Thomas Saunders of the Twin V Ranch in Parker County.

They all share a great respect for the ranching industry, and have faith in the future of the Hay Ranch. Lee and his wife, Jena, hope to pass that love and respect along to their two children, Zane and Sterling.

YO Ranch Mountain Home, Texas
Owner/operator: Charles Schreiner III

The YO Ranch, located 40 miles northwest of Kerrville, is a popular gathering place. Rancher Mike Levi says, "Charlie Schreiner has a flare for combining the old with the new to get people to come. He is able to capture the history of ranching, and introduce it to people not familiar with this way of life."

Entering the YO Ranch, a winding road takes visitors through the same type of Texas Hill Country terrain seen throughout the area. On the YO, however, this country begins to look more like the African veldt. You may see a longhorn cow mingling with zebras, ostriches, giraffes, blackbucks, or members of any one of forty-five different species.

Before you reach the ranch headquarters and chuck wagon, if you take the fork in the road to the lodge where hunters and other paying guests gather, you pass the YO Adventure camp on the right, and Charlie "Charley Three" Schreiner's huge house on the left. The house, with large rooms that serve as both a home and a showplace for Schreiner's collections, covers 4,000 square feet. The furnishings are Oriental, Victorian and Western.

Charlie's large gun collection is housed in one room. Among the guns are those that once belonged to Black Jack Ketchum and other outlaws and lawmen of the Old West.

Charlie Three's enterprise is not surprising for a man bearing the Schreiner name. His grandfather, Captain Charles Schreiner, was one of the state's most outstanding men in his day.

In 1852, the then-14-year-old Charles Schreiner came to Texas from his native Alsace-Lorraine, France, with his parents. He enlisted in the Texas Rangers at the age of 16, and began ranching in Kerr County shortly after his two-year enlistment ended. In time he developed an empire, amassing more than half a million acres of land.

During the Civil War, Captain Schreiner enlisted in the Confederate army. Upon returning home to his wife and infant son at the end of the war, he found his Hill Country home in bad financial condition. To revive his fortunes, he added sheep to his operation and became a partner in a store in Kerrville. It was also at this time that Schreiner started a bank, which later became a chartered national bank. The institution had its humble beginnings when several cattlemen from the area gave Schreiner some of their cash to hold for safekeeping. He hid it, along with his own money, under a loose board in the store.

Texas ranchers had begun trailing their herds to the railheads in Kansas, and Schreiner joined them in the cattle business. He started trailing cattle to Kansas, and

diversified to an even greater extent by founding a cooperative wool and mohair market. He encouraged stockmen to raise more sheep, and in time the area became a leading wool and mohair center.

As time went on, Schreiner placed his five sons in his business, with each son in the position where he showed the most promise. All the while, he continued to add land to his growing fortune. When he eventually divided his property among his children, Walter R. Schreiner, Charley III's father, inherited what is now the YO Ranch.

The ranch was given its name after Captain Schreiner purchased the Taylor-Clements Ranch, the 16,000 head of YO-branded cattle on it, and the brand itself, in 1880.

Today, Charlie Three Schreiner and his four sons operate the ranch. It is famous not only for one of the largest herds of Texas longhorns in the country, but also for its native wildlife and exotic imported game.

Trans Pecos

Kokernot O6 Ranch Fort Davis, Texas
Owner: Mary Ann Kokernot Lacy & Lacy Family; Operator: Chris Lacy

The Kokernot O6 Ranch has been operated continuously by the Kokernot family for more than a century. The O6 brand was acquired around 1837 by David L. Kokernot, who established a mercantile business and a large ranch in Gonzales County. Kokernot, a scout for Sam Houston during the battle of San Jacinto, was also instrumental in organizing the first Texas navy. His sons, Lee and John, followed him into ranching, buying land in 1883 in the Davis Mountains in far west Texas—land that Lee's son, Herbert Lee, would take over in 1897. Herbert Lee Kokernot, in partnership with his uncle, jumped horses, cowboys, and a herd of cattle off the train at Murphyville, which is present-day Alpine. The cattle grazed in the open range of the vast Alpine valley.

A few years later, they moved to Lubbock and ranched at what is now the site of Texas Tech University. Selling his holdings there and returning to the strong grama grass of the Davis Mountains, Herbert Kokernot repurchased the land in 1912 and established the O6 Ranch, which eventually extended through Brewster, Pecos, and Jeff Davis counties. Running top quality Hereford cattle, he was quite successful as a rancher in the highland country. He became president of the Texas and Southwestern Cattle Raisers Association, the Texas Livestock Marketing Association, and the National Finance Credit Corporation of Texas, and founded the First National Bank of Alpine. Herbert also helped found Bloys Cowboy Camp Meeting and Paisano Baptist Encampment in the Davis Mountains.

Herbert's son, Herbert Kokernot Jr., became a partner and, later, owner of the ranch. He was a director of cattlemen's associations, ranch finance associations, livestock marketing, banking, and baseball. Herber Kokernot Jr. loved baseball and, in 1946, started the Alpine Cowboys, a winning semi-pro team that went to the national finals nine times. One year, he had fourteen "All-Southwestern Conference" players on his team. "Mr. Herbert," as he was fondly called, built the famous Kokernot Field

in Alpine for the Cowboys to play in, and in 1952, the National Baseball Congress named him America's Number 1 sponsor of semi-pro baseball for the decade.

Herbert Kokernot Jr. served as County Commissioner of Jeff Davis County for sixty-five years, longer than any other elected official in Texas. He was a director of the First National Bank of San Antonio and the First National Bank at Alpine for sixty years, and was chairman of the board for an extensive period. He was on the Texas A&M University Board of Directors for twelve years, a director of both the National Credit Finance and Texas Livestock Marketing associations, and in 1976 was made an honorary vice-president of the Texas and Southwestern Cattle Raisers Association. H.L. Kokernot Jr. and H.L. Kokernot Sr. were inducted into the Texas Heritage Hall of Honor in 1996 for their significant contributions to the ranching heritage of Texas.

Representing six generations in the ranching business, Herbert Kokernot Jr.'s grandson, Chris Lacy, is now managing the O6 Ranch for his mother, Mary Ann Kokernot Lacy, and his sisters, Elizabeth Winn, Ann Brown, and Golda Brown. Chris served as County Commissioner of Jeff Davis County for twelve years and is currently serving as a director of the TSCRA, the Texas Livestock Marketing Association, and the Texas Hereford Association, and is president of the Highland Hereford Breeders Association.

Chris Lacy has been dedicated to improving the ranch and the quality of beef it produces (many O6 calves are selected for the Certified Hereford Beef program), while still working cattle in the traditional way. Because of the vast, mountainous terrain of the O6, it takes sixteen cowboys and a remuda of over one hundred horses for the roundup twice a year. When the crew goes into the mountains, they do not come out until roundup is over, camping out in teepee tents and eating off the chuckwagon for two to three weeks.

Chris and his wife, Diane, home-schooled their two children, Kristin and Lance, so they could grow up working on the ranch and not miss roundups. Lance represents the seventh generation in the family ranching business. His dream is to continue the tradition of running a quality cow-calf operation—working cattle with a good crew of men, a chuckwagon, a large remuda of registered quarter horses—and running the O6 brand.

Eppenauer Ranch Toyah, Texas
Owner/operator: Edwin Eppenauer & mother, Elizabeth Martin Fowlkes; Partner: Charley Stanford

S & E Ranches is a partnership between Charles Stanford of Verhalen, Texas, and Edwin Eppenaur of Fort Davis, Texas. They have ranching operations in Reeves, Jeff Davis and Culberson counties, consisting of more than 200 sections of land. Their business includes a cow-calf operation, stocker cattle, pasturing cattle for others, and raising good cowhorses.

Although the Stanford and Eppenaur partnership was officially established after 1990, it evolved from a 30-year friendship, and the family histories that started it date to nearly a hundred years ago.

Edwin's maternal grandfather, J. M. Fowlkes, started his ranching operation in the late 1800s, when the Fowlkes homesteaded in Jeff Davis County. At the end of World War I, A. R. Eppenaur, Edwin's paternal grandfather, got off a train in Fort

Worth with $14 in his pocket. From this beginning, "Mr. Epp," as he was known, eventually put together one of the best ranching operations in the state of Texas.

The partnership's Brangus herd totaled about 1,500 cows and bulls, and from 1,500 to 2,000 steers, the numbers depending on the amount of rainfall in the area. Mr. Epp had ranching operations in Mexico, as well, and sold many F-1 Brangus replacement heifers and herd bulls to ranchers in Mexico and the U.S.

During this time, he also started a successful horse operation, developing both cutting and running horses. One of his many accomplishments was breeding Caesar's Pistol, who won many cutting championships in the 1950s and early 1960s.

From his early years, Mr. Epp's grandson, Edwin, worked for both Mr. Epp and Charles Stanford on the Collier Ranches. He learned the ranching business, raising cattle, goats and horses. He later managed Mr. Epp's outfit, specializing in horses—supervising those that went to the racetrack and acting as head trainer, while continuing to develop and breed good working ranch horses.

Edwin has successfully kept this brand of excellence in both his cattle and horses. He and his wife, Elaine, have three children, two boys and a daughter, who are involved in the ranching operation today.

The Collier Ranch, in southern Reeves County in west Texas, was established in the early 1900s by H. T. Collier Sr., a west Texas pioneer. Collier also got off a train in Texas, in 1883. As a young boy seeking adventure in ranching, he accumulated his land by homesteading sections of land.

During the time Collier and his family were homesteading and improving the land, a State Land Award was issued by the state of Texas, guaranteeing permanent ownership. It was at this time that the "Buzzard on the Rail" brand was established for the three west Texas ranches Collier came to own, as well as the Hoban family ranch, the Screw Bean Ranch in eastern Culbertson County, and the Angeles Ranch in northern Reeves County.

One hundred and ten years after H. T. Collier Sr. landed in Pecos, the fifth-generation native Texans of the Collier family are still operating their ranching business under the Buzzard on the Rail brand.

Charles Stanford married Drue Collier in 1964, and became ranch manager for her father, Howard T. Collier Jr., who has continued to build upon his father's cattle ranching foundation. Charles and Drue have raised three sons and a daughter on the ranch.

When Charles joined the Collier Ranch business, he brought the love and knowledge of horses he had learned as a young boy from his uncle, G. W. Stanford, and from R. L. "Sonny" Chance Jr. He'd had the opportunity to ride and show many great cowhorses for Sonny, and had won the state cutting championship in Halletsville, Texas, and placed second at the Nationals in 1962.

As Charles learned the ranching business in west Texas, he applied his knowledge of horses to the everyday working of cattle on the open range, always trying to improve the ranch's working cowhorses.

Today, S & E Ranches brand SE on the cattle, and a walking cane on their horses.

Charles and Edwin are proud not only of the progress that has been made in the improvement of their cattle and horse operations, but also of the fine young cowboys and cowgirls they have raised, and who carry on their ranching heritage.

WEST TEXAS ROLLING PLAINS

6666 Ranch Guthrie, Texas
Owner: Mrs. Anne B. Windfohr Marion; Managers: J. J. & Mike Gibson

6666

The Four Sixes Ranch, known as the "Sixes," has had a long and illustrious history that initially began with Samuel "Burk" Burnett. He was born in Bates County, Missouri, on January 1, 1849. His father was a farmer there until the family home was destroyed during the Jayhawker raids in 1858. The family then moved south to Denton County, Texas, and became cattle ranchers on the open range.

By 1873, he had driven 1,100 steers to market in Wichita, Kansas, and the following year he purchased an additional 1,300 head from South Texas and drove them to the Little Wichita River.

Development of the West brought with it the end of the open range area, and in order for a man to stay in the cattle business he had to own his own land. So Burnett began buying land at 25 cents an acre. He established his headquarters where the town of Wichita Falls would later stand.

In the early 1880s, drought conditions caused Burnett to seek grazing land elsewhere. He and fellow ranchers convinced the Comanche and Kiowa tribes to lease them land on their reservation in Oklahoma. Burnett now had the land he needed to expand his herd. While leasing the Indian land, Burnett forged a lasting friendship with the last great Comanche chief, Quanah Parker, a relationship that benefited both men. Through his own cattle operations, Parker himself became a millionaire.

An ardent supporter of Indian rights, Burnett remained a loyal friend to the tribes. As a sign of respect, the Comanches gave him a name in their own language, Mas-Sa-Suta, meaning "Big Boss."

In 1900, the U.S. government ordered the ranches to vacate the Indian leases so the land could be opened to homesteaders. But by this time Burnett's land holdings had increased and so had his cattle herd. Burnett had purchased land near Borger in the Texas Panhandle, and in King County near Guthrie. He continued expanding his holdings until his death in 1922.

Burk Burnett's son, Tom, carried on in his father's footsteps. He had learned the cattle business by starting out as a ranch hand, then becoming a wagon boss, and later joining his father in management. He was a great judge of good horses as well as cattle, and was highly respected among cowmen and cowboys. Increasing his father's holdings, Tom acquired the Triangles Ranch near the towns of Iowa Park and Paducah, Texas.

Tom had only one child, a daughter known to all as "Miss Anne." She also became a good judge of livestock. One of the founders of the American Quarter Horse Association, she was also a founder of the Quarter Horse Hall of Fame and an avid supporter of the Texas and Southwestern Cattle Raisers Association. She also had only one child, a daughter named Anne Burnett Windfohr, known as "Little Anne."

Today, Little Anne, Mrs. Anne Marion, runs the Four Sixes, a job she has taken quite seriously since her mother's death in 1980. While Little Anne's civic and cultural activities extend throughout Texas and the United States, her deepest commitment is to the continuing success of the ranch, and the production of good cattle

and quarter horses.

The Four Sixes remains a vital part of the history of the Texas cattle industry and the development of the quarter horse.

Beggs Ranch Girard & Post, Texas
Manager: George Beggs IV

The Beggs family's 100-plus years in ranching and livestock began in 1876, when George Beggs Sr. settled in what is now Handley, Texas. He leased land in that area and began dealing in cattle and horses. In 1893, Beggs moved his family and business to Fort Worth, and opened a livestock commission and loan business in the Stockyards District.

Beggs's sons, W. D. and John Erin, were ranchers operating as Beggs Brothers. They ranched on leased land at Bluff Dale, Texas, and later moved their operation to Wellington. The senior Beggs's youngest son, George Jr., opened a real estate and insurance office in Fort Worth.

In 1923, the three brothers joined forces to operate the E. D. Farmer Ranch in Parker County, located between Weatherford and Fort Worth. In 1926, they purchased the Pete Scoggins Ranch in Garza and Kent counties. In 1932, the George Beggs Trust purchased the Pursley and Foley Ranches in Dickens, Kent, King, and Stonewall counties. In 1936, the Trust purchased the Farmer Ranch, and these ranches were all operated by Beggs Brothers.

In 1941, Ed Farmer Beggs and George Beggs III started a cattle operation on part of the family's holdings in Dickens and King counties. Beggs Brothers branded their cattle with a lazy 3 on the left hip. The partnership formed by Ed and George wanted to use a brand not previously registered, and their father, having long had ties with Great Britain, suggested the English Pound mark (£).

This new brand met all the requirements, and was registered as the brand for the partnership and later for the Beggs Cattle Company.

In the late 1940s, the Beggs Brothers partnership was dissolved as the original three brothers retired. The third generation, George Beggs III, took over the day-to-day operations, and in 1950 incorporated all the ranches as Beggs Cattle Company.

Today, the Beggs Cattle Company raises commercial cattle and quarter horses. Ed Farmer Beggs II operates the ranches in Parker County, while his brother, George Beggs IV, manages ranches located in King, Kent, Stonewall, Dickens, and Garza counties.

Moorhouse Ranch Benjamin, Texas
Owner: Moorhouse Corporation & Family; Manager: Tom Moorhouse

The Moorhouse Ranch, located in the Rolling Plains and Cross Timbers sections of Texas, near the town of Benjamin, was established in the early 1900s by the late J.C. "Togo" Moorhouse and his brother, Frank. It was originally a cow-and-calf operation.

The Moorhouse family had established root in west Texas when Togo was two years old, moving there from Kaufman County, east of Dallas, in 1907. When Togo began ranching, times had changed drastically from the days of the open range. A man could no longer move his herd out to public lands and establish an empire. If the man hadn't inherited large tracts of land, oil wells, or other resources, it was almost impossible to accumulate land.

Togo started in the cattle business as a young man. His father died when Moorhouse was 15 years old, and Togo worked on a neighboring ranch on weekends and during the summer. Togo's son, Bob Moorhouse, who now manages the Pitchfork Ranch in addition to his duties on his own land, said, "I've thought about it a lot, and don't know how Daddy did it. Most people who have ranches got them handed to them. Daddy worked for wages on the McFadden Ranch, and it wasn't very much."

Togo grew up on his father's ranch, located 16 miles west of Benjamin in King County. This ranch is now part of today's Moorhouse Ranch. His mother never lived on the ranch, but instead lived in Benjamin so her children could attend school there.

His father sold the ranch by the time he died in 1920, having been forced to sell because of the drought of 1918-19. The drought ruined a lot of other farmers and ranchers in the area, as well.

After graduation from high school, Togo attended college for one year at John Tarleton College in Stephenville. In 1935, Moorhouse leased his father's old ranch, later purchasing it. He was quoted as saying, "I had always wanted to own the land that had belonged to my dad, ever since my oldest brother, Frank, moved his family away from it in 1920."

Until he passed away on December 16, 1995, Togo remained active in the day-to-day operations of the ranch, sharing responsibilities with his sons, Ed, John, Bob, and Tom, who bought into the business when it was incorporated in 1979.

Today, the Moorhouses operate 96,000 acres, 10,000 of which they own. They lease the remaining land, in Knox, Stonewall, King, Hall, Borden and Haskell counties, under leases dating back to the early days of World War II.

In addition to their cow-and-calf operation, using commercial Herefords, the Moorhouses run yearlings on wheat during the winter. The cattle wear the AC brand on their left hip—not a fancy brand, but one chosen because it is simple and will not blot.

It has been said of the Moorhouse Ranch's owners that working together as a family is all they know, which is true. But they will be the first to tell you that without the help of faithful and dependable employees, it could not be done.

Pitchfork Ranch Guthrie, Texas
Owner: The Williams Family; Manager: Bob Moorhouse

From all accounts, the Pitchfork Land & Cattle Company would not exist were it not for the life-long friendship of two men—Daniel Baldwin Gardner and Eugene Flewellyn Williams. Both men were born in the South in 1851 to plantation-owning families, and as they were distant relatives, they spent a great deal of time together as they grew up.

Following the Civil War, Gardner continued to work his family farm, then attended bookkeeping school in New York and returned to Mississippi to pursue his new vocation. In 1871, tales of abundant opportunity in Texas lured him to Fort Griffin, located near present-day Albany.

With Fort Griffin as a base, Gardner worked for various ranchers in the area, participated in a cattle drive along the Goodnight-Loving Trail, and worked as a sur-

242

veyor for the Texas & Pacific Railway. He gained valuable knowledge of the terrain of west Texas during this time.

In January of 1875, Gardner was employed by Colonel J. S. Godwin and his son, D. W. Godwin. He later became a minor partner in several ventures with the Godwins. In February of 1877, Gardner was one of 17 men who drafted plans for what was to become one of the most powerful and prestigious livestock organizations in the world, and which is known today as the Texas and Southwestern Cattle Raisers Association.

In the summer of 1881, Gardner learned that Irish-born Jerry Savage, who had been running cattle on the South Wichita River under a Pitchfork brand, was interested in selling land, equipment and stock. Lacking capital, Gardner turned to Colonel Godwin, who agreed to finance the venture. But before they received the cattle, Godwin changed his mind and told Gardner he would have to seek financing elsewhere. It was then that Gardner thought of his boyhood friend, Eugene Williams.

By 1881, Williams had become vice president of Hamilton & Brown Shoe Company in St. Louis. In December of that year, he journeyed to Fort Worth and after a dinner meeting announced he was ready to close the deal. Godwin was flabbergasted. No self-respecting cattleman bought cattle or land without first inspecting the property. Williams said he was investing in the venture solely because he had the highest regard for his friend, Dan Gardner. Williams wrote a check and took the night train back to St. Louis.

The property Gardner and Williams purchased included 2,600 longhorn cattle, 70 horses, wagons, and camp equipment, but little land. They did obtain rights to the ranch that bordered the South Wichita River in eastern Dickens and western King counties.

Wishing to expand but lacking capital, the two men found a willing investor, A. P. Bush Jr., who owned a ranch near Snyder, Texas. On December 13, 1883, the partners merged with Samuel Lazarus, who had acquired title to some 52,000 acres in King and Dickens counties.

In the meantime, Williams persuaded two officers of his company to invest in the cattle operation. A. D. Brown and W. H. Carroll met with the other four investors in St. Louis on December 29, 1893, to adopt the by-laws and elect officers of the newly formed corporation known as the Pitchfork Land & Cattle Company. Brown was elected president; Williams became vice president. Bush Jr. became secretary-treasurer, and Gardner was chosen to be general manager, a position he held until his death in June of 1928.

Only five managers have filled the vacancy left by Gardner. These included O. A. "Red Mud" Lambert, Dee Burns, and Jim Humphreys. Today, the ranch is managed by Bob Moorhouse, son of Togo Moorhouse, another prominent west Texas rancher. The Pitchfork Land & Cattle Company stretches some 165,000 acres, with an additional 3,000 acres in Benjamin, Texas, and 3,300 acres in the Flint Hills of Kansas. The descendants of Eugene Williams continue to operate the 113-year-old ranch in the same conservative manner as did the ranch's founders.

PANHANDLE HIGH PLAINS

Harrell Cattle Company Claude, Texas
Owner/operator: Ed Harrell

Located in the Texas Panhandle, the Harrell Ranch had its beginnings in 1890, when Edward Dow Harrell filed on a section of land near the town of Happy, Texas.

Possessed with a pioneering spirit—the result, no doubt, of having a father who in 1832 was the first Anglo child born west of the Chattahoochee River in Georgia— Ed and his brother, Charlie, ventured west in 1890 in a covered wagon. They found the Texas Panhandle unusually abundant that year, for the rains had filled all the playa lakes and the antelope were never out of sight. Ed and Charlie decided to stay, and did not get to Colorado for another twenty years.

Charlie became the first dentist in Amarillo. Raising horses was Ed's original goal; however, horses got so cheap that the last of his stock was traded for molasses.

The next year, the homestead laws were changed to allow an individual to file on four sections of land. Ed immediately exchanged his original propery for four sections west of the town of Canyon. He leased more land and went into the cattle business with imported Hereford bulls.

In 1898, Ed married Samuella Barks—he was thirty years old, and she was fifteen. There was a dearth of marriageable girls in the Panhandle at that time, and there was much speculation among the bachelors as to who would win Samuella's hand. Ed proposed, saying that someone would marry her and it might as well be him. She accepted.

In 1900, Newton Samuel Harrell, the couple's only child, was born. In 1917, Ed and Newton bought a ranch in Armstrong County: the JJ division of the historic JA Ranch. The dominant feature of the property was the scenic Palo Duro Canyon, site of the Mackensie Battleground where the last battle between the U.S. Cavalry and the Comanches was fought. Also located there was Charlie Goodnight's first permanent white settlement in the Panhandle.

Ed liked to hunt coyotes and quail with bird dogs and greyhounds. He and Samuella moved to Canyon, Texas, where Ed died in 1932.

In 1924, Newton Harrell married his childhood sweetheart, Helen Virginia Croson, an accomplished musician. In 1947, he increased his land holdings when he bought a second ranch in Randall County, now operated by his daughter, Shirley, and her husband, William E. Howse.

Newton continued the ranching operations until his retirement in 1984. He died in 1991.

Today, Newton's son, Edward Charles Harrell, and his wife, the former Carol Ray Glynn, live on the Armstrong County ranch where they have resided since they married in 1957. Here, they continue the ranching operations with their three children, Lettie Helen Harrell, Newton Henry Harrell, and Samuel Edward Harrell.

Ed Harrell works with numerous agencies to ensure quality wildlife habitat in Texas. In 1996, he and Carol were recognized by the Texas Parks and Wildlife Department as Lone Star Land Stewards of Texas Natural Resources.

JA Ranch Clarendon, Texas
Owners: Monte Ritchie & Cornelia Bivins; Managing Partner: Jay O'Brien

The story of the JA is the story of a family: the land and the family are intertwined. This was heritage for Cornelia Wadsworth, who was born in 1837 in Geneseo, New York, on a farm her ancestors had purchased from the Seneca Indians. Her tradition was one of keeping land as a birthright.

In 1857, she married Montgomery Ritchie of Boston; they had two sons before he died in the Civil War. Cornelia took her two sons to Europe to be educated, and there met and married an Irish landowner named John Adair. Adair had made his fortune buying up estates that were bankrupt after the Irish potato famine, evicting the peasants and starting with more productive tenants. After the estates became profitable, he would resell them for a profit. He was not very popular, as he was heartless in the way he evicted widows, the aged, and children.

Adair moved to New York and became a money lender. In 1874, the Adairs went on a Colorado buffalo hunt guided by Charles Goodnight. Goodnight was already famous as a cattleman and for establishing the Goodnight-Loving Trail. Around the campfire at night, Goodnight told them of the Palo Duro Canyon in Texas. He portrayed a large ranch where the cattle could roam as the buffalo had and could thrive, grazing on the surrounding plains land in the summertime and wintering in the shelter of the canyons.

Returning in 1876, the Adairs rode with Mr. and Mrs. Goodnight from Pueblo, Colorado to the Palo Duro Canyon. Finding it as Mr. Goodnight had represented, they formed a partnership with Goodnight that lasted ten years. Charles Goodnight provided the expertise and the Adairs provided the money to purchase the land to control the grazing of almost one million acres on both sides of the Palo Duro Canyon. John Adair's initials formed the brand.

John Adair died in 1885, prior to the expiration of the original term of the contract with Charles Goodnight. Mrs. Adair, proving her commitment to the land, took an intense personal interest in the growth and operation of the ranch. She insisted on a remuda of all bay horses, and imported purebred Hereford cattle from England. Once, when she found a portion of the ranch stocked with spotted San Simone cows, she was so outraged that she discharged the foreman who had been responsible for this aesthetic affront.

Mrs. Adair's grandson, Montie Ritchie, had been told by his father that the happiest days of his life had been spent working as a youth at the JA. His stories so impressed young Montie that, in 1931, having completed an education in England, he came to the ranch to see these wonders for himself.

Mrs. Adair had died in 1921 in England, and Montie's father, Jack Ritchie, had died three years later. Estate taxes, depression, and drought had put a severe strain on the ranch's finances, and management (delegated to the executors) was trying to sell the ranch. After two years riding with the wagon on the ranch, Montie returned to England to gather up proxies and gain control of the ranch. He succeeded and, over the next decade, returned the JA to a sound financial base through prudent fiscal management and hard work. He, like his grandmother, took particular pride in his horses and Hereford cattle.

Over time, Montie purchased the rest of his family's interest in the ranch. He also expanded the JA brand into Colorado, purchasing a ranch near Castlerock. Unique among large Texas ranches, the JA has succeeded without any benefit from oil and gas income.

In 1976, Montie said, "No [person] or organization succeeds alone in this world; so, the fact that we are able this year to celebrate our 100th birthday is due in large part to the wonderful, loyal men and women, leaders who worked for and with us: men of imagination, men of skill, men of courage, men who braved the elements day or night, men who took pride in their crafts, loved their horses and understood their cattle and were eager to enhance the reputation of the JA and proud to be a part."

Today, Montie is retired. His daughter, Cornelia (Ninia) Bivins is president of the JA. Her school-age son, Andrew, plans to assume management when he completes his education. For the present, the JA is managed in a partnership with Jay O'Brien of Amarillo. O'Brien, a ranch owner and manager outside of the JA as well, is proud to be working with Ninia, Andrew, and a great cowboy crew. They are updating parts of the ranch, improving the cow herd, and broadening the yearling operation to be current in today's market. The goal is to be profitable and remain one of the top-reputation ranches in the United States.

Hopefully, the JA will remain a story of a ranch intertwined with one family.

LX Ranch Amarillo, Texas
Owner/operator: Miles Childers

The large ranches established in the Texas Panhandle in the early days were known more by their brands than by their owners' names. So it was with the LX, one of the oldest ranches in the region.

The LX Ranch was established in Potter County in 1877 by two Boston investors, W. H. "Deacon" Bates and David T. Beals, who were searching for a location where they could put excess cattle from their overcrowded Colorado operation. They established their headquarters in Ranch Creek, just north of the Canadian River. By 1878, the dozen or so structures around the headquarters represented the first permanent buildings constructed in Potter County.

In August of the following year, a post office opened at the site, which was known by then as Wheeler, Texas—not to be confused with the present-day Wheeler, located in Wheeler County in the eastern Panhandle.

This township was not incorporated until 1906, when it became thickly populated by five families who were living in dugouts within a two-mile radius. During those first years, several brands, including the LX, were used, but after 1883 the LX brand became the ranch's official designation.

The first seven years of the operation were quite successful, with two or three herds of cattle sent up the trail annually. Between 1877 and 1883, the owners purchased additional property until the ranch covered more than 180,000 acres, not counting the state land it utilized. The ranch stretched from Palo Duro Creek in Randall County to north of present-day Dumas in Moore County.

In 1884, Bates and Beals sold the ranch to the English-owned American Pastoral Company. By 1887, the ranch property totaled 320,000 acres. In 1900, its headquarters was moved to a site on Bonita Creek, south of the Canadian River, and early the following year, the post office at the original town of Wheeler was closed.

The American Pastoral Company sold portions of the ranch to Joe T. Sneed, R. B. Masterson, and Lee Bivins in 1910. Bivins, who later purchased additional land south of the Canadian River, received use of the LX brand.

Bivins had arrived in the Panhandle from Sherman, Texas, in 1882, and soon became a prominent businessman, rancher, and civic leader. The Bivins property—more than a million acres of owned and leased land—at times ran as many as 60,000 head of cattle, which carried both the LX and X Bar brands.

Bivins passed away in 1929, having become one of the largest landowners and cattle operators west of the Mississippi. His sons, Miles and Julian, then began operating the Bivins properties. Upon the death of Miles in 1949, his daughter, Betty Bivins Childers, inherited the LX brand, along with the ranch headquarters and property south of the Canadian River. Since 1973, her son, Miles, has operated the ranch. Mrs. Childers died in 1982.

The Texas Panhandle can be cruel or forgiving. Cold, harsh winters; hot, dry summers; rain, flash floods, drought, and ever-changing conditions in the cattle market test the mettle of those who challenge it. The continued use of the ranch and the brand stands as a proud reminder of the historic ranching heritage of this area.

North-Central Texas Cross Timbers & Prairies

Lambshead Ranch Albany, Texas
Owners: Watt Matthews and the Matthews family

Lambshead may seem to be a strange name for a cattle ranch. But rather than being named for an animal, the ranch, located on the rolling plains in Throckmorton and Shackleford counties, is named for Lambshead Creek, a tributary that flows into the Clear Fork of the Brazos River.

The Lambshead Ranch is owned and operated by one man, Watkins Reynolds Matthews, better known as "Watt." The ninth and last son of John A. "Bud" Matthews and Sallie Reynolds Matthews, Watt was born February 1, 1899, making him older than many of the so-called "old" ranches in Texas. Watt never married, and except for the four years he spent at Princeton University, has spent his entire life at Lambshead.

Carved by Watt's pioneering parents from the wilderness on the banks of the Clear Fork, reminders of the past are everywhere on the ranch. There is the family cemetery where Watt's ancestors are buried, and several houses, including one known as the "Stone House," built before the Civil War and where Watt's mother lived as a child. On a long, sloping piece of ground stands a small, restored one-room schoolhouse.

Watt's mother and father were married on Christmas Day in 1876. Sallie Matthews is best remembered for her book, *Interwoven,* the story of the Matthews and Reynolds families and their struggle to tame the wilderness.

By 1883, four of Sallie's brothers had married Matthews girls. The combined fam-

ilies pushed back the Comanche frontier and held the open range along the Clear Fork.

Built in 1867, Fort Griffin was one of a line of fortifications stretching from Fort Sill in Oklahoma to Fort Concho near San Angelo—at that time, the edge of Anglo-American civilization. The forts were built to defend settlers from marauding bands of Comanche and Kiowa Indians. Watt's grandfather supplied beef to the army serving under Mackenzie during his campaign against and ultimate victory over the Comanche in Palo Duro Canyon in 1875.

The town of Albany grew along the flatlands below Fort Griffin. It boasted only a few permanent residents, but a thousand or more transients—buffalo hunters and cowboys following the Western Trail.

Today, the Lambshead Ranch is basically a cow-and-calf operation. A few hogs are raised and butchered on the ranch, and 40 or 50 sheep graze near the headquarters to keep the grass short, in case there should be a fire such as the one in 1988 that burned 1,800 acres of pasture.

A herd of longhorns shares the pasture with Hereford cattle. Buffalo roam the ranch at will. Hard to contain, almost impossible to domesticate, buffalo do not consider fences a problem.

Watt could have any room on the ranch he wants, but prefers his simple room in the ranch bunkhouse. Revenues from oil leases are generous, but the money derived from this valuable resource is not intermingled with ranch income.

Surrounded on four sides by large ranches operated by the trust departments of large banks, Watt Matthews has maintained ownership of his ranch, where he continues his ranching family's way of life.

R.A. Brown Ranch Throckmorton, Texas
Owner/operator: R.A. Brown

Established in 1895, the century-old Brown Ranch is made up of land from the Brown, Donnell, and Thomas ranches. The Brown part of the ranch was established in 1900 in south Throckmorton County by Robert H. Brown, operator of a livestock commission company in the Fort Worth Stockyards.

Brown's son, R. A. Brown Sr., married Valda Thomas, daughter of D. B. and Hettie Thomas. D. B. Thomas was recognized as one of the best cattle breeders and horsemen in a wide area, as was R. A. Brown Sr., who helped organize and served as an officer and director of the American Quarter Horse Association (AQHA) until his death in 1965. He was named to the association's Hall of Fame in 1988. The senior Brown's son, R. A. (Rob) Brown Jr., served as the AQHA's president in 1995. Today, the third-generation west Texas rancher, his wife, Peggy Donnell Brown, and the couple's children operate the Brown and Thomas ranch lands, plus a portion of the fourth-generation Donnell Ranch located in Young and Stephens counties. The Donnell Ranch was established in 1876. Daughter Betsy and her husband, Jody Bellah, and son, Rob A. and his wife, Tally, are an integral part of the operation.

The Self family has worked side-by-side with the Browns for more than 60 years. Currently, George Self is ranch foreman and carries on in the tradition of his father, two uncles, and brother, who were all longtime Brown employees.

R. A. Brown Ranch operations now total some 110,000 acres in Texas and Colorado. Ranch headquarters is located near Throckmorton, Texas, where records

are maintained on 1,000 head of registered cows, 1,400 head of commercial cows, and 35 quarter horse broodmares. In addition, they purchase 5,000 head of stocker cattle annually, grow them out on grass and wheat, and feed them at the Tascosa Feedlot near Amarillo.

Along with a successful quarter horse operation, the ranch also raises registered Simmental, Simbrah, Senepol, Angus, Red Angus, and composite-bred Hotlander cattle. Traditionally, the Brown Ranch was a Hereford operation, with both registered and commercial herds. In the mid-1960s, Rob and his father began crossbreeding Hereford cattle with Brown Swiss in order to increase the milking ability of their cows. The Swiss-Hereford cross worked well, but did not bring top market prices.

In the late 1960s, Brown found what he wanted in the Simmental breed. He was so taken with these cattle that he became president of the American Simmental Association (ASA), and did much to promote the breed.

Through the years, Brown has continued to produce cattle as efficiently as possible—not only meeting consumer demand for lean, high-quality beef, but also keeping the rancher in mind. Brown knows that not all areas of the country are equal when it comes to raising cattle. There are wide variations in temperature, rainfall, and quality of grass. This has prompted him to continue in his crossbreeding efforts.

In the Southern states heat-tolerant cattle are necessary. In order to achieve this trait, Brown bred Brahman bulls to Simmental cows. These cattle proved so well suited to hot weather that a new breed, called Simbrah, was formed. Brown became chairman of the ASA's Simbrah committee. Never before had a breed association tried to keep records on two breeds, but the ASA now registers both Simmental and Simbrah.

Not locked in to any one breed, and a seed-stock producer, Brown continues to seek out quality traits that will ensure greater profits for his customers.

The cattle industry has seen many changes over the years—from open range to fenced ranches, from the days of driving grass-fat longhorns up the trail to the trucking of grain-fed cattle to market. Regardless of the changes, those in the cattle business appreciate men like Brown, who continue to open new and better trails into the future.

Saunders Twin V Ranch Weatherford, Texas
Owner: Tom B. Saunders IV; Manager: Thomas B. Saunders V

Thomas Bailey Saunders I came to Texas in 1850 from Mississippi, driving a small herd of cattle and carrying his family in an ox-drawn wagon. He settles in Gonzales County and established a ranch where the town of Rancho, Texas, now stands.

Finding better grazing elsewhere, Saunders moved his herd to Goliad County in 1860, and established the county's first Anglo ranch on Lost Creek.

During the Civil War, Saunders supplied beef to the Confederate Army, and, with his sons trailed cattle to New Orleans. He also sent his son W.D.H. Saunders with a herd to New Orleans in 1863, but the 17-year-old learned that New Orleans was occupied by Yankee soldiers. He changed his plans, trailing the cattle to the banks of the mile-wide Mississippi River, and swam the cattle across. He sold part of the herd in Woodville, Mississippi, and the remainder in Mobile, Alabama. His younger brother, George W. Saunders, a noted trail driver, was one of the founders of Union Stockyards in San Antonio, Texas.

Sixty years later, W.D.H. Saunders's son, Thomas Bailey Saunders II, was the first to truck cattle across the Mississippi. Saunders II moved to Fort Worth, Texas, from San Antonio, and became the first cattle dealer in the Fort Worth Stockyards, where the Saunders family operated for 75 years.

Saunders II was reputed to have been the largest cattle dealer in the United States from 1910 through the 1920s. He operated ranches in Borden, Archer, Tarrant and Parker Counties, and also had extensive ranching operations in Oklahoma and Kansas. His son, Thomas B. Saunders III, carried on his father's ranching operation and commission company.

In 1930, Saunders III also started a cattle clearinghouse for traders, order buyers and commission companies in the Fort Worth Stockyards, and also at the Port City Stockyards in Houston. During World War II, T.B. Saunders and Co. served as a major link between the cattle producers of Texas, the Corn Belt feeders, and the grazers of the Northeastern and western U.S. He was also extensively involved in ranching operations in Parker, Tarrant, Johnson, Hood and Mason counties in Texas, and had ranches in Oklahoma and Kansas.

Saunders III continued raising good cattle and good horses. He was one of the founders of the National Cutting Horse Association (NCHA), and was its president in 1949. For his contributions to the cutting-horse industry, he was inducted into the National Cutting Hall of Fame. In 1981, the city of Fort Worth dedicated Saunders Park to commemorate the Saunders family's contributions to the cattle industry.

After completing his education at Oklahoma State University in 1957, Thomas Saunders IV came home to manage the family ranches in Parker County, where they ran both a cow-and-calf and a yearling operation. In 1969, the yearling operation was extended, and Saunders and his brother-in-law, Jim Calhoun, became partners, operating 35,000 acres of lease country in Parker, Tarrant, Johnson and Mason counties.

Calhoun was owner and trainer of King's Pistol, a quarter horse he rode to the 1957 World Championship. He also served as president of the NCHA in 1972, and was later inducted into the National Cutting Horse Hall of Fame.

Thomas Saunders V carries on the family tradition by running his own cow-and-calf and yearling operation in Parker and Hood counties, as well as breaking more than a hundred horses a year. He works with brother-in-law Perry Williams, who also has a cow herd and trains horses. The two men produce ranch horses, and Thomas still finds time to provide cattle for various cutting horse competitions.

Thomas Saunders V is the sixth generation of the Saunders family to cowboy in Texas.

Veale Ranch Breckenridge, Texas
Owner/operator: Ward Veale and mother, Margie Veale

When Albert S. Veale married Ida Ward in 1892, two pioneering families were united. Albert was handsome, outgoing, and, as were his brothers and sisters, musically inclined. He ranched in Stephens County, and during the great drought of the late 1800s, drove his entire herd and that of his father-in-law to the Oklahoma Territory. He kept the cattle there until the drought broke.

Not wanting to leave his cattle unattended while in the Oklahoma Territory, Veale sent riders back to Breckenridge every six months or so to report on range conditions and to see if it had rained. He enlisted the help of local Indian herdsmen, and one of

them wove a saddle blanket for him. His family still has that well-worn blanket.

Monroe B. Veale was the only child of Albert and Ida to survive to adulthood, but he lived to be almost ninety years of age. He married Suda Stringer of Breckenridge in 1916. The marriage was not blessed with children, but when one of Suda's sisters died, the couple adopted two of her small children—Harris "Hack" M. Veale, and his sister, Mozelle.

When Monroe's father died in 1918, Monroe was 23 years old and ready to manage the ranches he had been working with his father for a number of years. This was not to be, however, because Ida felt he was too young. Instead, she leased the land.

As was often the case, the land was overgrazed during this time. When the lease was up, Ida told Monroe he could take charge. He remained in charge until the day he died in 1984.

Harris Veale lived in Breckenridge and was in the ranching business all his life, with the exception of four years of military service. He married Margie Ann Lee on October 5, 1946. As luck would have it, the wedding date was in conflict with a rodeo that had been rained out the previous weekend. As chairman of the event, Hack could not leave, so the wedding ceremony took place between the afternoon and evening performances. The couple could not leave on their honeymoon until 3 a.m., after all the cowboys had been paid and the arena closed for the season.

Ward Graves Veale, Margie and Hack's only son, was born about the time of the Korean War. When Hack suffered a heart attack in 1974, Ward had completed his degree at the University of Texas and was working in Houston. He returned to the ranch, however, and helped his father and grandfather until their deaths in 1984.

Today, Ward Veale, the fifth generation of the Veale family, is at the helm of a ranching empire that operates on more than 78,000 acres in five counties.

The Veale Ranch is like many others, in that it relies on diversity for its profitability. In addition to the traditional Hereford program, the ranch also uses extensive crossbreeding and alternative forms of agriculture. Herefords play a major role in every phase of the ranch's breeding programs.

Veale has implemented programs additional to the cattle that are both profitable and beneficial to the physical properties of the land. Mesquite control is, and always has been, a problem for Texas ranches. Veale uses Angora goats as a first line of defense against this moisture-stealing parasite. In addition to controlling the mesquite, the goats generate income through the sale of their wool.

Many things have changed since the day Ward Veale's ancestors began the ranch. By the same token, many things have remained the same.

Waggoner Ranch Vernon, Texas
Manager: Jimmy Lee Smith

Located 13 miles south of Vernon, Texas, in the Rolling Plains country, the W. T. Waggoner Ranch was begun by Dan Waggoner in 1849 in western Wise County.

As the land was cleared for settlement, Waggoner moved west, and in late 1870, he settled along Beaver Creek near Electra, Texas. Following the death of his father in 1903, W. T. "Tom" Waggoner continued operations on his own until 1923, when he formed what is known today as the W. T. Waggoner Estate. W. T. served as trustee, and his three children, Guy, Electra, and E. Paul Waggoner, comprised the board of directors.

The estate stretches over six counties and consists of approximately 520,000 acres. It is recognized as the largest ranch in Texas under one fence. Known as "The Ds" because of its distinctive three-backward-Ds-in-a-circle brand, its interests include cattle, horses, agriculture, and oil.

The estate's horses are bred for working ranch purposes, and many still carry the bloodline of the famous quarter horse, Poco Bueno.

The ranch takes care of its own. A well-loved and valued employee, Richard "Dick" Yeager, is buried on the ranch property. Dick accepted the position of assistant farm manager for the Waggoner Estate Ranch in 1964. He and his wife, Rosella, liked Vernon and decided it was where they wanted to bring up their children. Two-and-a-half years later, Yeager was promoted to the position of assistant farm and ranch manager. In 1975, he was named manager of the operation.

Yeager was devoted to ranching and the Texas cowboy, and was instrumental in organizing the first Texas Ranch Roundup, held in Wichita Falls. The Roundup is now the oldest working ranch cowboy rodeo. The 10th annual rodeo was dedicated to his memory, following his death on April 1, 1990.

Approximately 26,000 acres of the Waggoner Estate are devoted to farming, mostly crops that complement ranching. The ranching operation consists of 15 camps, or divisions, with from 20,000 to 30,000 acres in each camp.

A man in charge lives, along with his family, at each camp. Each man is responsible for the livestock, fences, and water on his division, and reports directly to the assistant ranch manager. At least twice a year, a wagon crew arrives to work the cattle at each camp. The camp crew and the wagon crew come together for the roundups, using a helicopter and cowboys on horseback to gather the cattle.

In spite of the modern touches added to the traditional jobs during roundup, the cowboys still find it expedient to rope the calves by the heel and drag them to the branding iron. The cattle are no longer branded with the famous reversed Three D brand, but the brand still remains the Waggoner family "coat of arms."

Electra Waggoner Biggs is a world-class sculptor. Probably her most-recognized work is the 15-foot-tall bronze statue of Will Rogers mounted on his horse, Soapsuds. There are two copies of this work, one located at the entrance to the Will Rogers Memorial Complex in Fort Worth, the other at the east entrance of Texas Tech University in Lubbock.

The cattle business brought the Waggoners wealth and fame, but oil cast them even further into the limelight when it was discovered on their land in 1902. There are a number of versions of what Tom Waggoner said when oil spewed from what he intended to be a water well, but it is generally agreed that he was sorely disappointed.

Today the ranch is owned by A. B. Wharton, Electra Waggoner Biggs, and family trusts. Co-directors include A. B. Wharton and Gene Willingham.

BIBLIOGRAPHY AND SUGGESTED READING

A Century of Cow Business, Mary Whatley Clarke, Evans Press, Fort Worth, Texas, 1976

A Historical Atlas of Texas, William C. Pool, Encino Press, Austin, Texas, 1973

A Vaquero of the Brush Country, J. Frank Dobie, Little Brown and Company, Boston, Massachusetts, 1929

Abraham Lincoln, The Prairie Years and The War Years, Carl Sandburg, Reader's Digest Illustrated Edition, The Reader's Digest Association, Pleasantville, New York and The Reader's Digest Association Ltd., Montreal, Canada, 1970

Cattle King of Texas, C.L. Douglas, State House Press, Austin, Texas, 1989

Cattle, Horses & Men, John H. (Jack) Culley, The University of Arizona Press, 1984

Charles Goodnight: Cowman and Plainsman, J. Evetts Haley, University of Oklahoma Press, Norman, 1949

Cowboy Culture: A Saga of Five Centuries, David Dary, University of Kansas Press, Lawrence, 1981

Cow People, J. Frank Dobie, Little Brown and Company, Boston Massachusetts, 1964

Horses I've Known, Will James, The World Publishing Company, Cleveland, Ohio, November 1945, second printing

If I Can Do It Horseback, John Hendrix, University of Texas Press, Austin, 1971, second printing

Long Days and Short Nights: A Century of Texas Ranching on the YO, Neal Barrett, Jr., YO Press, Mountain Home, Texas, 1980

"Making Good Horses," *The Quarter Horse Journal*, Jim Jennings, American Quarter Horse Association, Amarillo, Texas, July 1995

Pardner of the Wind, N. Howard (Jack) Thorp in collaboration with Neil M. Clark, The Caxton Printers, Ltd., Caldwell, Idaho, 1945

Ranching in South Texas: A Symposium, A Publication of the John E. Conner Museum, Texas A&M University, Kingsville, 1994

Shanghai Pierce, Chris Emmett, University of Oklahoma Press, Norman, 1953

Stephens County: Much to be Cherished, Taylor Publishing Co., Dallas, Texas, 1987

Stewards of a Vision, A History of King Ranch, Jay Nixon, King Ranch, Inc., 1986

"Texas Narratives," George P. Rawick, Vol. 5, Part 4 of *The American Slave: A Composite Autobiography*, Westport, Conn.: Greenwood Publishing Company, 1972

Texas Ranchmen, Dorothy Abbott McCoy, Eakin Press, Austin, Texas, 1981

The Cattle-Trailing Industry, Jimmy M. Skaggs, University of Kansas Press, Lawrence, 1973

The Chisholm Trail, Don Worcester, University of Nebraska Press, Lincoln, 1980

The Longhorns, J. Frank Dobie, Little Brown and Company, Boston, Massachusetts, 1941

The Pitchfork Land and Cattle Company: The First Century, David J. Murrah, Lubbock Prin Tech, Texas Tech University, 1983

The Ranchers, Ogden Tanner, ed., New York: Time-Life Books, 1977

The Slaughter Ranches & Their Makers, Mary Whatley Clarke, Jenkins Publishing Co., 1979

The Texans, David Nevin, ed., Time-Life Books, New York, 1975

The Texas Rangers: A Century of Frontier Defense, Walter Prescott Webb, University of Texas Press, Austin, 1995

The Trail Drivers of Texas, J. Marvin Hunter, ed., Cokesbury Press, Nashville, Tennessee, 1925

The Trampling Herd, Paul I. Wellman, J.B. Lippincott, Philadelphia, Pennsylvania, 1939

Watt Matthews of Lambshead, Laura Wilson, Texas State Historical Association, Austin, 1989

We Pointed Them North: Recollections of a Cowpuncher, E.C. "Teddy Blue" Abbott & Helena Huntington Smith, University of Oklahoma Press, New Edition 1955

Photographer's Notes

I can't believe this book is finally finished. Seeing its completion makes me both happy and sad—happy because I believe it is an outstanding testament to the Texas cowboy, sad because I am going to miss the great road trips I have taken with Tom B. Saunders. During our travels, Tom B. and I visited 23 different ranches within the state of Texas, and photographed more than 120 cowboys as they went about their daily work.

We did the best we could, but could not possibly photograph all the ranches in Texas. There are simply too many ranches and too many cowboys. Picking the right ranches and cowboys involved many difficult decisions. What we have tried to do in this book is to show a good cross-section of the ranches in Texas and the men who work on them.

We gave a lot of thought to our choices, and now, three and a half years later, I truly feel we were lucky to find some of the best. I hope you agree.

Technical Notes

David Stoecklein uses Kodak film and Canon cameras exclusively for all of his commercial photography, as well as for his books and calendars. All of his film processing is done at BWC in Miami Beach, Florida and the gallery prints are done at BWC in Dallas, Texas.

Some of the images from this book can be seen as limited edition iris prints in Dave's photographic exhibit, "The Texas Cowboys," co-produced as a traveling exhibit with the staff at the American Quarter Horse Heritage Center & Museum in Amarillo, Texas. All of the images from this book are available through our office in Ketchum, Idaho. For more information about custom prints and Dave's photographic exhibit, give us a call at 1-800-727-5191.

Other books by David R. Stoecklein

Sun Valley Signatures III—a beautiful coffee-table book featuring photographs of Sun Valley, Idaho, and its surrounding areas.
The Idaho Cowboy—capturing the life and times of the Idaho Cowboy, this book has become a classic western volume.
Cowboy Gear—a photographic portrayal documenting the early cowboys and their equipment, this coffee-table book features real cowboys in authentic 1800's to pre-1930's gear.
Don't Fence Me In, Images of the Spirit of the West—this photographic portrayal of the modern-day cowboy preserves the tradition and heritage of the American West.

Other books published by Stoecklein Publishing:

Trail Dust and Saddle Leather, by Jo Mora
Californios, by Jo Mora
Budgee Budgee Cottontail, by Jo Mora
Jo Mora: Renaissance Man of the West, by Steve Mitchell

Every year, Stoecklein Publishing produces a line of wall calendars, prints, and cards featuring the western photography of David R. Stoecklein.
For information please write or call:

Stoecklein Publishing

Tenth Street Center, Suite A1
Post Office Box 856
Ketchum, Idaho 83340
208/726-5191 FAX: 208/726-9752
Toll free at 800/727-5191

THE END

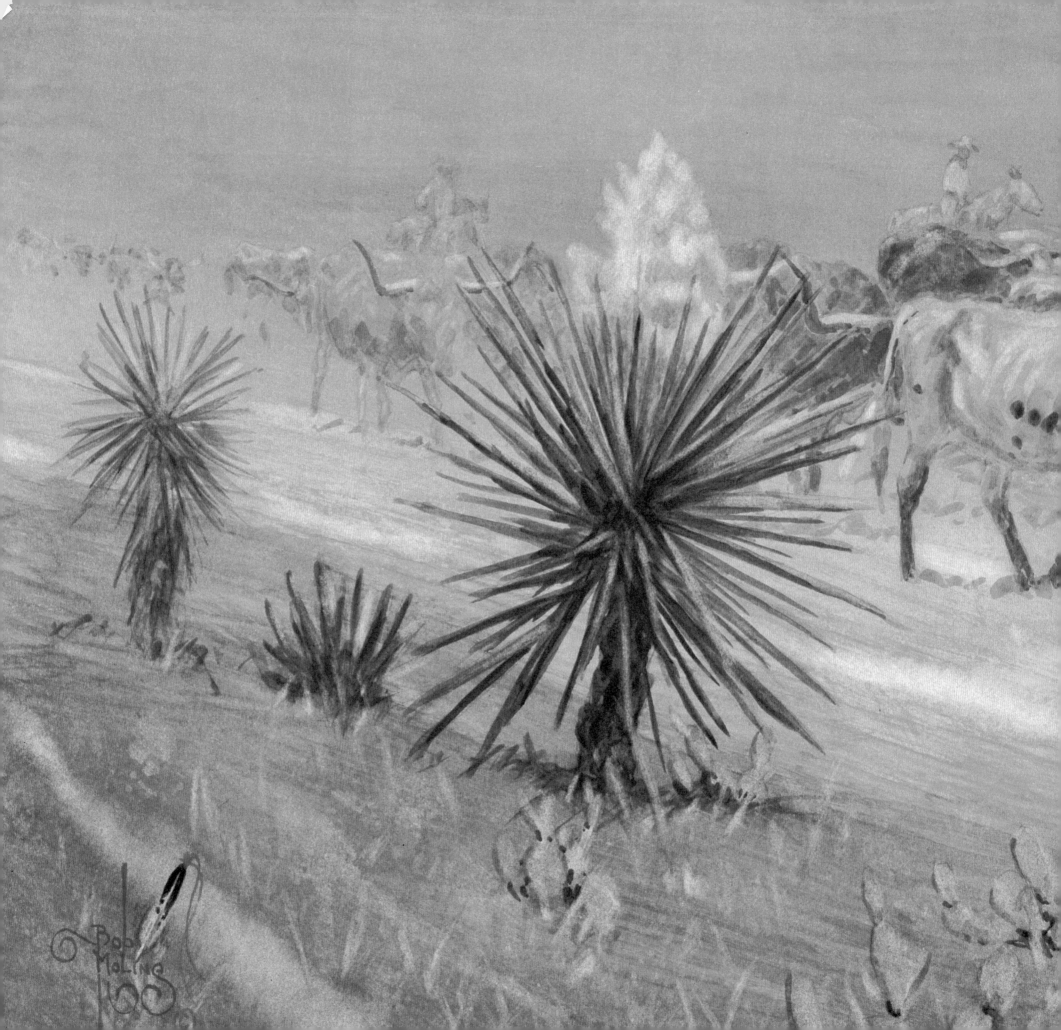